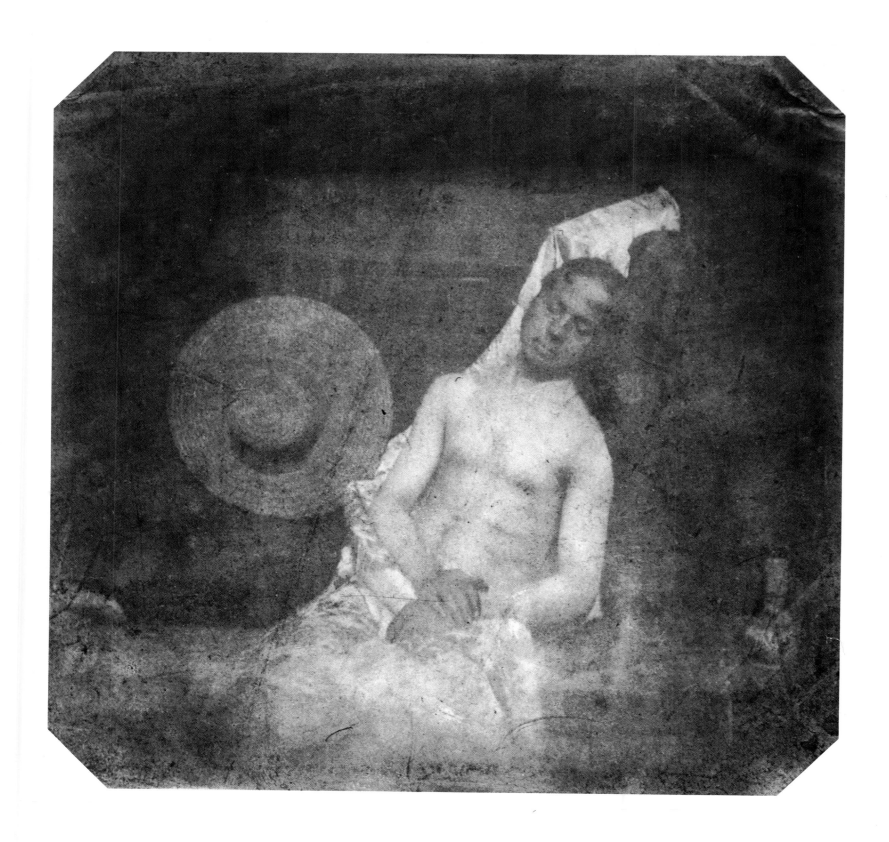

Bruce Bernard

THE SUNDAY TIMES BOOK OF
PHOTODISCOVERY

A Century of Extraordinary Images 1840-1940

Notes on the Photographic Processes by Valerie Lloyd,
Curator, Royal Photographic Society

with 214 illustrations in full colour

Thames and Hudson

Frontpiece: Hippolyte Bayard
Portrait of the Photographer as a Drowned Man. 1840
Bayard's direct positive process.

First published in Great Britain in 1980
by Thames and Hudson Ltd., London

Printed and bound in Japan

CONTENTS

For Sally Bernard

FOREWORD

Bruce Bernard has written a passionate first "novel" from the raw material of his experience as a photo editor. The book grew out of a series of articles in the London *Sunday Times* magazine about the strong, mostly unpublished photographs hidden in libraries and in public and private collections. While working on the series, he developed a liking for the distinct voice of his determined eye and, like very many collectors of images, written or visual, decided to expand his enthusiasms into a book, to the pleasure of everyone who had cooperated with him on the project.

Coming from the press side of photo culture, where the public is king, Bernard knows all those professional tricks of how to catch our conscience with low-status subjects, vernacular excitement, and useless but fascinating information. Understanding the particular seductiveness of original photographic prints, he has insisted on reproducing every image in full color, and it is doubtful that the lover of photographs will ever be satisfied with less again. With a profound respect for art and a healthy disdain for much that goes with it, he has chosen artless pictures and modest studies alongside some resounding images in photographic history, thereby producing much more than a mere bombardment of the senses. This is not a revisionist history of photography but one man's biased clues as to where the treasure lies—the epicenter of photography—not dedicated to the proposition that all photographs are created equal or unequal, but that many ugly, or beautiful, untouchables have been overlooked in high places. In that sense, Bernard makes an optimistic statement about a state of health in the realm of photography.

Sam Wagstaff

PREFACE

This book originates in the belated discovery by a photographic editor that the history of photography is much more interesting than he had thought it to be. My first contact with old photographs came very early in life through my enthusiasm for the new magazine *Picture Post*. This now legendary British weekly ran a series on nineteenth-century photography, and I vividly remember the impact made on me by Robert Howlett's famous picture of I. K. Brunel against the launching chains of the steamship *Great Eastern* and by Paul Nadar's photographs of the centenarian scientist Michel Chevreul. Later on, the Gernsheims' *History of Photography* made a strong impression on me, though I confess I paid more attention to the pictures than the text. (I did not see Beaumont Newhall's history, which preceded it, until later.) But after I had looked at a very few more anthologies and monographs, I imagined that I had seen most old photographs of real interest—and also that it was enough. Since I had seen no original nineteenth-century prints of high quality, and because all photographs were reproduced either in black and white or a uniform "sepia," I could not tell what I was missing. I assumed that the unpleasant brown had been happily superseded, rather late in the day, by the more "real" black-and-white silver bromide print and the color photograph. I did not realize that economics and the taste and judgment of publishers were concealing something important from me.

I was only made aware much later of what I had been missing, when getting some features together on historical photography for the London *Sunday Times* magazine. I saw for the first time whole albums of Hill and Adamson and Julia Margaret Cameron. I was shown the entire photographic archive of Dr. Barnardo's Homes, the British orphanage that pioneered the institutional portrait. The latter demonstrated that pictures taken with no artistic motive or intention to impress can be as interesting as any others, and also that the best pictures from such archives are not always selected for anthologies, although most people tend to assume that they have been. And when the *Sunday Times* magazine was asked to celebrate the opening of the Fox Talbot Museum at Lacock Abbey, I was introduced to the extraordinary beauty and variety of color of the salt prints produced by the calotype process. It became clear that Talbot had taken very many beautiful photographs apart from his well-known anthology pieces, which had, anyway, always been reproduced in black and white or an arbitrary "sepia," losing much life in the process.

Some time later the editor of the *Sunday Times,* Harold Evans, who has a true passion for the photograph, suggested that the color magazine should assemble a series on great or extraordinary unpublished or little-known photographs of the past, and I began to learn a lot more. I also found that, although Europe was slowly awakening to the unexplored wealth of photographs hidden away in archives, albums, and attics, it was the Americans who were much more alive to them, as they always have been in a real sense (perhaps because they first fully comprehended their own country through photographs). So, while André Jammes, for instance, was a relatively isolated figure in

Paris, in America many more were following the lead of people like Arnold Crane of Chicago and Sam Wagstaff of New York and starting to collect photographs with tremendous enthusiasm and no little perception. They, as well as many well-endowed museums, were attracting the world's best photographs to the United States, and during this process many narrow preconceptions about what a good photograph is were being broken down.

This book seeks to demonstrate, with a necessarily personal selection, the new historical and artistic perspective that has been opened up by these recent discoveries. The basis of my choice has been that I have had to be able to sustain my first interest in each photograph after long reflection and many temptations to switch my allegiance over two and a half years. I have sometimes resisted a picture offered and have had to be persuaded by the nagging memory of the image itself to let it in. The collection, as it grew, sometimes seemed to close ranks and not admit a candidate I favored, and, conversely, one "curiosity" I would never have thought I could seriously consider (plate 126) seems to have insinuated itself. All the images had to be relatively unknown, certainly to the larger public, although I have broken that rule at least once, in the case of Paul Nadar's photograph. Also they have all been chosen as images in their own right and never only as documents or anecdotes, and I have particularly responded to pictures that do not seem typical of their time and that seem to foreshadow our own pictorial sensibility. While the collection cannot claim to be systematically instructive or comprehensive, I hope that, in its own way, it covers the different possibilities of photography demonstrated up until 1940. I have stopped there because I think that the range of pictures in photography's first hundred years does tell one sufficiently about further possibilities demonstrated since then and, also, that there is a kind of finality about the epoch preceding the Second World War. I have included most but not all of the photographers I consider to be of the first rank, but no one new to photographic history should think all are represented by their most characteristic work. The opposite is as likely to be true.

This anthology's chief purpose is to stimulate and restimulate interest in the photograph's past and, consequently, in its present and future. I am sure that the distortions of my own personal perspective can quickly be corrected by consulting other more expert and balanced works and looking at as many good and bad photographs as possible. Original prints tell one much more about photography than even the best reproductions.

My chief hope is that the pictures in this book will show all but the most knowledgeable reader—as the discovery of the pictures showed me—that the invention which so excited and alarmed the world a hundred and forty years ago has produced a more exciting, and sometimes more alarming, variety of images than he or she had ever thought possible.

Bruce Bernard

INTRODUCTION

This collection of photographs is intended to be a celebration of the achievements of the first hundred years or so of photography, presented in a way that enables the pictures to be enjoyed or experienced for their own sake. Books concerned with technical or aesthetic history have never quite managed this, so that photographs of the more distant past have been shown to us in anthologies in a way that does not really do them justice. This is not to deny the value of these books; it is just that, since they are works of historical analysis, the selection and juxtaposition of their illustrations cannot adequately isolate the triumphs (or the really interesting curiosities) of the photographic art, and must indeed demonstrate its technical limitations and occasional absurdities. Thus, portrait daguerreotypes and salt prints are often chosen in which people's heads look positively clamped for a long exposure, rather than those which managed to look instantaneous and natural. And follies (admittedly not without interest) like Henry Peach Robinson's *Fading Away* and Oscar Rejlander's *The Two Ways of Life* are given as much space as the best works of Fenton and Nadar.

This historicist bias also tends to pick photographs which date themselves emphatically with costume and props, rather than those which do not give their age away. Engineering projects of the nineteenth century always seem to have figures with stovepipe hats on, while other very good pictures without them are passed over. And we all tend to go along with this bias because of our own involuntary feelings about photographs and our appetites for historical curiosities. For everyone, photographs have been vehicles for nostalgia and elegy about their own childhoods and the lives of their parents and grandparents. The artistic and technical weakness of most family photographs gives us portraits and scenes which are not fully realized images and are therefore poignantly elusive. We come to think that a kind of negative pathos is a more essential characteristic of the photograph than it is, though admittedly it can never be far away in a process that must concern itself with fleeting moments and unique occasions. But if we look at the best photographic portraits of people now dead, the better they are, the more dry-eyed we remain. A good, unfaded portrait of a hundred and twenty years ago can be truly death-defying and give us something of the sensation of a stimulating personal encounter. And the streets of Paris recorded by Marville and Atget before their destruction were preserved for us by photographs in a real sense, whatever elegaic undercurrents we are bound to feel in them.

The anthologies, because they generally integrate the text with the pictures, also give the impression that the individual photographic images do not stand up by themselves, and that the cumulative effect of a series with words, as in a lantern-slide or television lecture, is the best way of getting an idea of them. Such works do not differentiate sufficiently between real photographic achievement, the illustration of social and general history, and the making of photohistorical points. In recent years, though, the status of both the historical and the contemporary photograph has radically changed. Individual photographs are much more keenly appreciated by many more

people, not so much as historical evidence as for their existence as images in their own right, and many collectors, particularly in America and France, speak of them as such.

Those who are not partisans of this surge of enthusiasm have been shocked by some of the prices that have been paid recently in the auction room for a commodity thought.to be so easy to reproduce without appreciable loss of quality (surely the point of negative-positive photography?). But the fact remains that, even where the negative of a nineteenth-century photograph still exists, no amount of skill in printing will produce a picture as authentic as one made by the photographer. Indeed, a print could even be made too well in the case of those photographers whose primary concern seems not to have been perfect print quality. Atget is perhaps an example. And a very few prints do somehow gain in beauty from age. There is occasionally something fitting about a photograph showing victorious scars after its battle with time. I think that the only really famous picture in the book—that of M. Chevreul, a centenarian who had also won through (plate 115)— proves this. Time has also strangely but effectively vignetted the marvelous news agency picture of Karl Liebknecht speaking at the Spartacists' graveside (plate 176). On the other hand, a perfectly preserved albumen print of the 1850s, and until recently it was believed that there were none without some flaw, is an even greater triumph which the best modern print from the original negative could not replace. Not only is it almost certain to be a more authentic interpretation of the negative, but also, surely, a small but very important part of the sensation we get from all visual art depends on our knowing that we are in the presence of the original achievement.

Another aspect of historical photography that is played down—partly for reasons of publishing economies and partly because it has not been considered sufficiently important—is the variety of color that can be found in earlier monochrome photography. Black-and-white and color photography are now entirely distinct and separate practices, and sepia or color toning is generally seen only in commercial parodies of old photographs. But in the beginning, though color photography was devoutly wished for and hand tinting began immediately (Hippolyte Bayard painted over some of his early prints so thickly that they cannot be distinguished as photographs), black and white was not considered the alternative. In European art it was for a long time thought appropriate only to replicative processes like the woodcut and engraving. Artists nearly always preferred sepia inks, red, brown, and white crayons, and tinted papers for drawing, since with them one or two colors could seem to embody all color. When Talbot found he could not get a uniform tint from his process because of chemical impurities and inconsistencies in the papers he used, he commented, "These tints might undoubtedly be brought nearer to uniformity if any great advantage appeared likely to result, but as the process presents us spontaneously with a variety of shades and colour, it was thought best to admit whatever appeared pleasing to the eye" (*The Pencil of Nature*). The range of colors he achieved included lilac, ochers, and near crimsons among many others, and though

a reasonable soft black could be obtained from the process, he did not pursue it. Then, as photographers gained more control over color, they favored the tints that seemed to them expressively right.

It is impossible to imagine, for instance, the work of Captain Linnaeus Tripe (plate 60) looking right in any other color than his beautiful purplish-pinkish black. Later on, a very satisfying rich and soft black could be obtained from the carbon print, which can be seen at its best in the photographs by Adolphe Braun (plate 83) and Etienne Carjat (plate 112). Black and white had been used before that only in photolithography (as in plate 20, the Chartres of Henri Le Secq), which seemed right to publishers in the same way as it had with artists' engravings. As photographs began to be reproduced in portfolios and books in the 1850s, they were seen in a context where woodcuts and engravings were the norm. By that time, Blanquart-Evrard, who also made beautiful photolithographs, had modified the calotype process to produce a photographic proof which appeared very black and fine-toned and was very close to the quality of a lithograph, as can be seen here in the pictures by Auguste Salzmann printed by the Blanquart-Evrard process (plates 29 and 30).

Black and white did not become the true "color" of photography until the early twentieth century, when in spite of the passionate rearguard action of the pictorialists, newspaper reproduction made it the authentic purveyor of stark reality and public events. Many photographers stayed with the soft and subtle grays of the platinum process until it became very expensive after the First World War; quite soon after that, those who considered themselves in the vanguard of photography embraced the black-and-white silver bromide print as an aesthetic in its own right. With its aura of authenticity it seemed forthrightly to reject the effete artiness of the pictorialists, and to distinguish photography more clearly from "art" in general. Color photography seemed to them fit only for advertising, fashion, and ephemeral magazines, though Paul Outerbridge, a commercial photographer, used his skill and the carbro color process to make powerful images (plate 210) which, along with the work of a few others, seemed the most exciting use of color since the introduction of the autochrome. (Although capable of producing beautiful images, the autochrome was in the form of a glass transparency and was, therefore, inaccessible to comfortable inspection.)

Many photographers demonstrated that black-and-white bromide need not be hard or unsubtle. Edward Weston is subtle indeed within his rigorous code of photographic purity. August Sander is another great figure whose pictures (plate 178) would not look right in any other process, and Martin Chambi's wedding picture (plate 196) infuses deepest blackness with the gentlest poetry. Even straight news agency pictures (plates 176 and 199) can give us stunning images which we would not wish otherwise. They are often better, though, when time has broken down the pure blackness. They then acquire, sometimes only subliminally, some of the resonance of earlier processes. It seems

quite clear that, for the future of serious photography, black and white and color will pursue their distinct courses (while often being used by the same photographer). One can hope, however, that the photographic companies, now much more concerned with the mass market than with the professional's or artist's requirements, might find ways of refining the black-and-white process still further. Such new methods might regain for black and white the tonal subtleties and detail of the older large-format monochrome photography without sacrificing the maneuverability of the small-format camera and at the same time might increase film speeds. A great increase in the speed (and quality) of the best color film as well could be technology's last major gift to the photographer.

Many of the photographs in this book are imbued, or partly imbued, with painterly sensibility. This should not seem surprising or reprehensible, because until photography was invented, painting and drawing were the principal ways human beings realized and organized their optical sensations into coherent images on a flat surface. Indeed, many early photographers were painters, of varying accomplishment. Photography has since found many more essentially photographic ways of seeing the world and has educated our vision by making fixed images of things otherwise only momentarily glimpsed and not remembered or valued. The painterly thread, though, runs through the history of photography until the present day, just as painting continues to respond, positively or negatively but definitely, to photography.

Painting and photography have a complex and indissoluble relationship which can be said to have existed long before the achievement of the photograph, or even the invention of the camera obscura. To put it in this way is to emphasize that, for millennia, one of the aims of art has been to achieve illusions of reality, so that painting and other visual art forms have been pursuing and gaining part of the purely replicative capability of the camera for a long time. Precise definition, the freezing of movement—even what Henri Cartier-Bresson named the "decisive moment"—can all be seen in art hundreds of years before Niépce produced his crude but historic image of the view from the window.

In thinking about the relationship of art and photography while preparing this book, I have been more struck by the way they have adumbrated qualities in each other than by how they have influenced each other in the ordinary chronological way. Much more interesting than the painter's pursuit of trompe l'oeil (which only really occurs in photography in stereoscopy and, recently, holography), or the camera obscura's influence on Vermeer or perspective in art, are moments like Rembrandt's seeming emulation of a modern photographer in *The Syndics of the Clothmakers' Guild*,

where the man on the left has paused in the act of sitting down and the whole group seems to be looking at the artist with surprised respect. It is as if Rembrandt had produced a camera instead of his brushes; the result is a photographic "decisive moment" as well as a very great painting.

Recently I noticed for the first time that Daumier's revolutionary little street paintings of around 1840, when the photograph was barely invented, look very like the 35mm reportage of the 1930s and much later. Then it struck me that in the salt prints of the 1840s and early 1850s by Talbot, Salzmann, Robert, and many others one can detect, if one looks at them afresh, the presence of Cézannesque "modulations." It seems as though the camera is translating space and volume into marks of varying weight on the picture plane, and deliberately avoiding illusion. The lack of detail inherent in the plain paper negative is certainly partly responsible for this quality, but photographers perhaps unconsciously exploited it. Also, the fact that they saw an inverted image in the ground glass screen may have encouraged an abstract bias in their picture making. Later, after the Impressionists' enthusiastic (if not always acknowledged) incorporation of some of the optical principles and involuntary naturalism of the camera, we find a great painter, Seurat, both echoing the structural and spatial character of the salt print (Henri Le Secq's public bathhouse, plate 21, reminds me of Seurat's *Le Parade*) and at the same time seeming to coinvent the autochrome, with its little dots of colored starch, more than fifteen years before it appeared. This interaction between painting and photography can seem almost like a time warp, a curiously mistimed attempt at cross-fertilization between two different kinds of image making. The arts, being continuous processes of discovery, inevitably have an incomplete awareness of their own natures, and these two uncomfortably closely related ones have mainly been able to acknowledge only the more obvious aspects of their effect on each other. We know that the caveman drawing an animal on stone, perhaps to bring himself luck in hunting, could not have acknowledged that he was making the invention of the camera inevitable any more than Talbot could admit to a relationship with Mondrian, if we were in a position to suggest it to him.

It is important to remember how the actual temporal relationship of photography and art had its sticky beginning, and what a dreadful panic seized so many painters at the sight of their first daguerreotype. One cannot help wondering whether the agonizing that continued for at least a century after that was entirely necessary. When the painters had reassured themselves about their survival, it was the turn of the photographers to worry about their artistic status. Many of them still do, however much they deny it is no longer an issue. It seems likely that most issues which have only been resolved painfully have needed at least some of the pain for their resolution, but it seems a pity that all painters could not have been like Delacroix, or like Degas, of whom Paul Valéry wrote, "He loved and appreciated photography at a time when artists despised it or did not dare admit that they made use of it." (Degas's teacher, Ingres, had been secretive about his use of daguerreotypes.)

14

And why should Peter Henry Emerson, who took such beautiful photographs of Norfolk people and landscape, not have been content with doing just that, instead of needing to feel so sure that he was practicing high art. It is interesting that he did take some of his best (and most artistic) photographs after he had concluded with bitterly expressed disappointment that photography was hardly art at all.

"From today, painting is dead" is perhaps the most ill-judged would-be momentous statement ever made, and it was made by an able but second-rank history painter, Paul Delaroche. "From today, painting is not alone" would have been less dramatic, but more accurate. But then even a great painter, Turner, exclaimed with what must have been a real sense of pain, "This is the end of art. I am glad I have had my day." Both reactions demonstrate vividly the impact of the photograph on artists. Turner thought of himself mainly as a purveyor of true optical sensations, and to witness a machine, the daguerreotype camera, doing something so well so early in its life must have been a considerable shock to someone so conscious of his own great technical powers. Fortunately, though, he was soon trying to learn from daguerreotypes. He even took a keen interest in some portraits of himself taken in Regent Street by Mayall with "Rembrandtesque" lighting, which have unfortunately been lost.

John Ruskin was meanwhile (in 1841) "enchanted" with the daguerreotype in Venice. "Daguerreotypes taken by this vivid sunlight are glorious things," he wrote. And also, "Among all the mechanised poison this terrible 19th century has poured upon men, it has given us at any rate one antidote, the daguerreotype." In 1868, however, the former handmaiden of art was dismissed. "They're not true, though they seem so. They are merely spoiled nature," he warned his students at Oxford, having concluded that photographs were at best of dubious value to artists.

Baudelaire's famous polemic of 1859 against the influence of photography on art was really directed more against the artists of the Salon and the philistine public than against photographers, but his strictures seem very harsh when we can see, by looking at the earlier pictures in this book, what beautiful photographs had been taken in France during the first twenty years. "A vengeful God has granted the wishes of this multitude, Daguerre was his Messiah. And now the public says to itself 'Since photography gives us all the guarantees of exactitude that we could wish (they believe that, the idiots!) then photography and art are the same thing.'" And then, discounting any idea of peaceful coexistence, he continued, "Poetry and progress are two ambitious creatures who hate each other instinctively. And when they meet on the same road, one of the two must give way to the other." Baudelaire concluded his denunciation by insisting on photography's permanent subjection. "It must return to its real task, which is to be the servant of the sciences and the arts, but the very humble servant, like printing and shorthand, which have neither created nor supplanted literature." This is stirring stuff which makes one want to seek out and contemplate the best image of the poet,

a photograph by Etienne Carjat, which is perhaps a better portrait than Courbet's painting of him. (Courbet, incidentally, was not at all reluctant to use photographs as a basis for his landscapes.)

At the end of the century, after the enormous but often unacknowledged influence of the camera on the Impressionists, organized movements staked the most earnest claims yet to photography's being an art in its own right. Starting with such groups as the Linked Ring in Britain and the Photo Club de Paris, the leadership was eventually taken over by the Photo-Secession of New York, led by the charismatic Alfred Stieglitz, who had strong European connections. Some members took straight objective photographs, using straight refined processes like the platinum print. Frederick H. Evans, a great British photographer (plates 153 and 154), is a good example. Others made extraordinary pictures by the shameless manipulation of new processes like the gum bichromate print. Although some of these images cannot escape provoking ridicule or, at best, patronizing approval, it is surprising what good pictures many of them are. I think the most interesting example here is Robert Demachy's *The Crowd* (plate 160). Demachy's work is usually weakly erotic and not graphically very strong, but here he has taken a snapshot of a street melee and submitted it to aesthetic handwork. He has further distanced but not destroyed the dramatic reality, and has made one of the most interesting pictures in the book.

The rare print of *The Crowd* comes from the collection of Alfred Stieglitz, who kept cool in the artistic hothouse he presided over, only rarely manipulating his own pictures other than by strictly photographic means. Stieglitz was a great photographer, but his most celebrated picture and his own favorite, *The Steerage*, has become the kind of icon that dominates public attention, as some paintings do, to the detriment of a true appreciation of what an art is really about. Apart from its interesting though somewhat unsatisfactory composition, the picture seems to me to be about a first-class passenger getting a rather ingenuous sense of revelation about the predicament of the other ninety percent of humanity. But, on the whole, Stieglitz's work is full of skill, variety, and imagination, and I am pleased to have found another of his many extraordinary portraits of Georgia O'Keeffe and his rather shocking but beautiful snapshot (plates 171 and 172).

The other members of the Photo-Secession and its allied movements who made especially good photographs are, I think, Alvin Langdon Coburn, Gertrude Käsebier, Heinrich Kühn, and a great master of photography, Edward Steichen, who was originally a painter. From his beginnings as one of the most painterly photographers, and later in his work in the fields of fashion, aerial reconnaissance during the First World War, and portraiture, Steichen proved himself one of the dozen or so great photographers of the century. (I used to think Steichen half-spoiled by a kind of portentousness, but later decided it was true grandeur.) It is being able to speak of great photographers only in such small numbers that testifies to the very special talents that photography demands. Photography is one art that one might think fairly easily mastered by its better critics, as it is within almost anyone's technical reach, but it resists all but the truly gifted.

16

Alvin Langdon Coburn was the first to make consciously "abstract" photographs, with his Vortograph having a direct relationship to Vorticist art, the British version of Futurism. Christian Schad, Man Ray, and László Moholy-Nagy, also painters among other things, followed by reviving Talbot's photogenic drawing in the form of Schadographs, Rayograms, and Photograms with more sophisticated technique and entirely nonrepresentational aims. Man Ray, one of the great twentieth-century photographers but a considerably less than great painter, said one of the most willfully ignorant things ever said about painting and photography in an interview in *Dialogue with Photography* by Paul Hill and Thomas Cooper. Explaining that he painted what he could not photograph, and photographed what he could not paint, he said, "I think the old masters weren't artists, they were just good photographers before the camera was invented." I find his straight portrait photographs more rewarding than the Rayograms and Solarizations, though the latter are well worth looking at. Moholy-Nagy was also a painter who took a wide range of photographs which, apart from the Photogram, extended from straight reportage on subjects like Eton College and London street markets to very spare and sophisticated photographs that depended on being taken from beautifully conceived and original angles. Sam Wagstaff has a marvelous Moholy Photogram which looks like pure design of the highest order, with hardly any photographic characteristics at all—so much so that it seemed it would be an alien presence in this book.

Since the 1930s, and after the period covered by the pictures in this collection, the direct influence of photography on painting has been most notable in the work of a major European painter, Francis Bacon. At one time Bacon was deriving most of his imagery from Muybridge's studies of human and animal motion and from other photographic sources, such as the still of the nurse from Eisenstein's *Battleship Potemkin.* He has also used photographs for nearly all his portraits. Other painters, among them the Pop Artists and Photo-Realists, have exploited them in various ways, and now photographers are getting pictures into galleries normally devoted to painting by attaching captions to their pictures describing how and when they were taken, or simply nominating them as equivalents to painters' pictures. The uncomfortable dialectic, with its evasions and its hostile undertones, will no doubt go on indefinitely. Photographers will continue to mutter an echo of Edward Weston's rash words about "soft, gutless painting," and painters will still continue to think that photographs can achieve the status of true images only when processed by them.

The trouble is that both photography and plastic art at their most ambitious are aiming at the same thing—the creation of an unforgettable and inexhaustibly interesting image. There can never be perfect peace with such an objective shared. But of course that is not the whole story. Many photographers are far from resenting painting's special capacities for invention and expression; many painters have an enthusiastic and friendly interest in photographs.

Only one thing is certain: both painting and photography would be completely different from what they are today if, impossibly, during their coexistence neither had known about the other.

The camera has been found to favor certain subjects and certain people, and in the past photographers have also tended to be specially attracted to a limited range of subjects. This may be much less the case today. Nevertheless certain archetypical subjects will probably always dominate photographic picture making just as they do figurative painting. This book contains 158 photographs in which people are the main subject or of crucial importance to the image and only 56 of inanimate objects, still lifes, landscapes, and architecture. Since the proportions of subject matter here have not been determined by any principle of choice other than strength of image, it seems that the most photogenic subject must be the human being, and that the evocation of the human presence confers a power on photography before which all its other capabilities pale. There are an infinite number of valid ways to photograph people, but perhaps this selection proves that the best individual portraits are those not submitted to with enthusiasm. They may be those in which the subjects defy the camera to underline their mortality or take away their spirit (or a thin spectral layer of their physical being, as Balzac believed it did), and consciously and confidently put aside their reluctance, as blood donors do. Inferior cheerful snapshots are much more likely to provide the memento mori, with their sense of fleeting moments insecurely captured.

What good photographs emphasize best to me is not human mortality, but human endurance, and a very photogenic aspect of that is human beings at work or standing by their work. No other means of representation has ever done the subject as much justice, except perhaps the works of Van Gogh in the more generalized way that painting has. It has never been a fundamental subject of painting, but the camera has shown us what is known as the dignity of human labor more eloquently than any other medium. It is a pity that the camera did not record the building of the pyramids or of St. Petersburg. People would then not so readily name the pharaohs or Peter the Great the builders of those places. To imagine the laboring masses of antiquity is difficult, and neither nineteenth-century Salon painting nor Hollywood has been any help. Photography, though, has struck a blow for "democracy" and mutual human appreciation. America has predictably excelled in this romantic-realist genre, and it is not surprising to find that many British photographs of the kind show the worker looking diffident rather than proud, implicitly deferential to the providers of labor. The sickle grinder (plate 46), though, is a freelance artisan, determined to look like a yeoman of England and just succeeding. I think that easily the best picture of workers in this book is German, and entirely free from any feeling of the Teutonic work ethic—the August Sander masterpiece of the tailors (plate 178), quite different in feeling from nearly all others in his great photographic catalogue of the German people.

Some of the most powerful photographic images ever made depict another form of human endurance, war, but it is doubtful if they have done much to discourage it. Our tendency to get grim satisfaction from disaster and our relief at our own absence from the scene, together with the fact that the camera's record is only visual, make photography, I think, a poor force for peace. It has

even, in fact, been used to provoke the desire for revenge and resistance by showing the enemy's destructive power. "Optical gluttons feeding on the misfortunes of others," O. Henry called the photography of suffering, with some reason. The photograph of the dead soldier (plate 81) is a powerful testimony to our brutal curiosity, because as a stereocard it enabled virtuous Yankees to look at a dead Confederate by their own firesides, just as today we watch the deaths of both "friends" and "enemies" on television with some detachment unless we are strongly partisan or we know and care about someone who is there. I do not share Susan Sontag's opinion that the photograph helped end the Vietnam War (though admittedly I'm not American), although it did produce some of the strongest and most harrowing pictures from any war and the ones from My Lai did provoke a strong feeling of outrage. I think that the seated Civil War amputee with his rather arrogant stoicism (plate 79) tells us as much about the folly of it all as any, and that it is not quite enough. The question arises of how much we are entitled to expect from photographs; moral enlightenment should perhaps come from several sources, with photography helping as best it can.

Photographs can make some things achieve the symbolic quality which we endow them with in our thoughts and dreams, but which they do not properly convey to us in visual reality. Ladders and bridges are examples. No ladder in reality or in a painting seems the symbol of upward progress that we know it to be, and no real bridge, however graceful or majestic, looks quite the symbol of joining two otherwise unjoinable places that it does in a photograph. There are many ladders in early photography (plate 1); bridges come a little later, and all structural steelwork is photogenic. We have also a destroyed bridge (plate 92) that seems equally symbolic.

The waterfall and the torrent are other subjects very susceptible to the camera. Water in movement too fast to be frozen by earlier slow film becomes a wonderful and unearthly substance (plates 66 and 87), and the happy absence of sound in photography is an important part of this magical metamorphosis. (Photographs can be said to be quieter than paintings and drawings, as their actual moment of creation is entirely noiseless and they somehow convey this. There is none of the rubbing or scraping or muttering that one can often feel in painting.) With the faster exposures that became possible late in the nineteenth century, as in the beautiful Niagara of plate 122, water as we recognize it is breaking in but not enough to spoil the unearthly sensation. It is interesting that there have been no really great photographs of waterfalls since all film became relatively fast. Niagara can look very banal in modern photography. This is not to suggest that real waterfalls are not at least as exciting as the older photographs of them, but I think that great waterfall photographs clearly demonstrate that the art of photography lies in the recognition of its inability to record things exactly as we see them and, conversely, its ability to show things to us in ways we could not imagine without it. The person who can identify with and manipulate this equation is a photographer.

The nude is, of course, photogenic and compelling in a special way, as it is the medium that first satisfies nearly everyone's curiosity about nakedness and sex. Males seem to be particularly visually

fixated about sex, but I think that is only one of the reasons that the female nude is so dominant. It is not just because she is considered a sex object, but because her body is more essentially mysterious, and an object for contemplation even to herself. After all, she is the main source of all our earthly existences, male and female. Male nudes can make good photographs, but there is no real mystery about them unless they are invested, as in plate 150, for example, with a voluptuousness which is not most people's idea of their essential character. We have two nudes here that seem artistically many years ahead of their time. Braquehais, it appears, has next to nothing to learn from modern fashionable fetishists (plate 26), and the daguerreotype of the black girl (plate 43), with its total lack of connection with concurrent painterly or even photographic notions of composition, gave me the biggest and one of the best surprises of my search.

Landscape is not primarily photogenic, but some very beautiful photographs indeed have been taken of it. Benjamin Brecknell Turner's *Sunken Road* (plate 48) is one of the pictures I like best in this collection, although it is one of two modern prints from a negative of the 1850s. I admit this at the risk of seeming to contradict my opinions expressed elsewhere herein about new prints from old negatives. I also very much like Roger Fenton's *Clouds* (plate 63), which is so different from most of the other landscapes he is justly renowned for. It seems starkly mysterious, if that is possible: the scene universal, not just English.

Architecture, though, is I think completely photogenic—from the wonderful early salt and albumen prints and photolithography of cathedrals by Nègre, Le Secq, Baldus, Bisson Frères, to the great photographs from Egypt and Palestine by Maxime Du Camp, Frith, Salzmann, Teynard, and from the East by Bourne and Shepherd, Tripe, and others. They all testify to the infinitely superior powers of the camera over the draftsman as a recorder of the reality of buildings and monuments. The information is less precise because less schematic, but it is more accurate. The sensation of real volume cannot be better conveyed, as I think some photographs in this book confirm.

The still life is interesting in that it proves itself a very photogenic subject, but is not generally recognized as a primary interest of the medium. There are not a very great many still lifes in photographic history or in this book, but they have been taken since the time of Niépce, Daguerre, Talbot, and Le Secq, and many of them are very beautiful. Most photographers of the past, though, did not take up photography with this particular subject even remotely in mind, and it is still too much identified with its wide commercial use. In this collection, Adolphe Braun is revealed once more as a great photographer with his flowers and dead game (plates 52 and 85), while Carleton Watkins, perhaps the greatest photographer of Yosemite Valley, gets unexpectedly tempted by fruit (plate 131). That remarkable, and happily still living, photographer Frederick Sommer does something very impressively nasty with a chicken (plate 212). Their accomplishments make one think the still life should be considered a more central concern of serious photography.

What can invade every subject in photography is the "surreal," and it grips us all. Reality and formal beauty are satisfying and rewarding, but for fascination nothing equals the incongruous juxtapositions and metaphors which the eye does not notice or the camera invents. The surreal can occur in all categories of subject matter. While it makes us ponder the mysterious connections between all phenomena, and can constitute much more than intelligent entertainment, it can also be an empty indulgence and a kind of aesthetic confectionery. Susan Sontag has some hard things to say about it in her collection of essays *On Photography.*

Everyone really interested in photographs should read Sontag's book. It is like a stern and articulate speech for the prosecution of photography on various charges. She accuses it of surfeiting us with images and blunting our feelings. Of distancing us from the world rather than bringing it closer. Of violating people and being "voracious." Of being essentially elegaic and in mourning for the transience of things. Also, of aestheticizing everything, making anything at all beautiful. All these and many more accusations are both interesting and necessary to consider. They have never been put as well, if at all, and their validity can clearly be seen in many pictures in this book. Photography can certainly not be acquitted with its character unblemished. But Sontag is not, I think, seriously asking for a conviction, only for a sharp reprimand for those who use or enjoy it thoughtlessly. She seems to imply, though, that because reality directly fashions its images, photography should manage to maintain a consistent level of moral or philosophical hygiene above that of other forms. Her attitude is understandable but perhaps not quite in sufficient sympathy with the emotions on which photography thrives and which brought it into being (though there is no doubt she is well aware of what these are).

Photography has certainly lost, as things must, its too briefly enjoyed innocence. While photography must always strive to recover that innocence, if it is to remain of any real value, we must acknowledge that, like ourselves, it can probably never quite do so. So I hope that the pictures in this book show, as clearly as has ever been shown in an anthology, how immutably human photography is. Also how fruitless it would be to think that there could or should be any medium of picture making that could resist being molded by the all-powerful imperatives of human expression, willful or involuntary, or that this is not, in the end, as it must and should be.

THE PHOTOGRAPHS

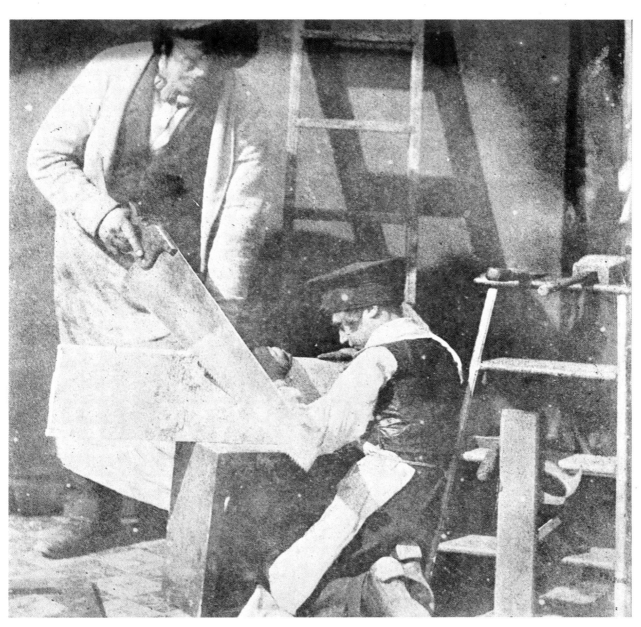

1. William Henry Fox Talbot (England).
Carpenters on the Lacock Estate. 1842.
Salt print from a calotype negative

2

2. Robert Hunt (England). Photogenic drawing. 1840s
3. William Henry Fox Talbot (England).
The Photographer's Daughter, Rosamund. 1843–44.
Salt print from a calotype negative

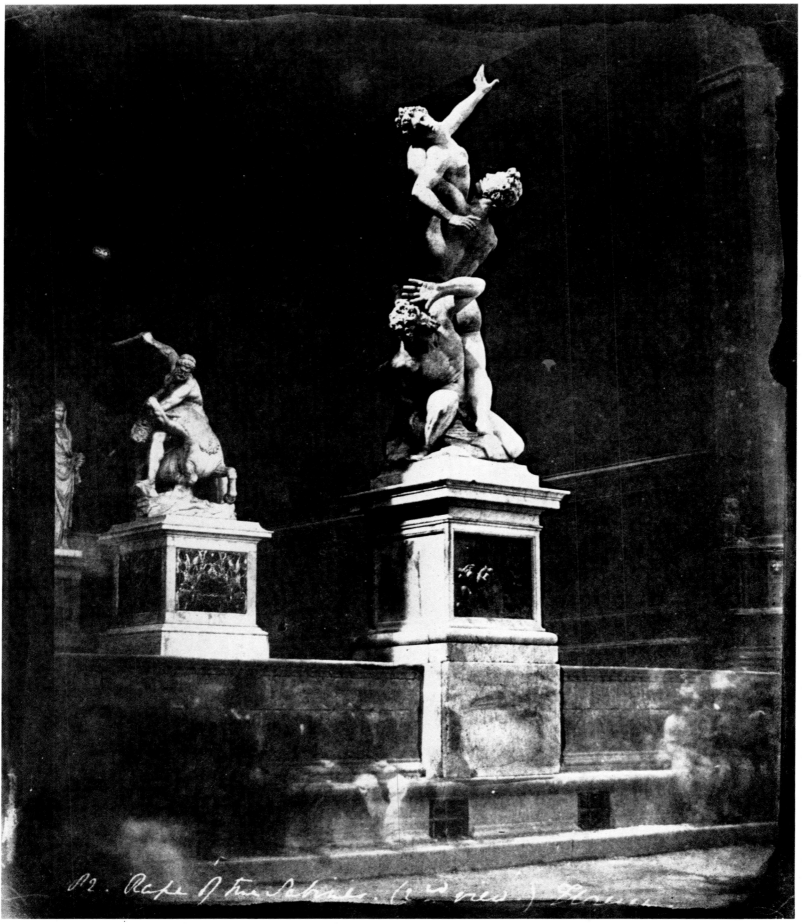

2. Rape of the Sabines. (2nd view) Florence

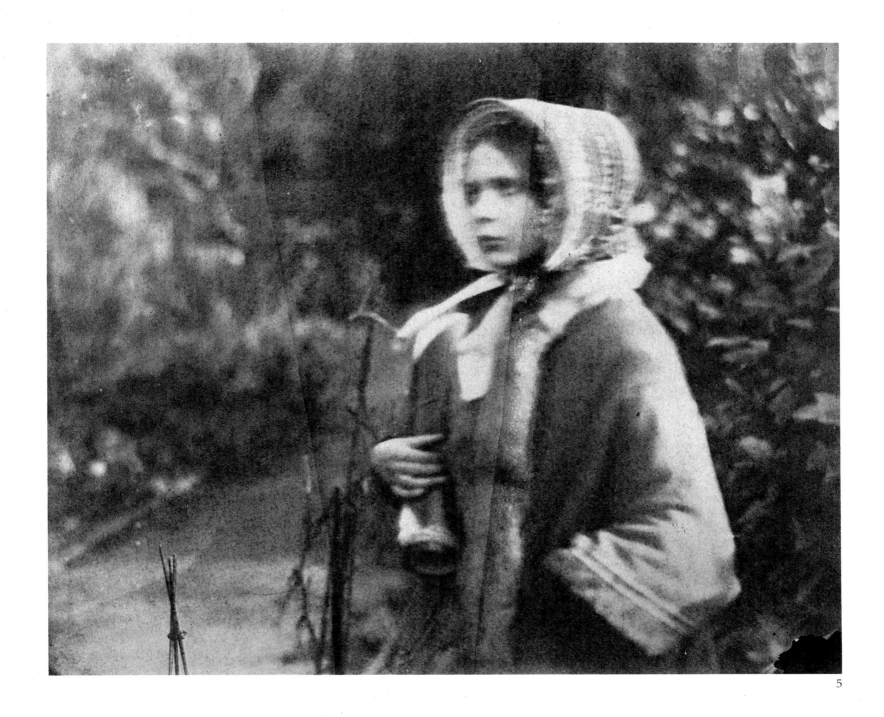

5

4. Rev. Calvert Jones (Wales).
Florence, "The Rape of the Sabines." 1845–46.
Salt print from a calotype negative
5. *Attrib.* Robert Hunt (England).
Suzanna. c. 1845.
Salt print from a calotype negative

6

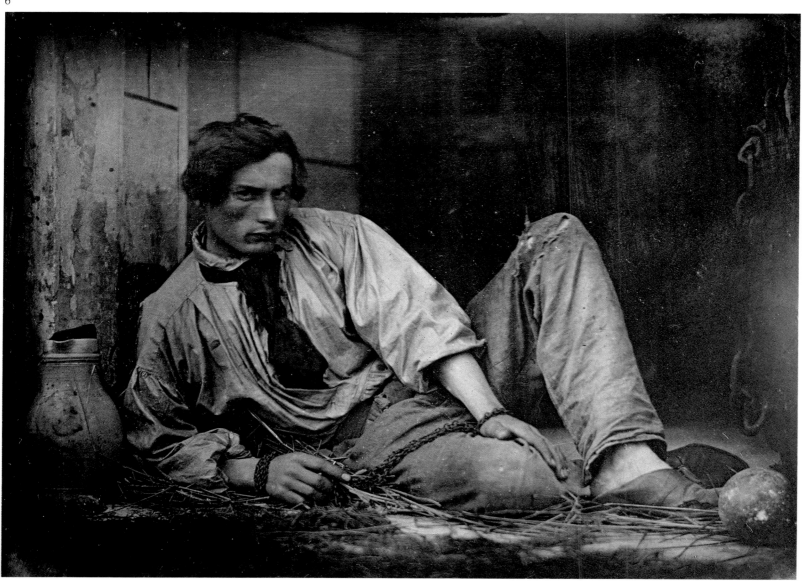

6. Baron Louis-Adolphe Humbert de Molard (France). *His Assistant,*
Louis Dodier, as a Prisoner. 1847. Daguerreotype
7. Gustav Oehme (Germany). *Three Girls, Berlin*. 1843. Daguerreotype

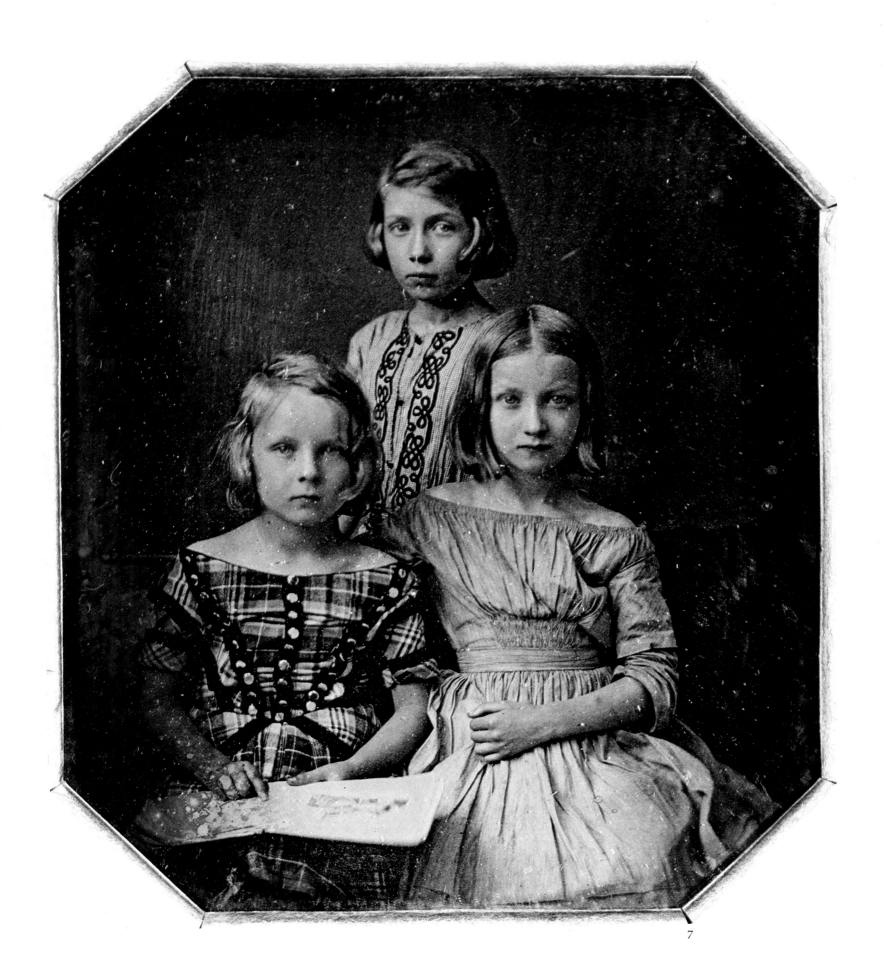

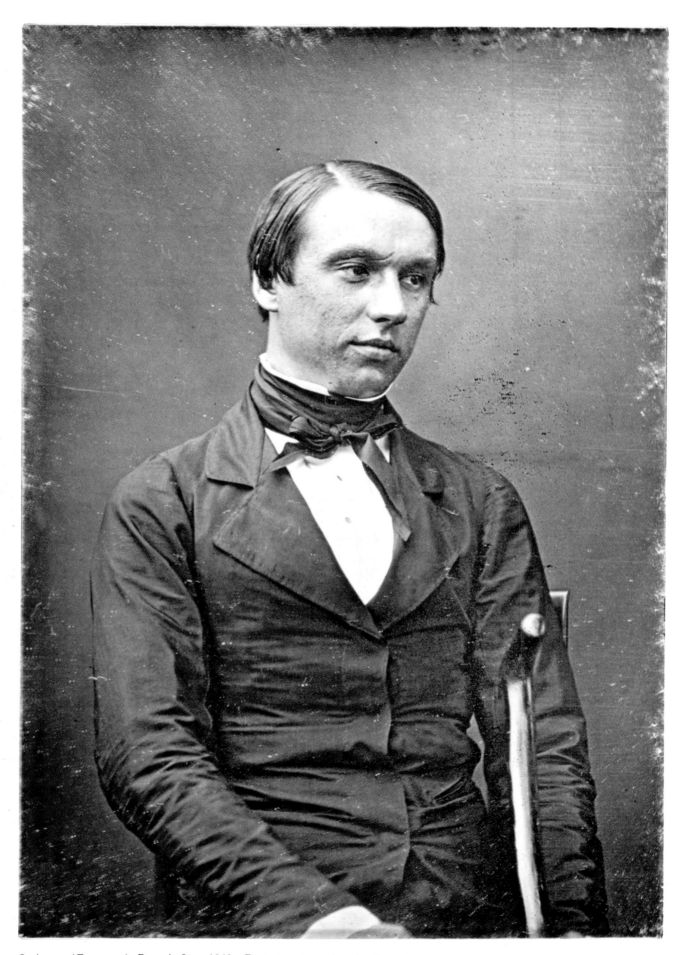

8. Anon. (Germany). *Portrait*. Late 1840s. Daguerreotype, hand-colored

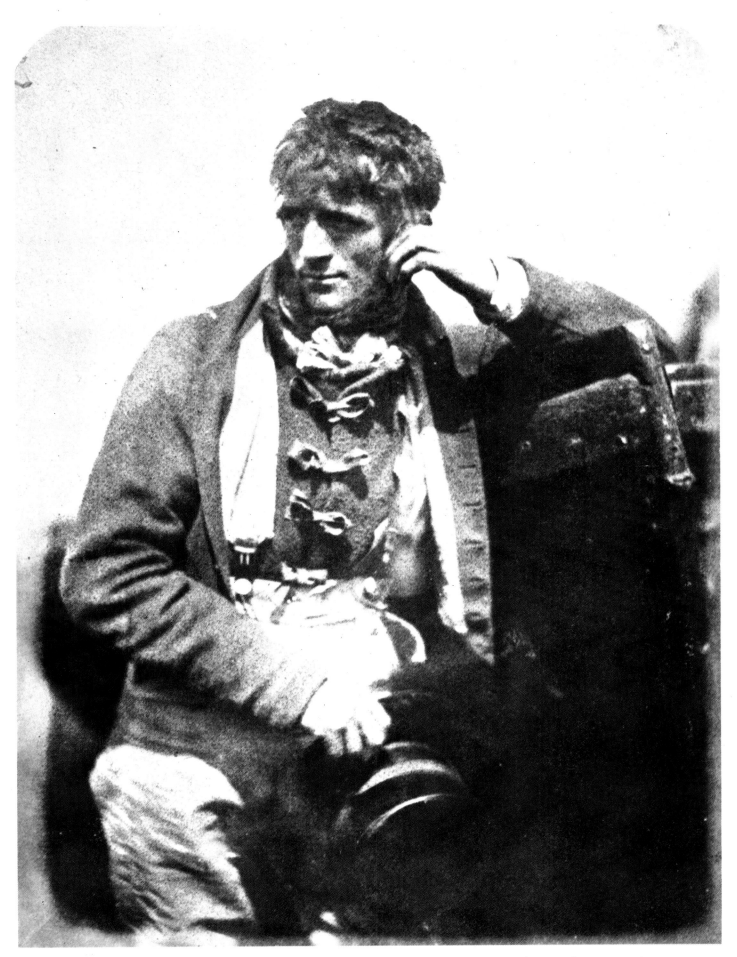

9. David Octavius Hill and Robert Adamson (Scotland). *The Newhaven Pilot*. c. 1844. Salt print from a calotype negative

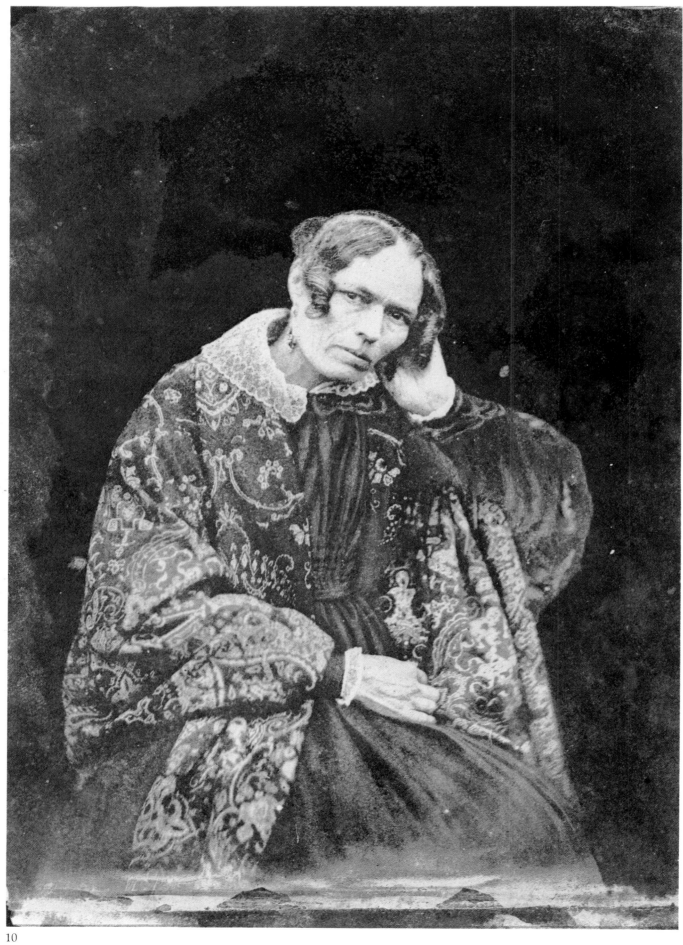

10

10. Baron Louis-Adolphe Humbert de Molard (France).
Portrait of the Photographer's Wife, Henriette-Renée Patu.
c. 1847. Salt print from a wet paper negative
11. R. H. Cheney (England). *Guyscliffe, Warwickshire.*
Early 1850s. Albumen print from a calotype negative

12

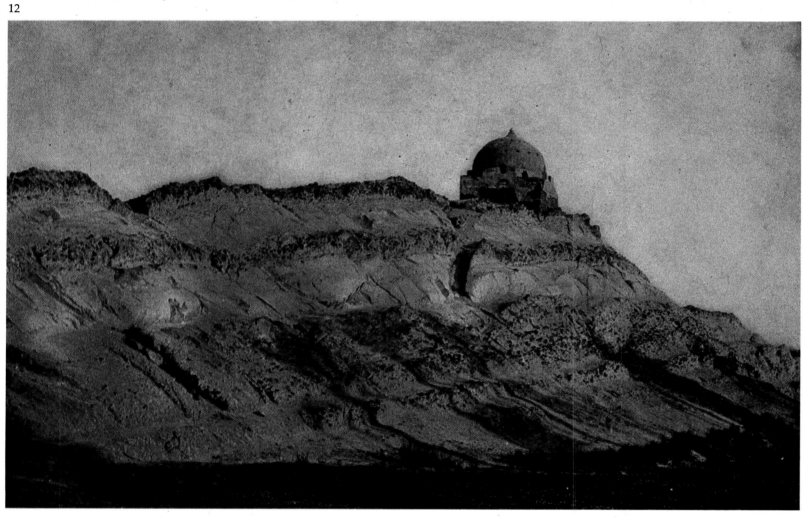

12. Maxime Du Camp (France). *Middle Eastern Subject*. 1849–51.
Salt print by Blanquart-Evrard
13. **John McCosh** (Scotland). *Burmese Girl*. 1852. Salt print

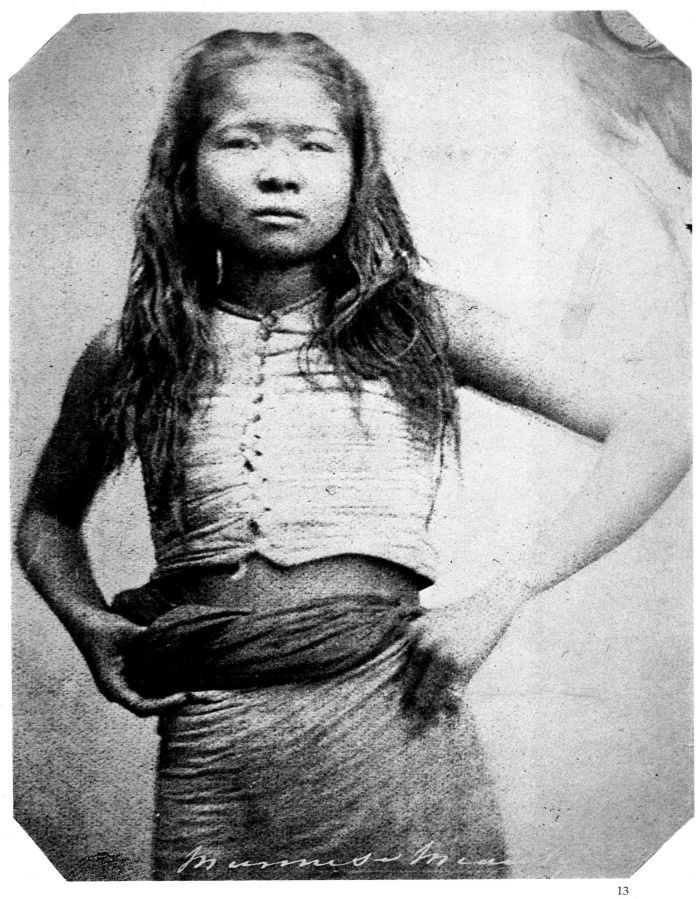

Burmese Men

13

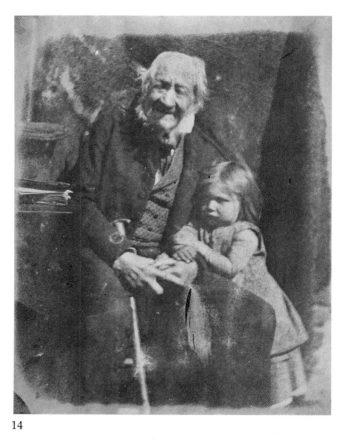

14

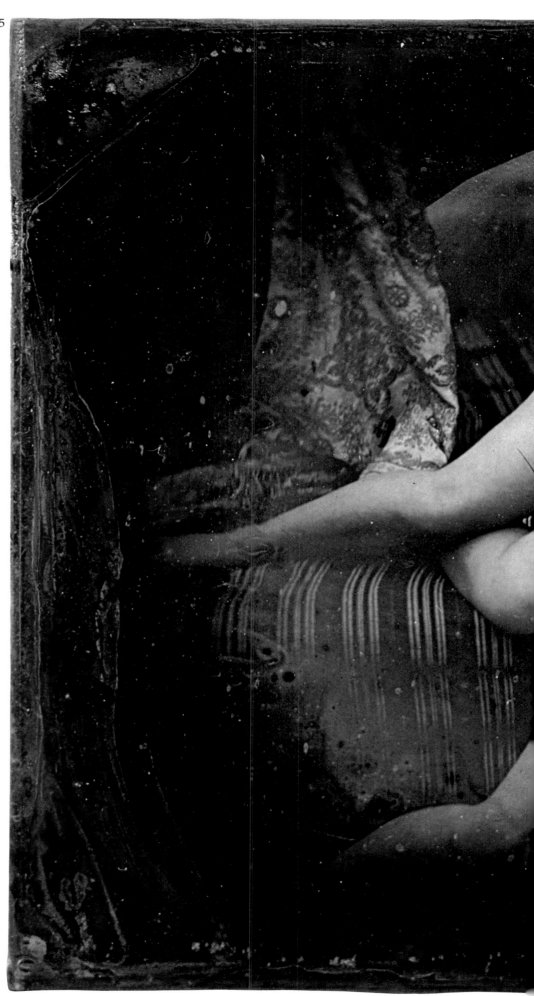

14. William Collie (Jersey).
"The Jersey Patriarch" (Aged 102)
and His Great-great-granddaughter. c. 1848.
Salt print from a calotype negative
15. Anon. (France).
Two Reclining Nudes with Mirror.
c. 1850. Daguerreotype

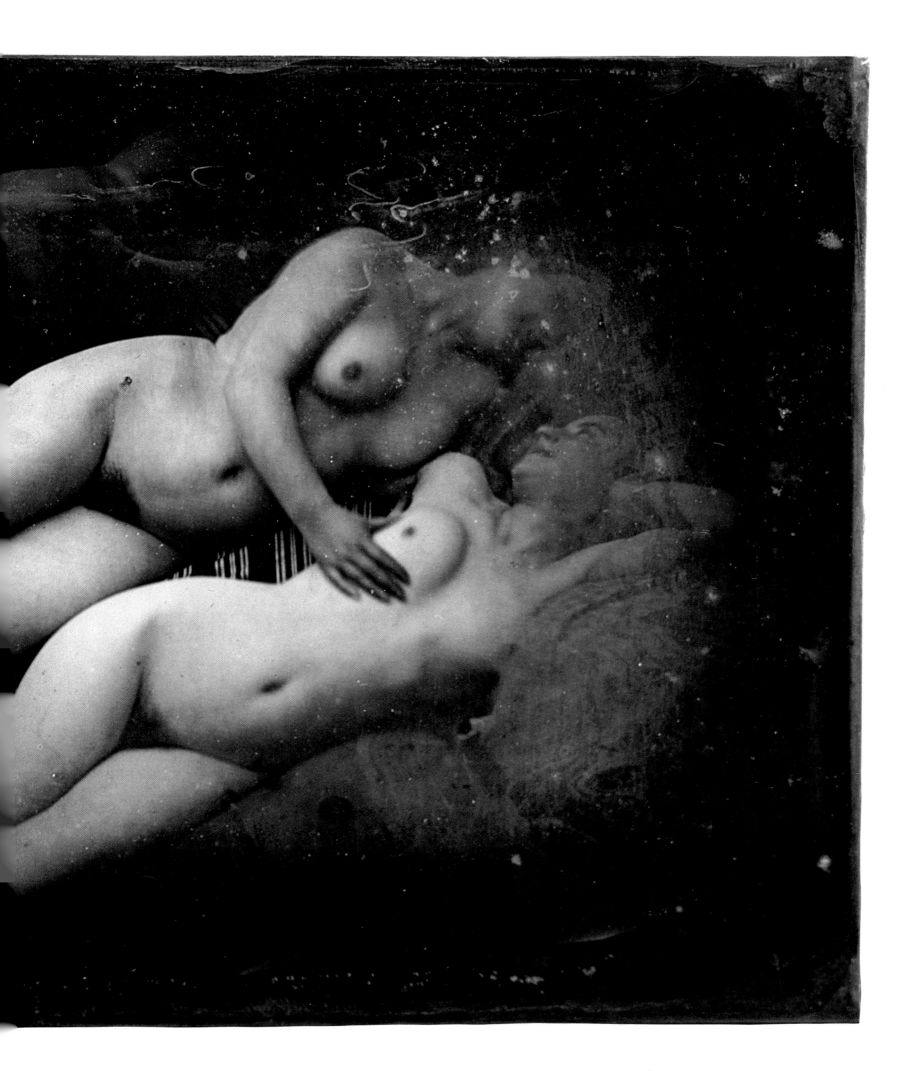

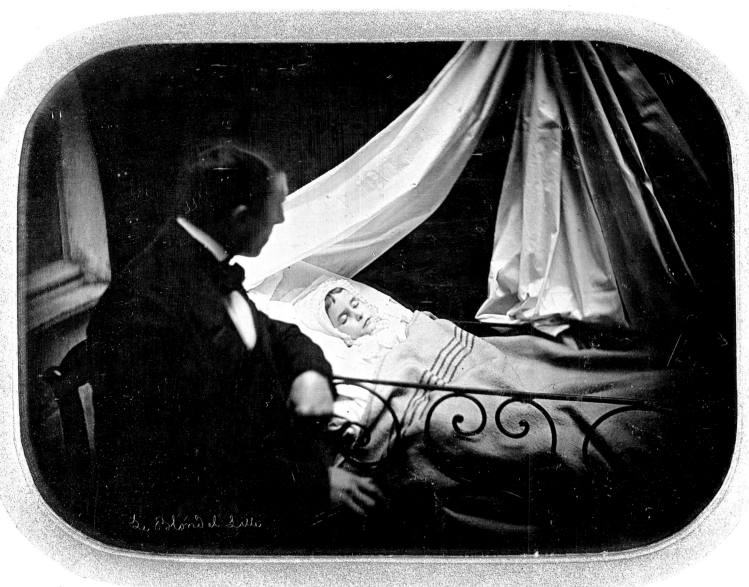

16

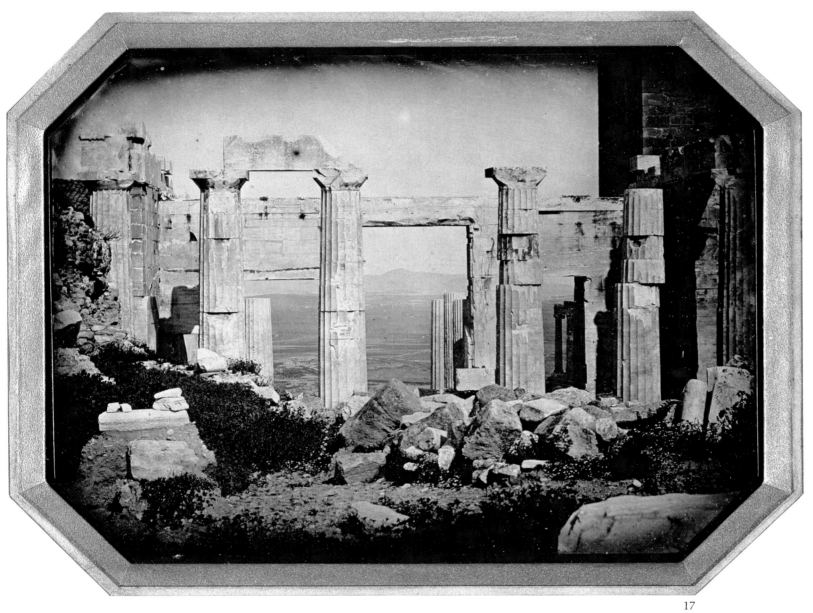

17

16. A. Le Blondel (France). *Post-mortem Picture*. c. 1850. Daguerreotype
17. Baron Jean-Baptiste Louis Gros (France). *The Propylaea
from Inside the Acropolis*. 1850. Daguerreotype

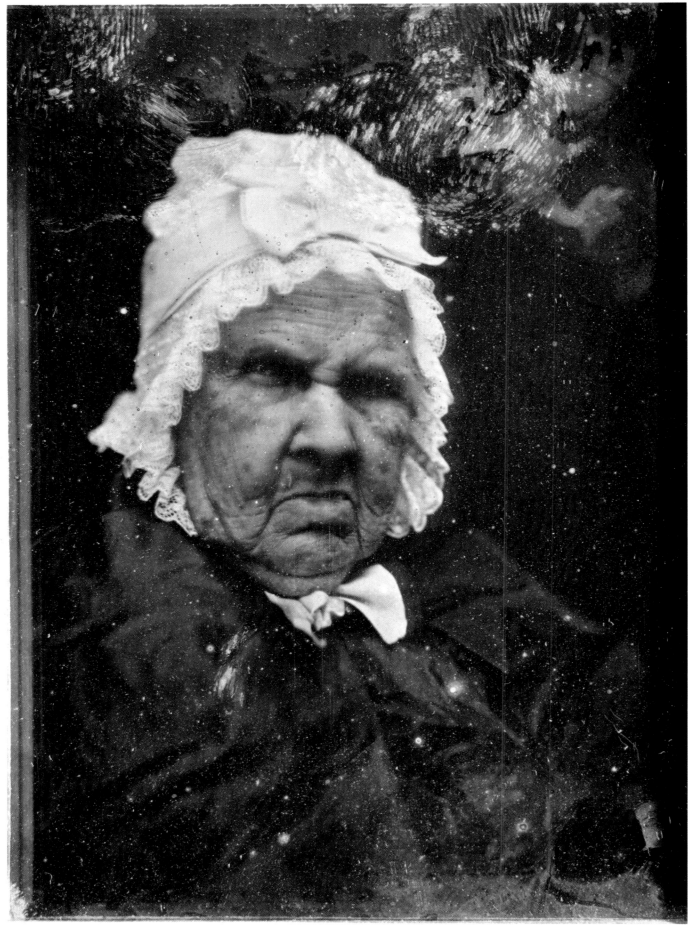

18

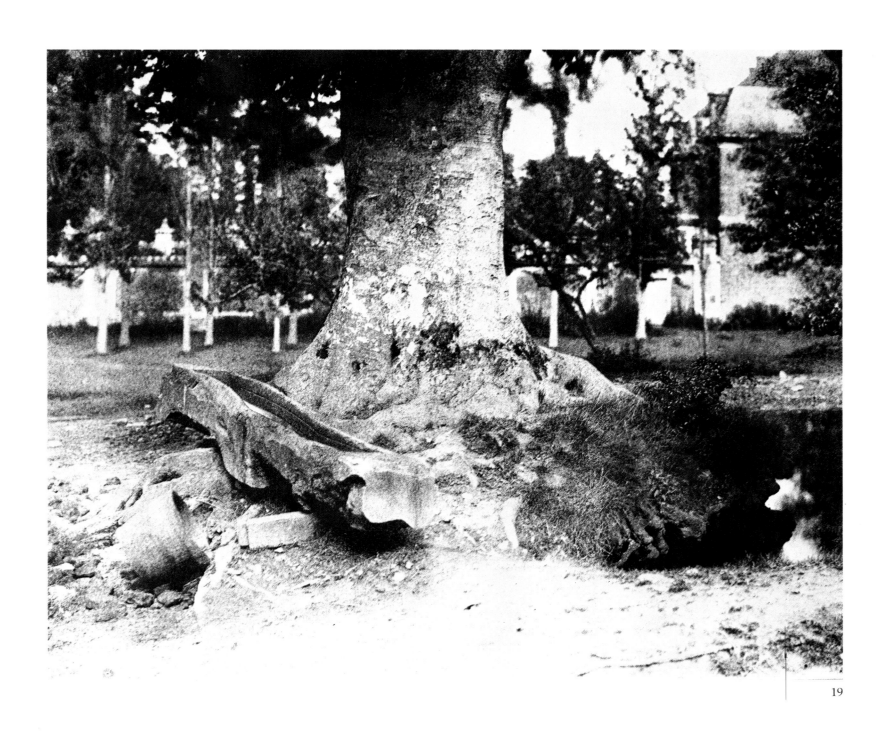

19

18. Albert Sands Southworth and Josiah Johnson Hawes (United States).
Unidentified Old Woman. 1850s. Daguerreotype
19. Louis Robert (France). *Tree at La Verrerie*. c. 1850.
Salt print from a paper negative

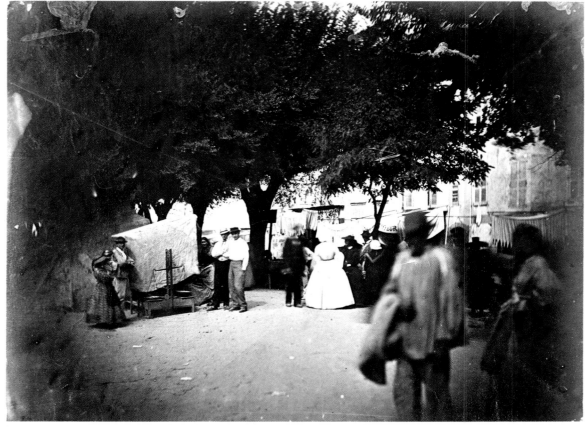

22. Charles Nègre (France). *Place aux Aires, Grasse*. c. 1852. Albumen print
23. Charles Nègre (France). *Young Girl with Basket and Baby*. Early 1850s. Salt print
24. Anon. (United States). *Blacksmiths*. 1850s. Daguerreotype, hand-colored

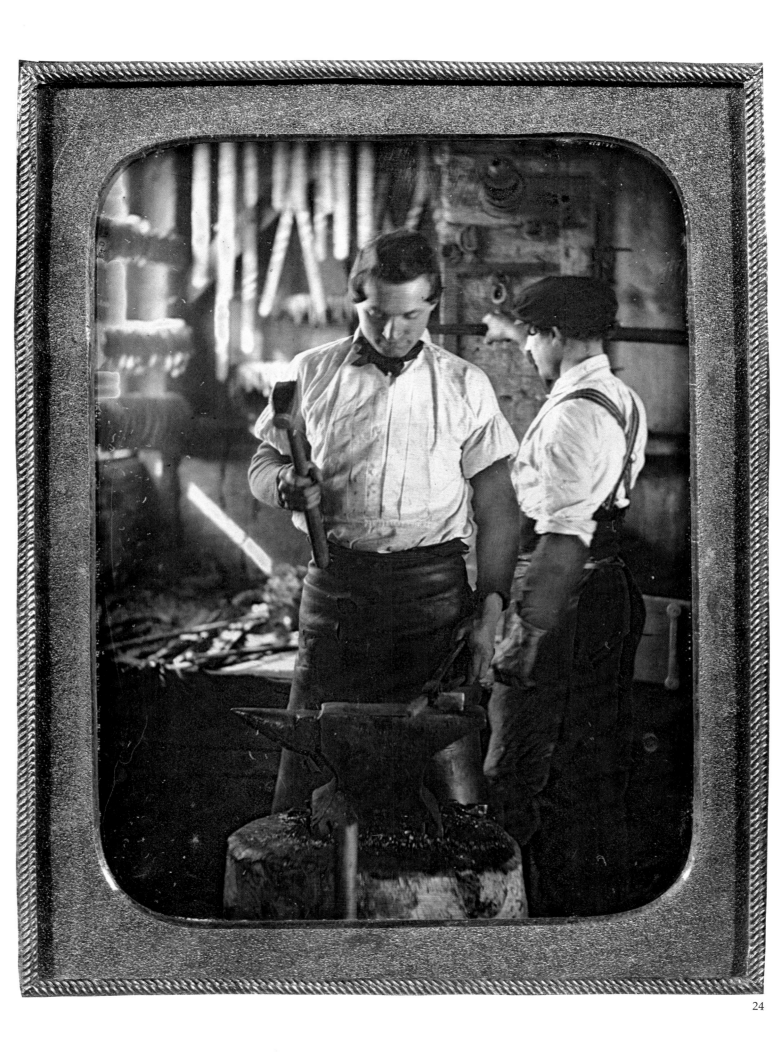

25

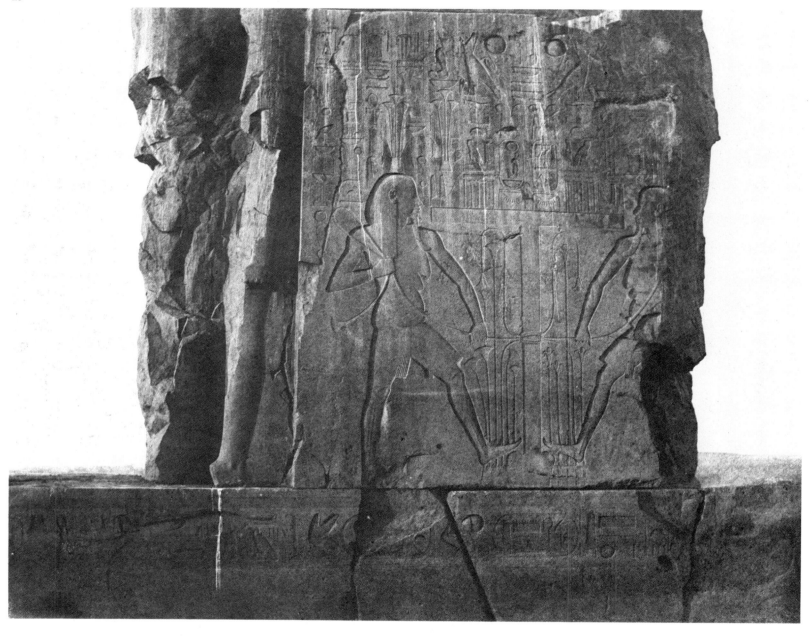

25. Félix Teynard (France).
Colossus, Decoration on Northeast Side of Throne
(Thebes, Qurna). c. 1851–52. Salt print
26. Braquehais (France).
Veiled Nude with Suit of Armor.
1854. Albumen print

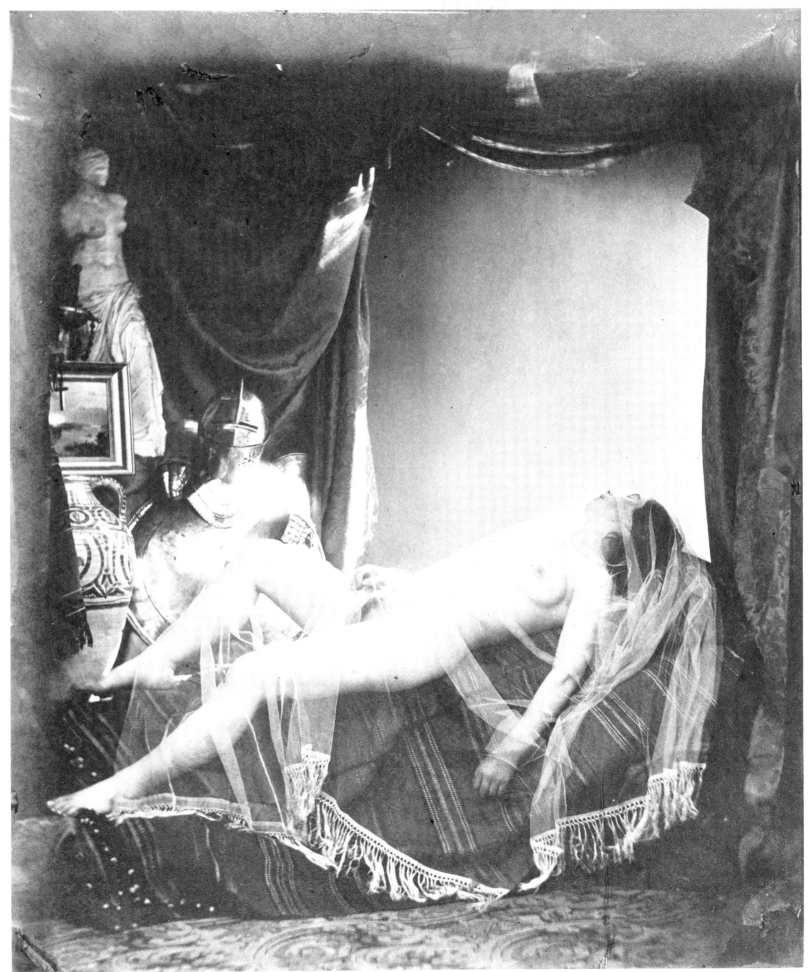

27

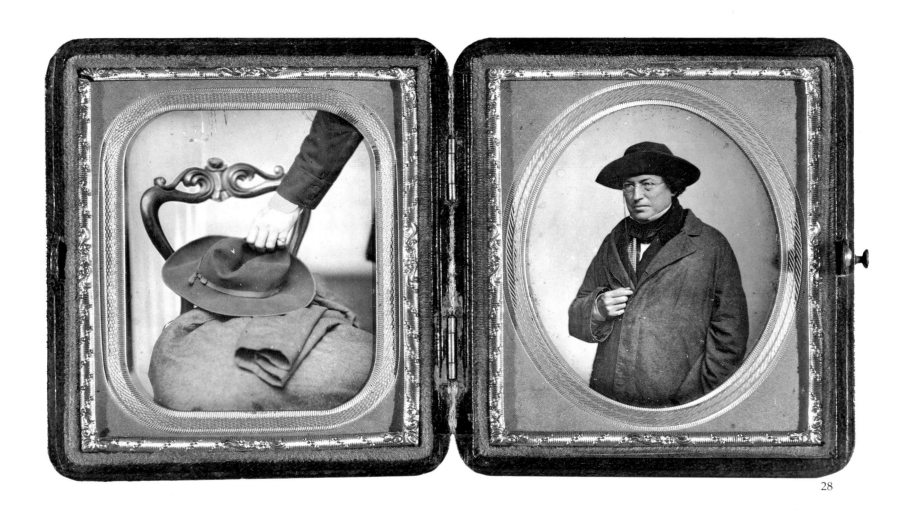

28

27. Anon. (France). *A Domestic Servant*. 1850s. Daguerreotype
28. Anon. (United States). *Man with Hat and Coat*.
c. 1850–55. Pair of daguerreotypes

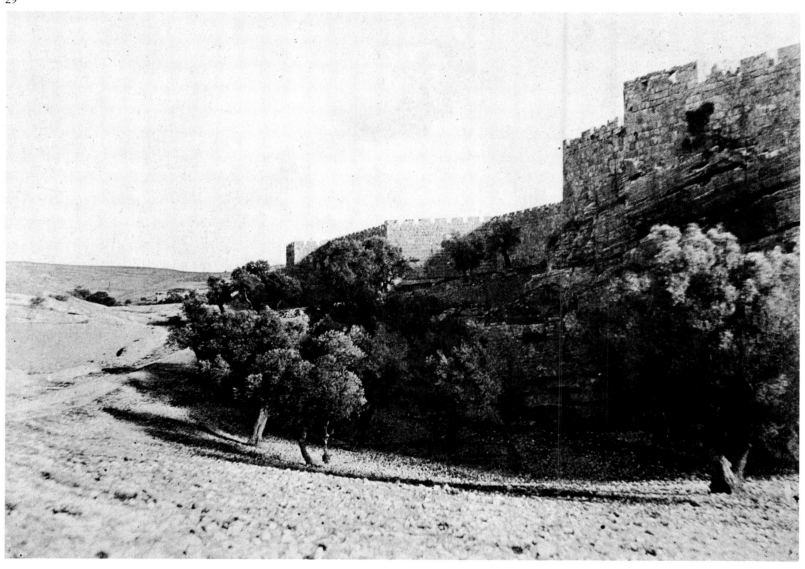

29. Auguste Salzmann (France).
North Wall, Jerusalem. 1854.
Salt print by Blanquart-Evrard
30. Auguste Salzmann (France).
Cactus on Column of Porte Judiciaire, Jerusalem. 1854.
Salt print by Blanquart-Evrard

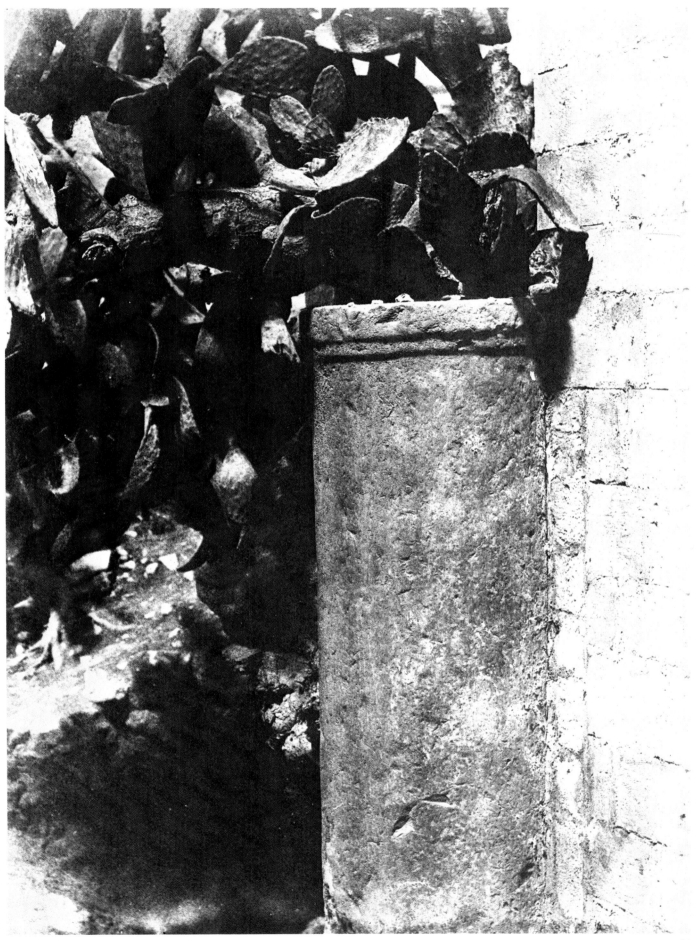

31

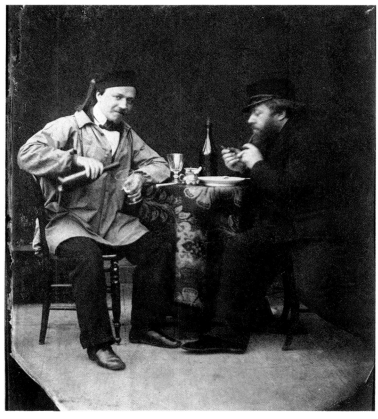

31. A. Le Blondel (France). *Wine Drinkers*. 1850s. Salt print
32. Anon. (probably France). *Flemish Landscape*. Before 1855. Salt print

33. Colonel Jean-Charles Langlois (France). *The Battlefield of Sebastopol*
(¹⁄₁₄th part of panorama). 1855. Albumen print
34. Joseph Cundall and Robert Howlett (England). *"Crimean Braves."*
Pub. 1856. Photogalvanograph

35

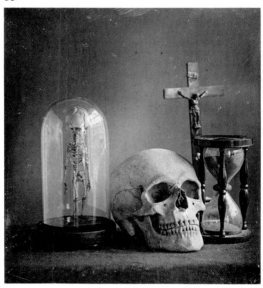

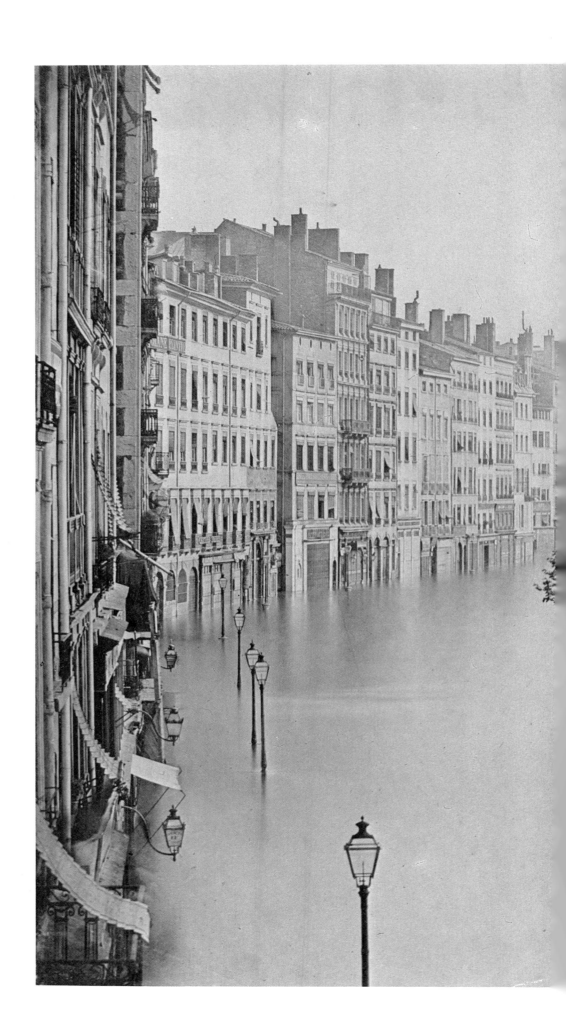

35. Duboscq-Soleil (France).
Memento Mori. After 1854.
Daguerreotype
36. Froissart (France).
Flood at Lyons. 1856.
Salt print

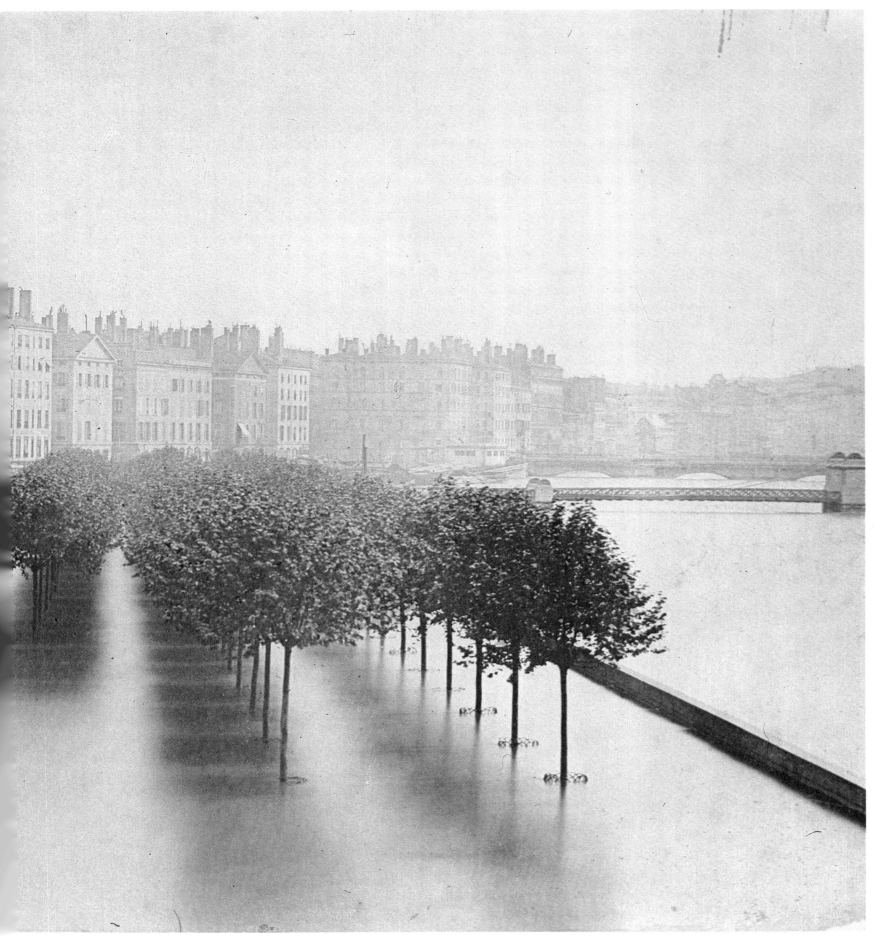

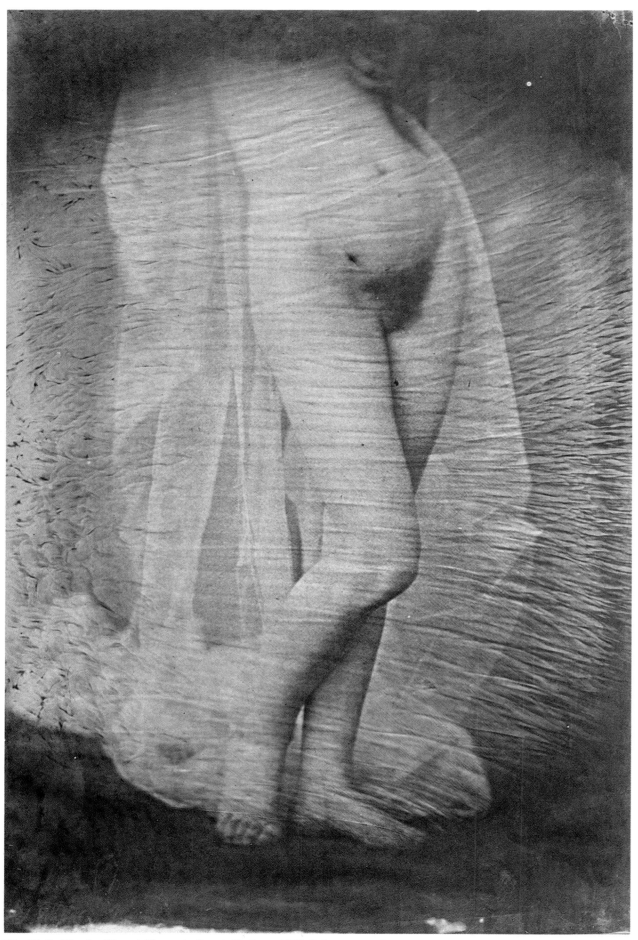

37. *Attrib*. **Charles Simart** (France). *Female Nude*. c. 1856. Salt print, enlargement from a small collodion negative

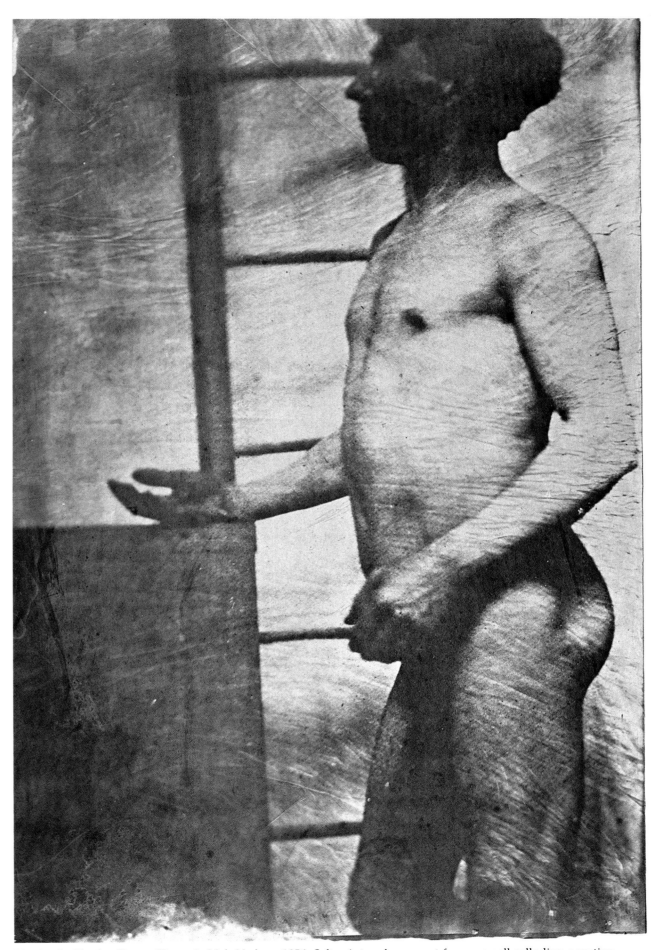

38. *Attrib.* Charles Simart (France). *Male Nude.* c. 1856. Salt print, enlargement from a small collodion negative

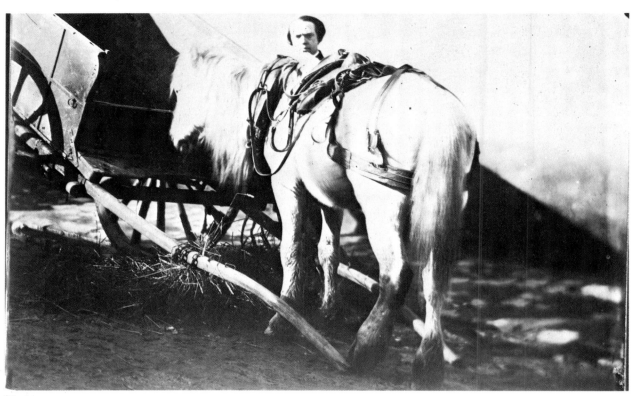

39

40

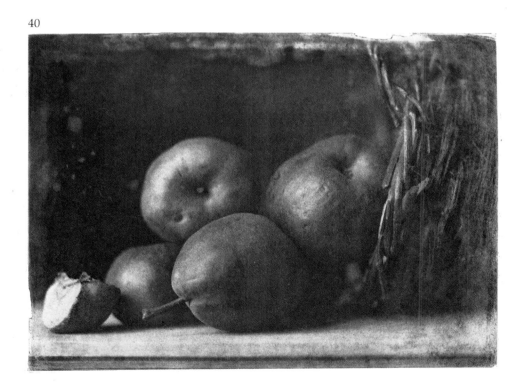

39. Anon. (France). *Farm Study.* c. 1855. Albumen print
40. Henri Le Secq (France). *Still Life.* 1850s. Modern print from a paper negative
41. Edouard Duseigneur (France). *The Village Tailor.* Early 1850s. Salt print

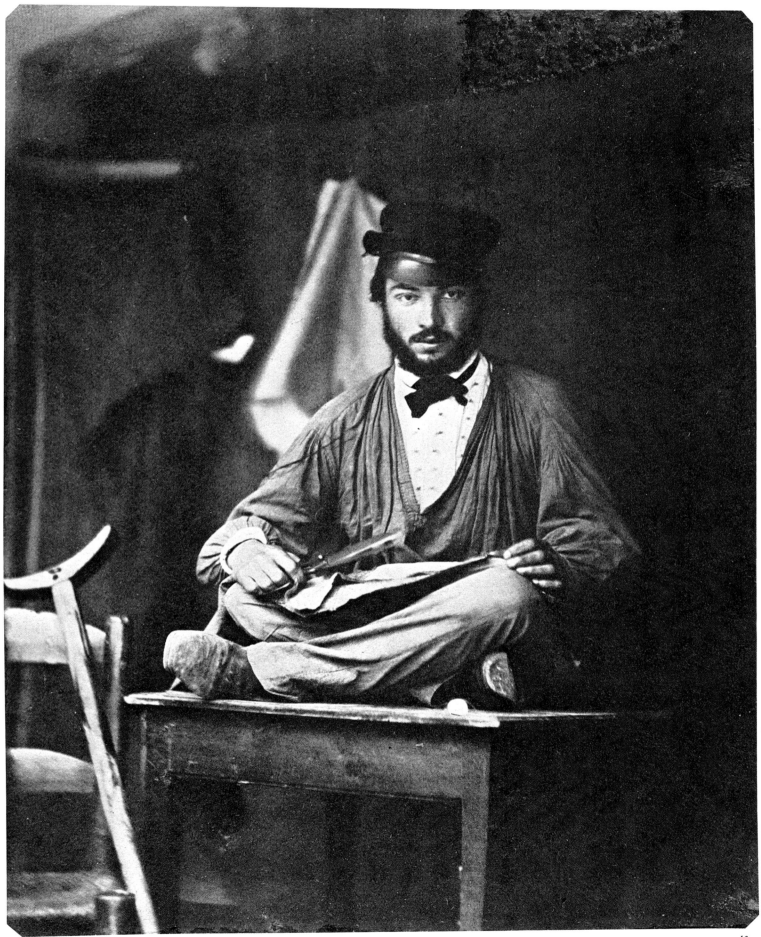

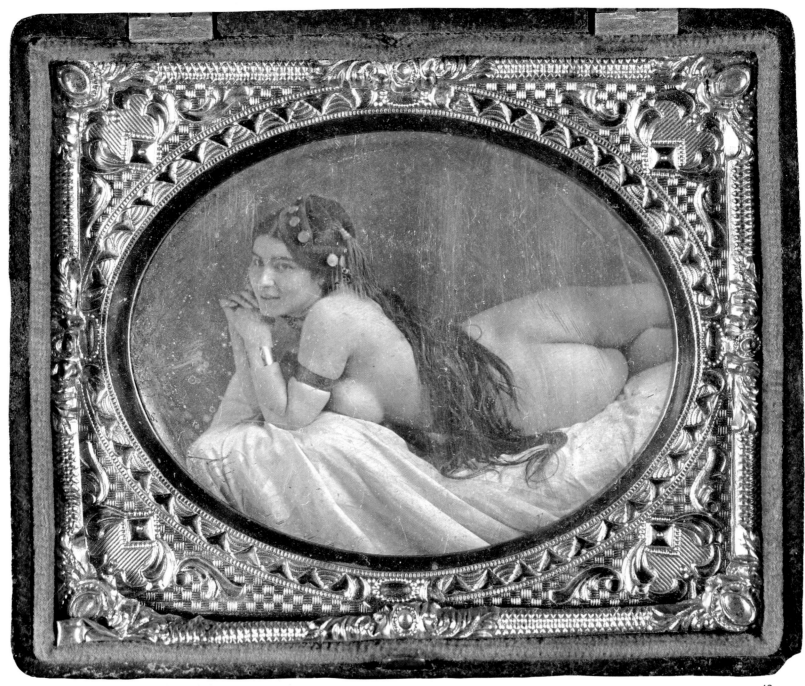

42. Anon. (France). *Nude*. c. 1850. Daguerreotype
43. Anon. (France). *Nude*. 1850s. Daguerreotype

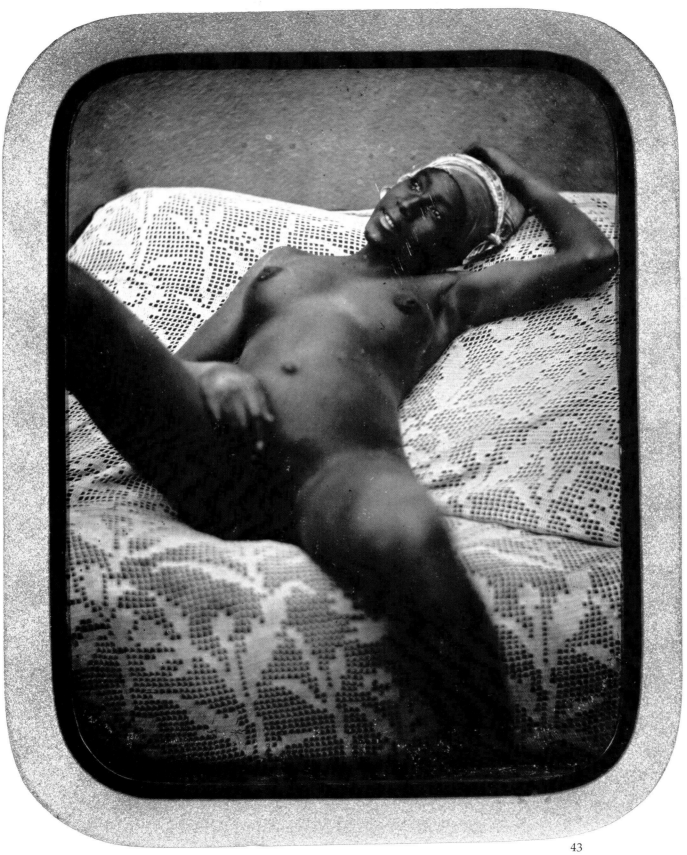

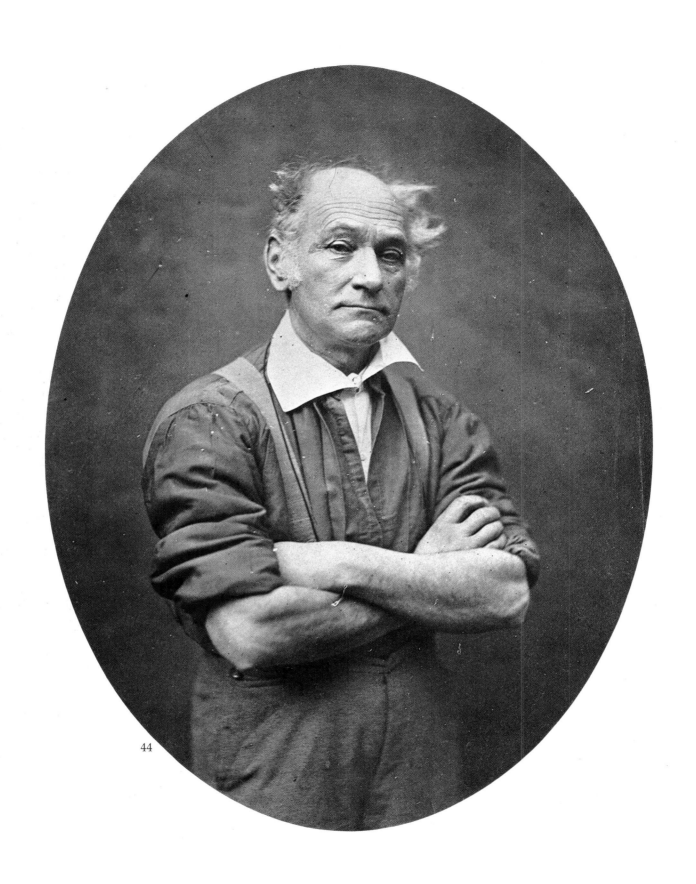

44

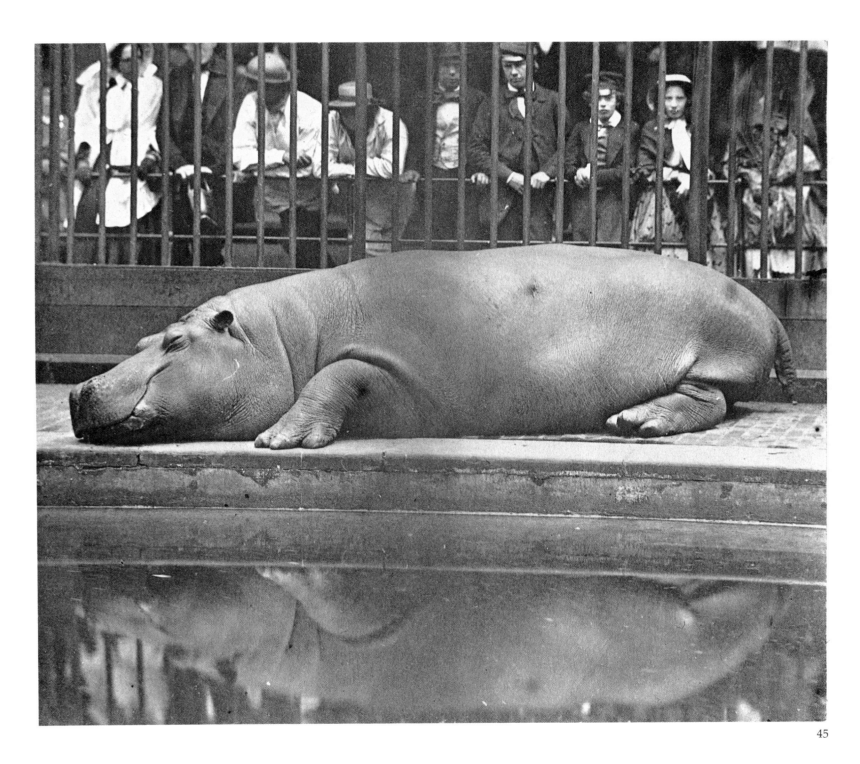

44. Nadar (Gaspard Félix Tournachon; France).
Portrait of Napp(?).
n.d. Salt print
45. Count de Montizon (France).
*The Hippopotamus at the Zoological Gardens,
Regent's Park.* 1855. Albumen print

46

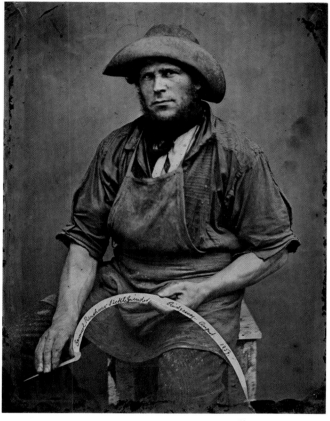

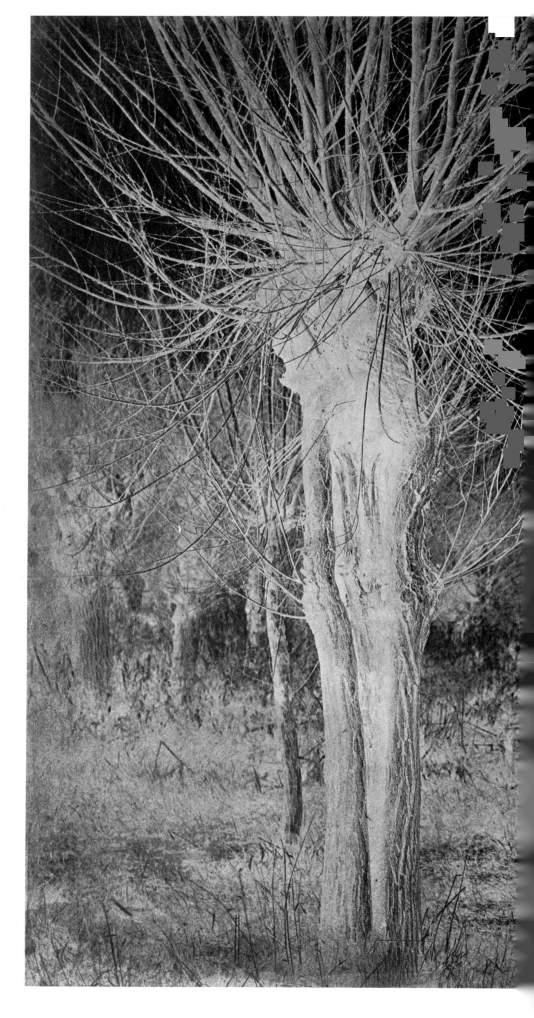

46. Anon. (Great Britain).
Samuel Renshaw, Sickle Grinder.
1854 or 1857. Ambrotype, hand-colored
47. Benjamin Brecknell Turner (England).
The Willow Walk, Bredicot. c. 1856.
Waxed paper negative

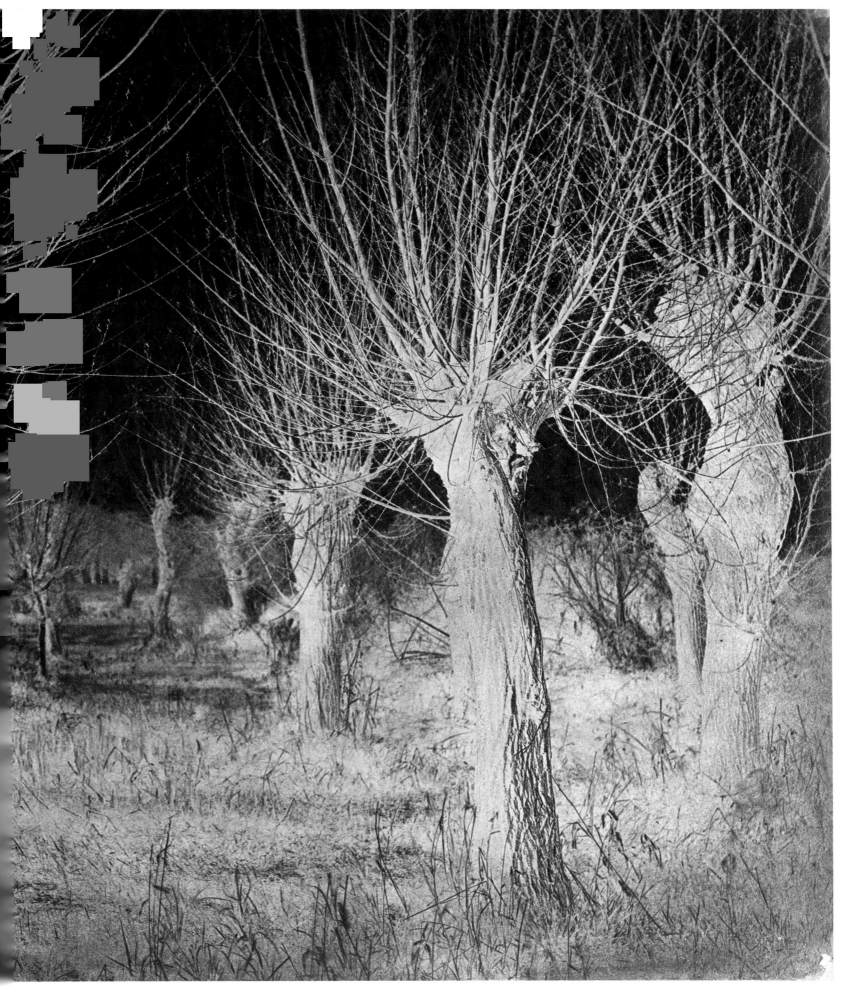

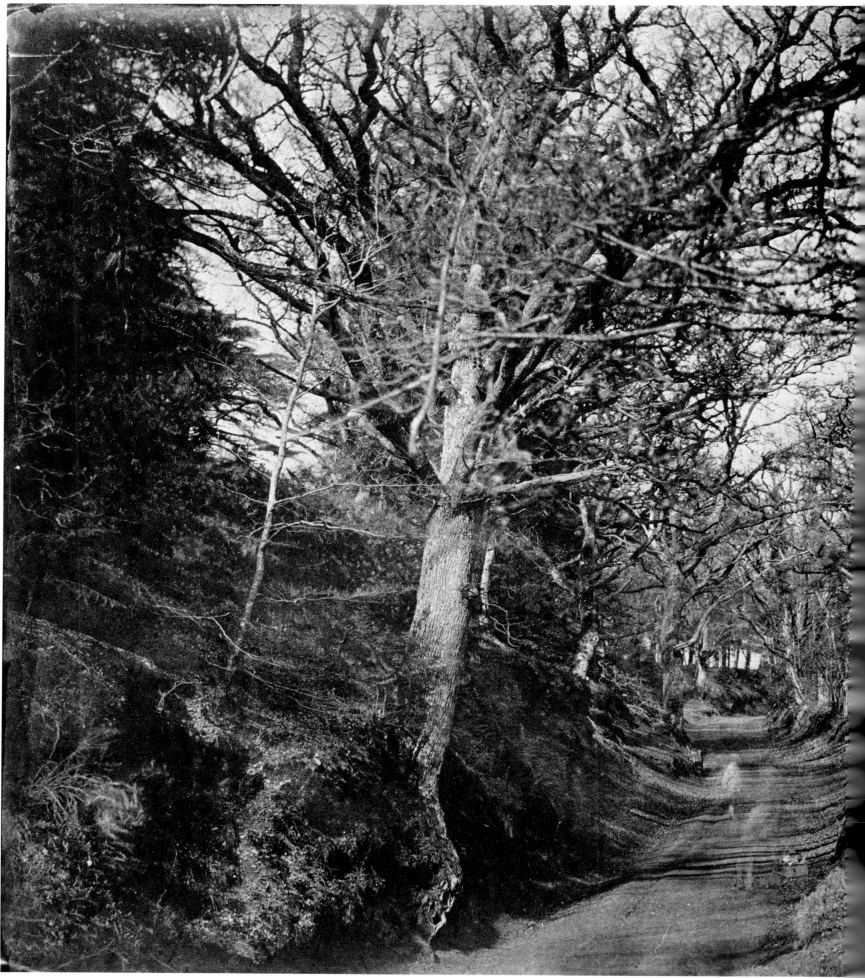

48

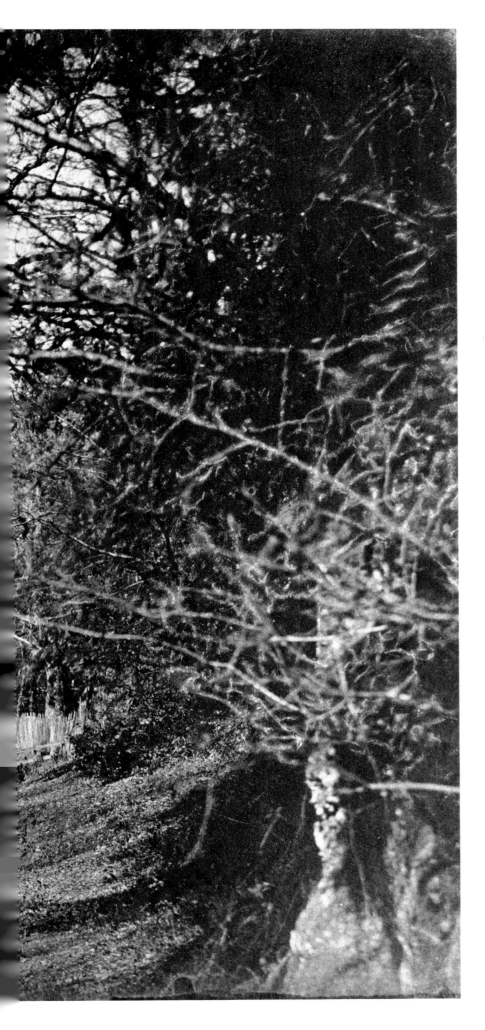

49

48. Benjamin Brecknell Turner (England).
Sunken Road. c. 1856.
Modern print from the original waxed paper negative
49. Anon. (N. France or Belgium).
Portrait of an Old Woman.
c. 1850–60. Hand-painted photograph

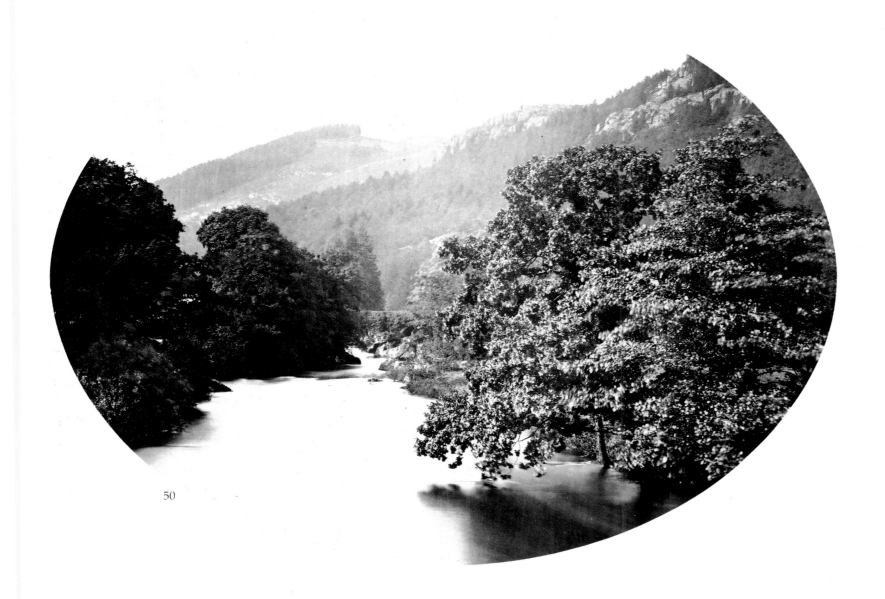

50

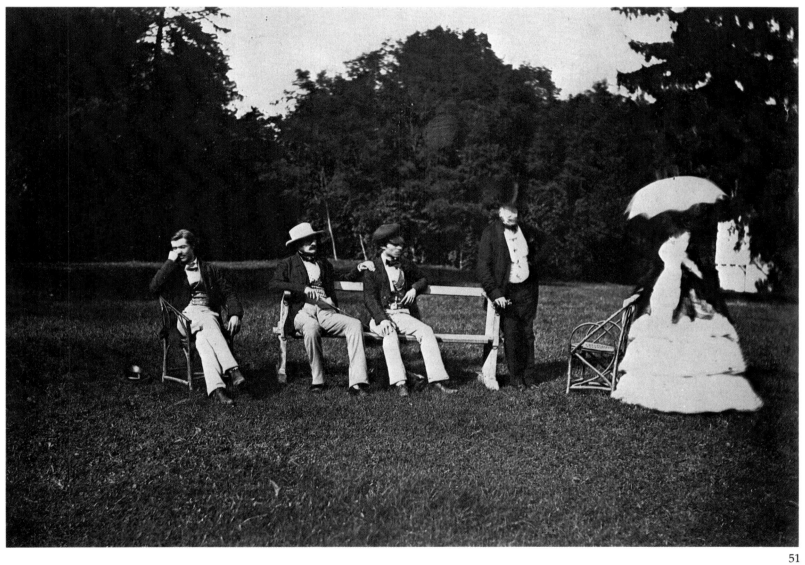

51

50. Henry White (England).
The River at Bettws-y-Coed, North Wales.
c. 1856. Albumen print
51. Edouard-Denis Baldus (France; b. Germany).
"An Afternoon in the Country."
1857. Salt print

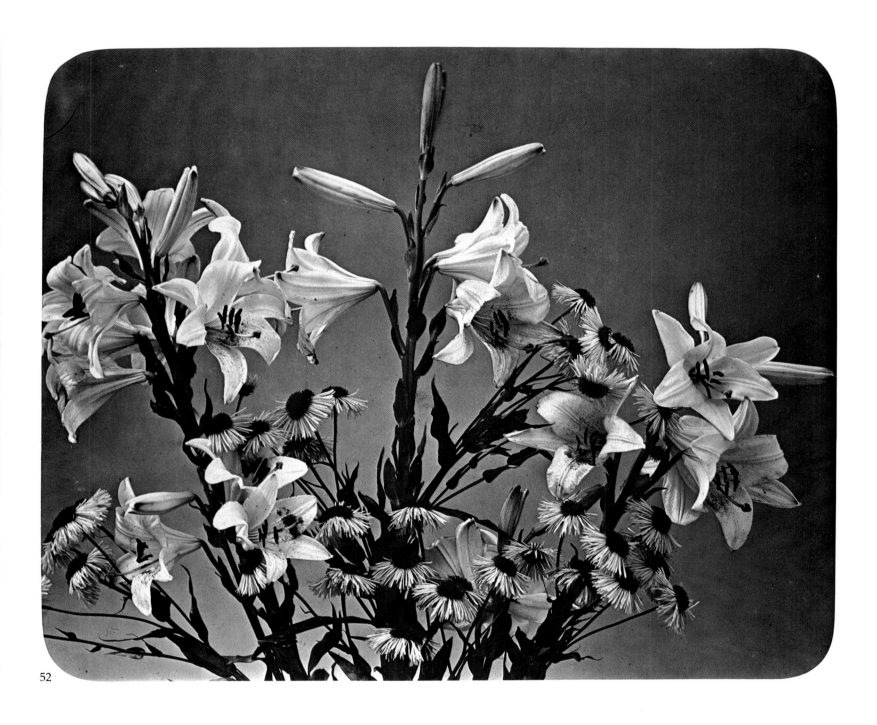

52

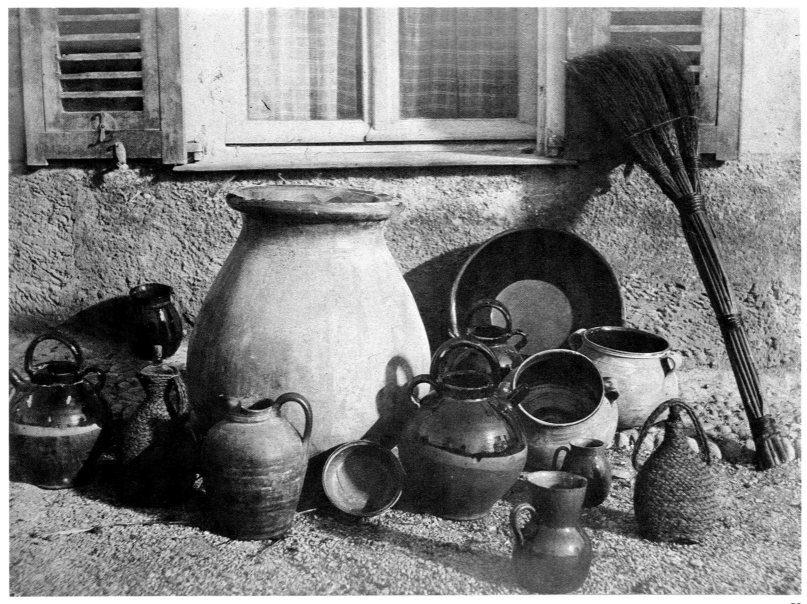

53

52. Adolphe Braun (France). *Still Life*. c. 1855. Albumen print
53. Arthur Backhouse (England). *Pots and Pans at Nice*. 1855. Albumen print from a waxed paper negative

54. Albert Sands Southworth and Josiah Johnson
Hawes (United States). *Young Girl*. 1850s. Daguerreotype
55. Gustave Le Gray (France). *French Military Maneuvers,
Camp de Châlons: The Guard Behind a Breastwork.*
1857. Albumen print

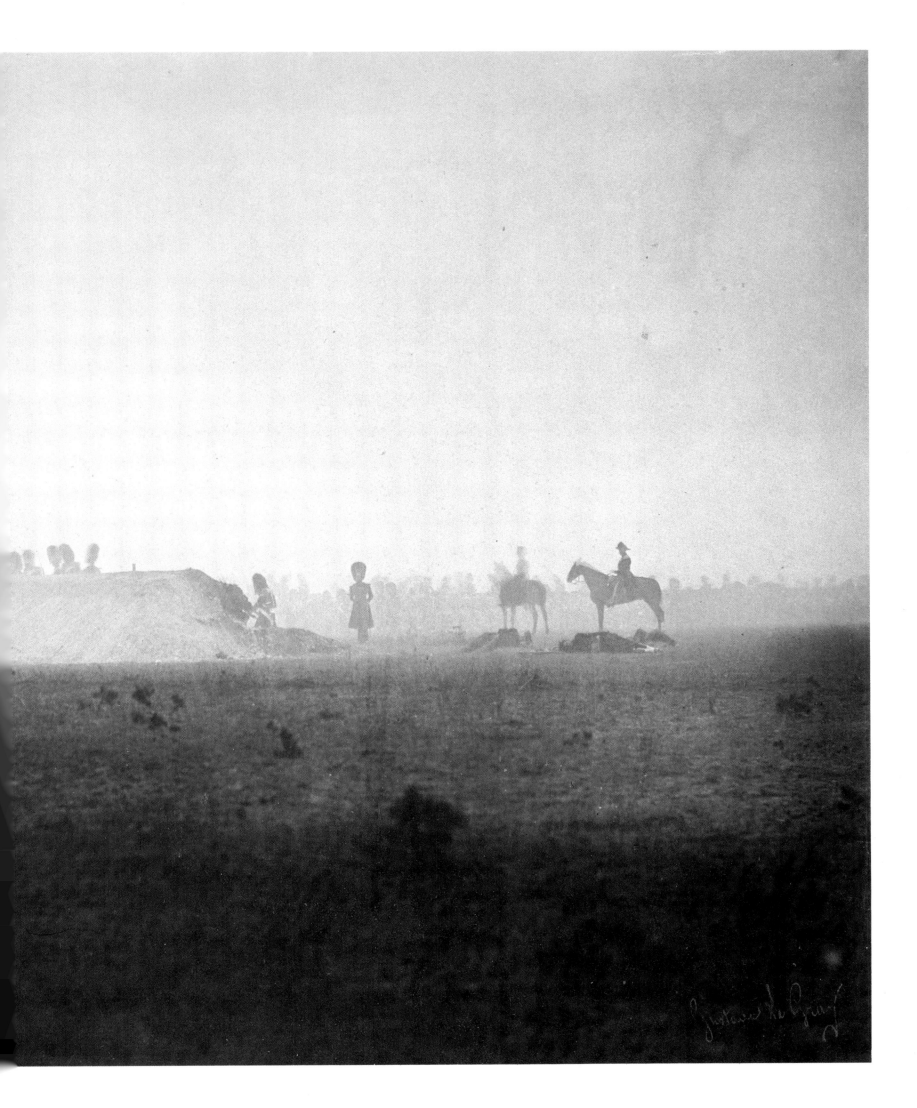

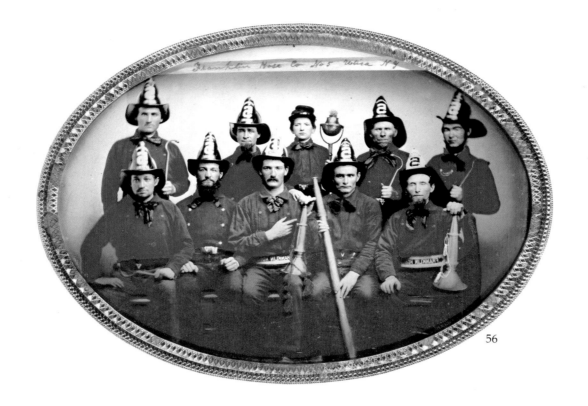

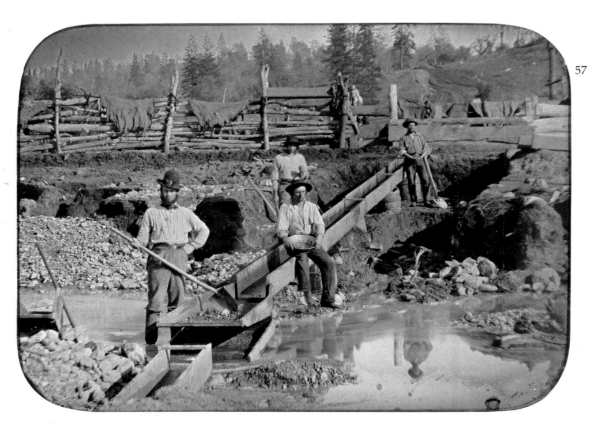

56. Anon. (United States). *The Franklin Fire Hose Co., Utica, N.Y.* 1858. Ambrotype, hand-colored
57. Anon. (United States). *Gold Miners, California.* c. 1850. Daguerreotype
58. Anon. (France). *Two Standing Nudes.* c. 1850. Daguerreotype

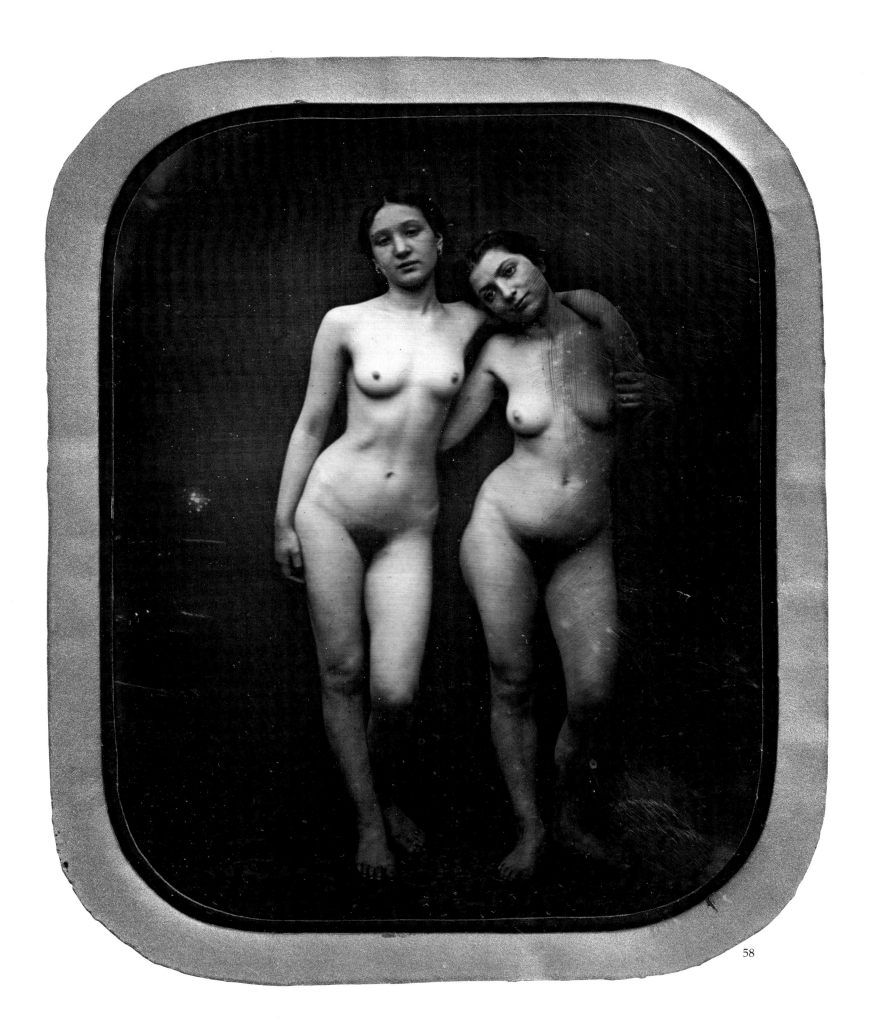

58

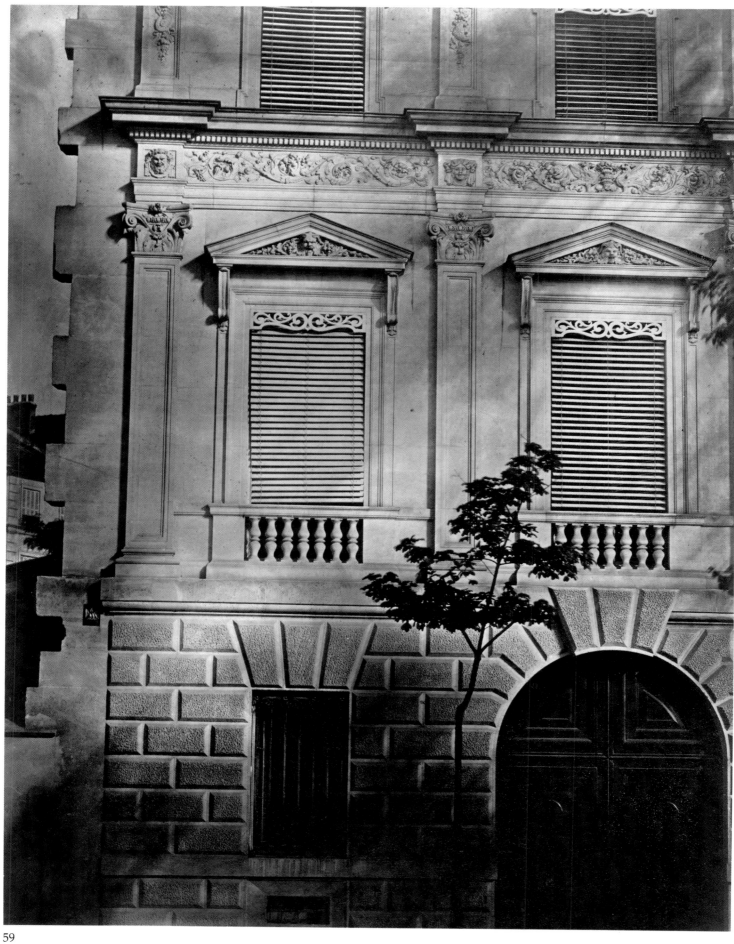

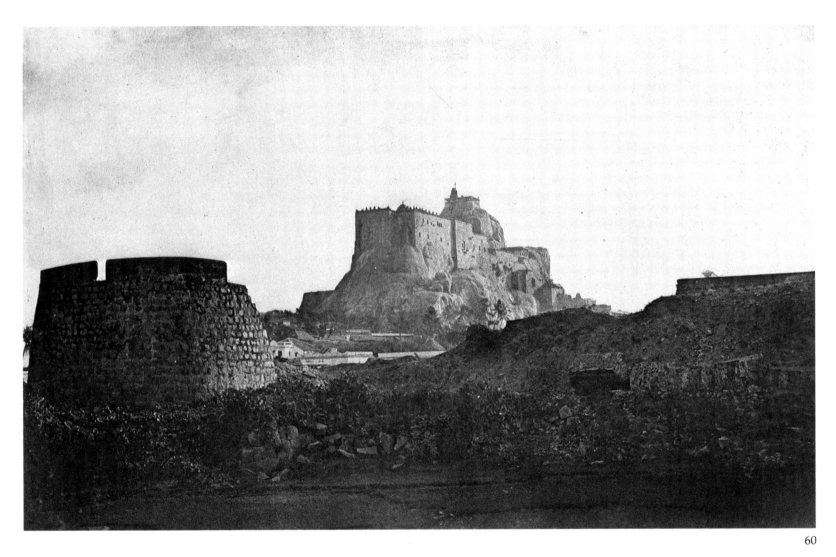

59. *Attrib.* Edouard-Denis Baldus (France; b. Germany).
A Private House, Paris. c. 1855.
Albumen print
60. Capt. Linnaeus Tripe (England).
Temple Fort, Southern India.
Before 1858. Albumen print from a waxed paper negative

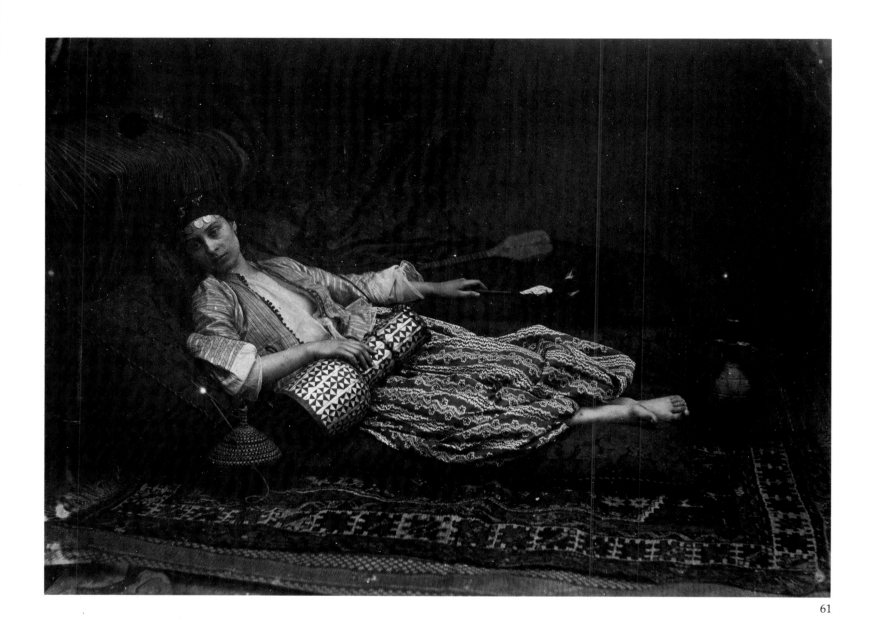

61

61. Roger Fenton (England). *Odalisque*.
1858. Salt print
62. Charles Piazzi Smyth (Scotland).
*"Lookers-on Taken Unconsciously,
Novgorod, 1859."* Lantern slide

OVERLEAF:

63. Roger Fenton (England). *Clouds*.
c. 1859. Salt print

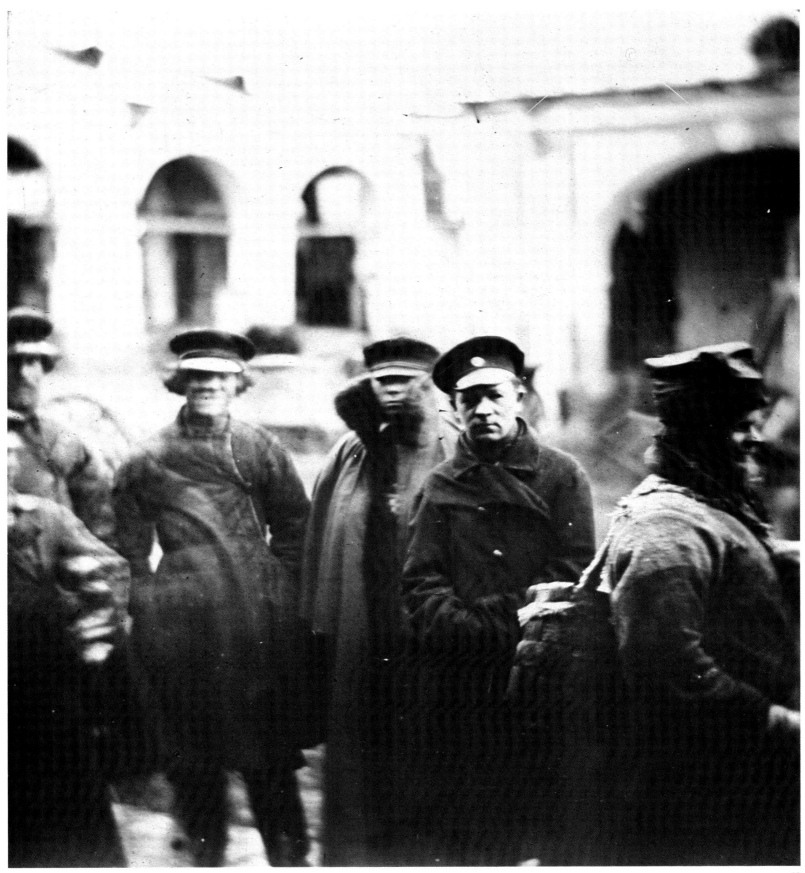

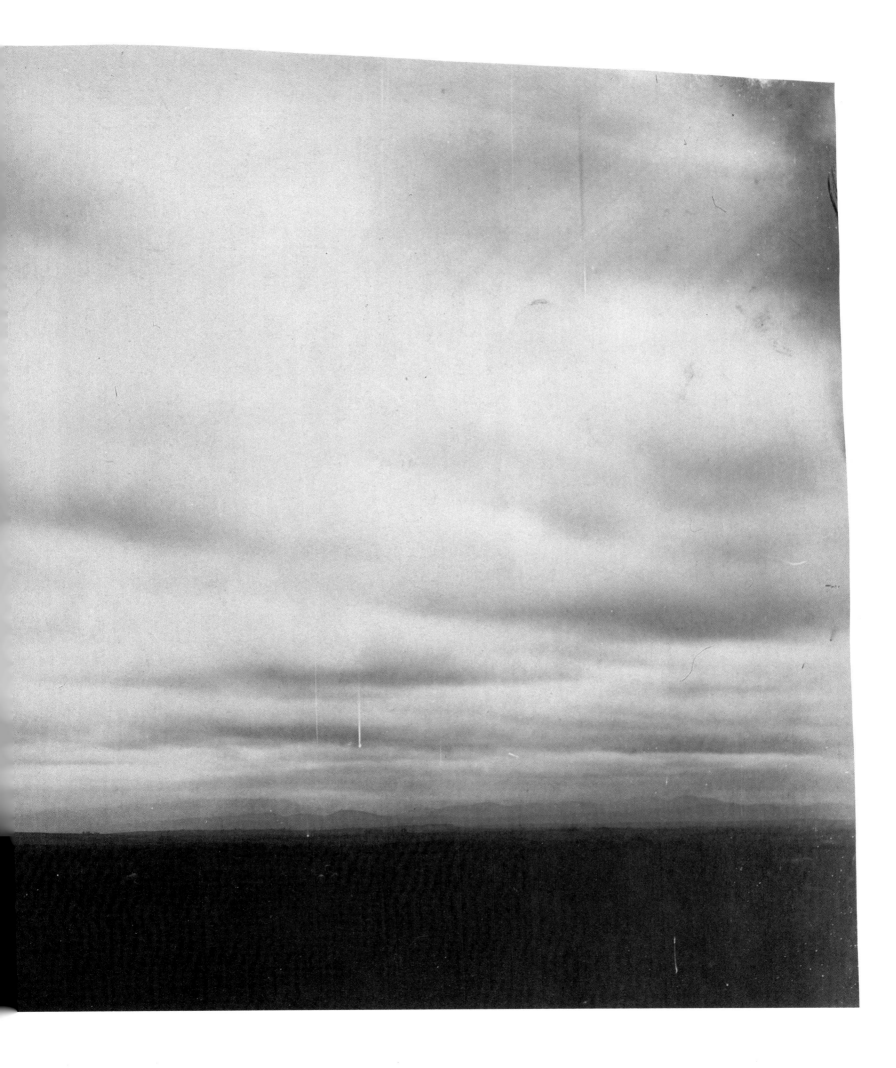

64

64. Count Olympe Aguado (France). *Admiration*. 1860. Albumen print
65. Anon. (Great Britain). *An Elderly Veteran and His Wife*.
c. 1860. Ambrotype, hand-colored

65

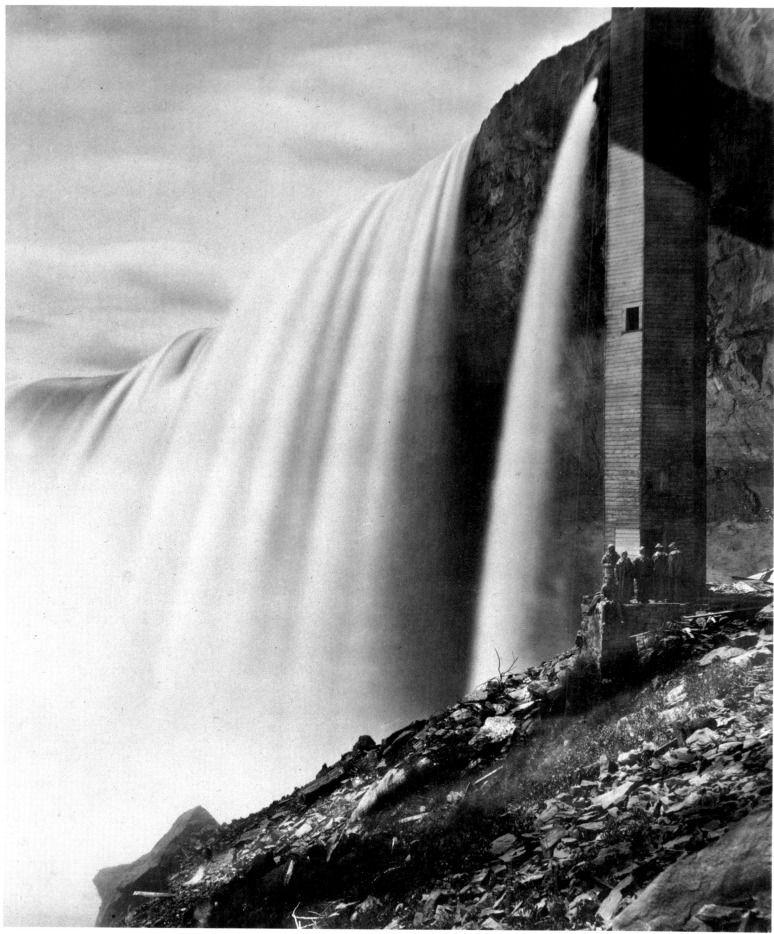

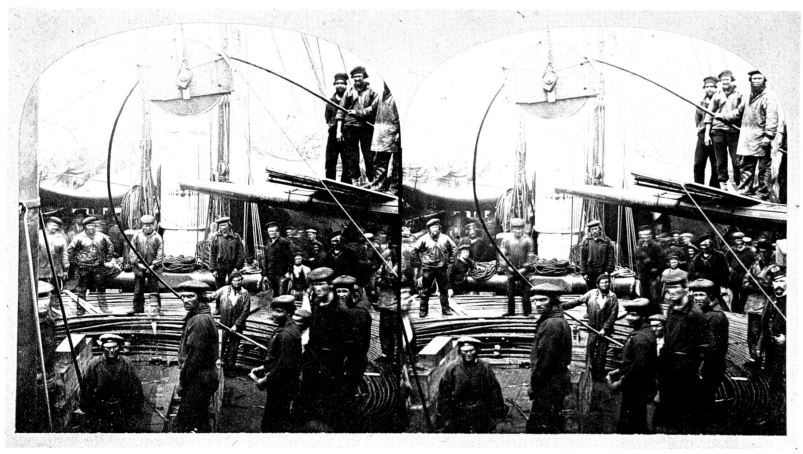

66. Anon. *Niagara Falls with Group and Tower.* c. 1860. Albumen print
67. Anon. (Great Britain). *Laying the Atlantic Cable*(?). 1858. Albumen stereocard
68. William Notman (Canada; b. Scotland). *Victoria Bridge over the River St. Lawrence.* 1859. Albumen stereocard

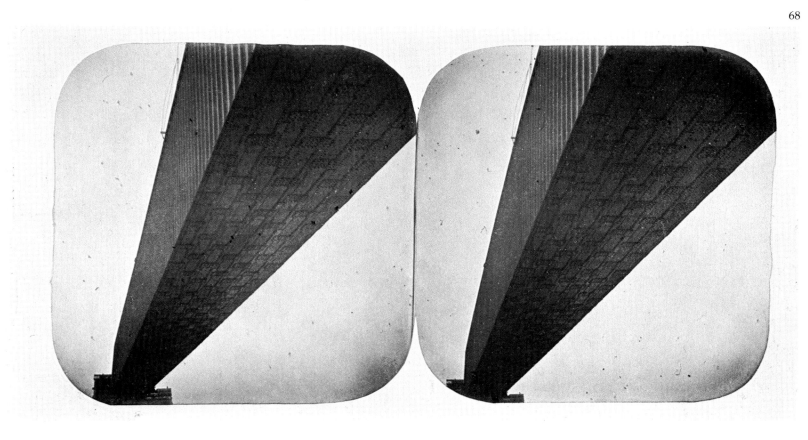

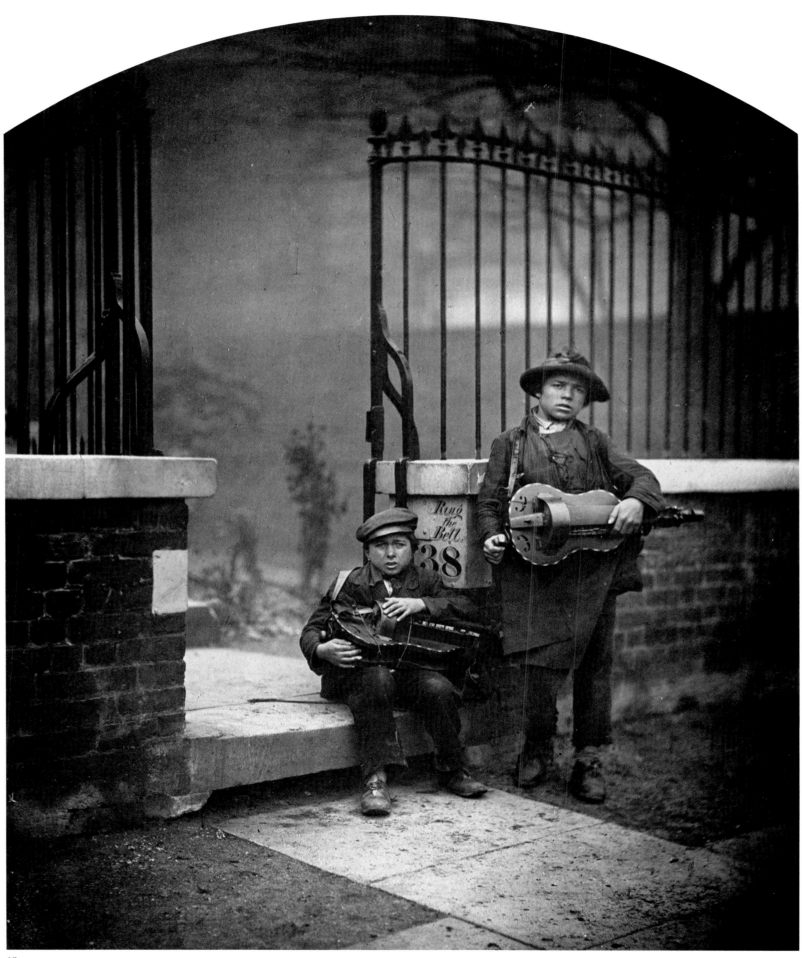

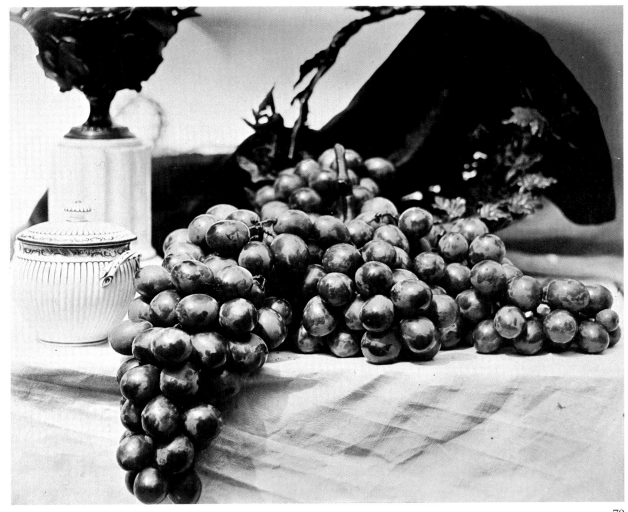

70

69. Camille Silvy (France). *Street Musicians in Porchester Terrace, London.* c. 1860. Albumen print
70. Roger Fenton (England). *Still Life.* c. 1860. Albumen print

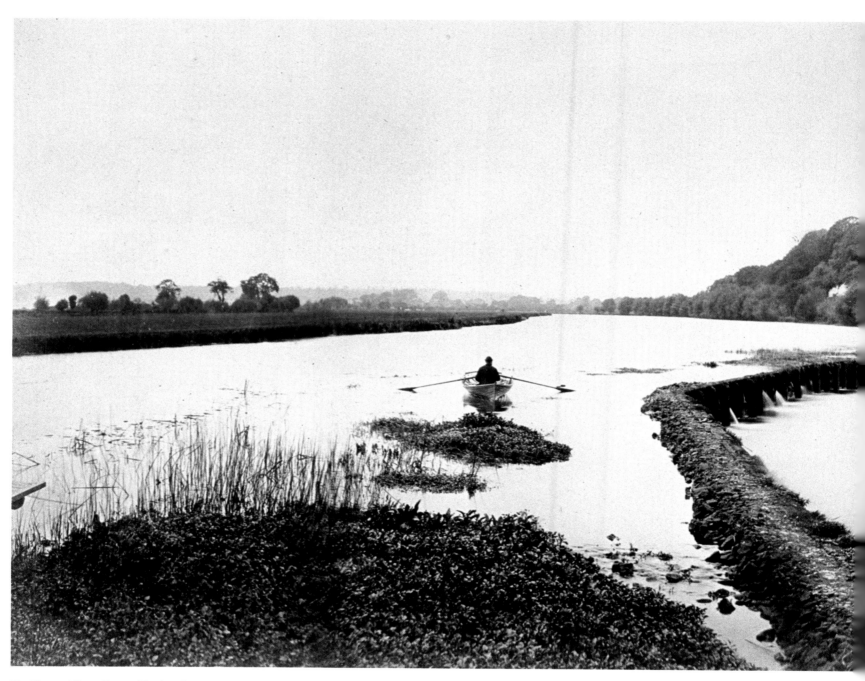

71. Victor Albert Prout (England).
New Lock, Hurley. c. 1862. From *The Thames from London to Oxford.* Albumen print

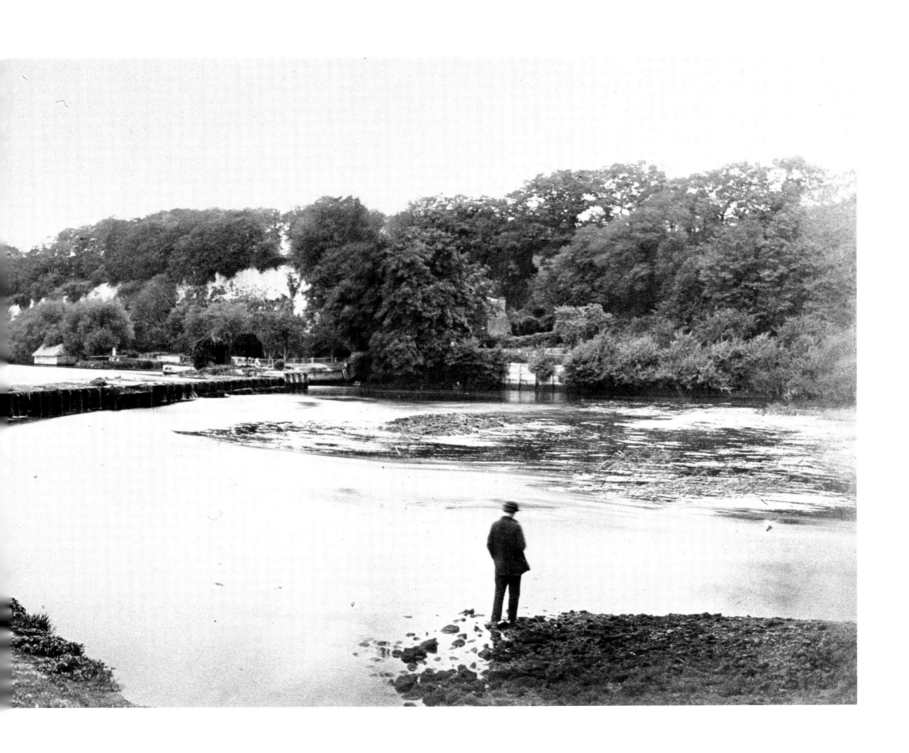

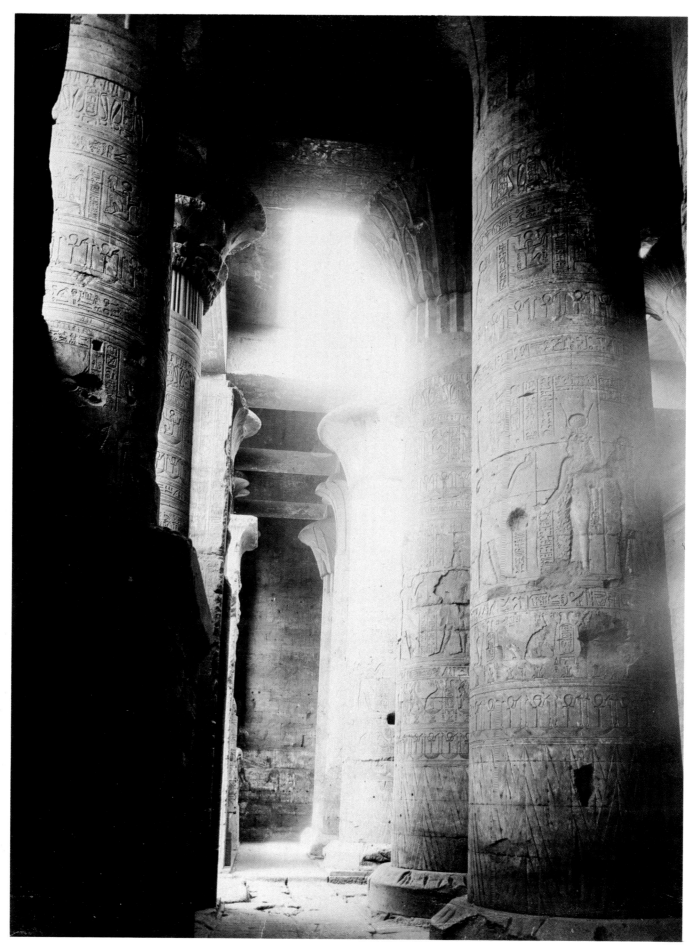

72. Felice A. Beato (England; b. Italy). *Hypostyle Hall at Edfu.* After 1862. Albumen print

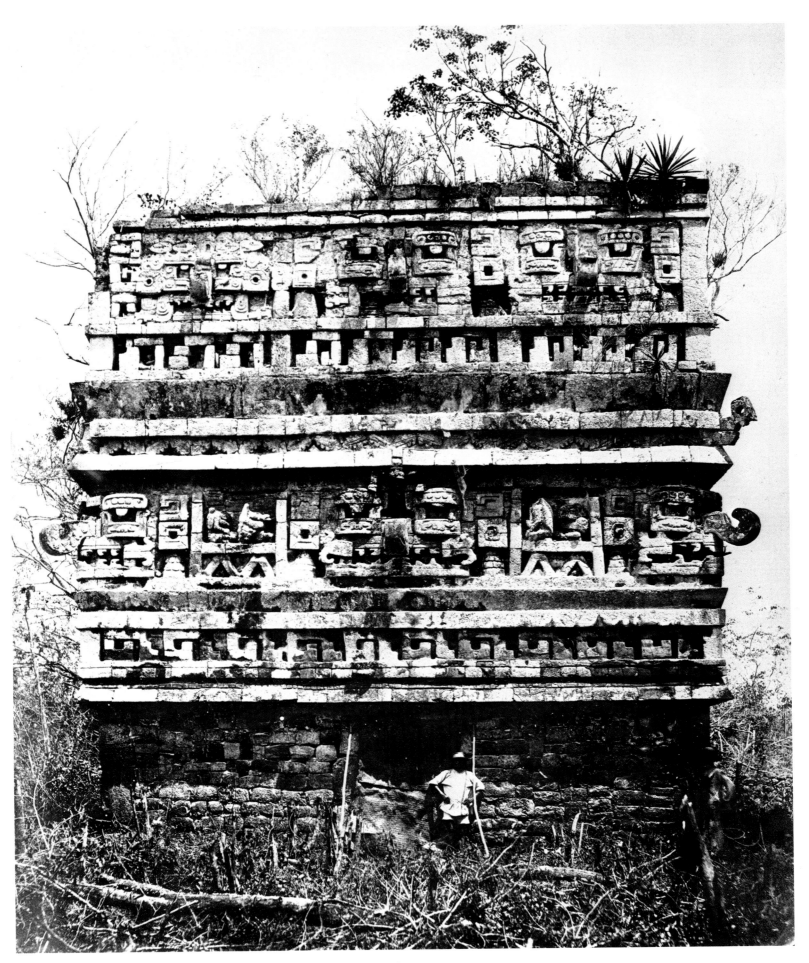

73. Désiré Charnay (France). *Chichén-Itzá, Mexico*. c. 1860. Albumen print

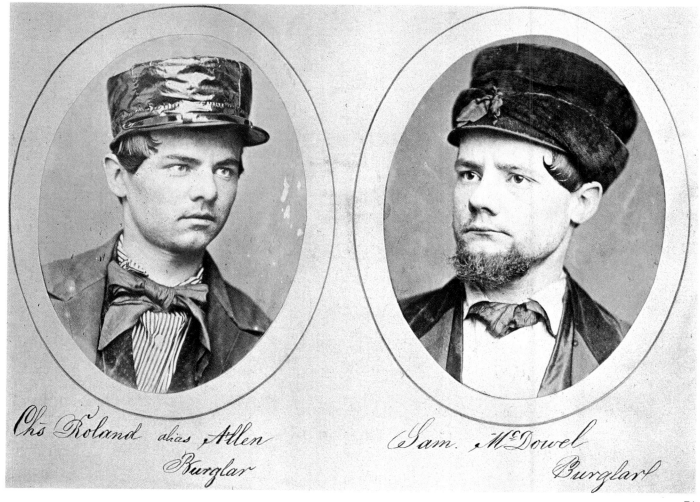

74

74. Anon. (United States). *Two Burglars.* 1860. Albumen prints
75. Nadar (Gaspard Félix Tournachon; France). *Hand of M. D. . . .Banker.* c.`1860. Albumen print
76. Collard (France). *Roundhouse on the Bourbonnais Railway (Nevers).* 1862–67. Albumen print

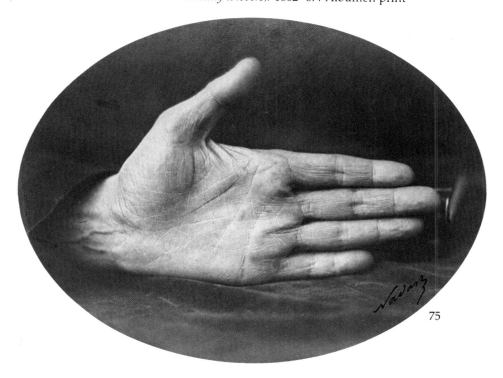

75

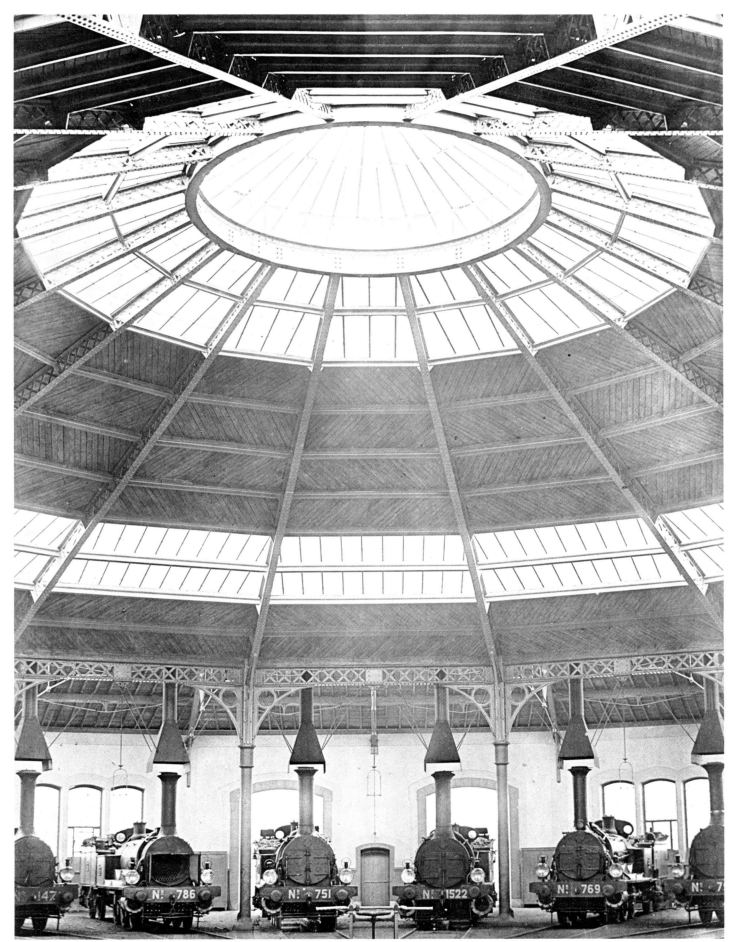

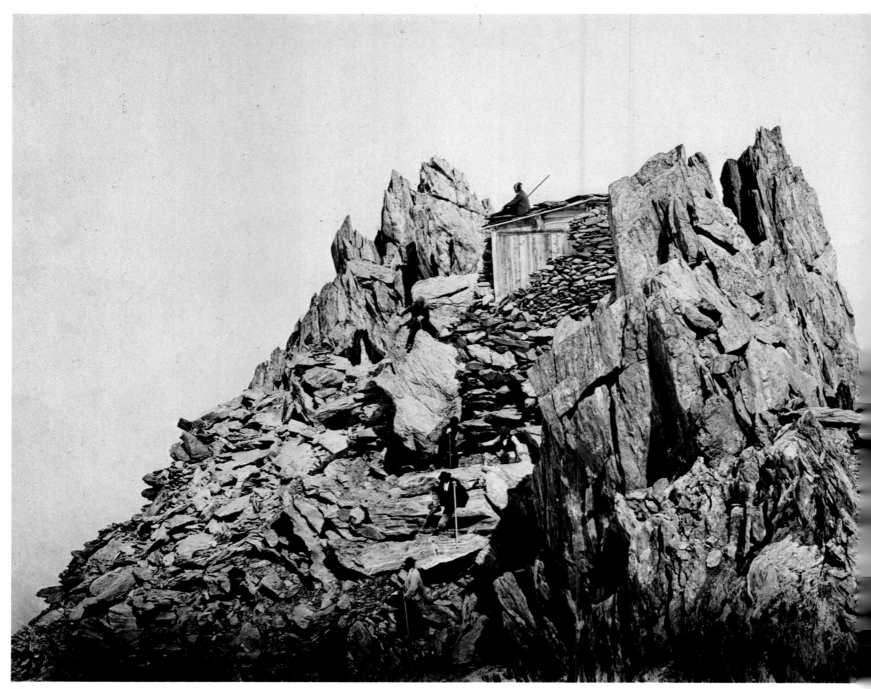

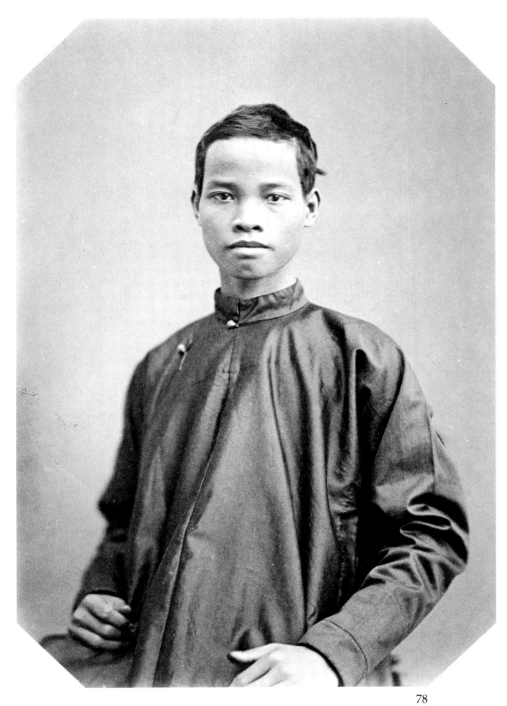

77. Auguste-Rosalie Bisson (France).
Cabane des Grands Mulets, Savoie.
1861. Albumen print
78. Louis Rousseau (France).
Envoy from Cochin China in Paris.
1863. Albumen print

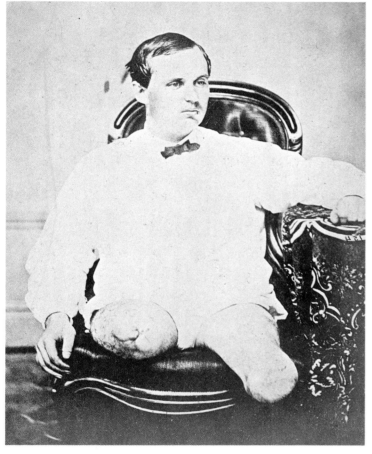

79

79. Anon. (United States).
Private Charles N. Lapham, Civil War Amputee.
1863. Albumen print
80. A. J. Russell (United States).
Union Soldier at an Arsenal near Washington, D.C.
c. 1865. Albumen print

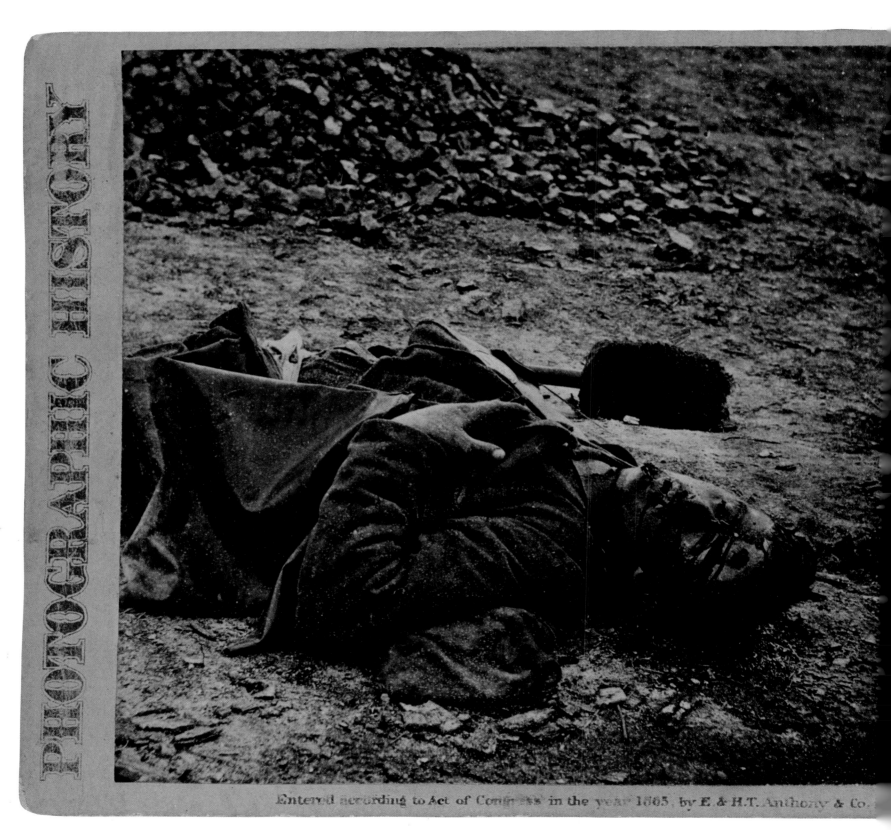

81. Timothy H. O'Sullivan (United States). *Dead Confederate Soldier.* 1865. Albumen stereocard

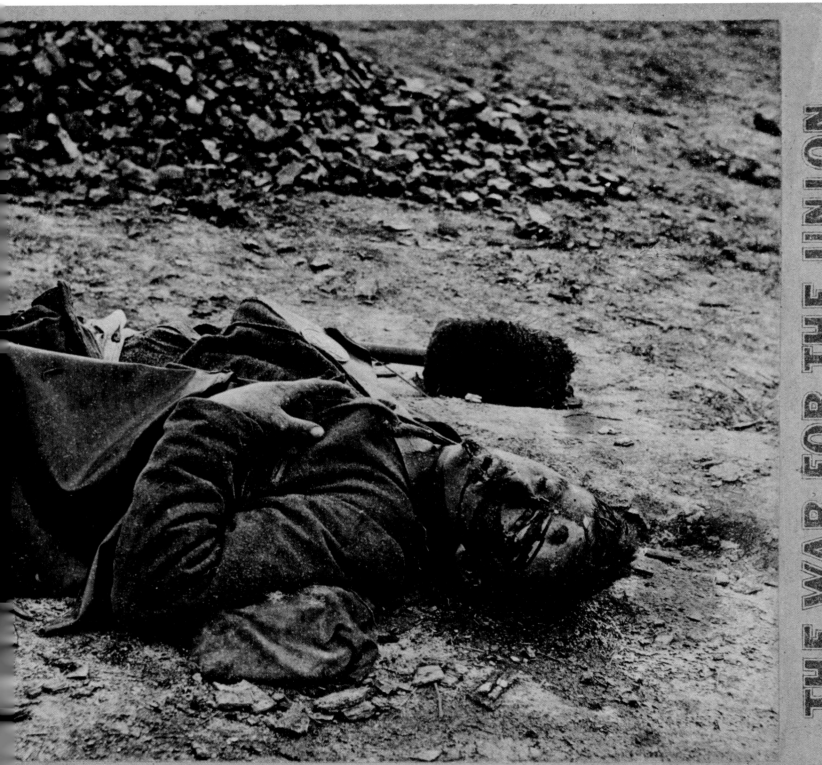

THE WAR FOR THE UNION.

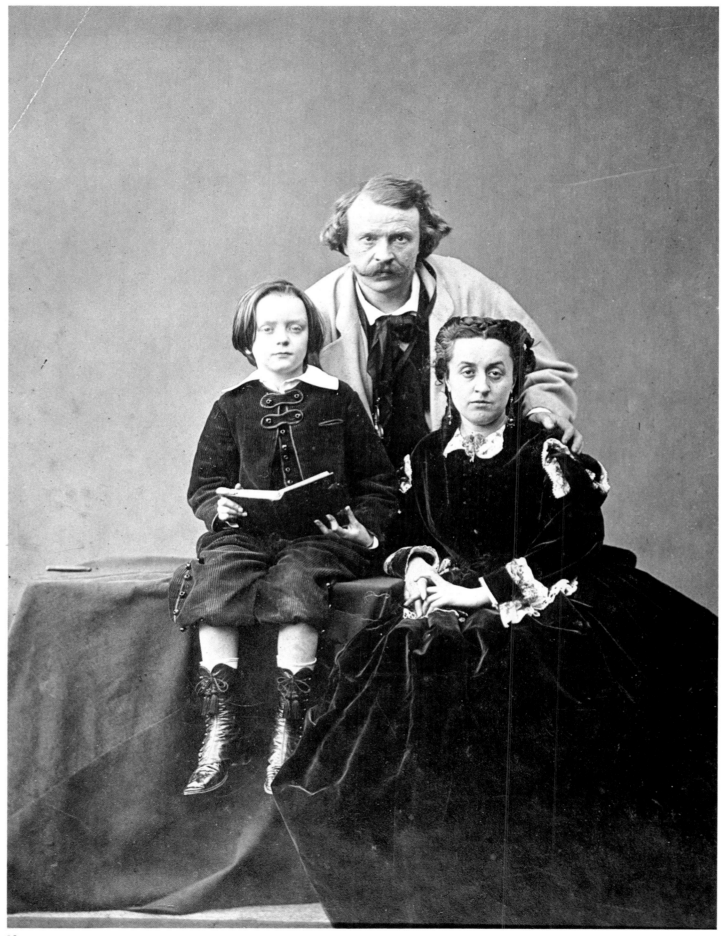

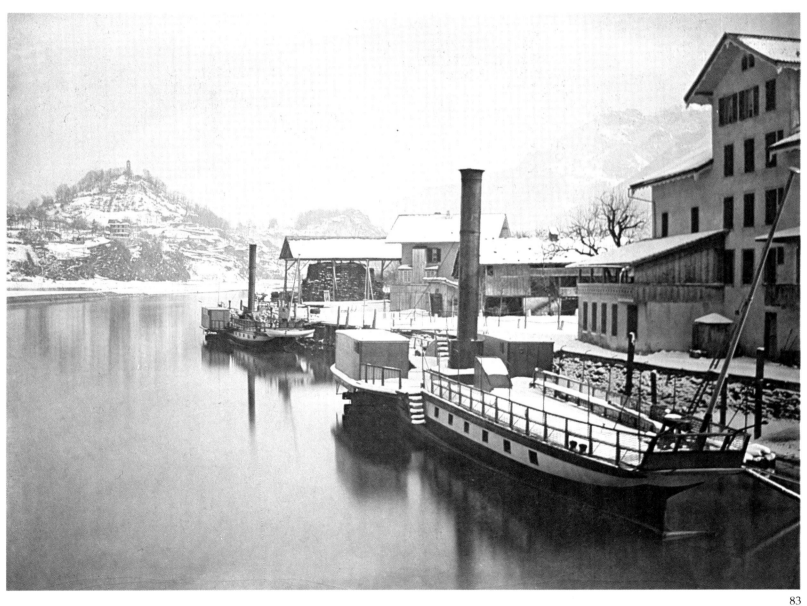

82. Nadar (Gaspard Félix Tournachon; France).
Self-portrait with Mme Nadar and Paul Nadar.
c. 1865. Albumen print
83. Adolphe Braun (France).
Lake Steamers at Winter Moorings, Switzerland.
c. 1865. Carbon print

84. Samuel Bourne (England). *The Cawnpore Memorial Well*. c. 1865. Albumen print
85. Adolphe Braun (France). *Still Life with Deer and Wild Fowl*. c. 1865. Carbon tissue

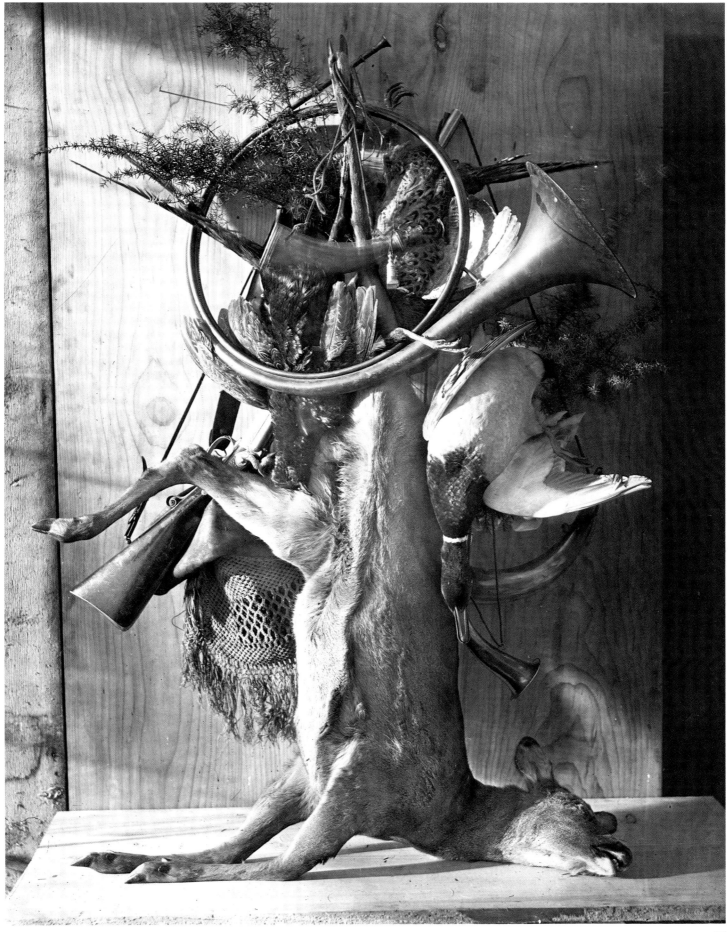

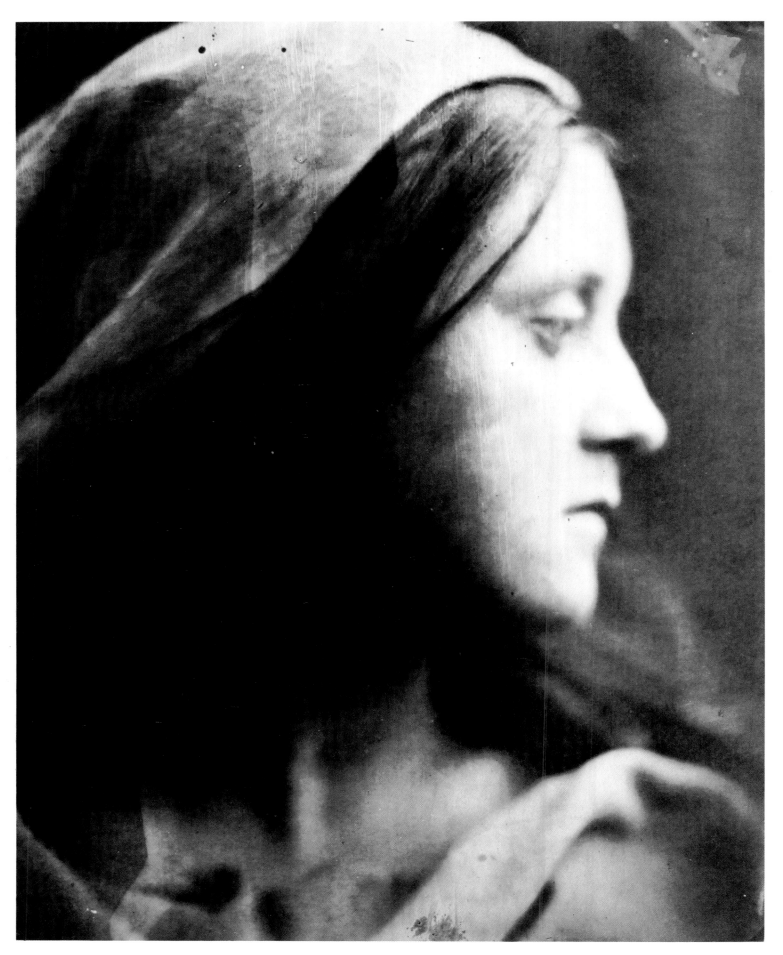

86. Julia Margaret Cameron (England; b. India). *Mary Hillier, Her Maid.* c. 1867. Albumen print

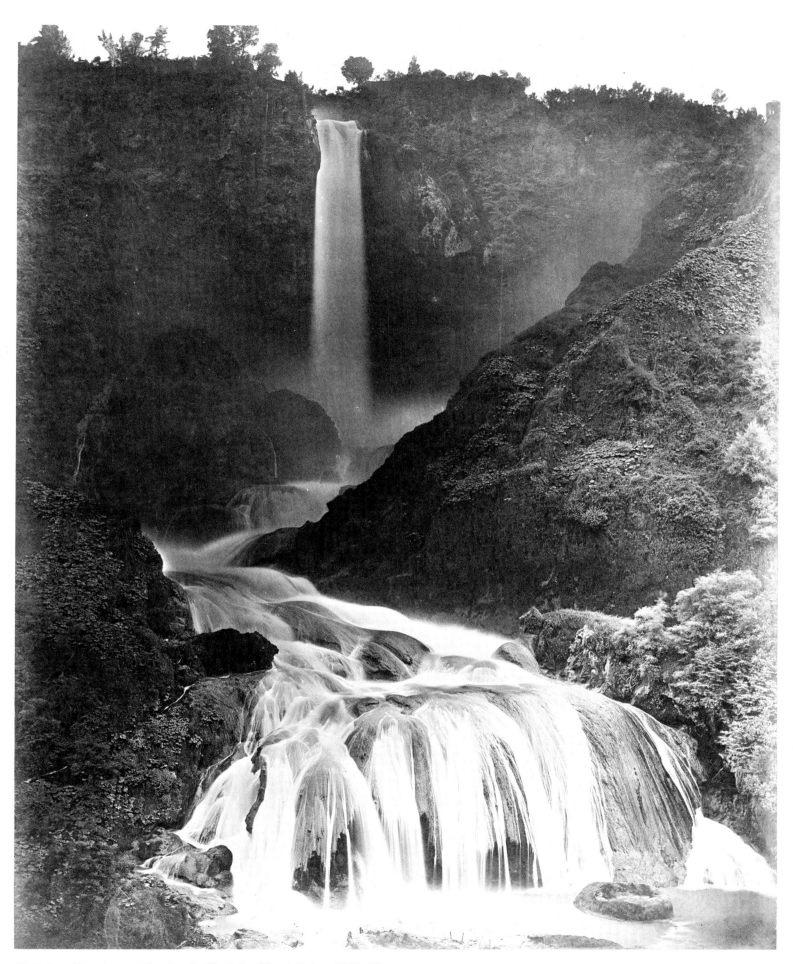

87. Robert Macpherson (Scotland). *The Falls of Terni*. Before 1867. Albumen print

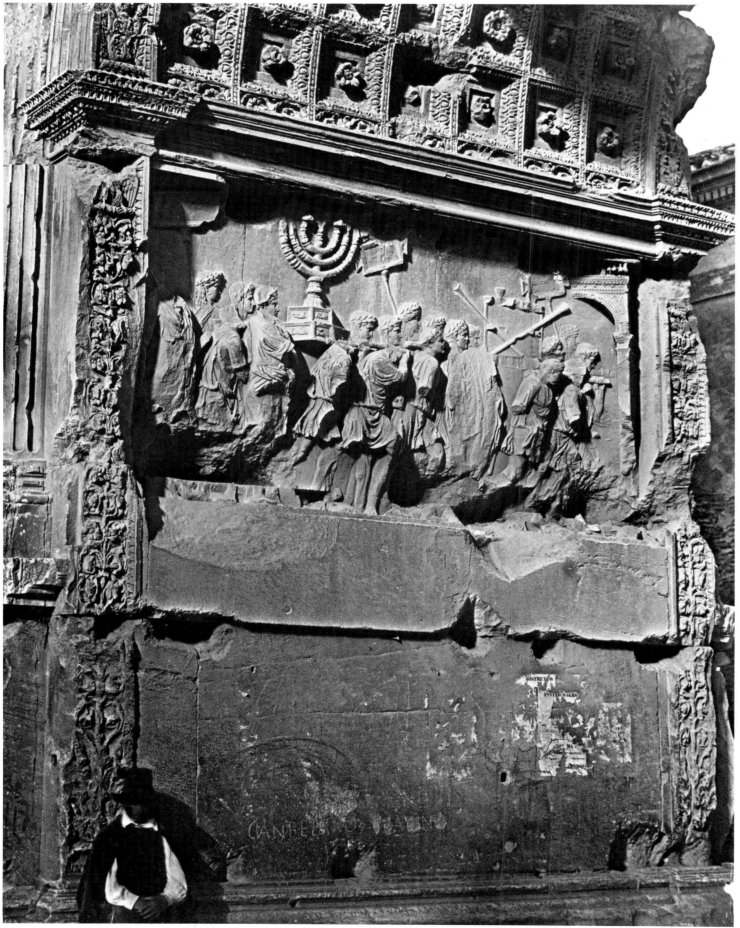

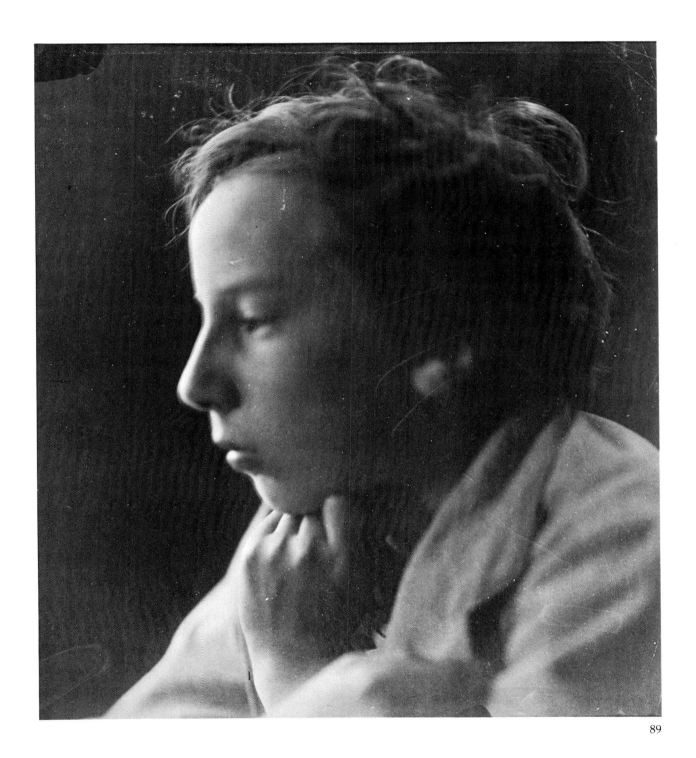

89

88. Robert Macpherson (Scotland).
Bas-relief on the Interior of the Arch of Titus, Rome.
c. 1865. Albumen print
89. Julia Margaret Cameron (England; b. India).
The Photographer's Son, Henry Herschel Hay Cameron.
1865. Albumen print

90

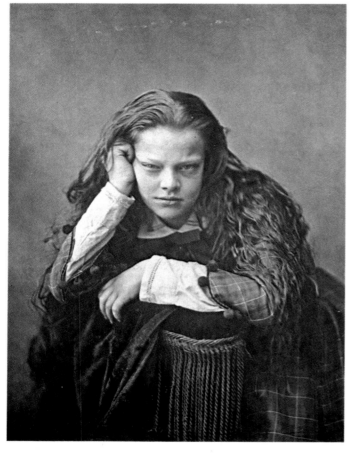

90. Cyprien Tessié du Motay (France).
Young Woman. c. 1867. Phototype
91. Carleton E. Watkins (United States).
Self-portrait, Geyser Springs, The Witch's Cauldron.
1860s. Albumen print

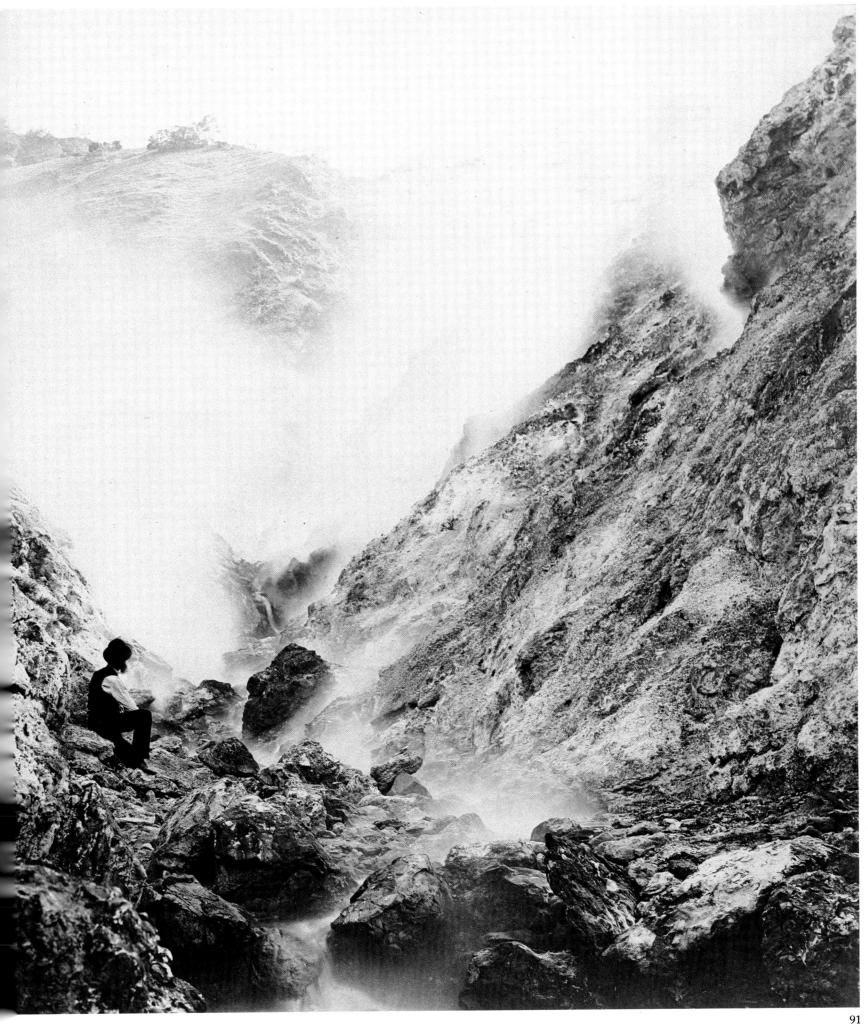

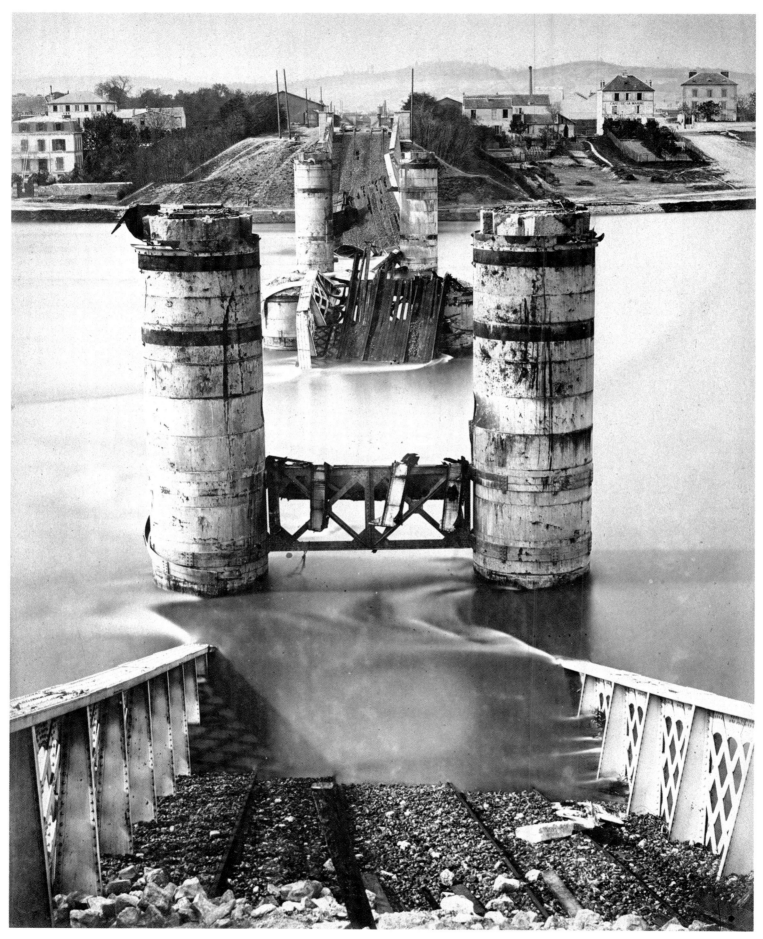

92. J. Andrieu (France). *The Bridge at Argenteuil.* 1870–71. Albumen print

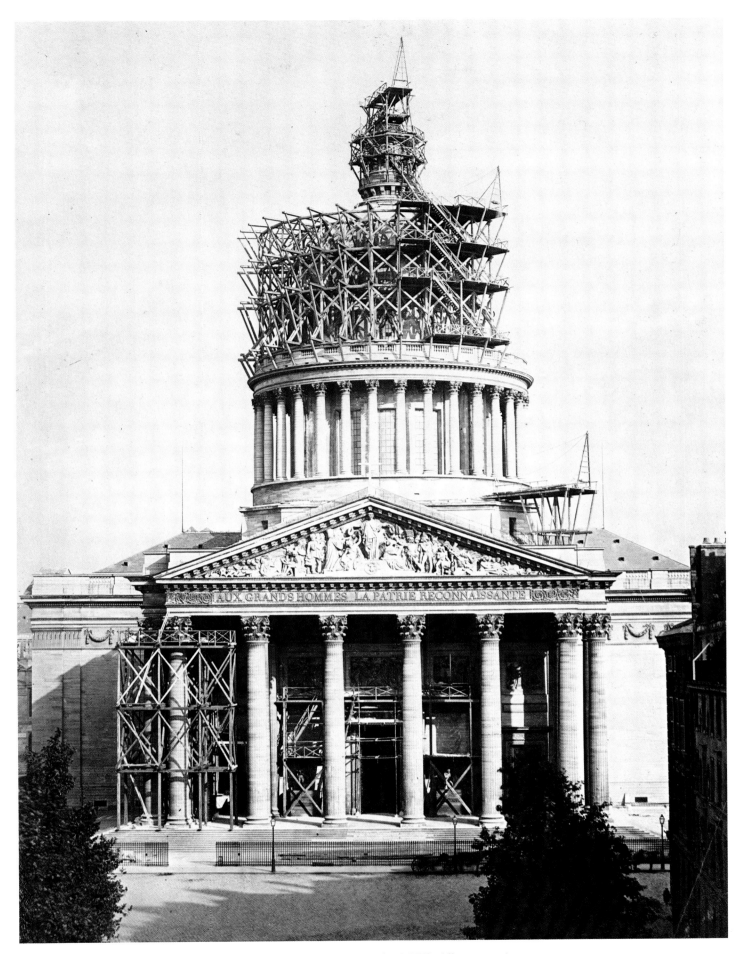

93. **Charles Marville (France).** *The Church of the Panthéon Under Repair.* c. 1870. Albumen print

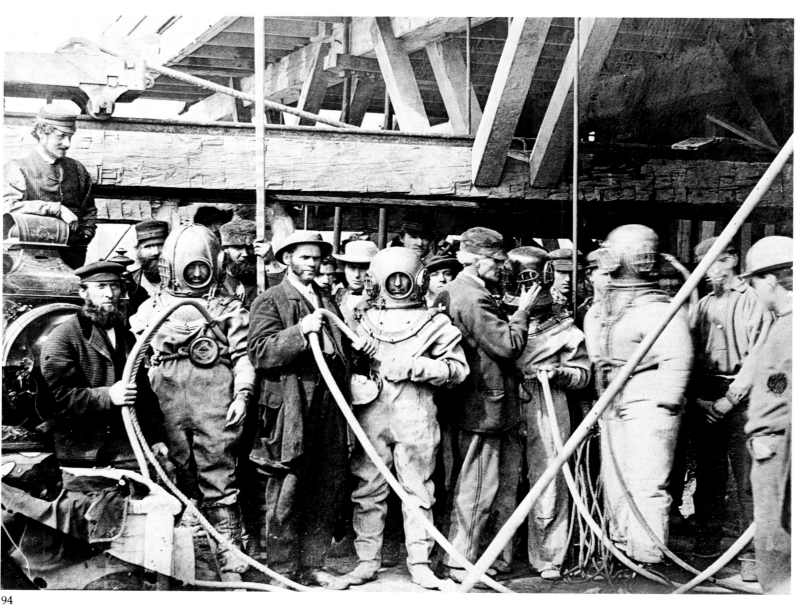

94

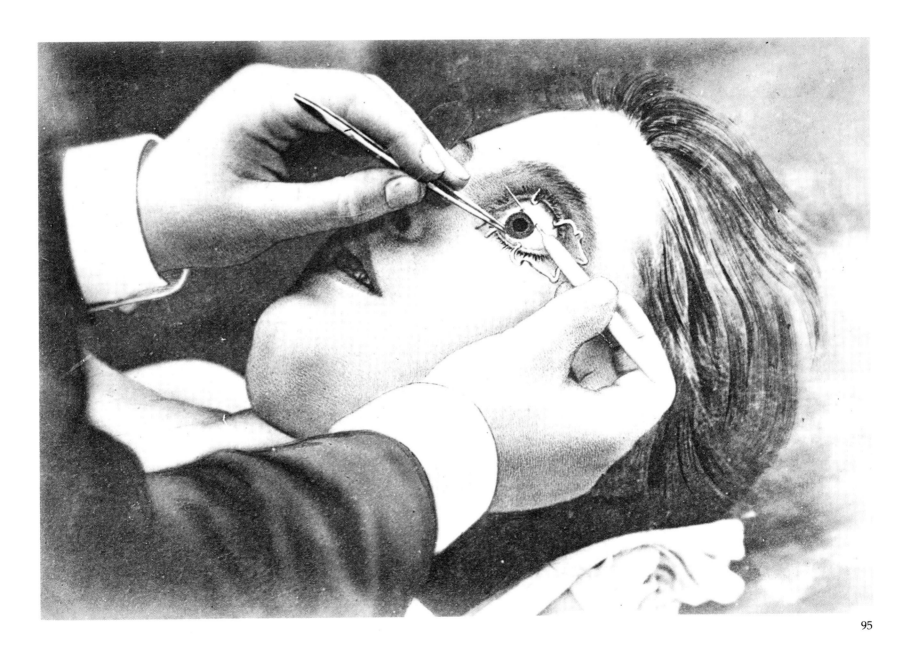

94. Anon. (United States).
Divers at Pier No. 4, Kansas City Bridge.
1869. Albumen print
95. Dr. A. de Montmeja (France).
Linear Incision of the Eye. Pub. 1871.
Retouched albumen print

96. Charles Aubry (France). *Flower Study.* 1864–70. Albumen print

97. **Pietro Th. Boysen** (Denmark). *Elisabeth Jerichau Baumann with Her Son in Rome.* 1873. Albumen print

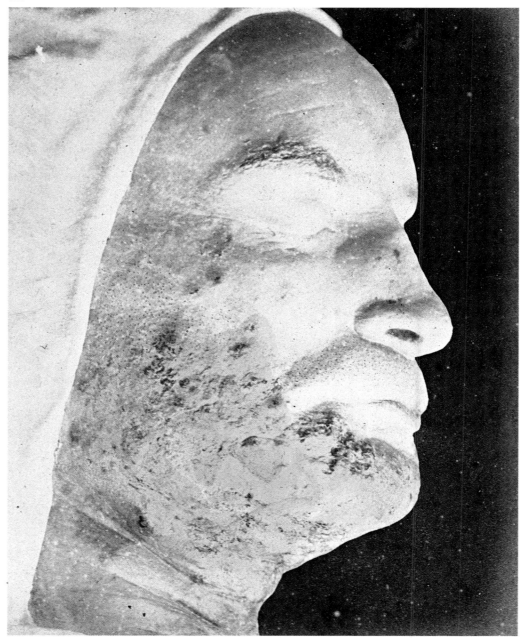

100. Dr. A. Hardy (Great Britain) and Dr. A. de Montmeja (France).
Sycosis, a Skin Disease. 1872. Albumen print, hand-colored
101. **Anon**. *Hindu Priest from Southern India with Attendants*.
1870s. Albumen print

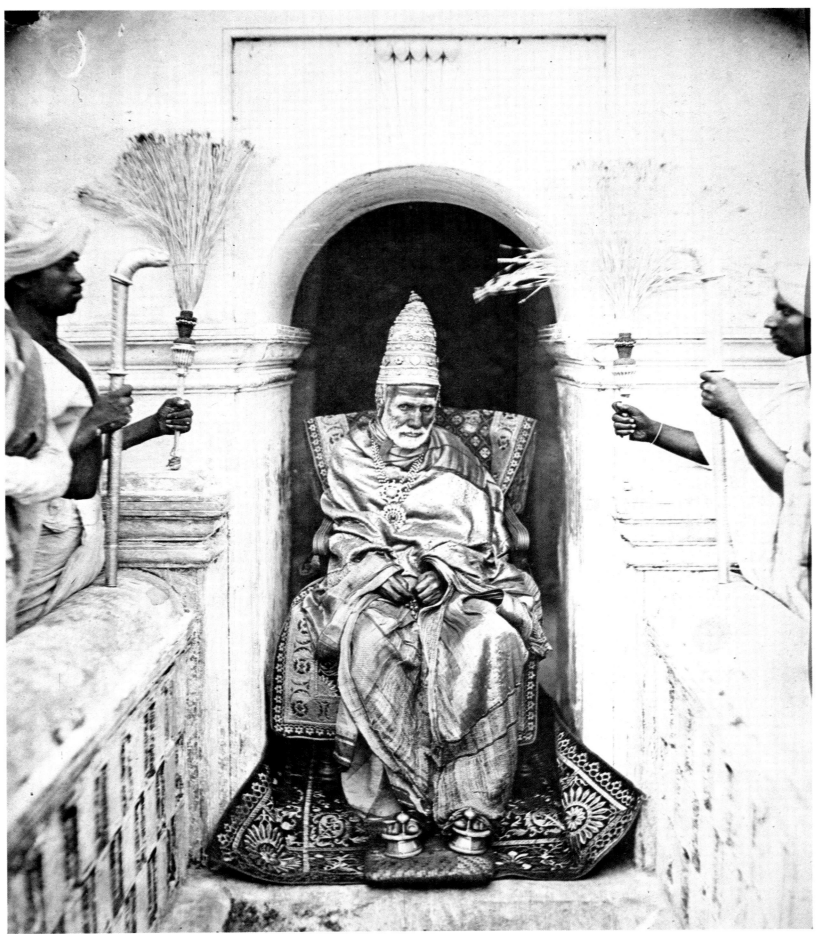

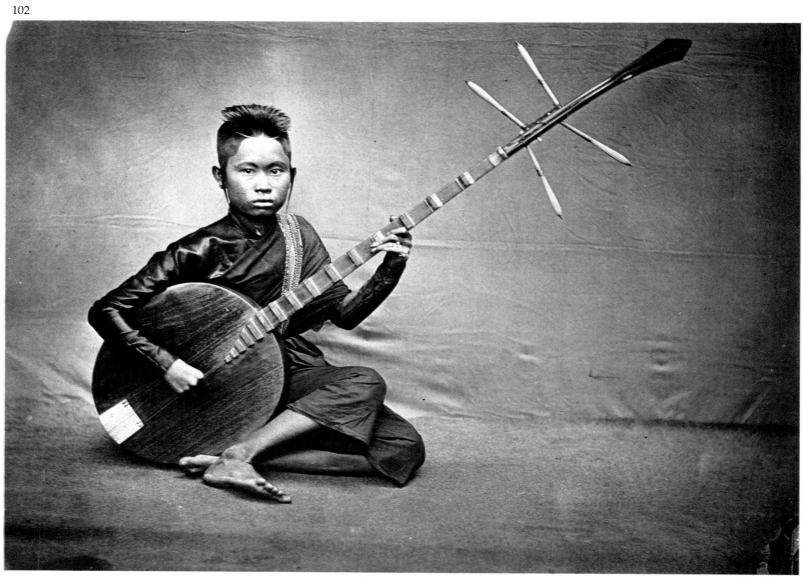

102. Anon. (probably Great Britain).
Siamese Boy Musician. c. 1875.
Albumen print
103. W. L. H. Skeen and Co. (active in Ceylon).
Tamil Girl. c. 1880.
Albumen print

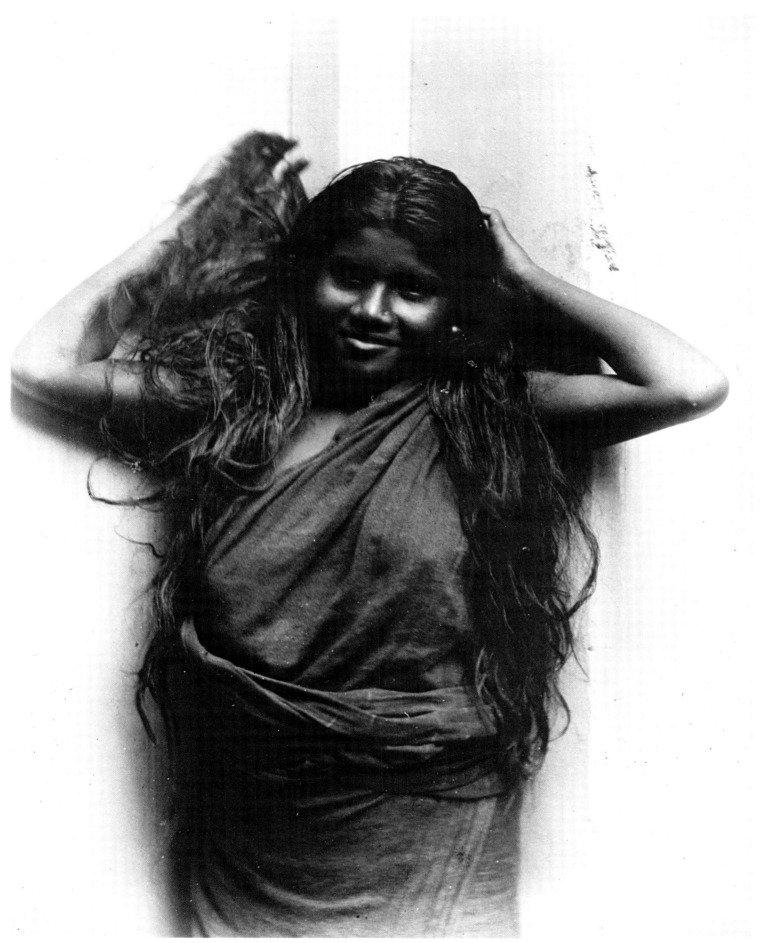

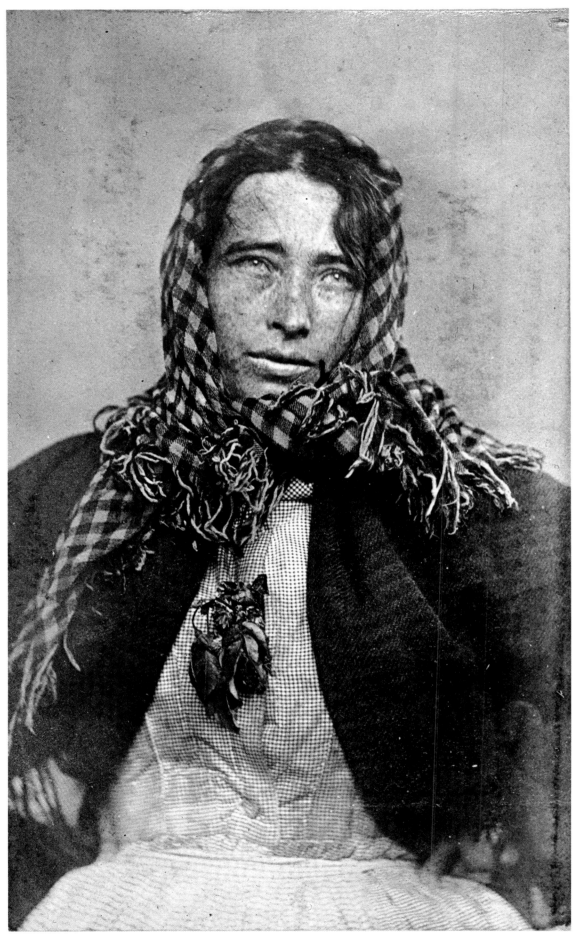

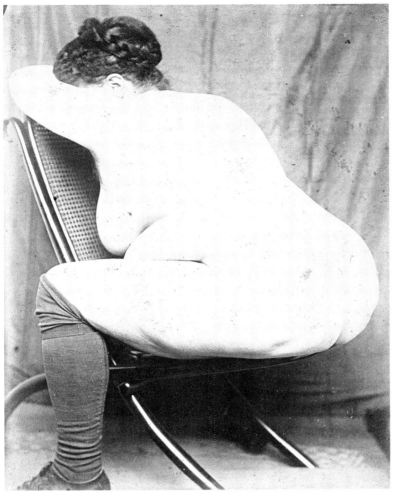

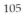

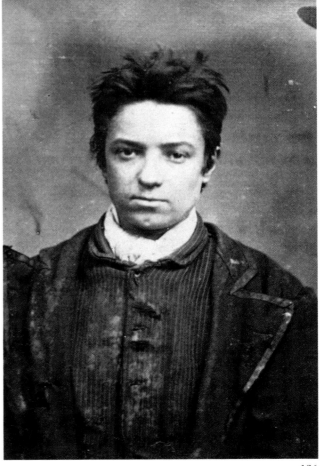

104. Anon. (Great Britain).
Asylum Patient Suffering from Melancholia.
1876. Albumen print
105. Anon. (probably France).
Fat Woman. c. 1875. Albumen print
106. Anon. (Great Britain).
Barnardo Boy. 1876. Albumen print

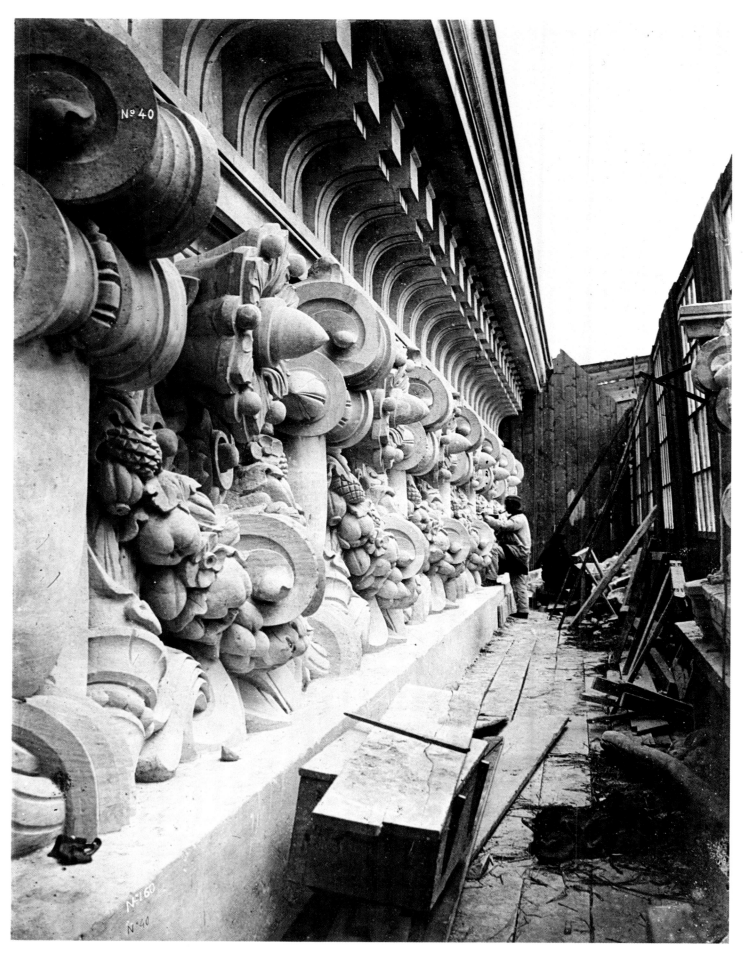

107. Durandelle (France). *Stonemasons at Work on the Paris Opera.* Pub. 1876. Albumen print

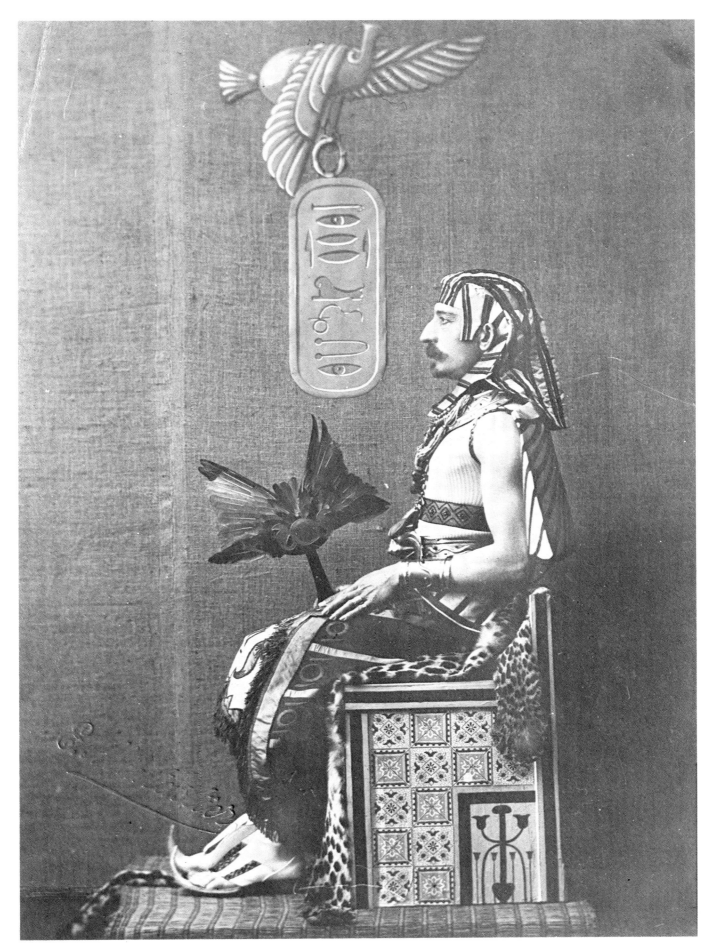

108. E. Montastier (France). *Pierre Loti Dressed as Osiris for a Fancy Dress Ball.* c. 1880. Albumen print

109. John K. Hillers (United States;
b. Germany). *Albino Zuni Indians.*
c. 1879. Albumen print

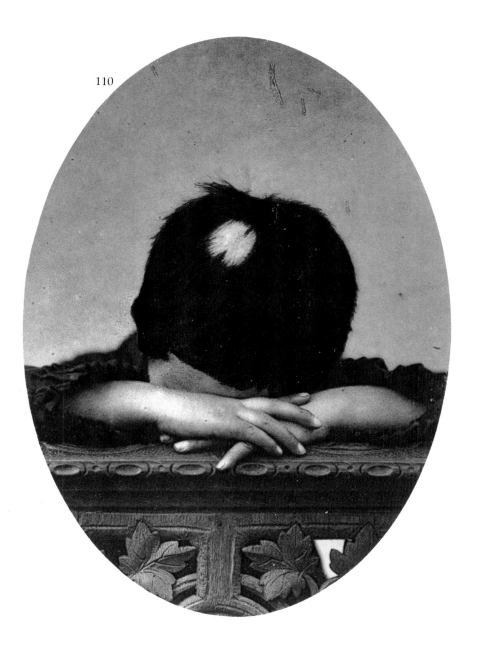

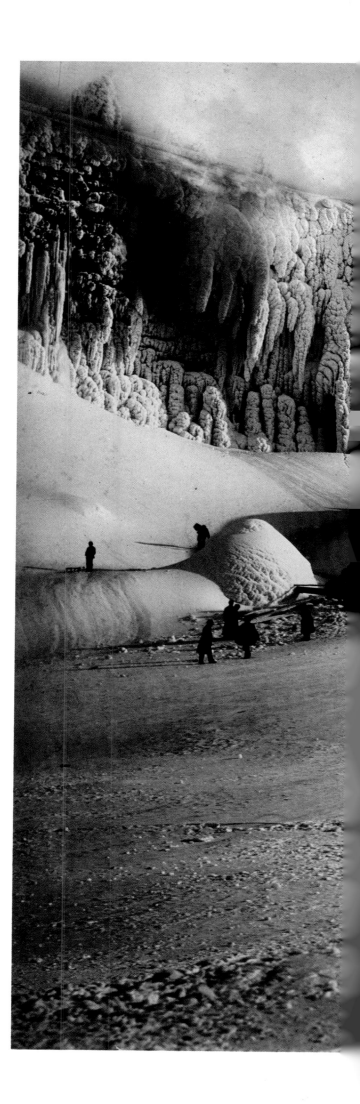

110. Léon Vidal (France).
Study of Ringworm of the Scalp.
Pub. 1878. Photochrome (Vidal process)
111. *Attrib.* H. F. Nielson (United States).
Niagara Falls Frozen. 1880s.
Albumen print

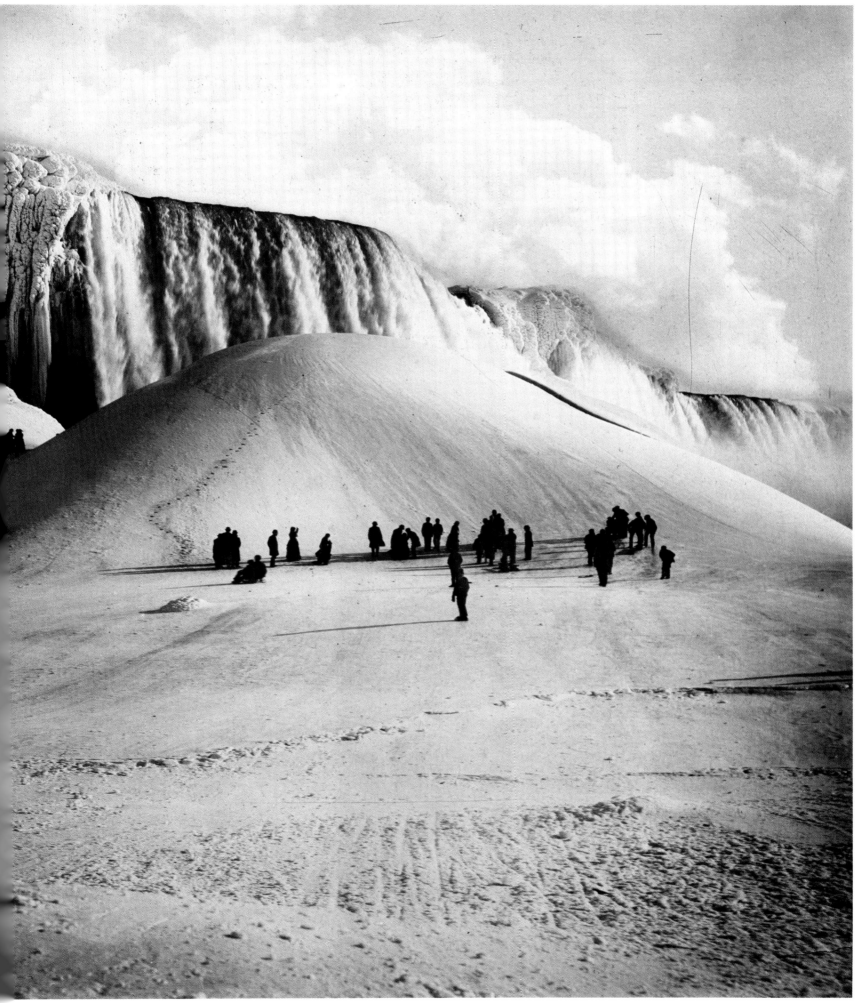

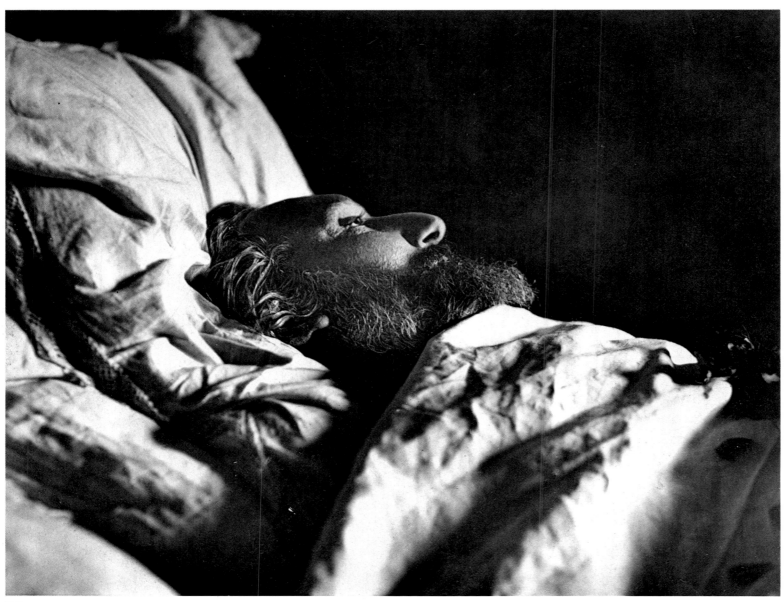

113

112. Etienne Carjat (France).
Léon Gambetta on His Deathbed.
1882. Carbon print
113. Anon. (probably United States).
Statuary in a Museum. 1880s.
Albumen print

114. Jules Robuchon (France). *Saint-Jouin-des-Marnes, Poitou, Ruins of the Cloisters.* c. 1885. Woodburytype

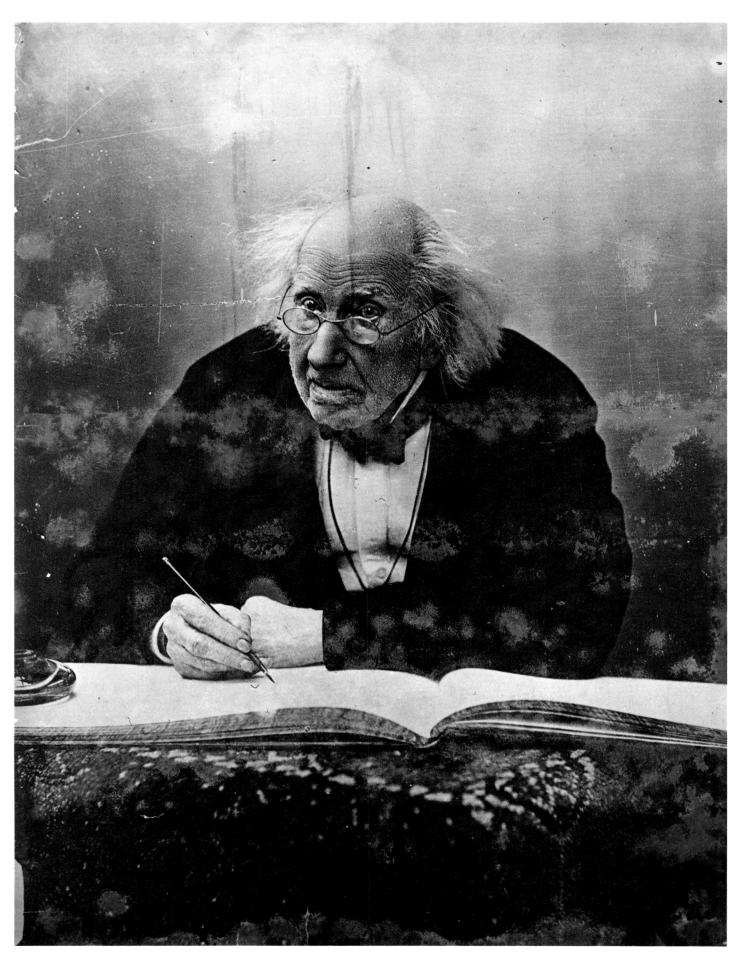

115. Paul Nadar (Paul Tournachon; France). *Michel Chevreul on His 100th Birthday, at an Interview with Nadar.* 1886. Albumen print

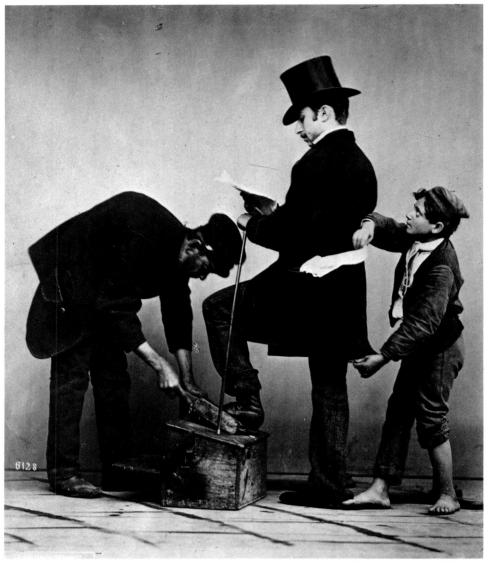

116

117

116. Giorgio Sommer (Italy; b. Germany).
Shoeshine and Pickpocket. 1870s. Albumen print
117. Giorgio Sommer (Italy; b. Germany).
Ancient Roman Horn. 1870s. Albumen print
118. Giorgio Sommer (Italy; b. Germany).
Pulling in a Boat, Naples. c. 1875. Albumen print

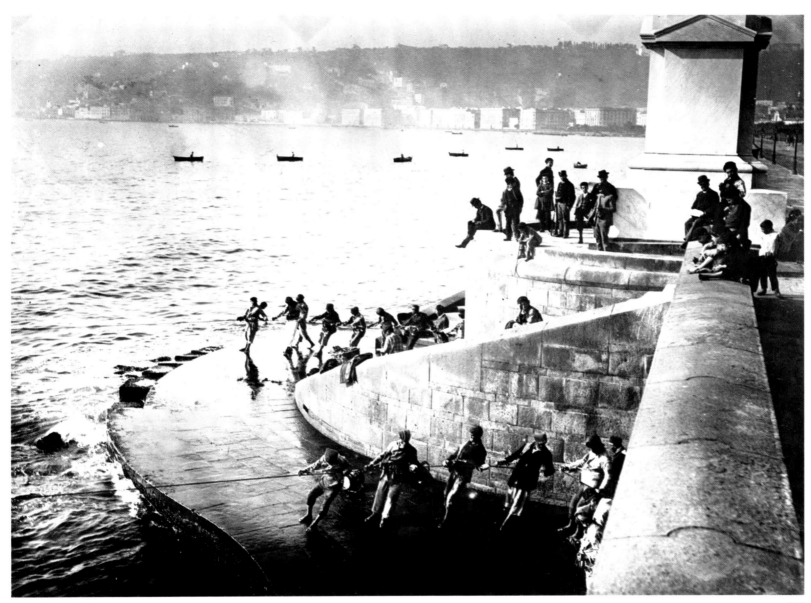

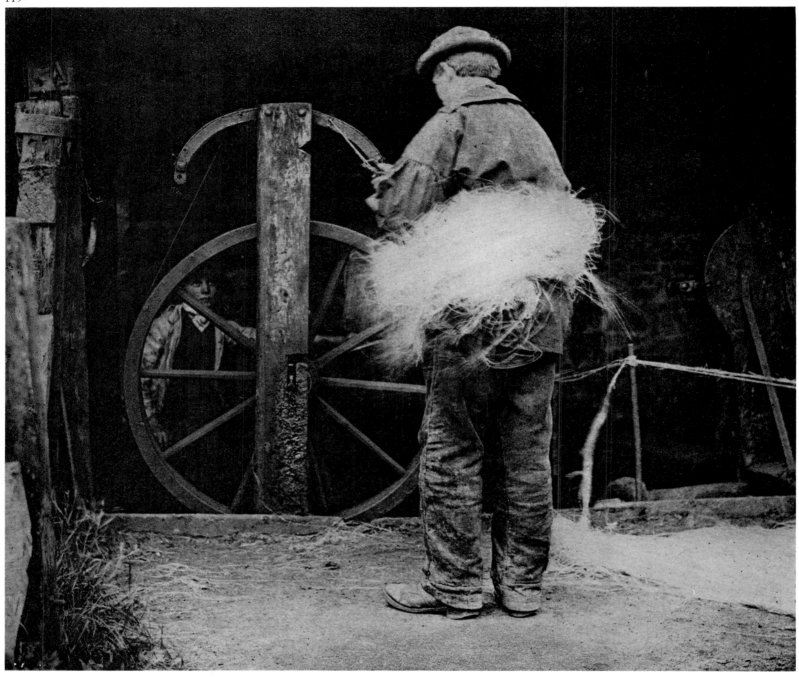

119. Peter Henry Emerson (England; b. Cuba).
Rope Spinning. 1887. Photoetching
120. Anon. (probably Scotland).
Construction of the Forth Bridge.
c. 1884. Silver bromide print

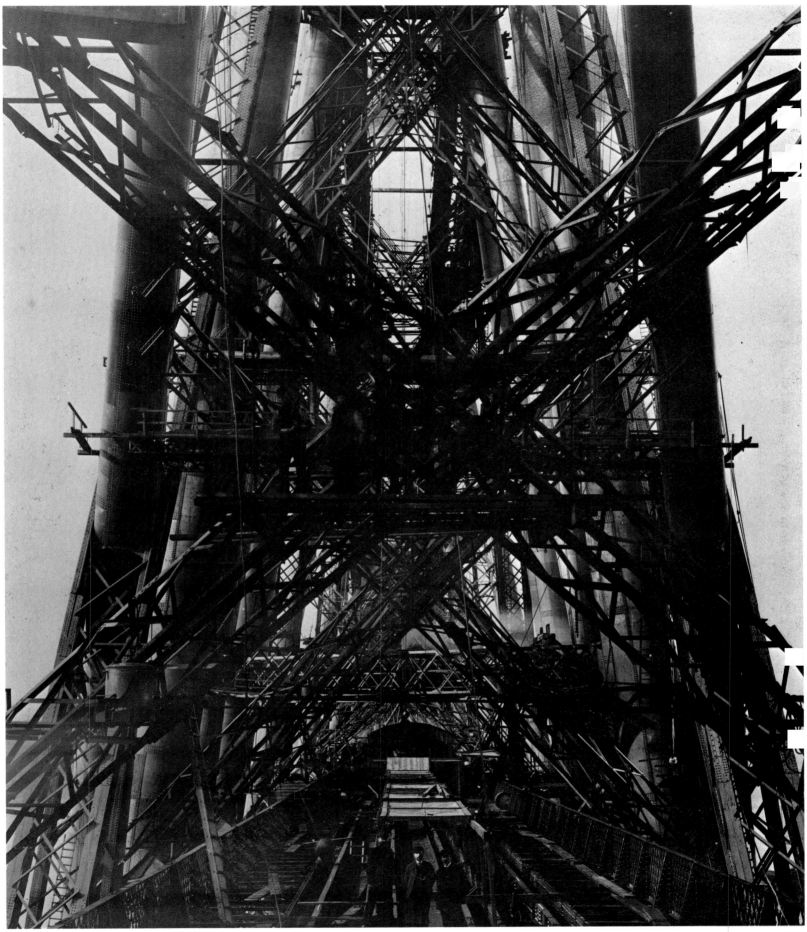

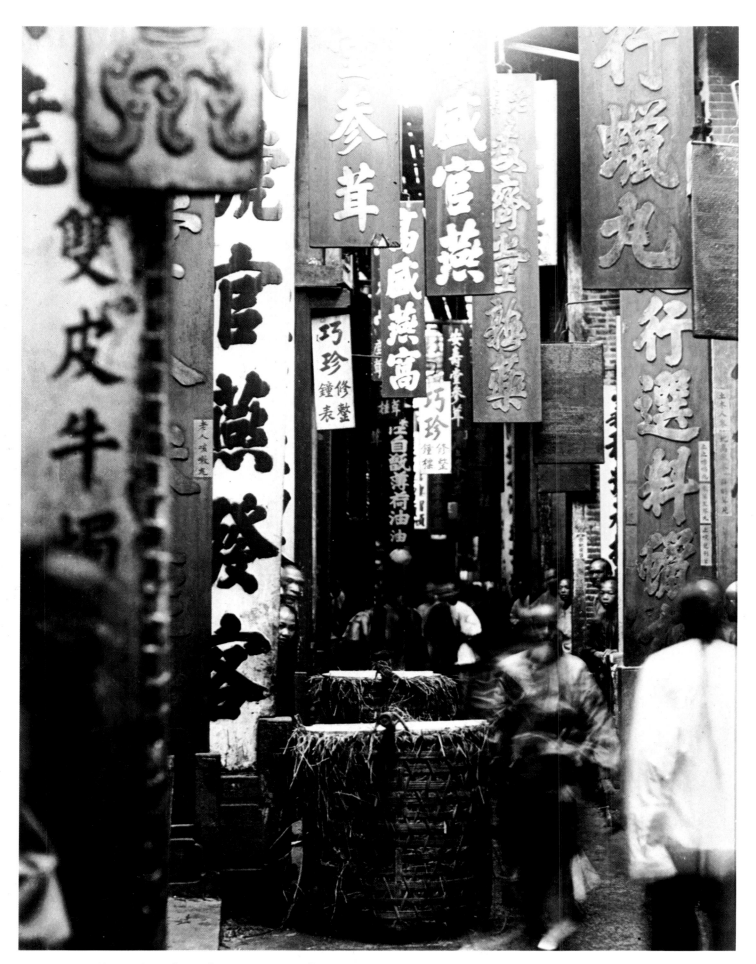

121. A. Fong (China). *Street Scene, Canton.* 1885–90. Albumen print

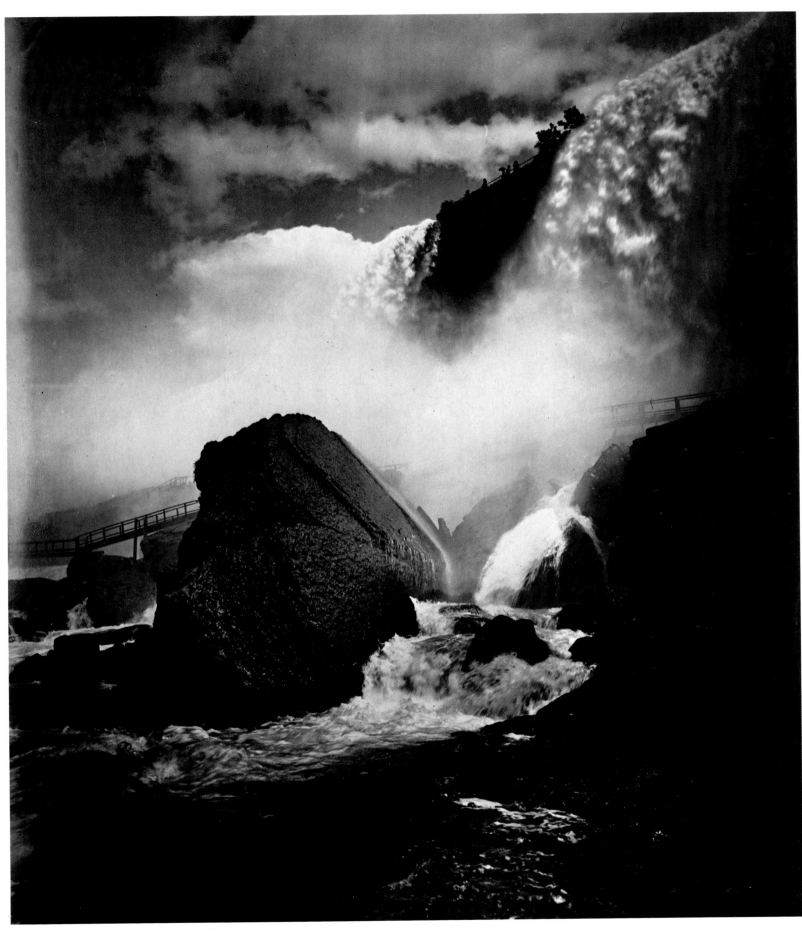

122. George Barker (United States). *Niagara Falls*. 1888. Albumen print

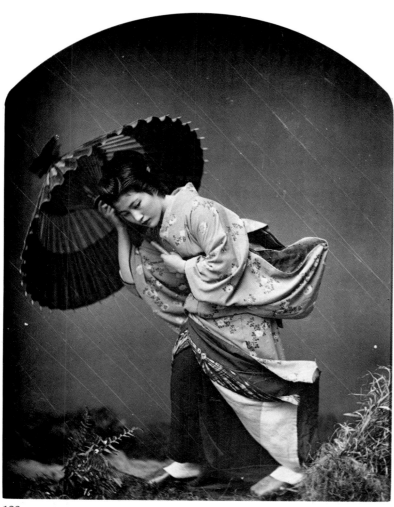

123

123. Baron R. von Stillfried (Austria).
Studio Study. c. 1890. Albumen print
124. Jacob Riis (United States; b. Denmark).
Blind Man. 1888. Silver bromide print

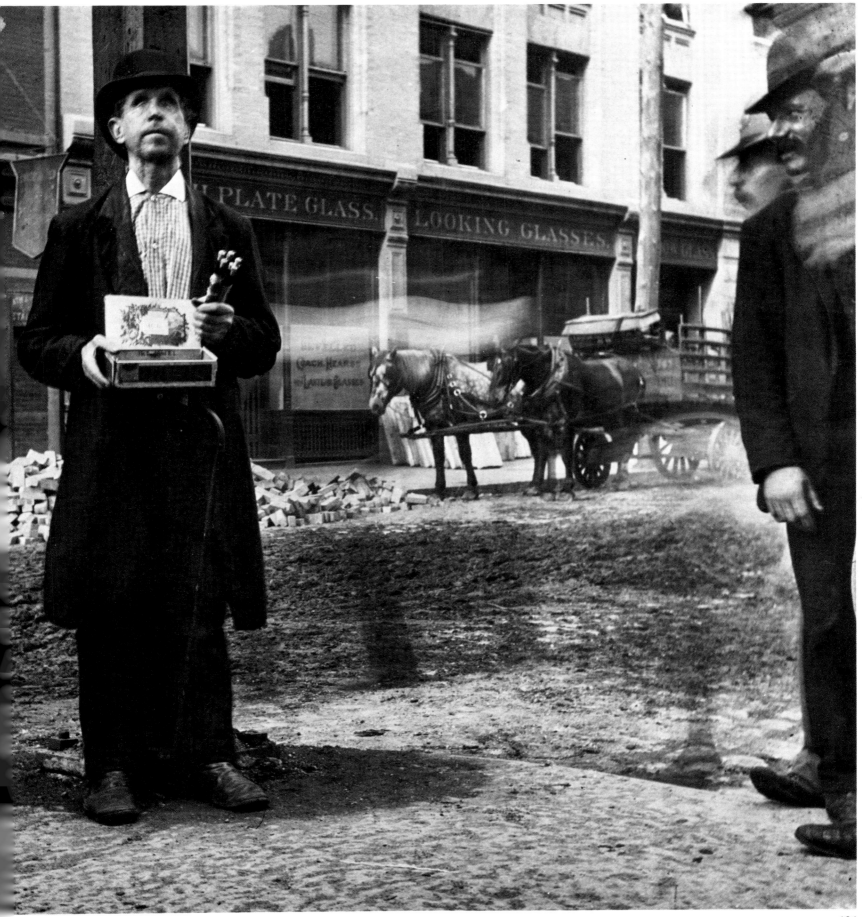

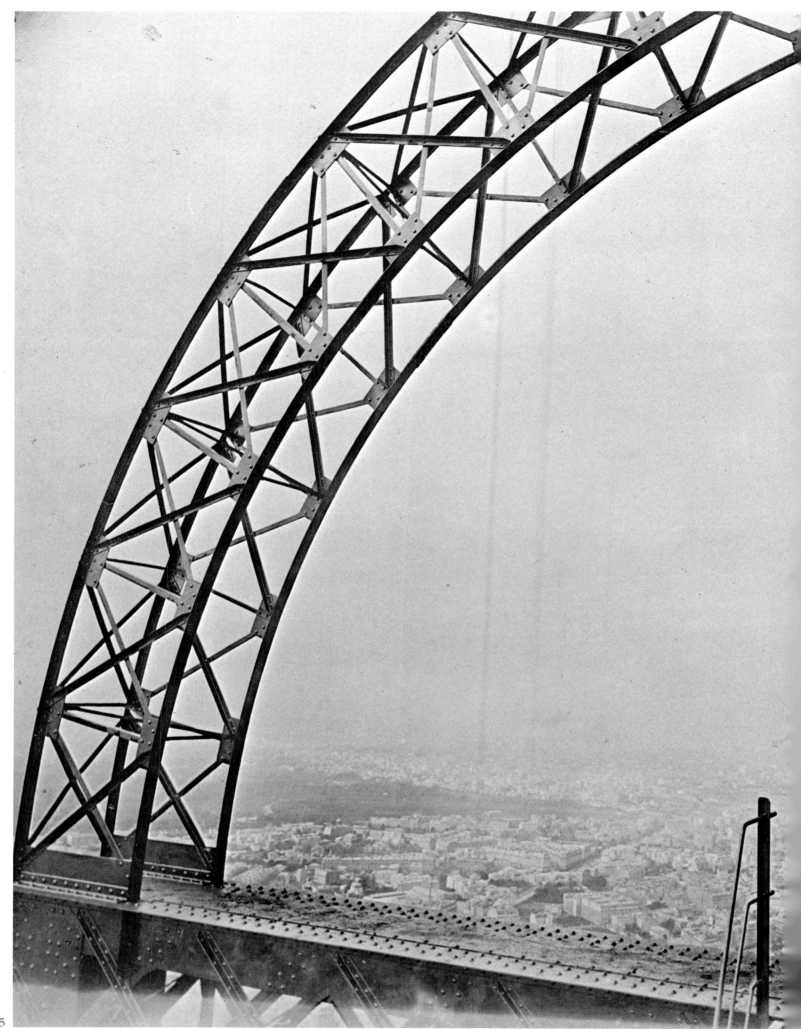

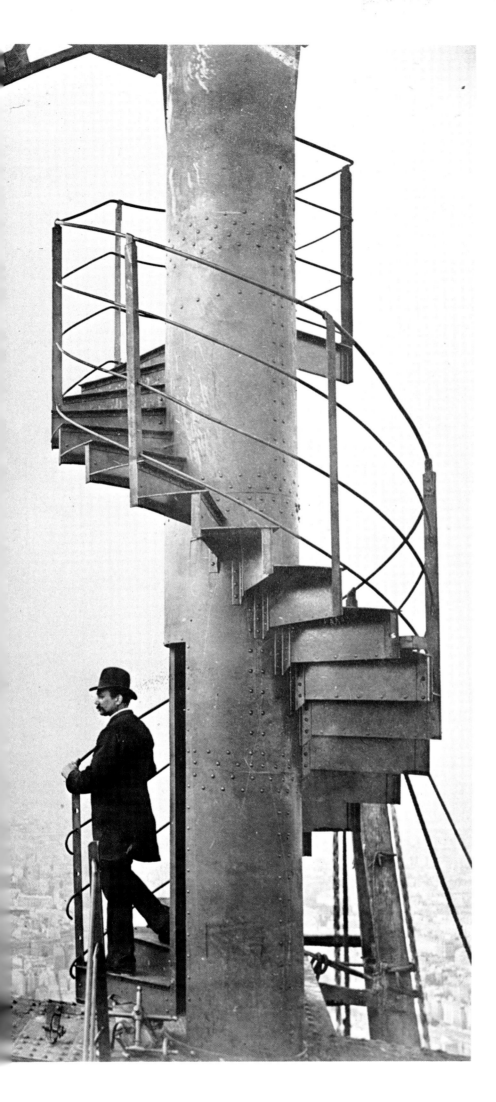

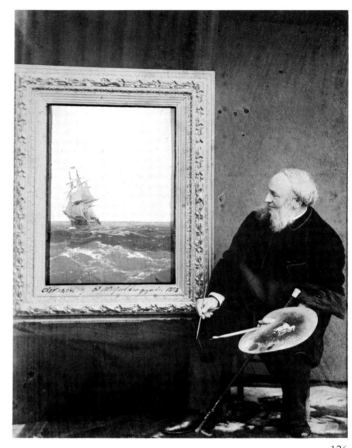

126

125. N. D. (Neurdien; France).
Detail of the Eiffel Tower.
1889. Albumen print
126. Babayeva Studio (Russia).
Portrait of the Artist Ivan Constantinovich Aivasovski.
1893. Albumen print, oil-painted

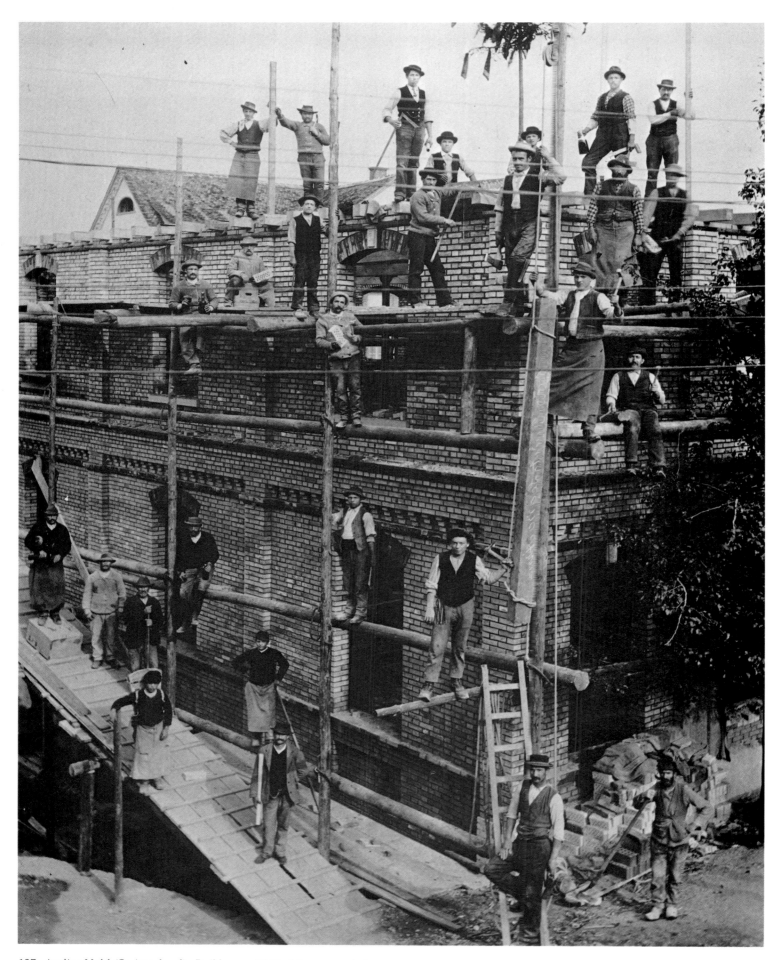

127. Atelier Held (Switzerland). *Builders*. c. 1890. Albumen print

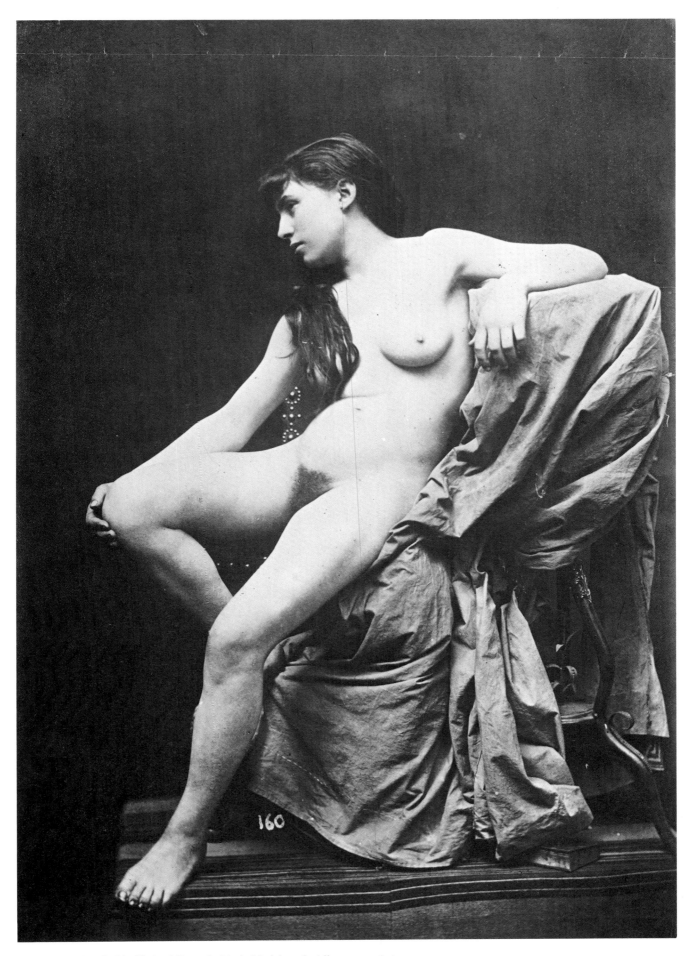

128. Anon. (probably United States). *Nude Model*. n.d. Albumen print

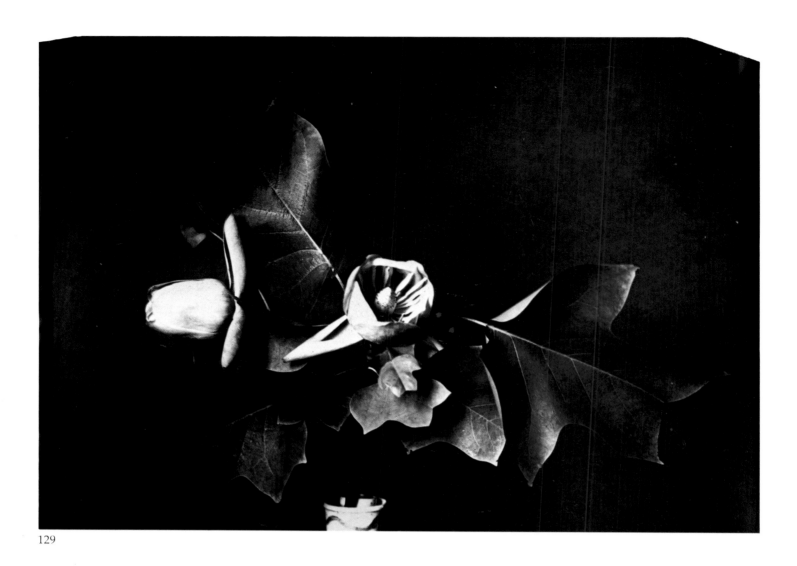

129

130

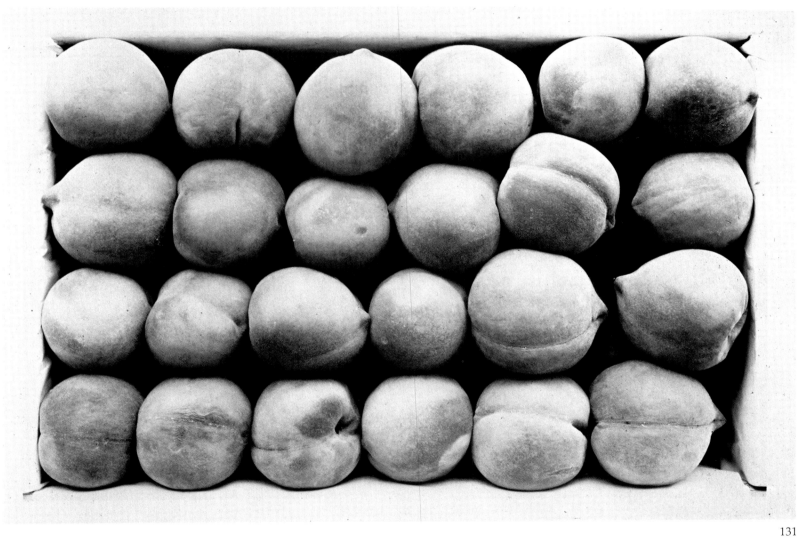

129. Anon. (United States).
Flowers. 1890s. Gelatin print
130. Auguste and Louis Lumière (France).
Untitled. c. 1895. Stereo gum trichromate on glass
131. Carleton E. Watkins (United States).
Cling Peaches, Kern County, California.
c. 1889. Albumen print

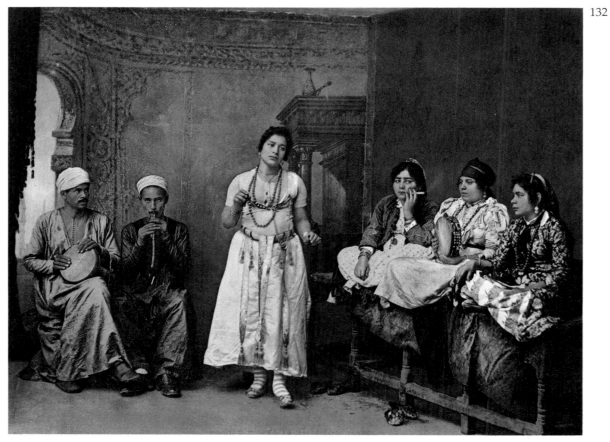

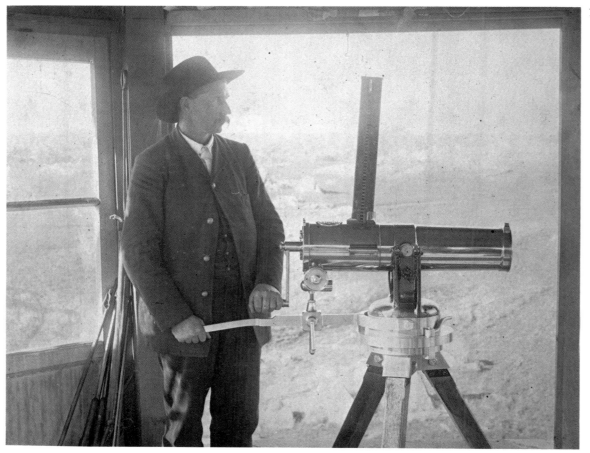

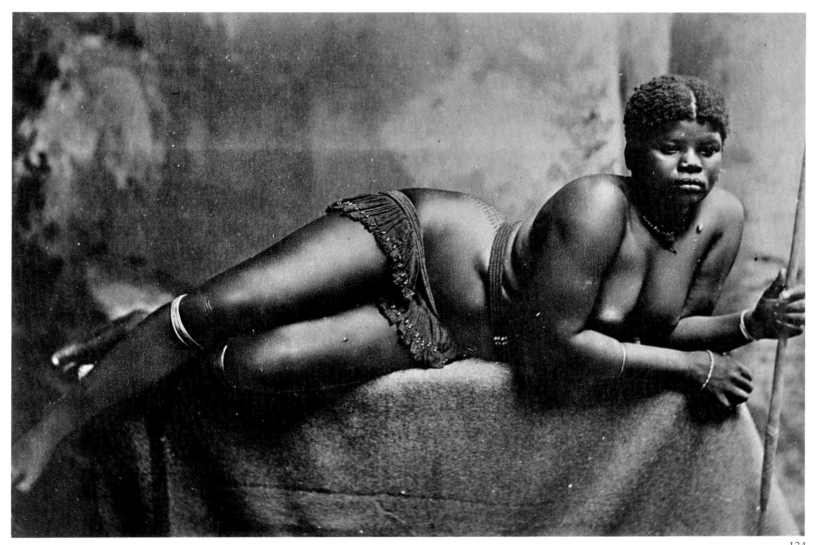

134

132. Anon. (France). *Egyptian Dancer and Musicians.*
c. 1890. Photochrome
133. Skylar (United States). *Guard at Polson Prison, Montana, with Gatling Gun.*
c. 1892. Silver bromide print
134. Lloyd of Natal (probably Wales). *Zulu Girl.* 1885–90. Albumen print

OVERLEAF:
135. Lala Deen Dayal (India). *Hyderabad Famine.* 1890s. Gelatin print

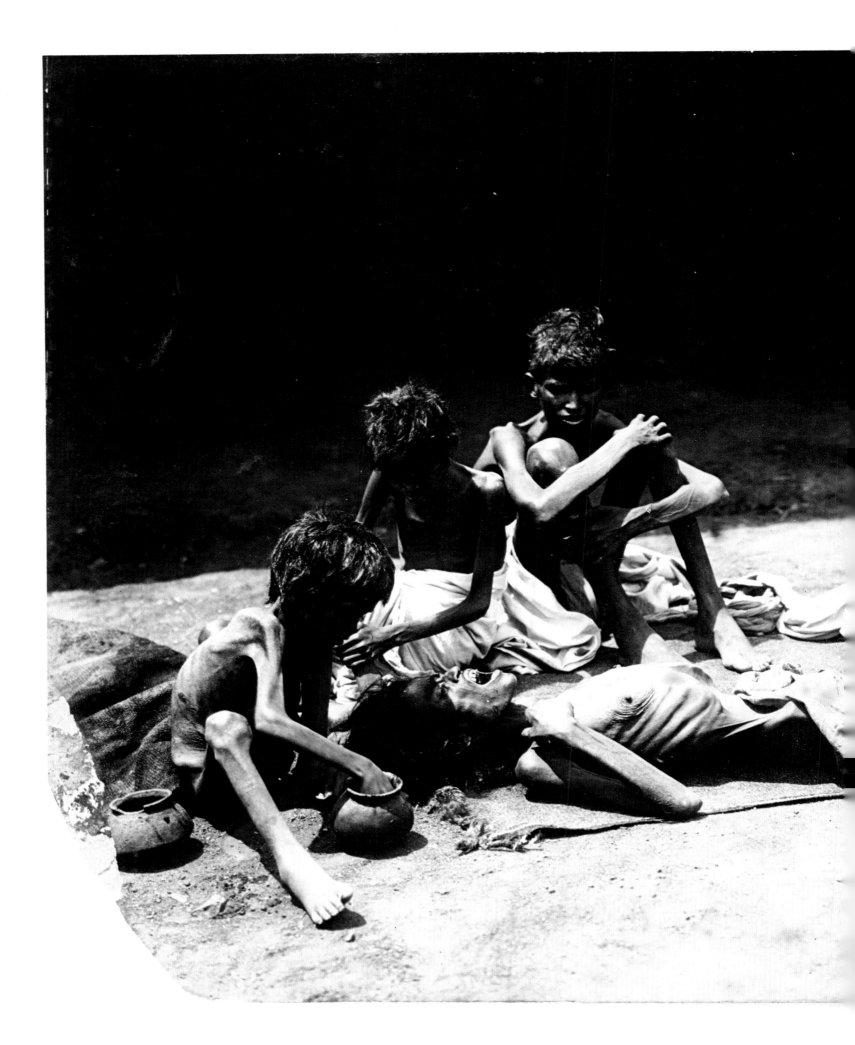

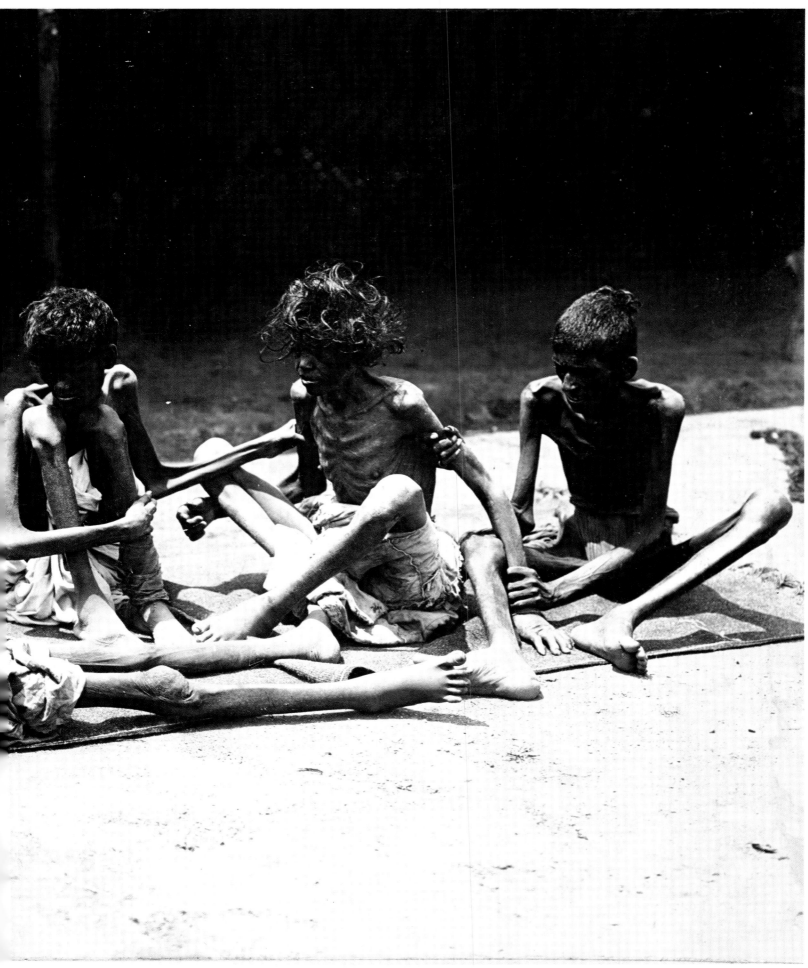

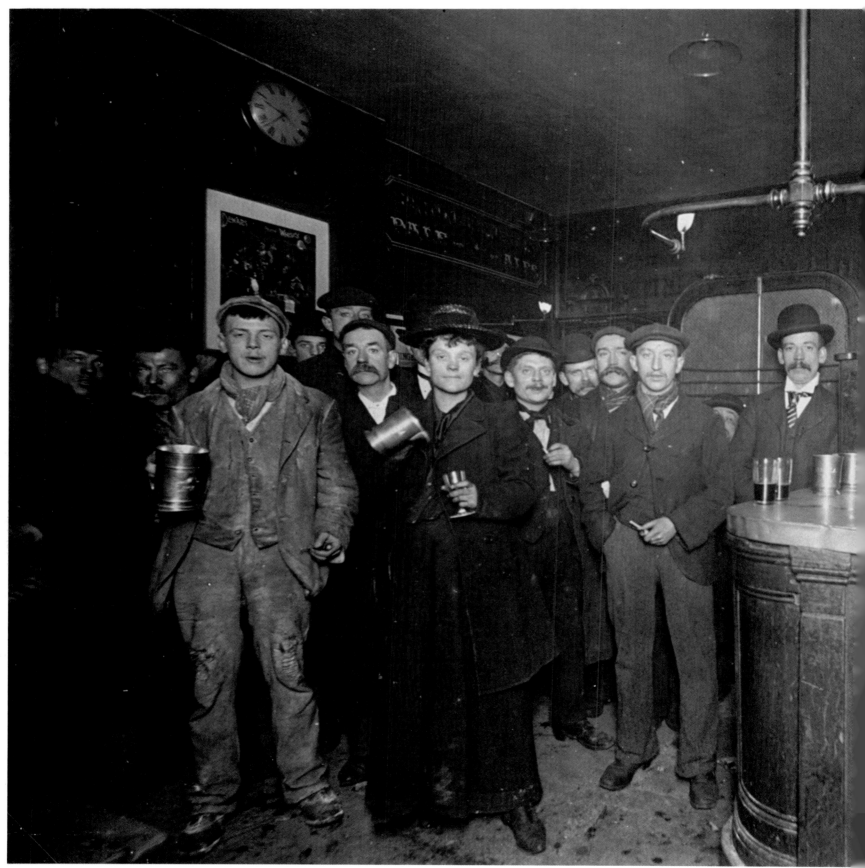

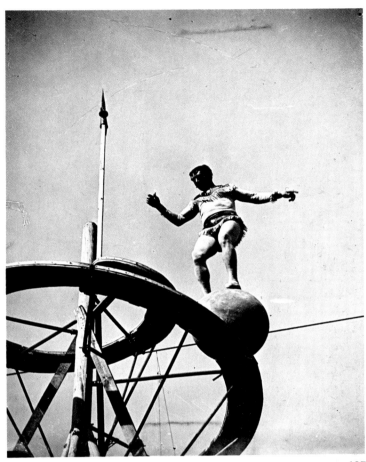

137

136. Harry Ellis (United States).
London Pub Interior. 1898.
Silver bromide print
137. Count Giuseppe Primoli (Italy).
Balancing Act. c. 1895.
Modern silver bromide print
from the original negative

138

138. Edouard Vuillard (France).
Misia and Thadée Natanson at Home.
c. 1900. Albumen print
139. Edouard Vuillard (France).
A Departure. c. 1901. Albumen print
140. *Attrib.* Edgar Degas (France).
Back of a Nude. c. 1890–95.
Silver bromide print

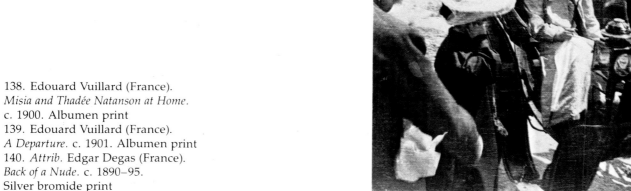

139

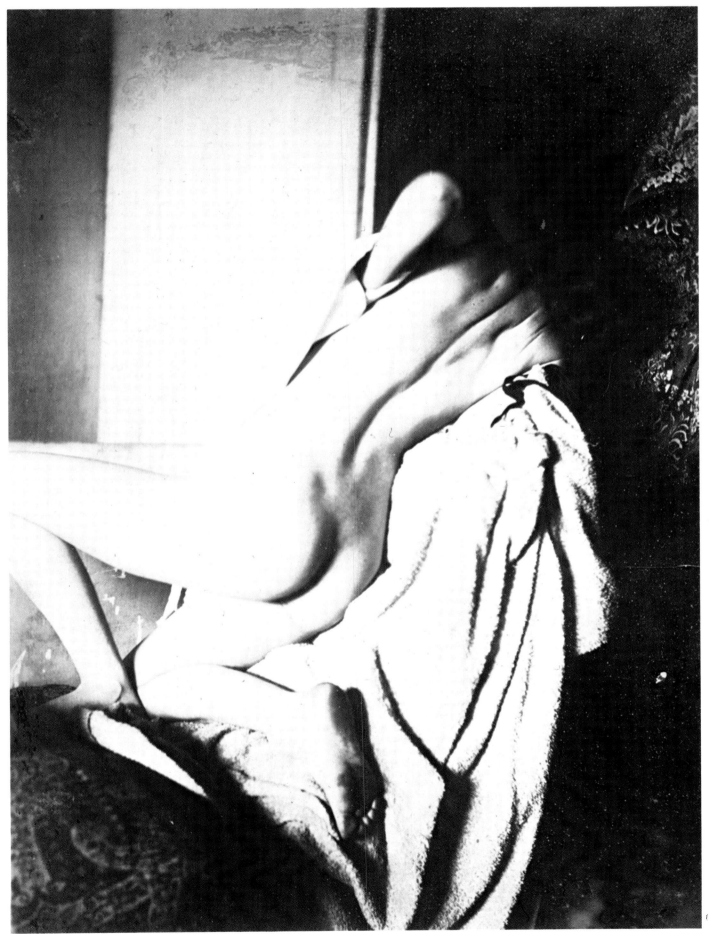

141. Anon. (Great Britain).
The Battleship Hatsuse *on the Tyne at Newcastle.*
1900. Modern silver bromide print from the original negative
142. Anon. (France). *"Study for Artists."*
c. 1900. Gelatin silver print

H.C.W. PARIS N° 66

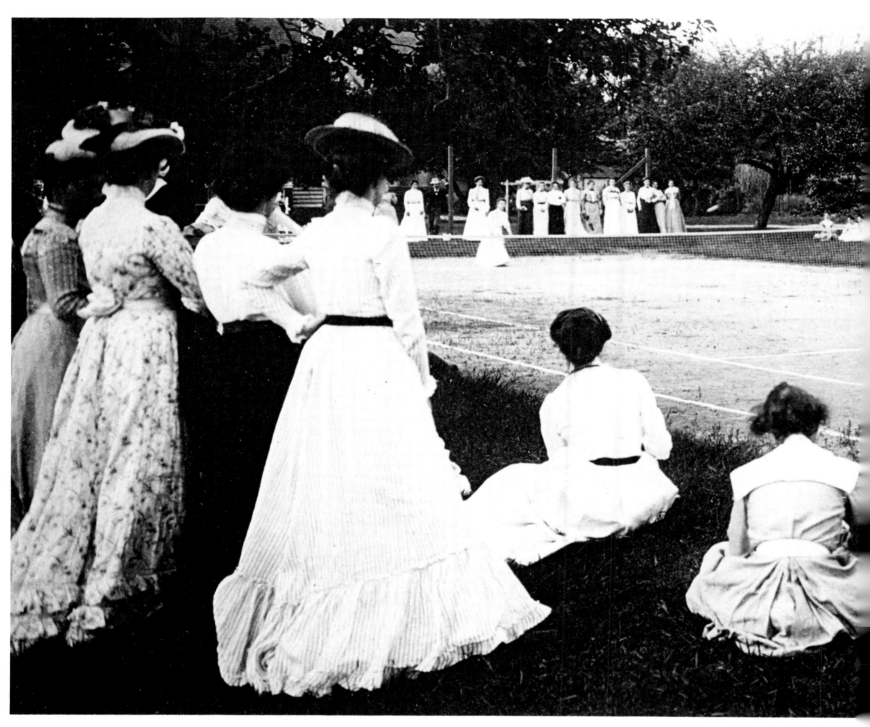

143. Anon. (United States).
Tennis Match at Smith College, Northampton, Mass.
1901. Cyanotype

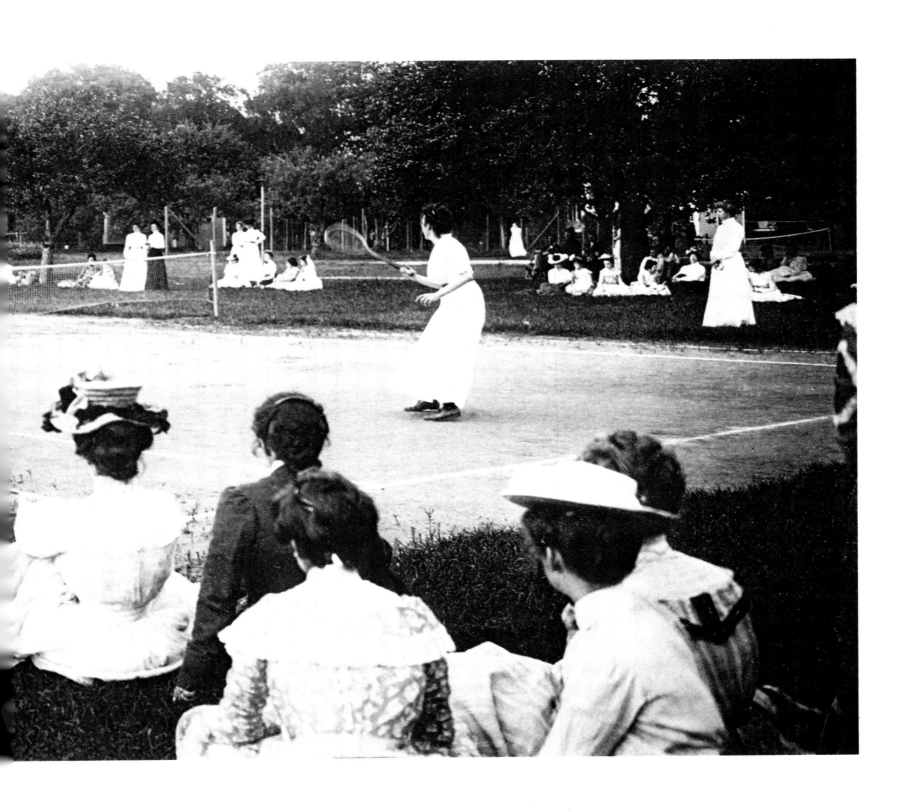

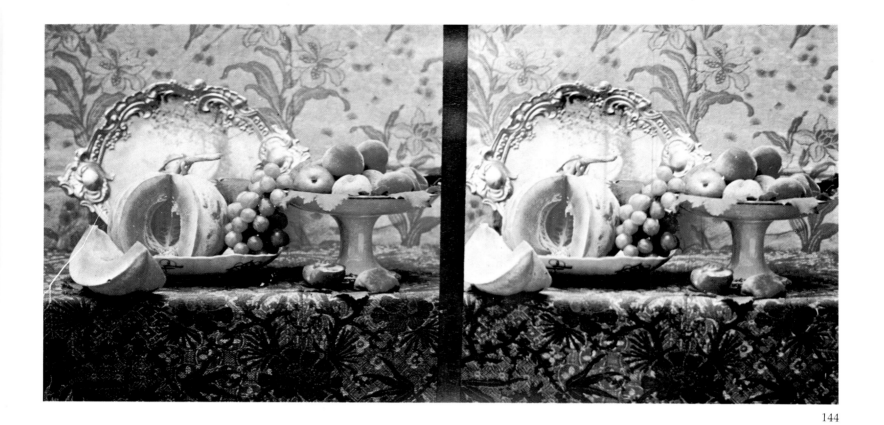

144. Auguste and Louis Lumière (France). *Still Life*. 1899 or 1900. Stereo gum trichromate on glass
145. H. H. Bennett (United States). *Phyllis*. 1900. Silver bromide print
146. Hans Watzek (Austria). *Portrait*. 1898. Gum bichromate print

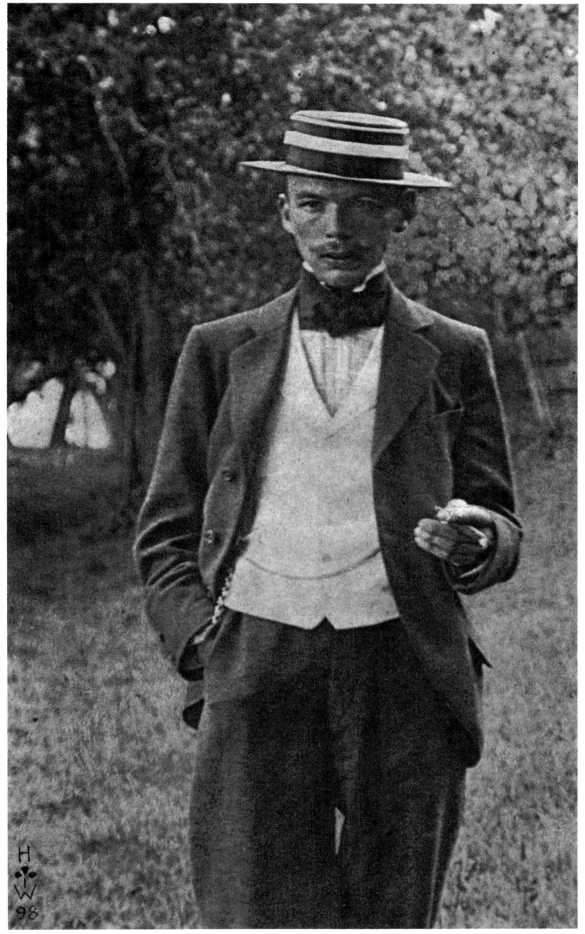

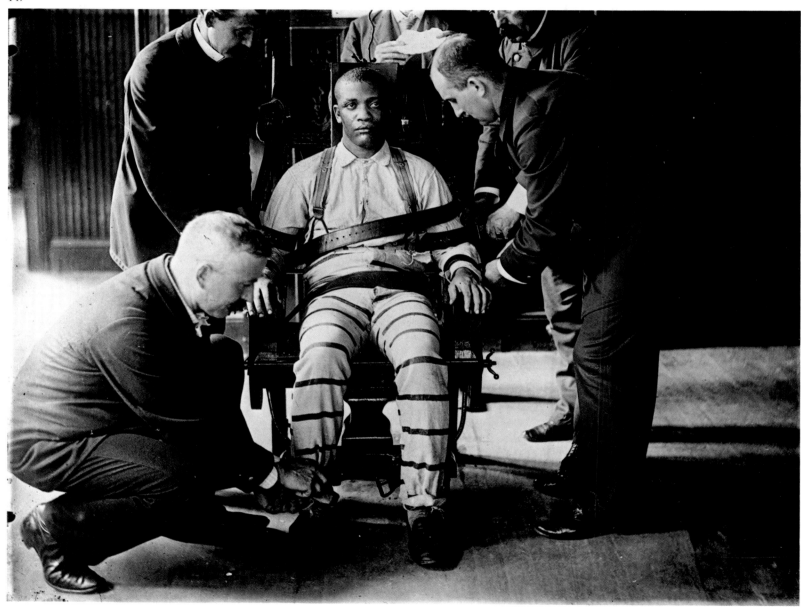

147. William van der Weyde (United States).
Man in the Electric Chair.
c. 1900. Modern silver bromide print
148. Frank Meadow Sutcliffe (England).
The Fisherman's Daughter.
1900. Silver bromide print

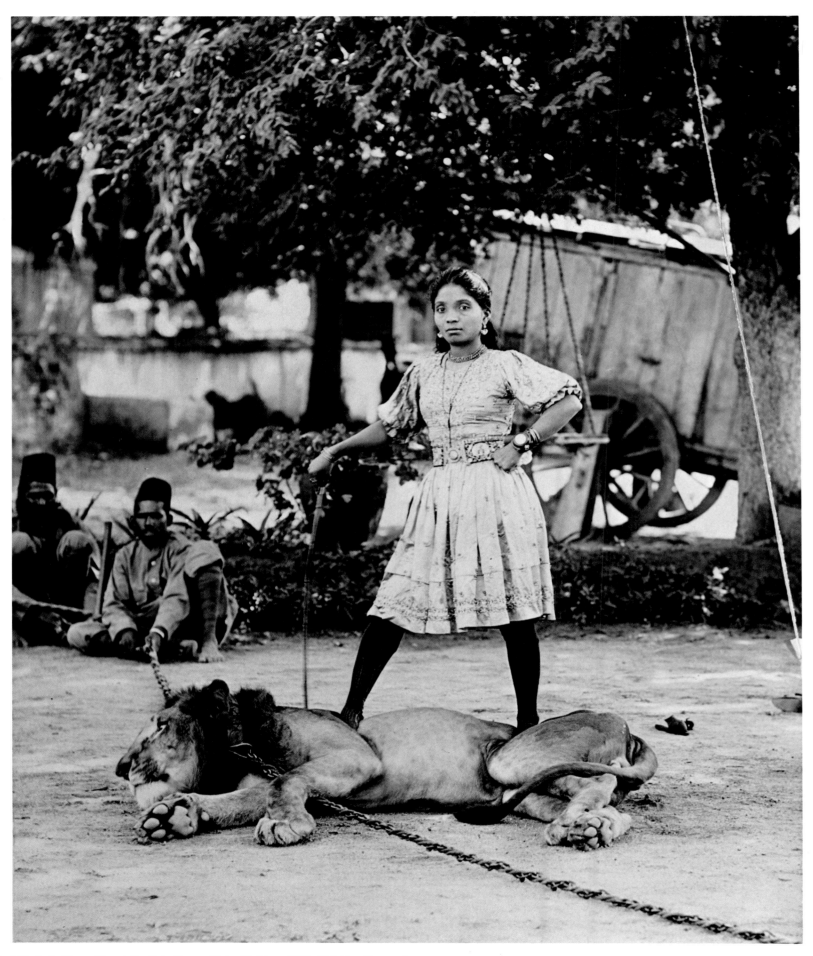

149. Lala Deen Dayal (India). *Gypsy Girl with Lion*. 1901. Gelatin silver print

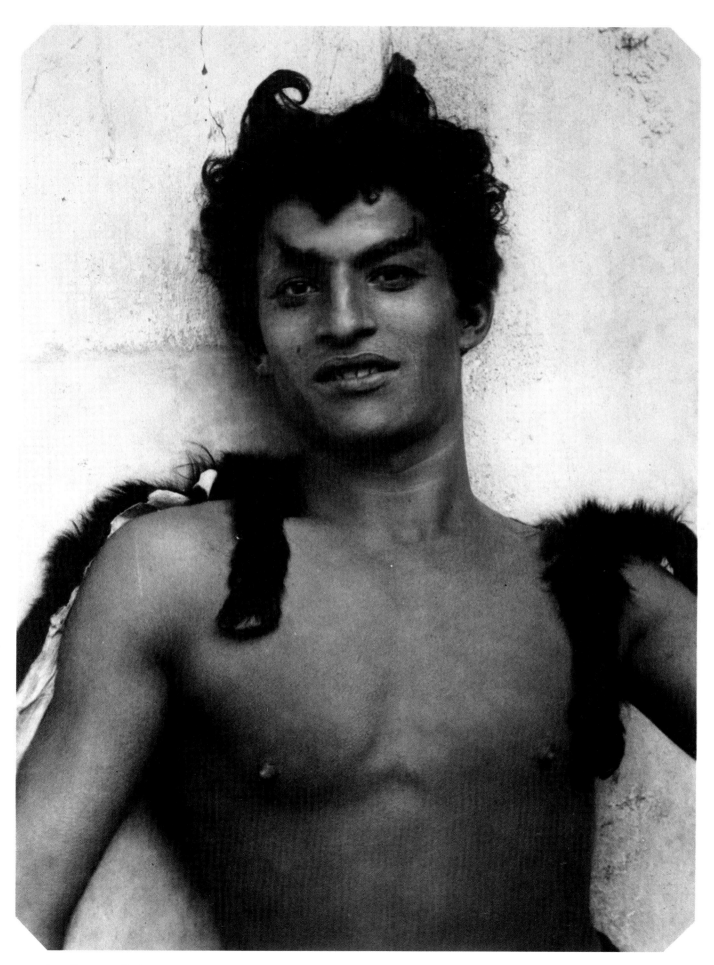

150. Baron Wilhelm von Gloeden (Germany). *Youth as Faun.* n.d. Gelatin silver print

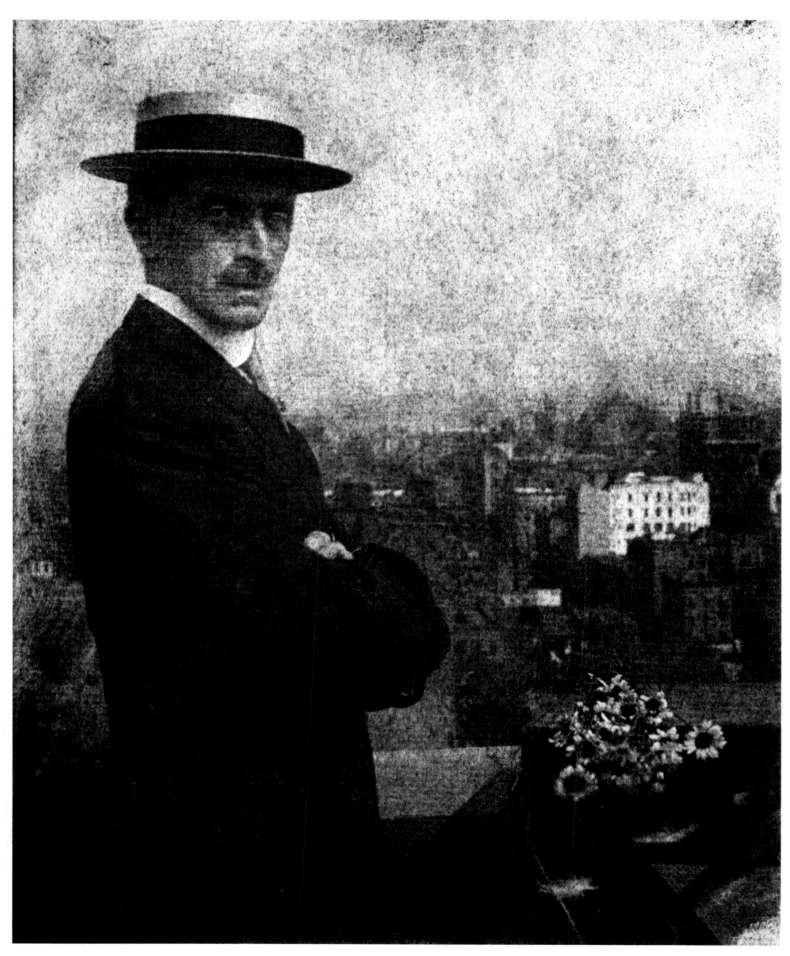

151. Gertrude Käsebier (United States). *Man on Roof.* c. 1905. Gum bichromate print

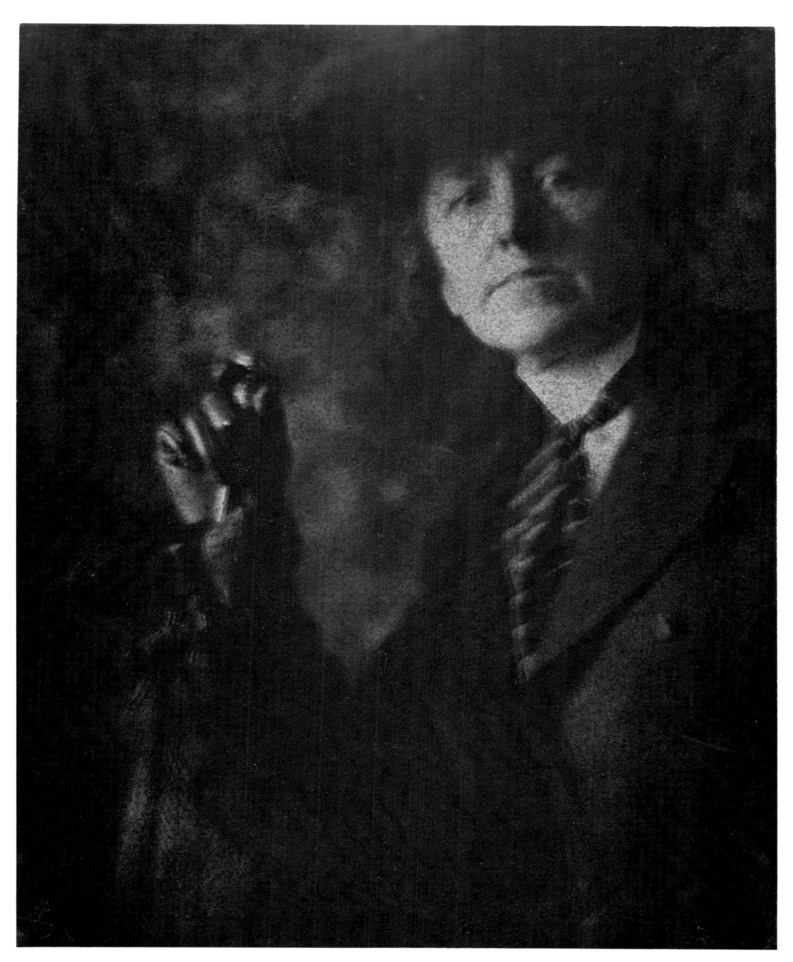

152. Alvin Langdon Coburn (United States–Great Britain). *Gertrude Käsebier.* c. 1903. Gum platinum print

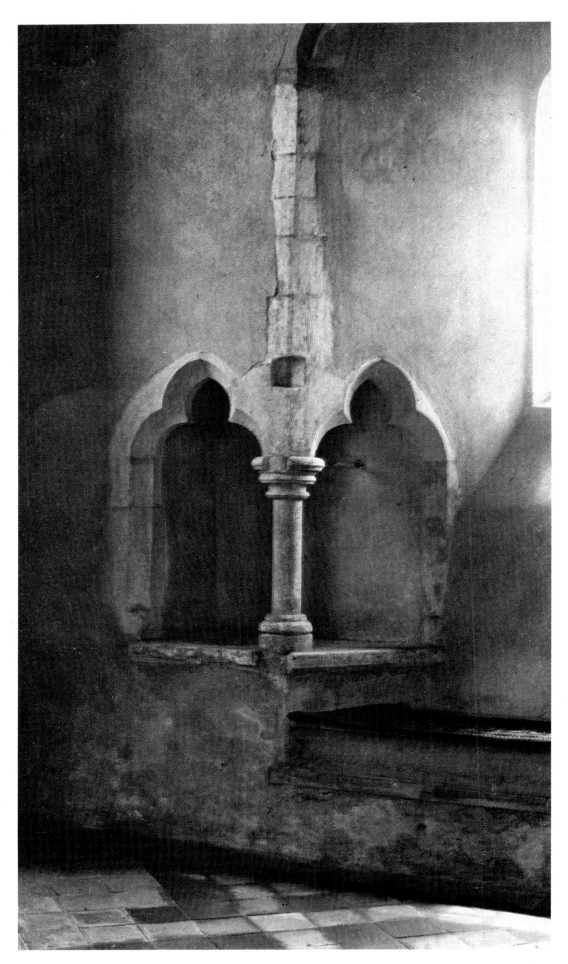

153. Frederick H. Evans (England). *A Norfolk Piscina, Little Snoring Church.* c. 1905. Platinum print

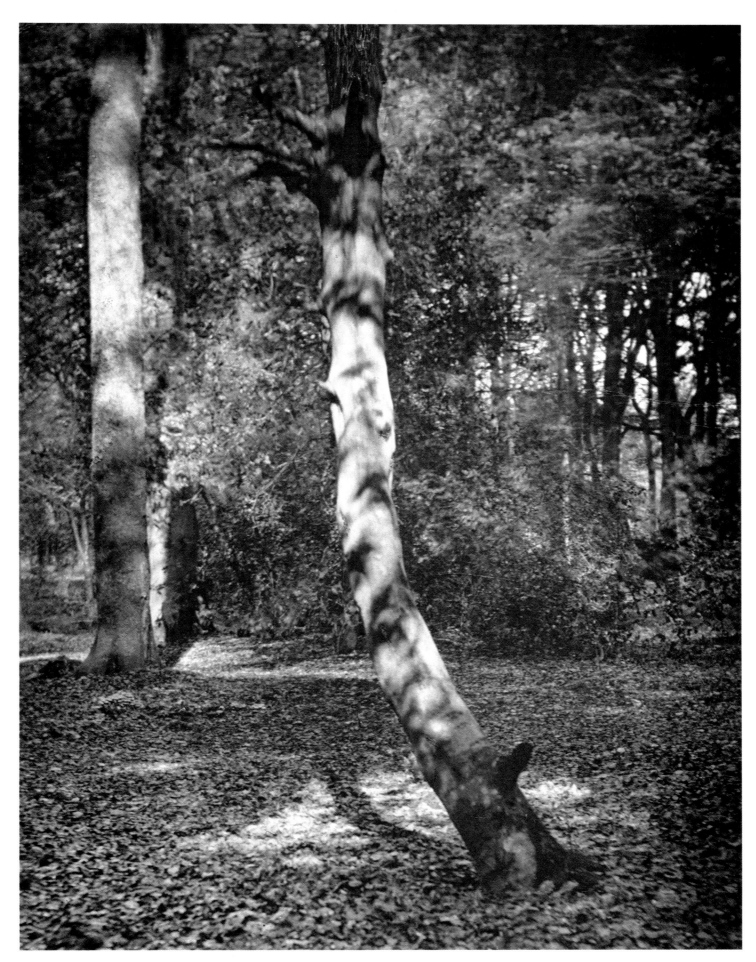

154. Frederick H. Evans (England). *Deerleigh Woods.* c. 1905. Platinum print

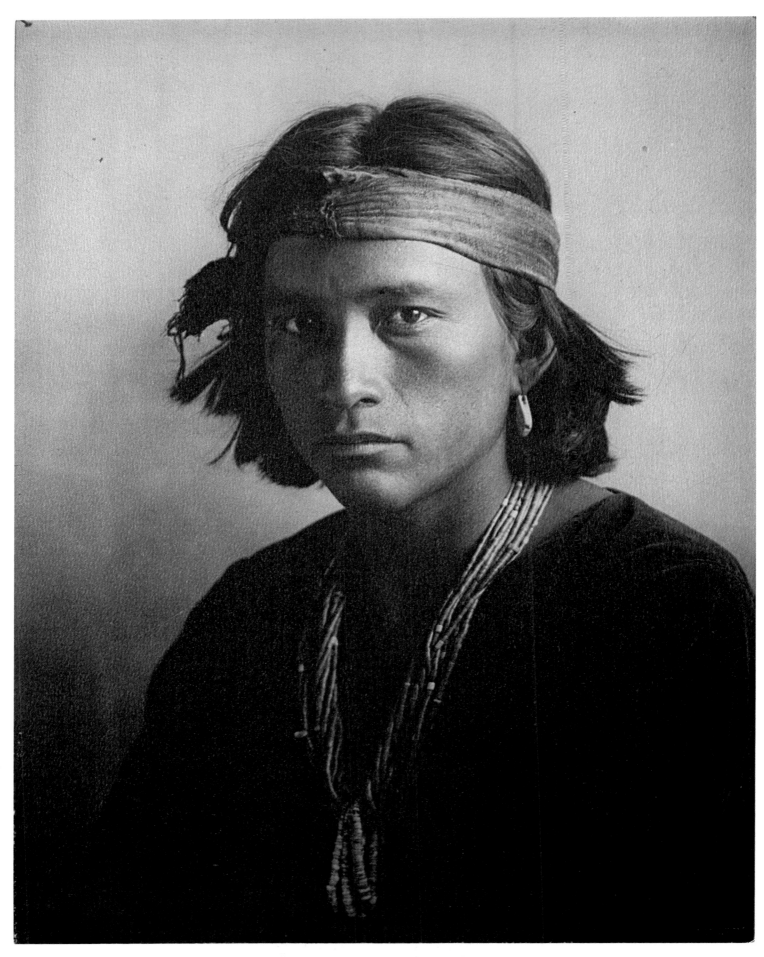

155. **Karl Moon** (United States). *A Navajo Youth*. 1907. Toned silver bromide print

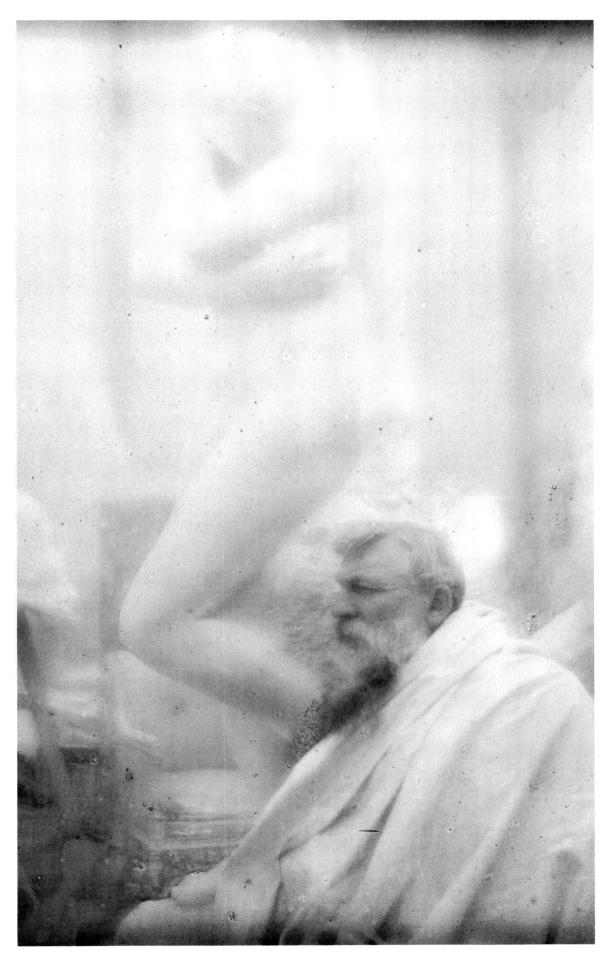

156. Edward Steichen (United States; b. Luxembourg). *Rodin with Sculpture of Eve*. 1907. Autochrome

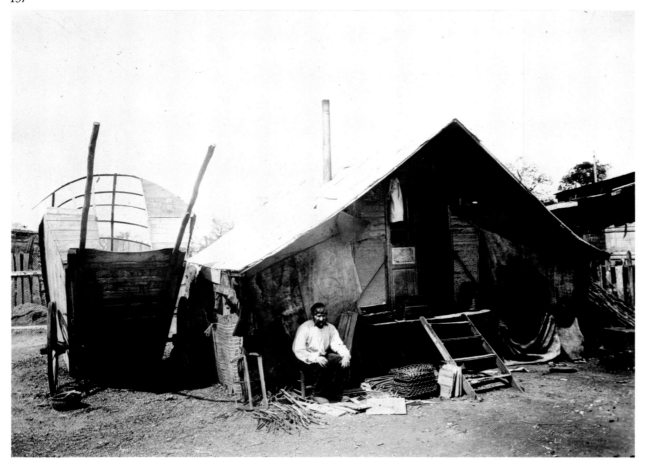

157. Eugène Atget (France). *Ragpicker's Dwelling, Porte d'Ivry.* c. 1910–14. Printing out paper
158. Eugène Atget (France). *A Windmill, Somme.* Before 1898. Printing out paper
159. Eugène Atget (France). *Faun Sculpture, Versailles.* n.d. Printing out paper

OVERLEAF:
160. Robert Demachy (France). *The Crowd.* 1910. Oil pigment print

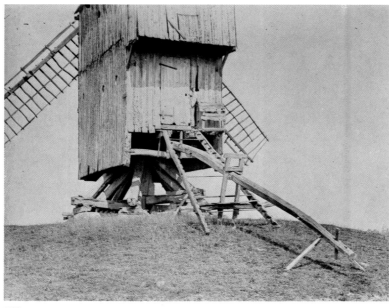

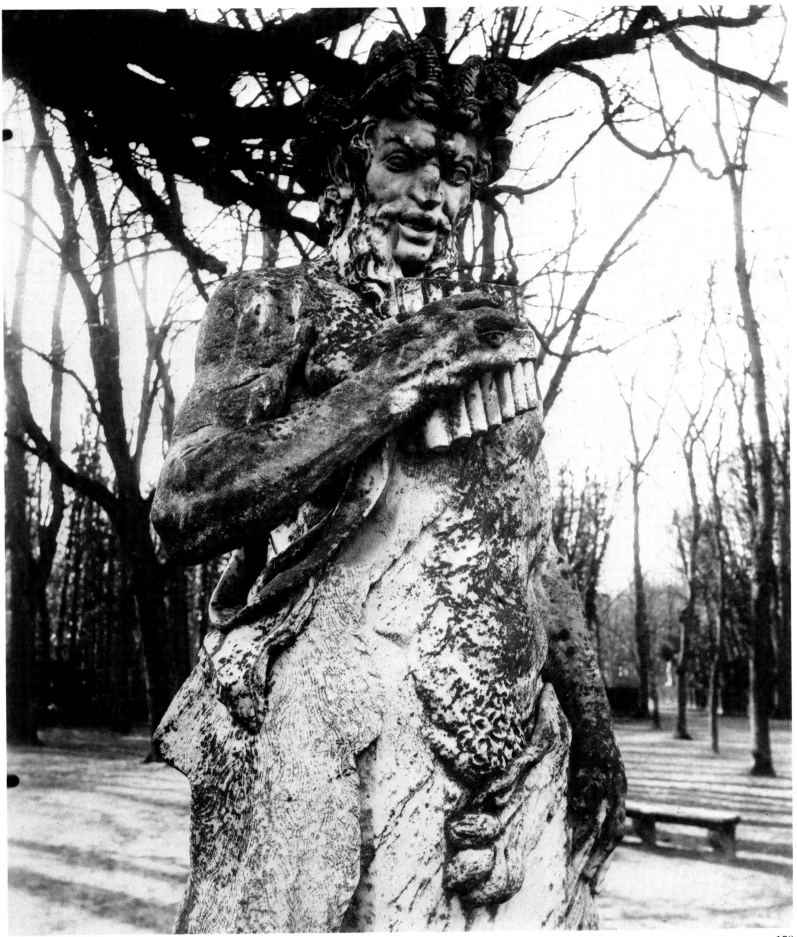

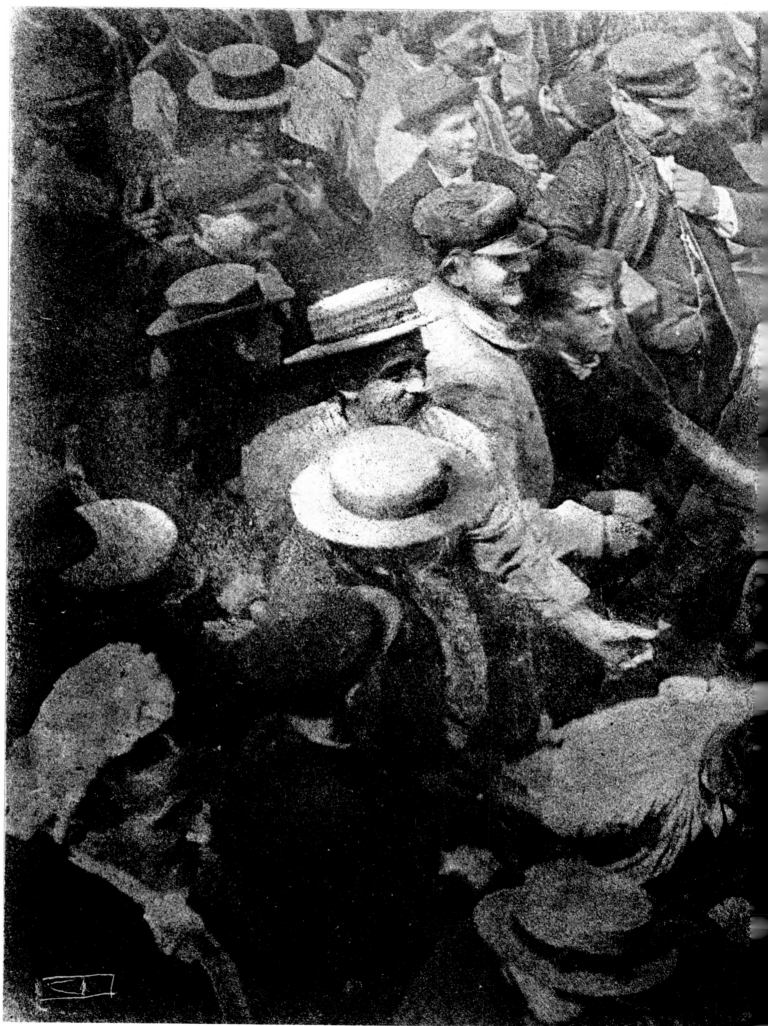

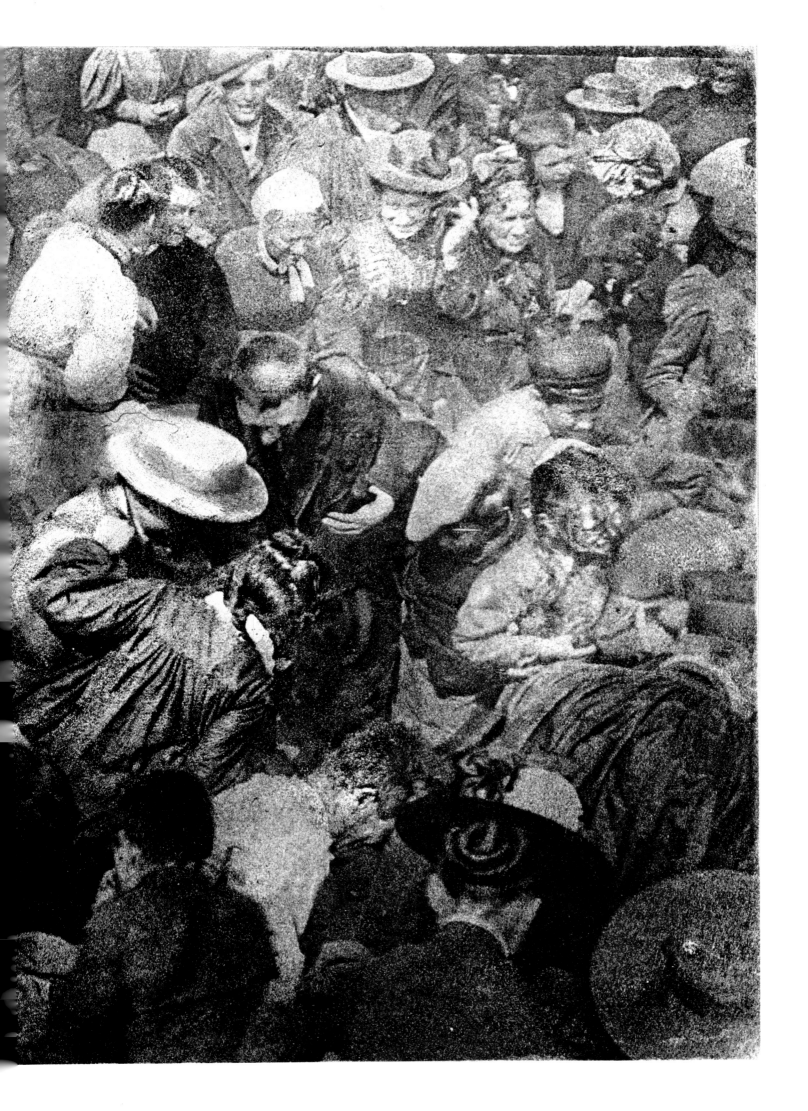

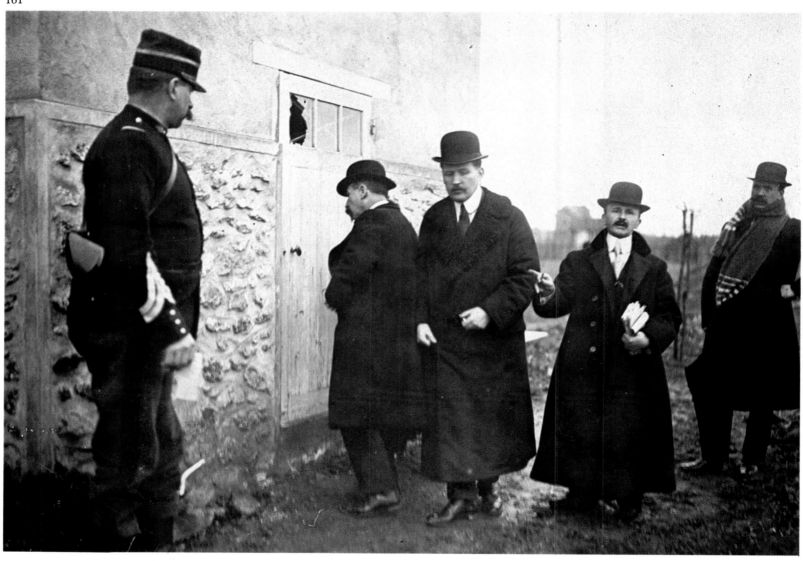

161. Anon. (France).
Police at the Scene of a Crime.
c. 1910. Silver bromide print
162. Arnold Genthe (United States; b. Germany).
Portrait. c. 1910. Autochrome

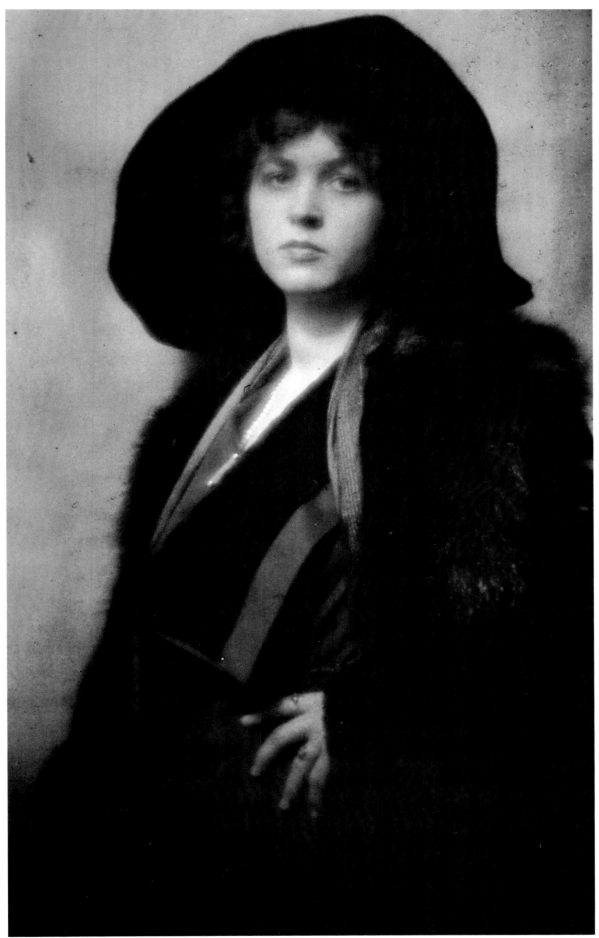

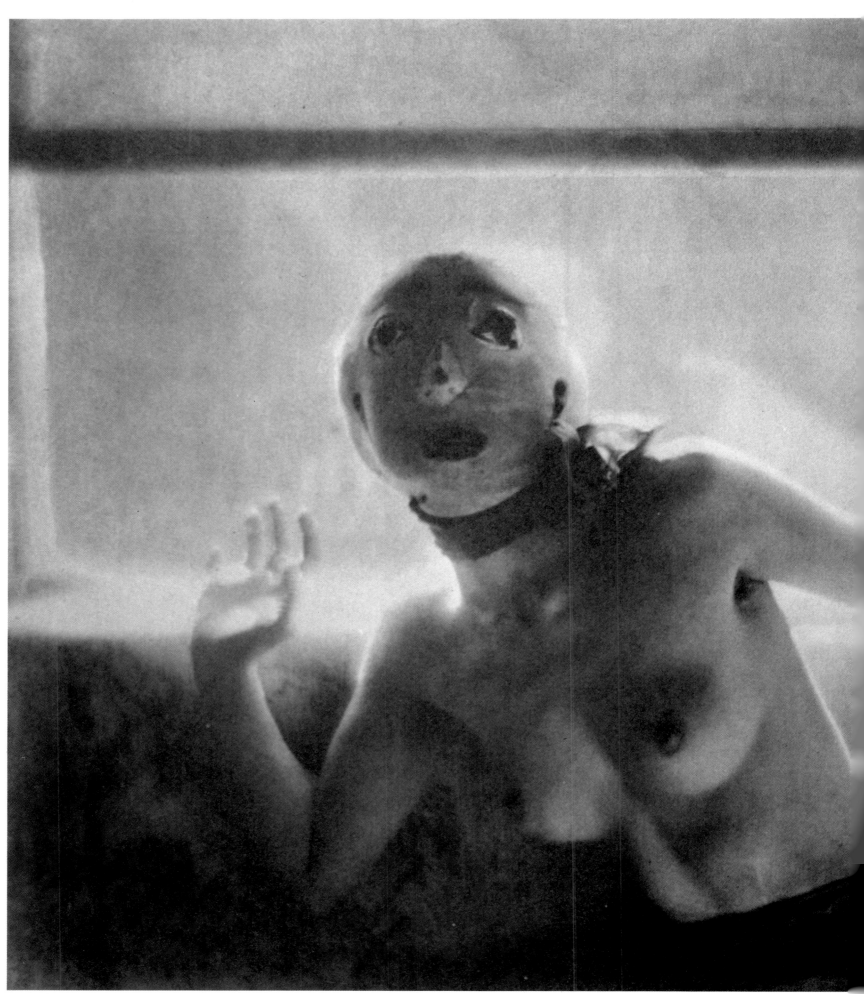

163. Baron Adolf de Meyer
(England–United States; b. France).
Dance Study. c. 1912.
Gelatin silver print
164. Anon. (United States).
Plate 31 from *Practical Poses
for the Practical Artist.*
1912. Silver bromide print

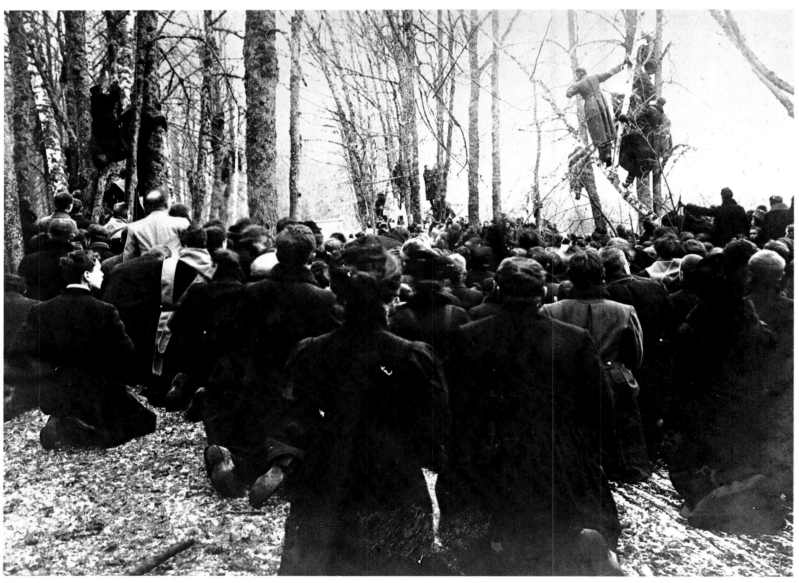

165

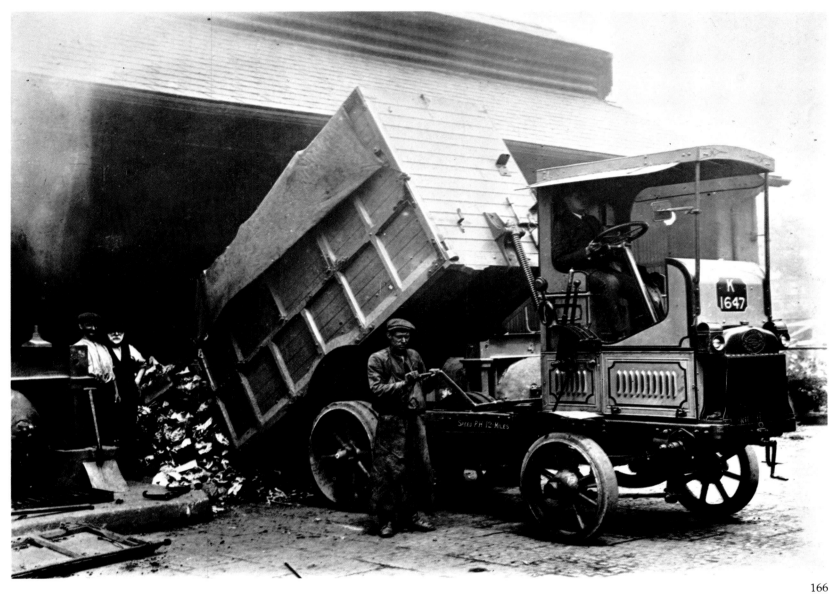

166

165. Anon. (Russia). *The Burial of Leo Tolstoy.*
1910. Silver bromide print
166. Anon. (Great Britain). *New Leyland Tipper at Wavertree, Liverpool.*
1914. Modern silver bromide print from the original negative

167

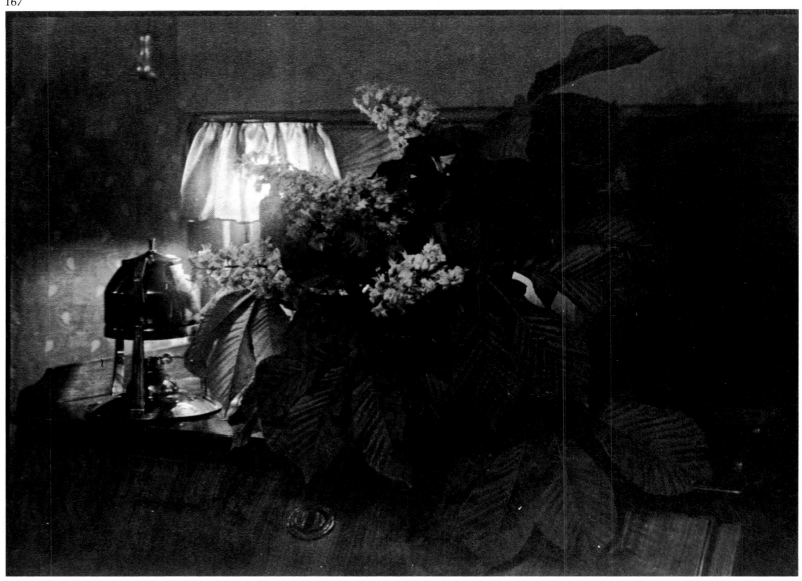

167. Heinrich Kühn (Austria; b. Germany).
Still Life. After 1911.
Gum bichromate print
168. Richard N. Speaight (England).
Victoria Sackville-West in Costume for the Shakespeare Ball.
1911. Silver bromide print

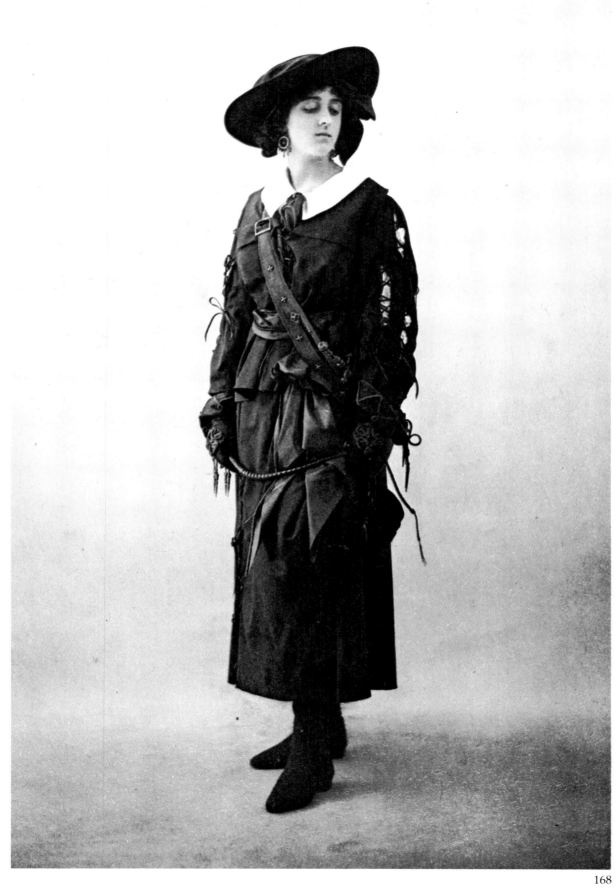

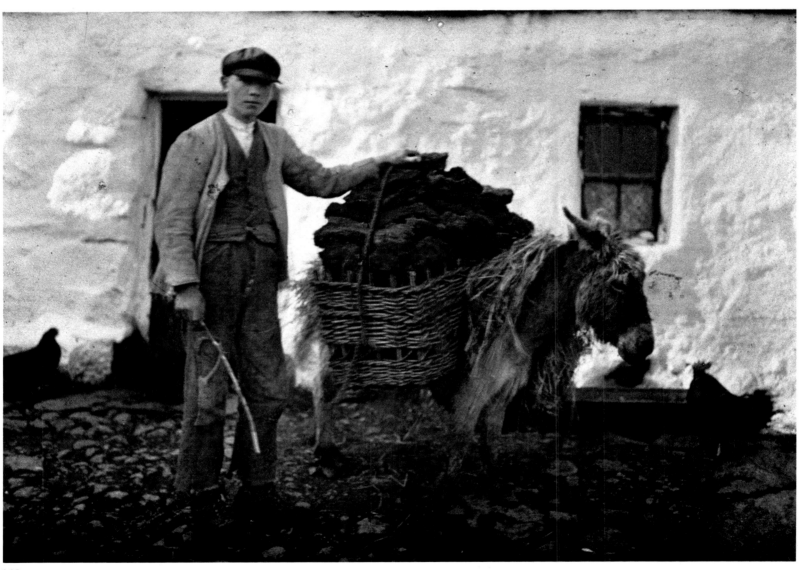

169

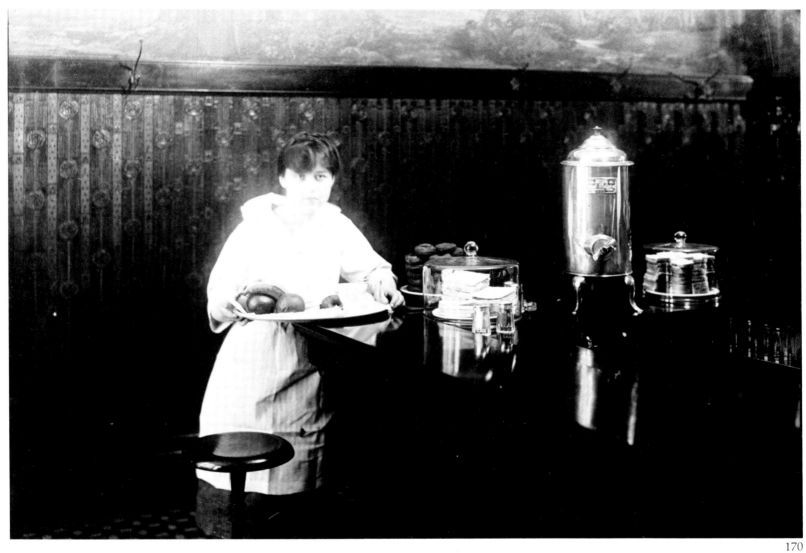

169. Mespoulet and Mignon (France).
Boy with Donkey Carrying Peat, Connemara, Ireland.
1913. Autochrome
170. Lewis Hine (United States).
Young Waitress. c. 1915. Silver bromide print

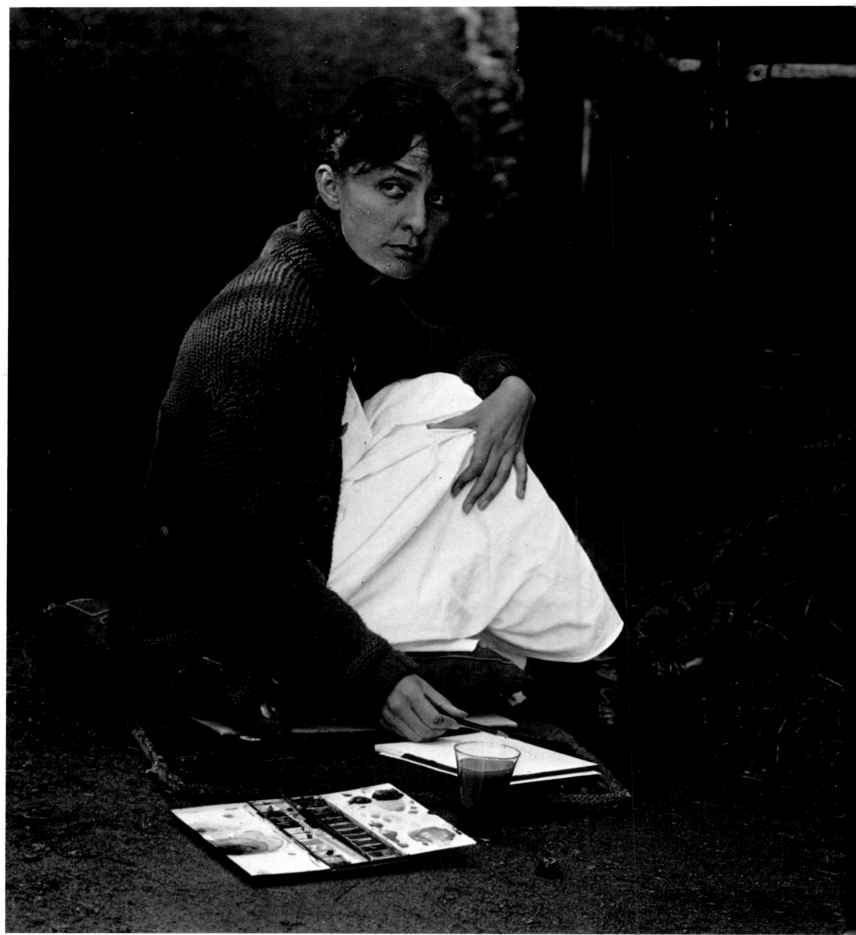

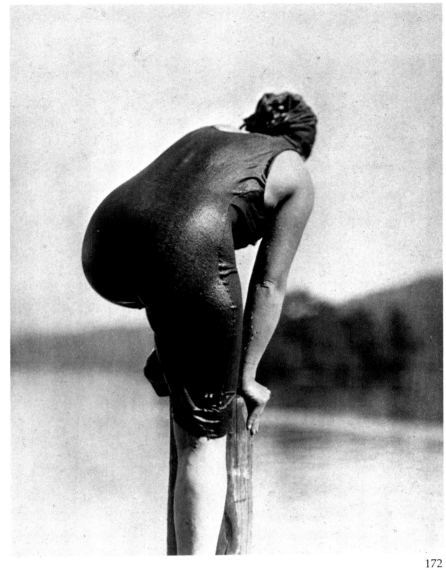

172

171. Alfred Stieglitz (United States).
Georgia O'Keeffe with Paints.
c. 1916–17. Silver chloride print
172. Alfred Stieglitz (United States).
Ellen Morton at Lake George.
1915. Silver chloride print

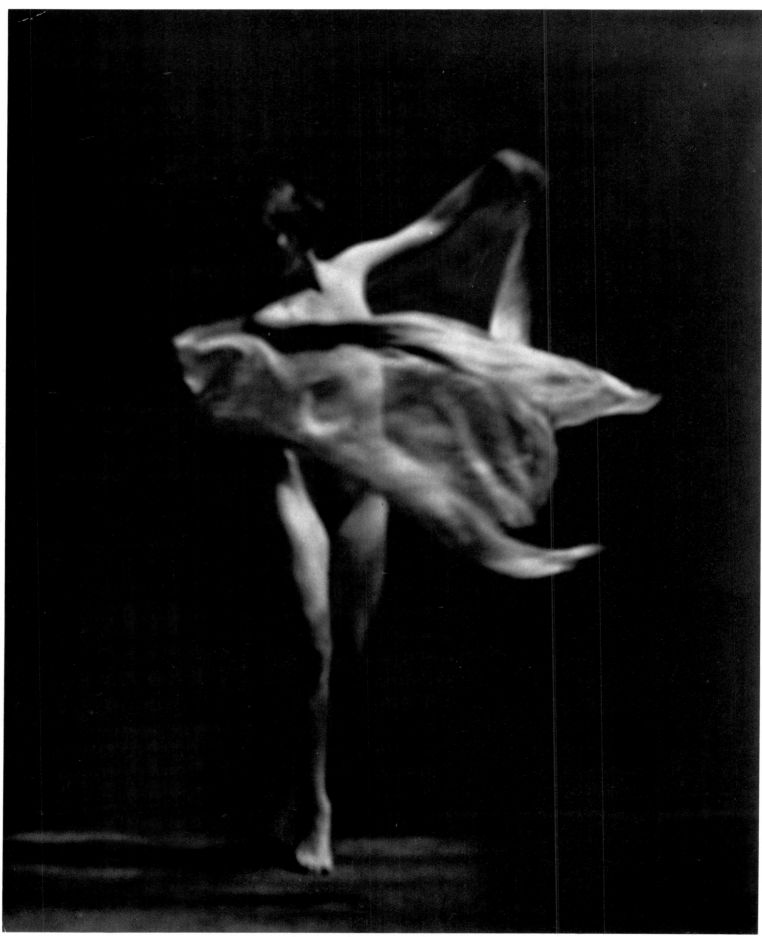

173

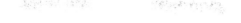

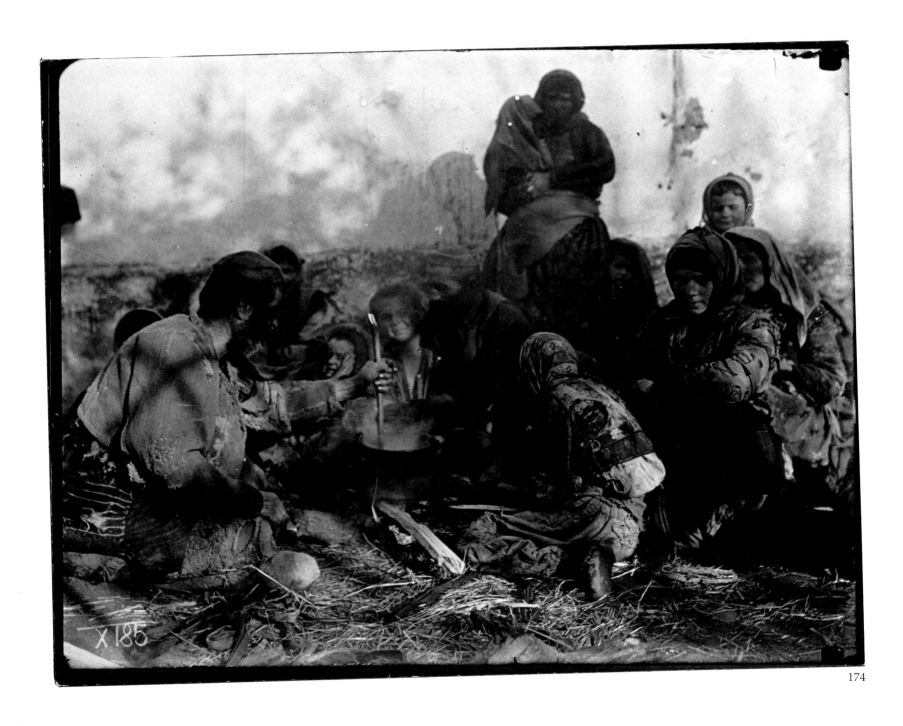

174

173. Arnold Genthe (United States; b. Germany).
Doris Humphrey Dancing Naked. c. 1916.
Silver bromide print
174. Lewis Hine (United States).
Serbian Refugees Returning Home. 1918.
Silver bromide print

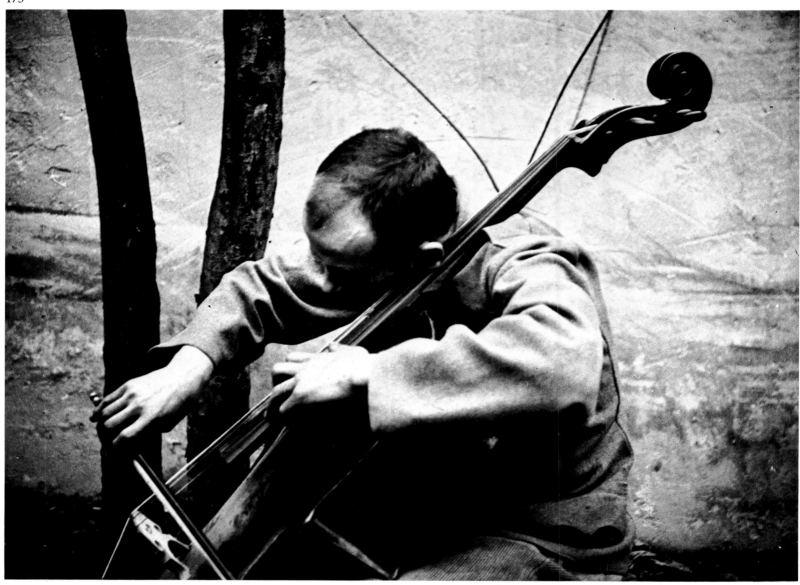

175. André Kertész (Hungary–France–United States).
Cellist. 1916. Silver bromide print
176. Anon. (Germany). *Karl Liebknecht Speaking
at the Mass Grave of Fallen Spartacists, Berlin.*
1919. Silver bromide print

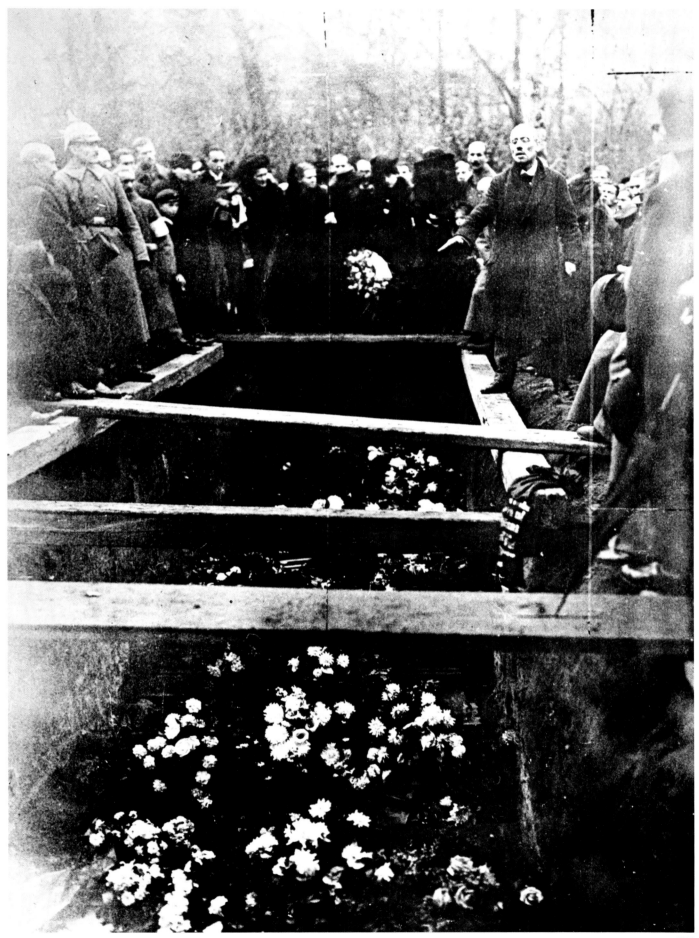

177

177. Dr. J. B. Pardoe (England). *Waiting for the Train*.
1923. Chlorobromide print
178. August Sander (Germany). *Tailors' Workshop, Germany*.
c. 1924. Silver bromide print

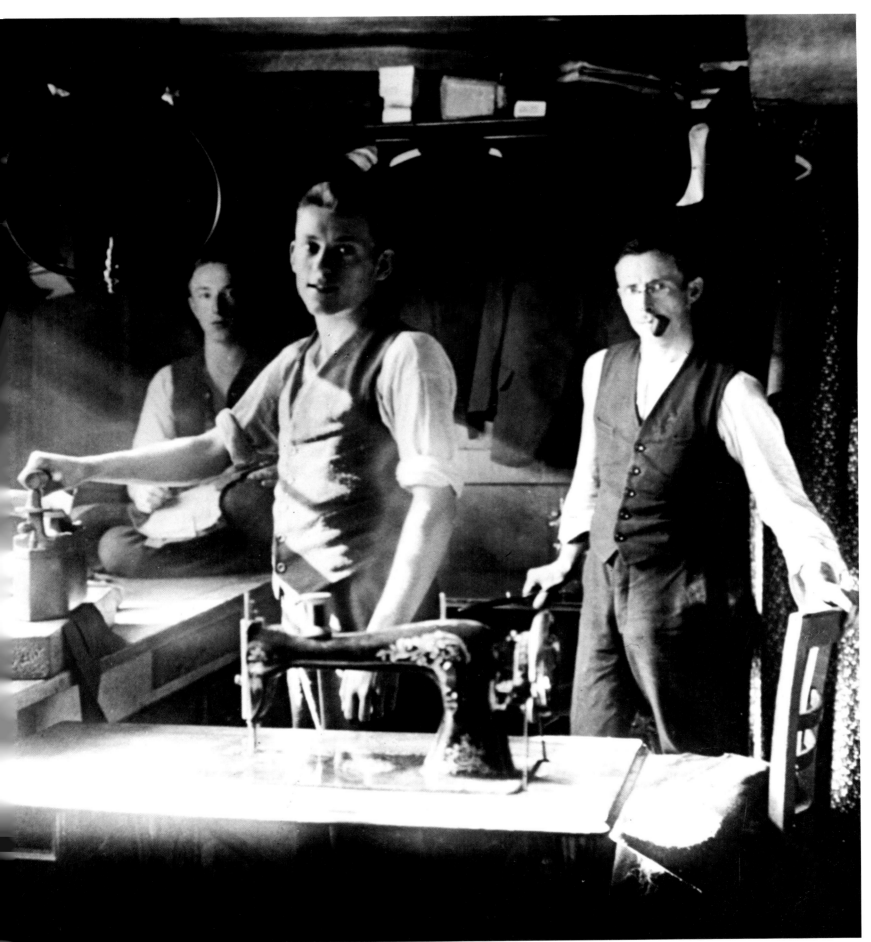

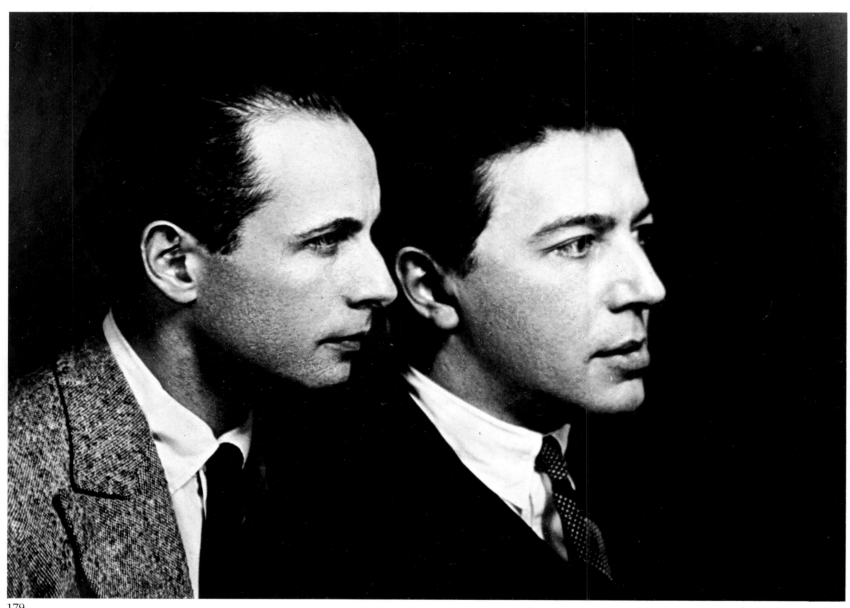

179

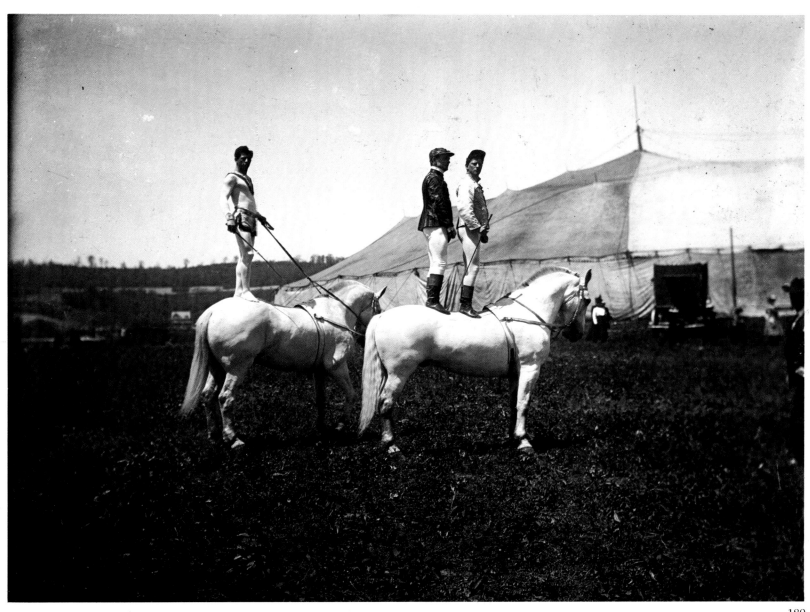

180

179. Man Ray (United States–France).
Louis Aragon and André Breton.
c. 1924. Silver bromide print
180. Nathan Lazarnick (United States).
Three Bareback Riders. n.d.
Printing out paper

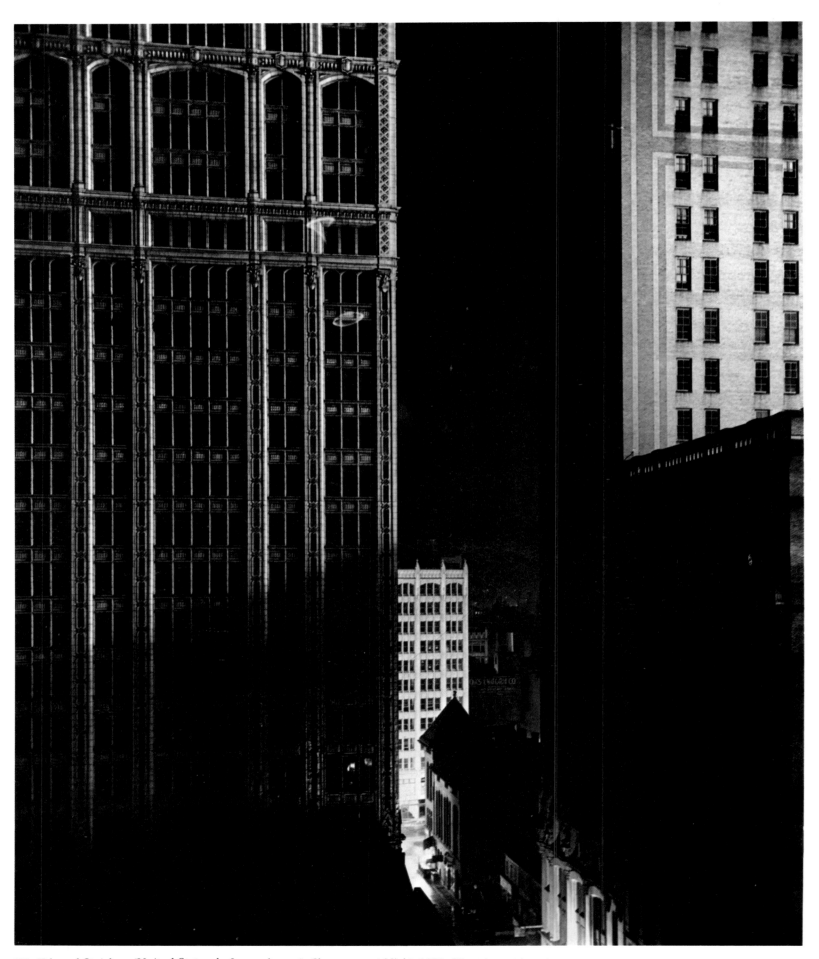

181. Edward Steichen (United States; b. Luxembourg). *Skyscrapers at Night*. 1925. Silver bromide print

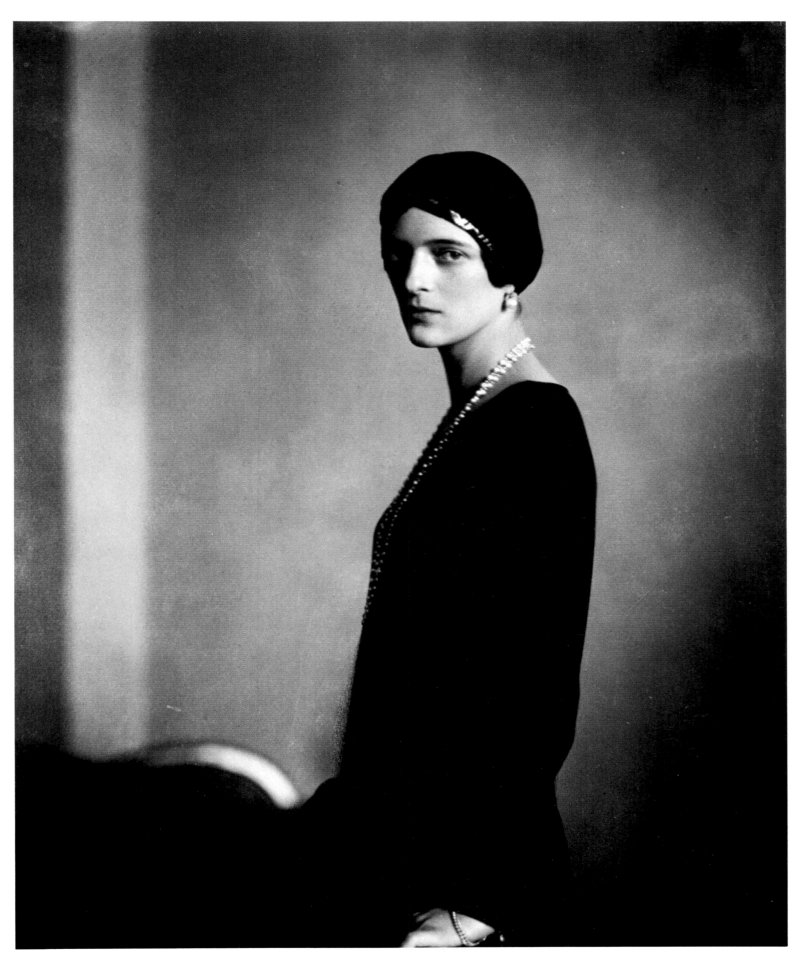

182. Edward Steichen (United States; b. Luxembourg). *Princess Youssoupoff.* 1924. Silver bromide print

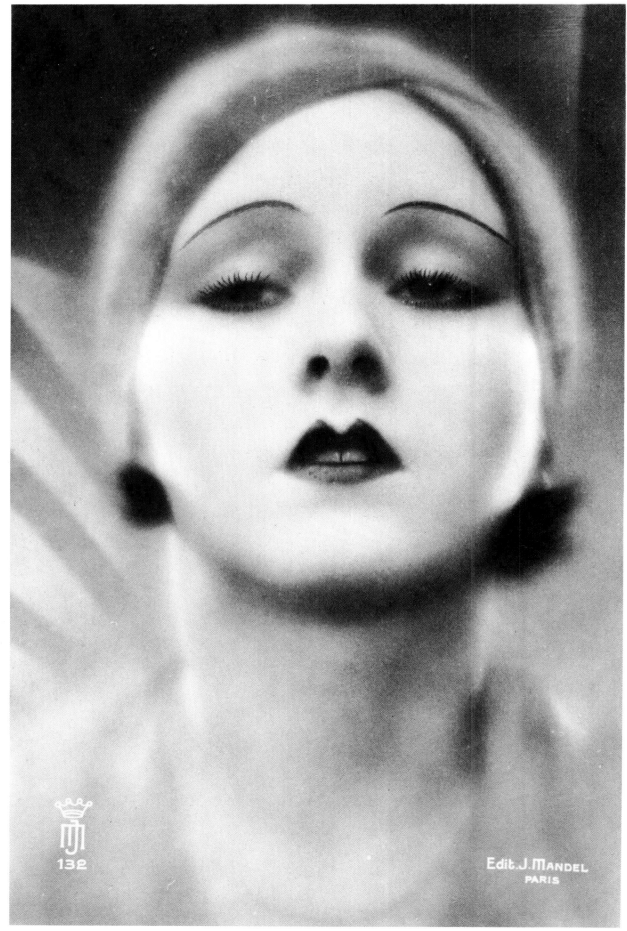

Edit. J.MANDEL
PARIS

183

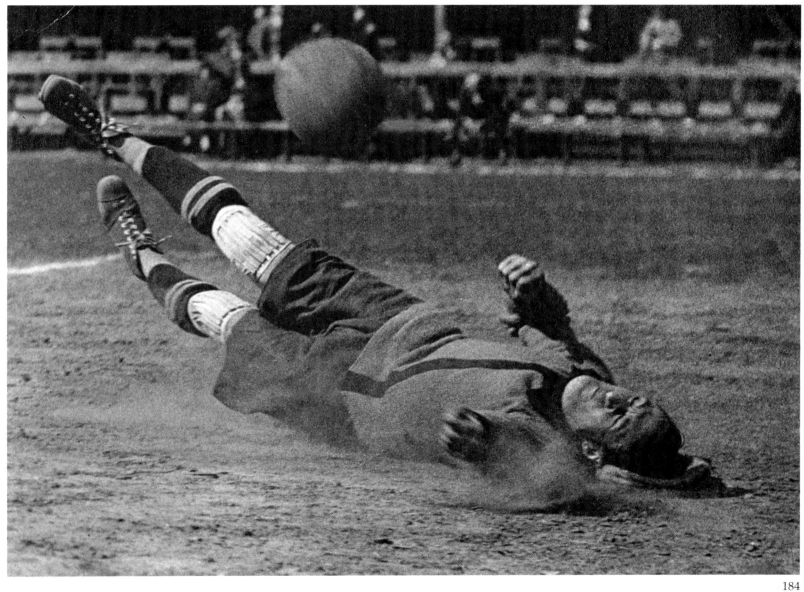

184

183. Anon. (pub. J. Mandel, Paris).
Postcard. 1920s.
Silver bromide print, toned and hand-colored
184. Martin Munkacsi (Hungary).
Goalkeeper. 1926.
Modern silver bromide print from the original negative

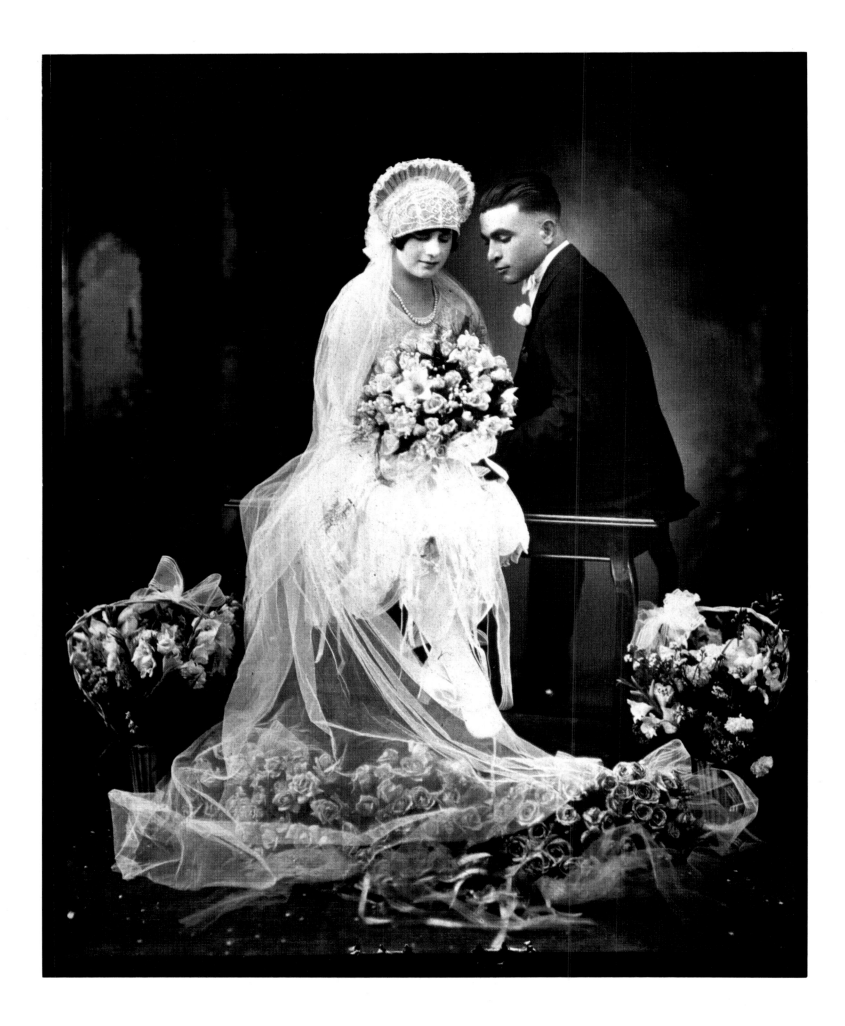

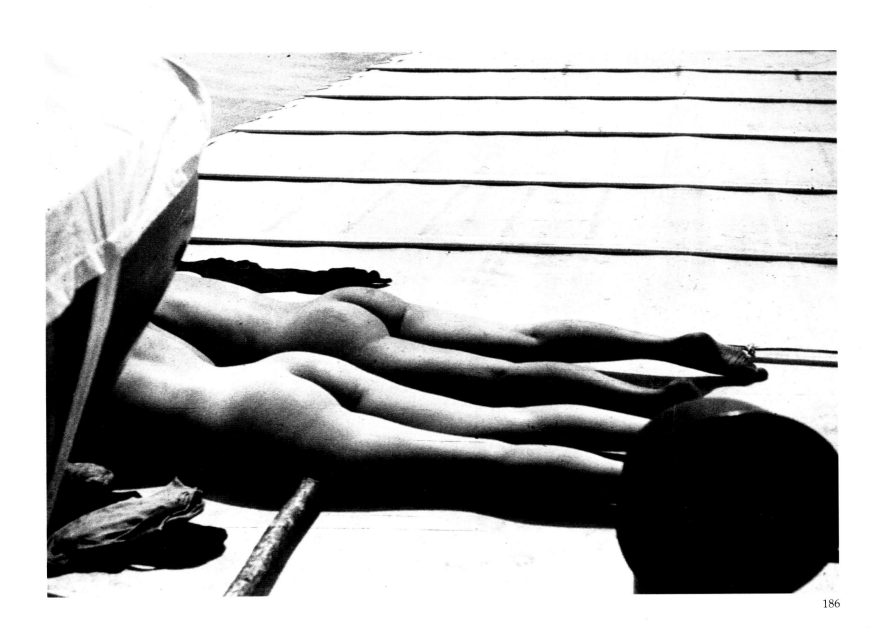

185. Mach (United States).
Mr. and Mrs. John Locicero. 1926.
Silver bromide print
186. Jacques-Henri Lartigue (France).
Bibi Lartigue and Denise Grey on Deck. c. 1926.
Silver bromide print

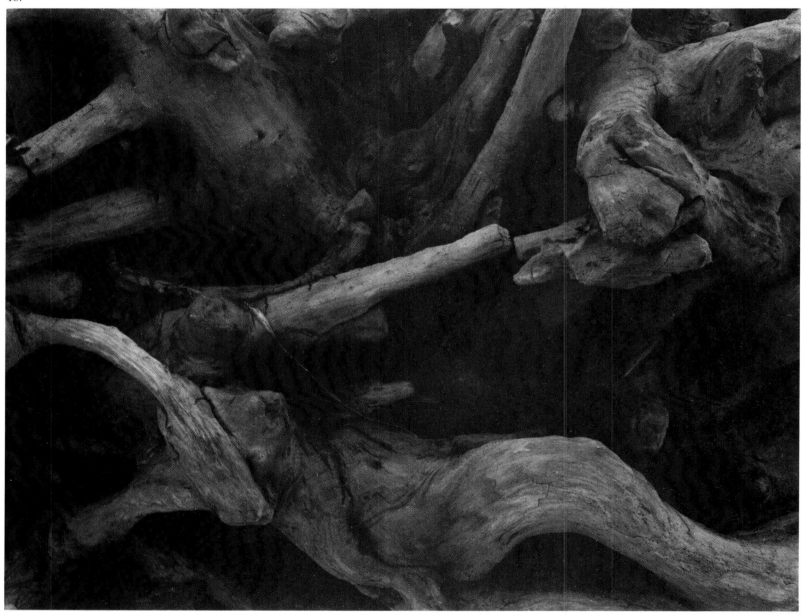

187. Paul Strand (United States).
Driftwood, Dark Roots, Maine. 1928.
Gold-toned platinum print
188. Doris Ulmann (United States)
Old Woman with a Pipe. 1920s.
Platinum print

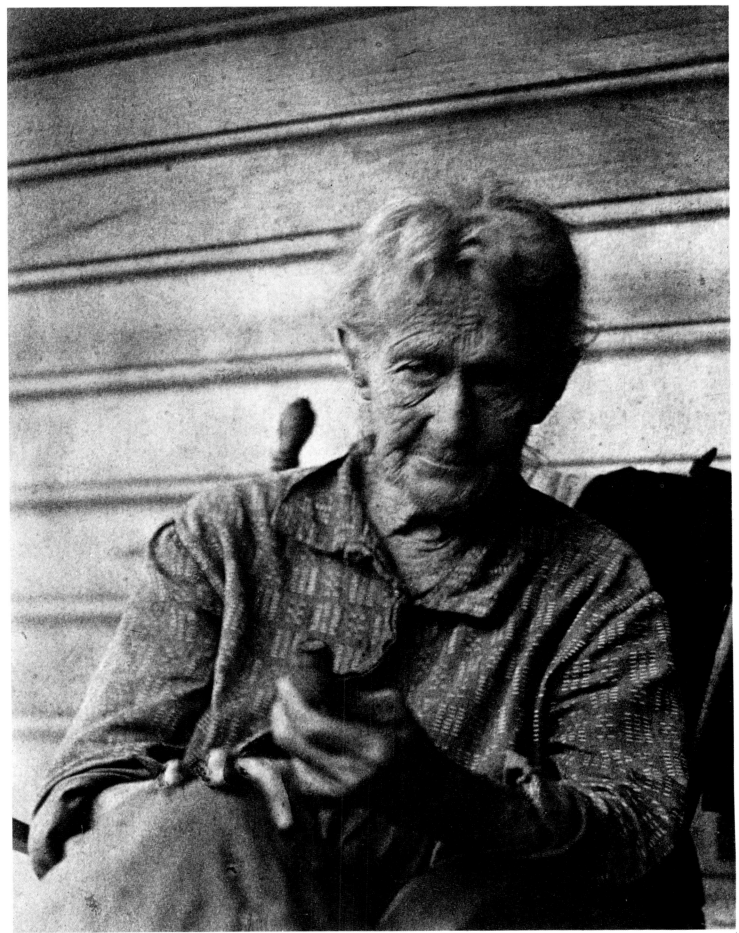

189. Albert Renger-Patzsch (Germany).
Praying Hands. c. 1927.
Silver bromide print
190. Werner Mantz (Germany).
Study in a Private Villa. 1928–29.
Silver bromide print

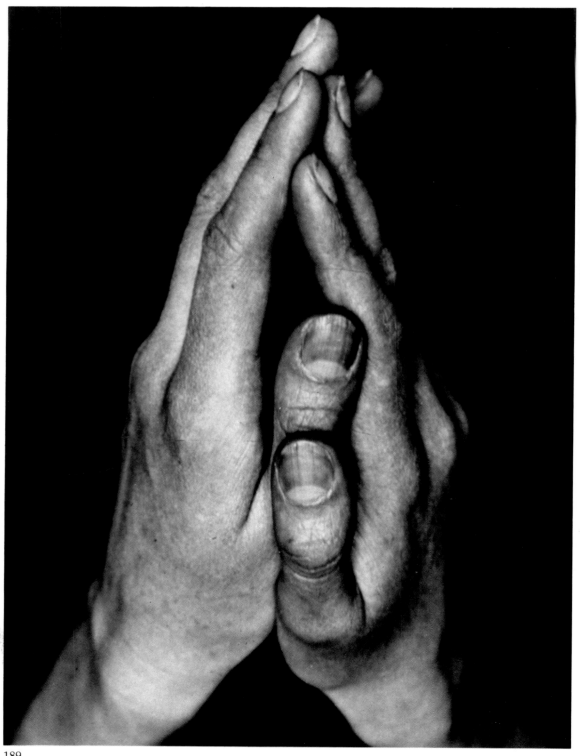

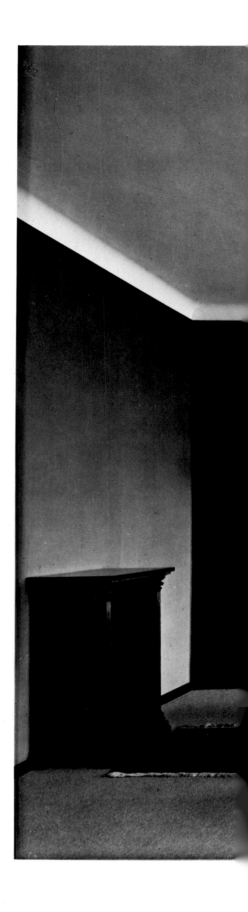

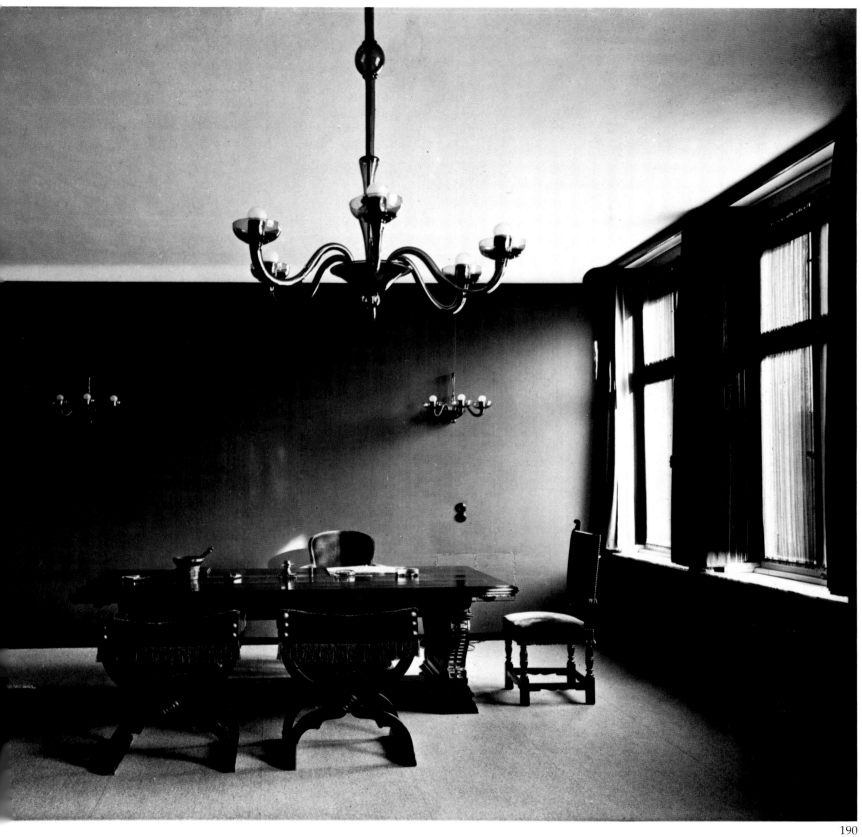

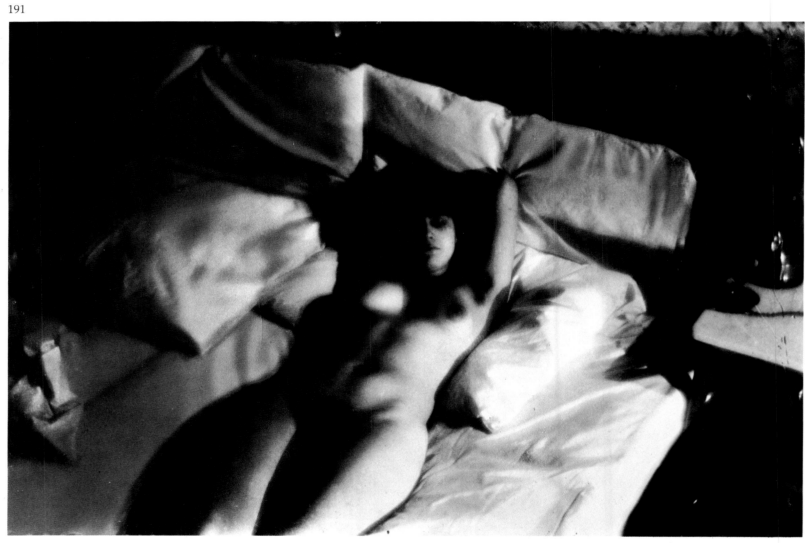

191. Martin Munkacsi (Hungary).
Nude on Bed. 1929. Modern silver bromide print from the original negative
192. Walker Evans (United States).
Man Sleeping on Brooklyn Bridge. c. 1929. Silver bromide print

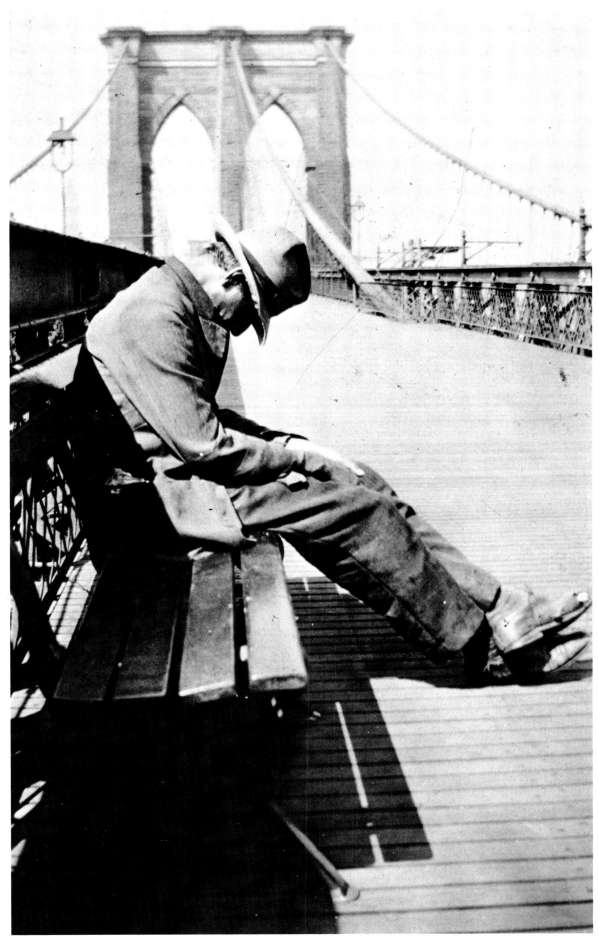

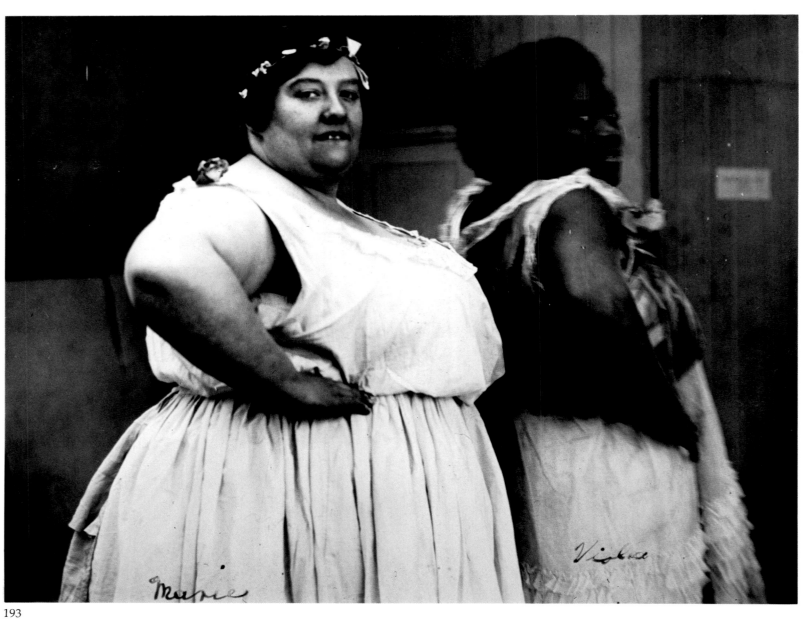

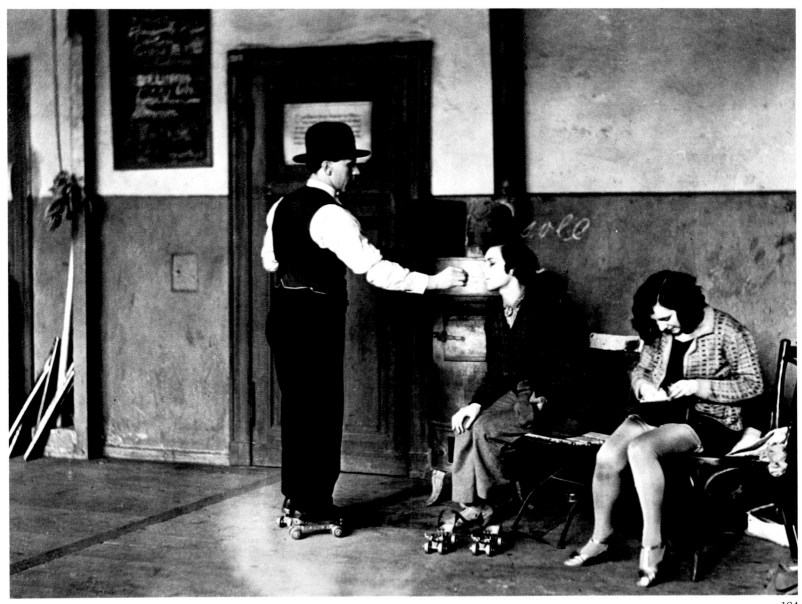

194

193. Anon. (France).
"The Fattest Women in the World."
c. 1930. Silver bromide print
194. Umbo (Otto Umbehr; Germany).
Artists' Rehearsal Room. 1930.
Silver bromide print

195. Henri Cartier-Bresson (France).
Face with Stocking Mask. c. 1931.
Silver bromide print
196. Martin Chambi (Peru).
The Gadea Wedding, Cuzco. 1930.
Modern silver bromide print from the original negative

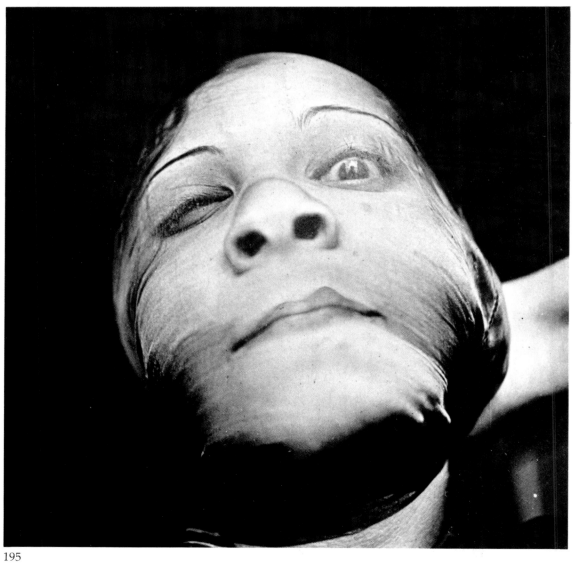

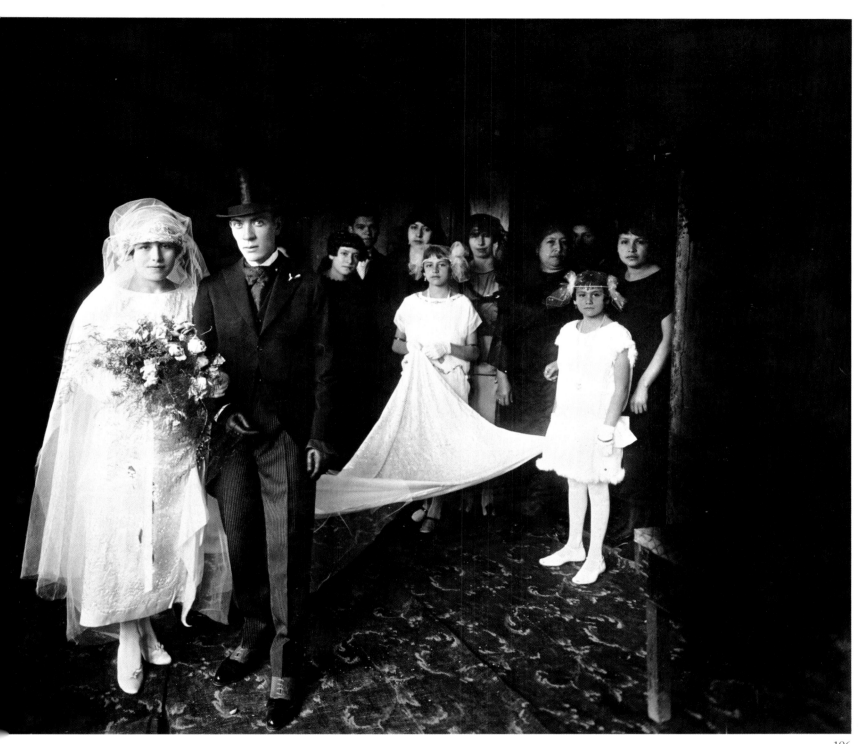

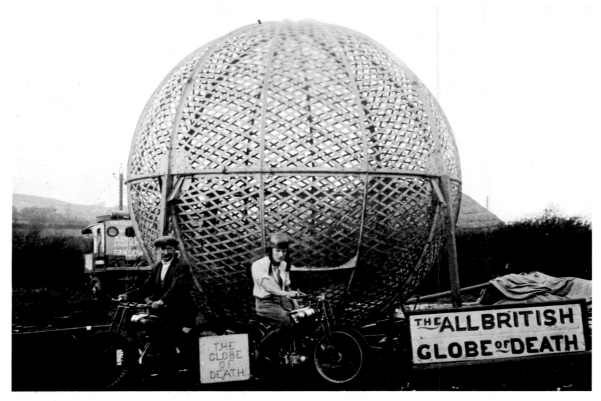

197. Anon. (Great Britain).
The All-British Globe of Death. 1930s.
Silver bromide print
198. Dorothea Lange (United States).
May Day, 1934.
Silver bromide print

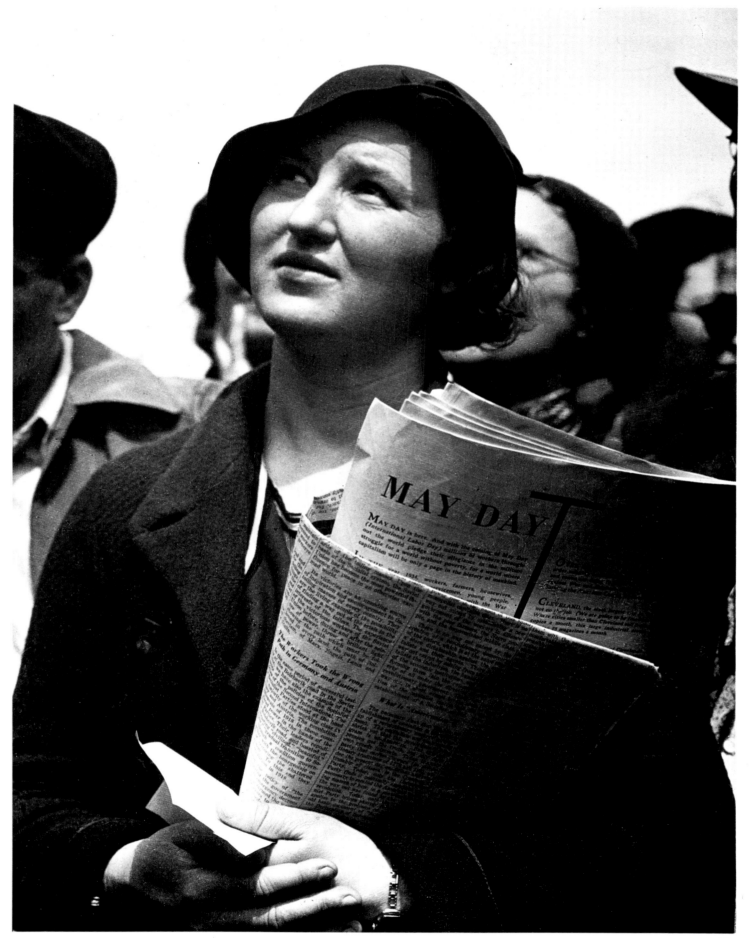

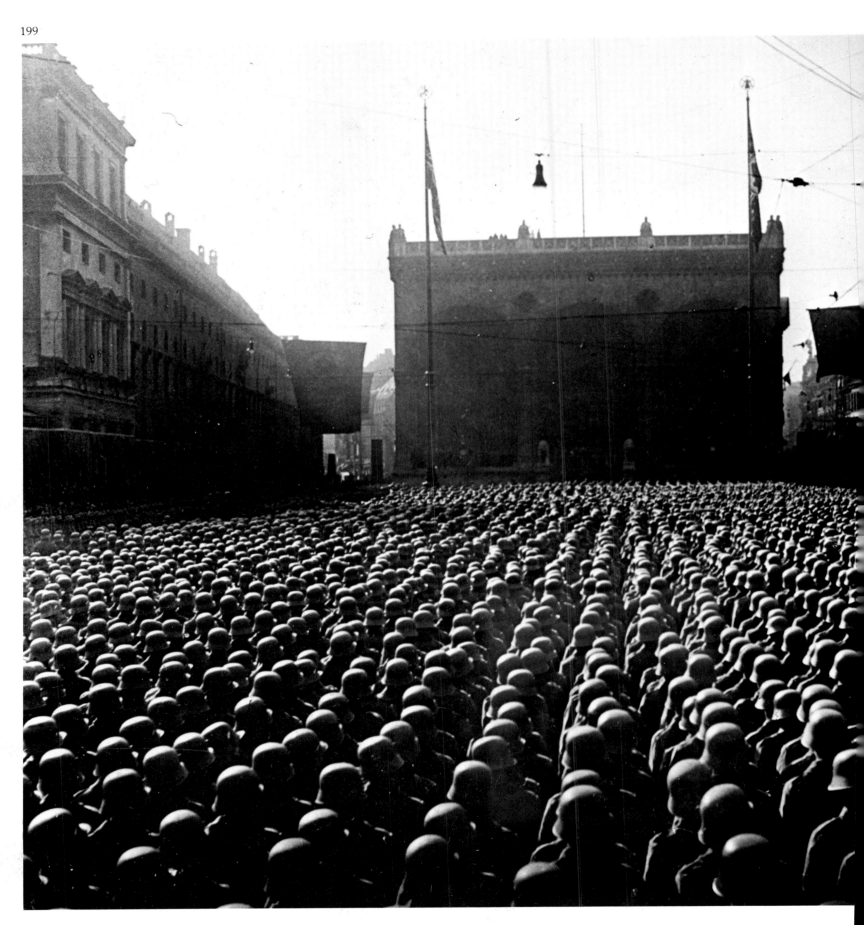

199. Anon. (Germany). *The Wehrmacht at the Feldherrnhalle, Munich*. 1935. Silver bromide print
200. Margaret Bourke-White (United States). *Russian Tractor Factory*. Late 1930s. Silver bromide print

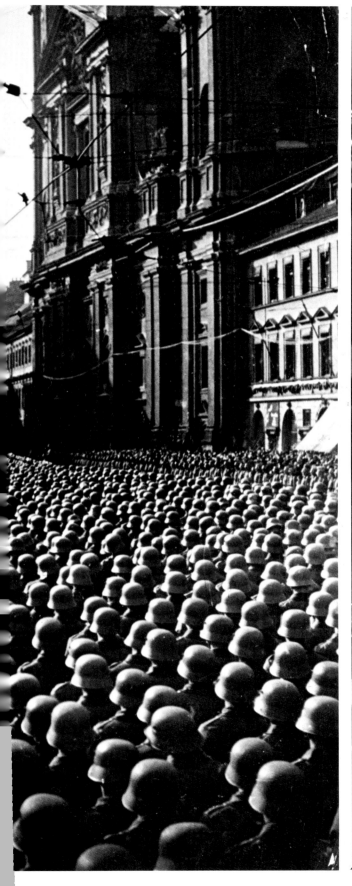

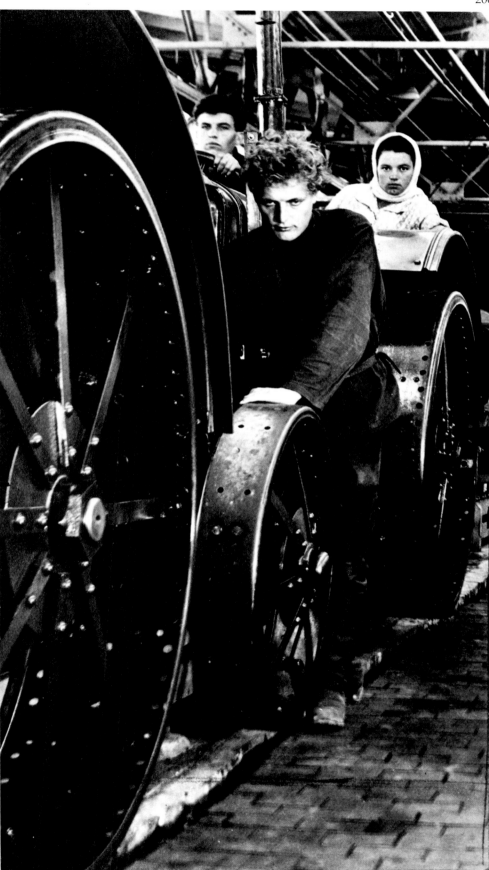

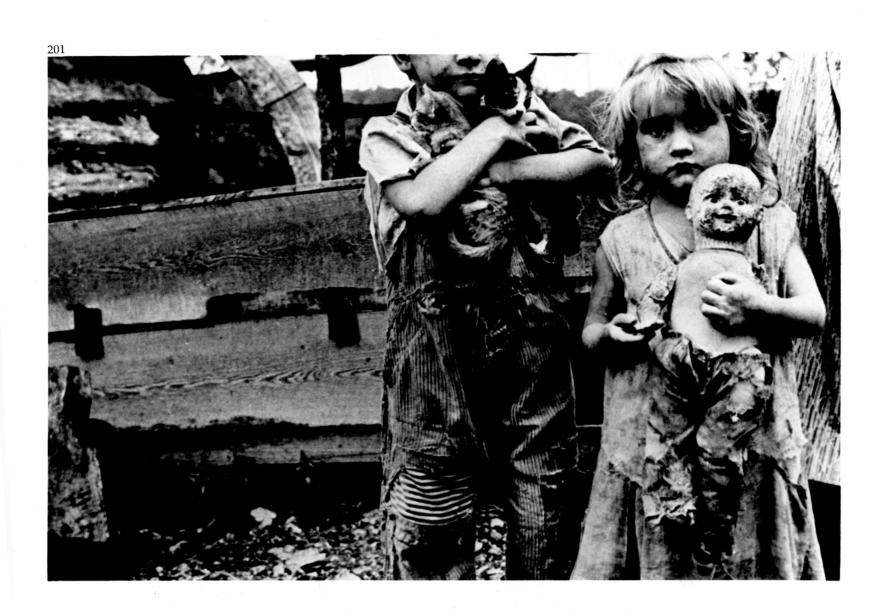

201. Ben Shahn (United States; b. Lithuania).
The Mulhall Children, Ozark Mountain Family.
1935. Modern silver bromide print from the original negative
202. George Hoyningen-Huene (United States; b. Russia).
Gary Cooper. 1935. Silver bromide print

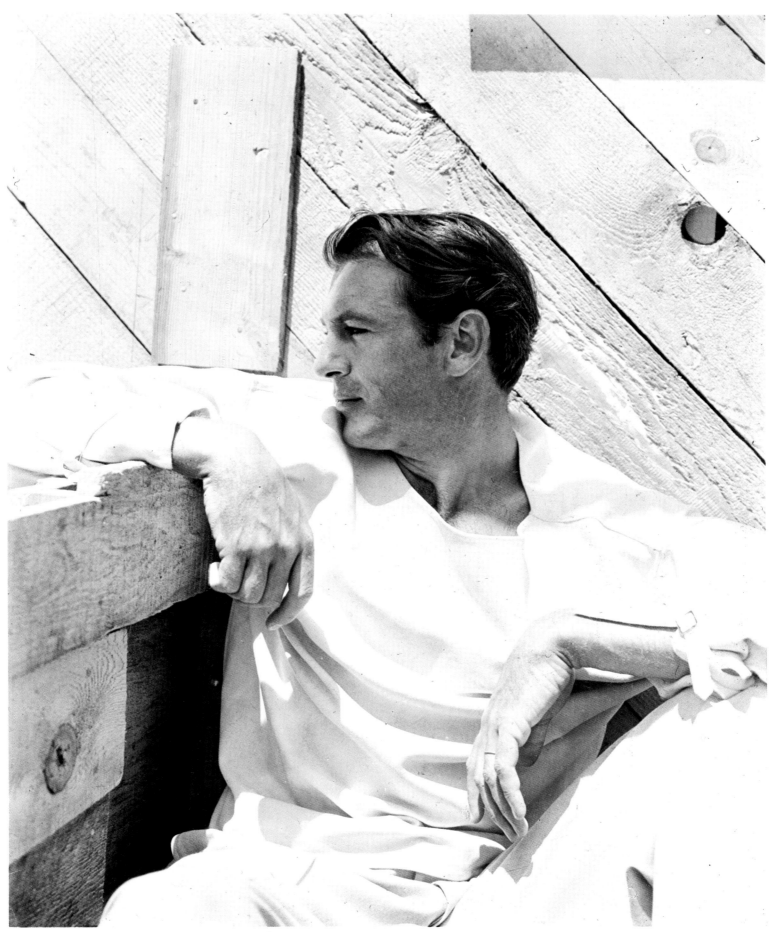

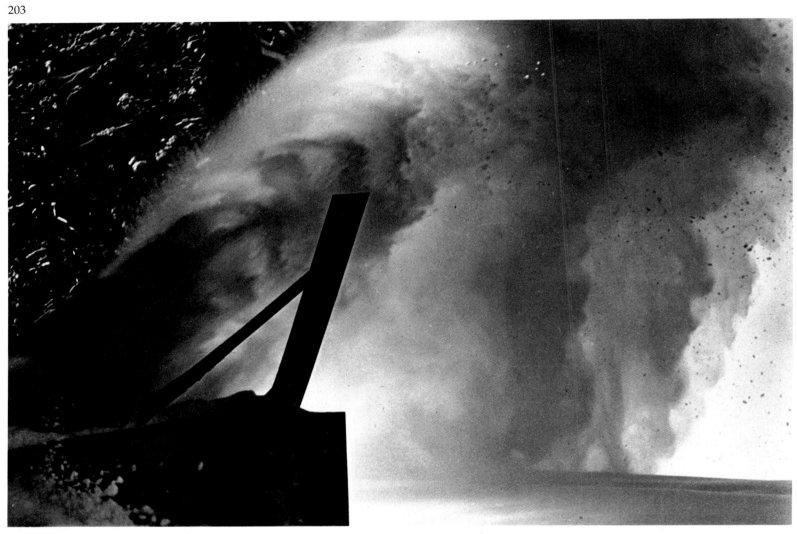

203. Ansel Adams (United States).
Snowplow. c. 1935.
Silver bromide print
204. László Moholy-Nagy (Hungary–United States).
Photogram. n.d. Silver bromide print

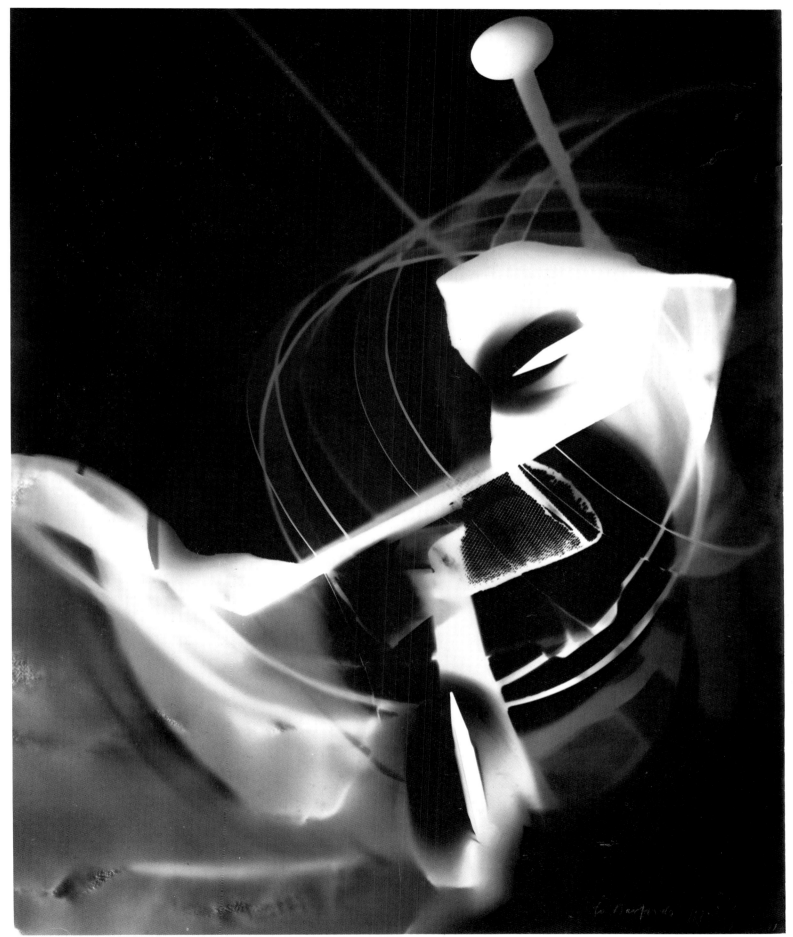

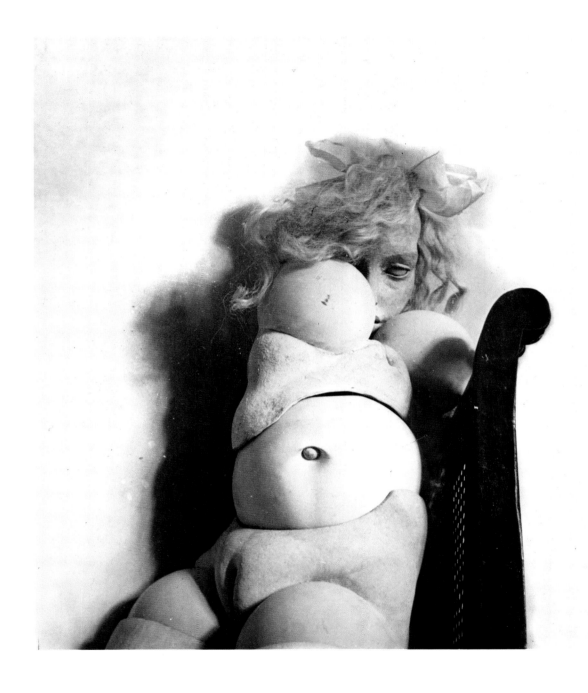

207. Paul Strand (United States).
Trois Rivières, Quebec. 1936.
Gold-toned platinum print
208. Hans Bellmer (France; b. Poland).
Doll. Late 1930s.
Silver bromide print

209

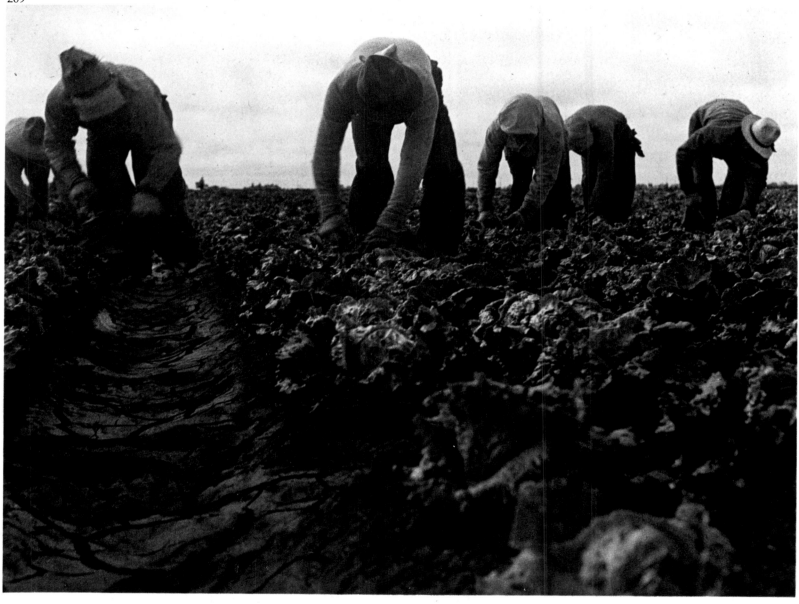

209. Dorothea Lange (United States).
Lettuce Pickers, Salinas Valley.
1938. Silver bromide print
210. Paul Outerbridge (United States).
Torso. c. 1936. Trichrome carbro print

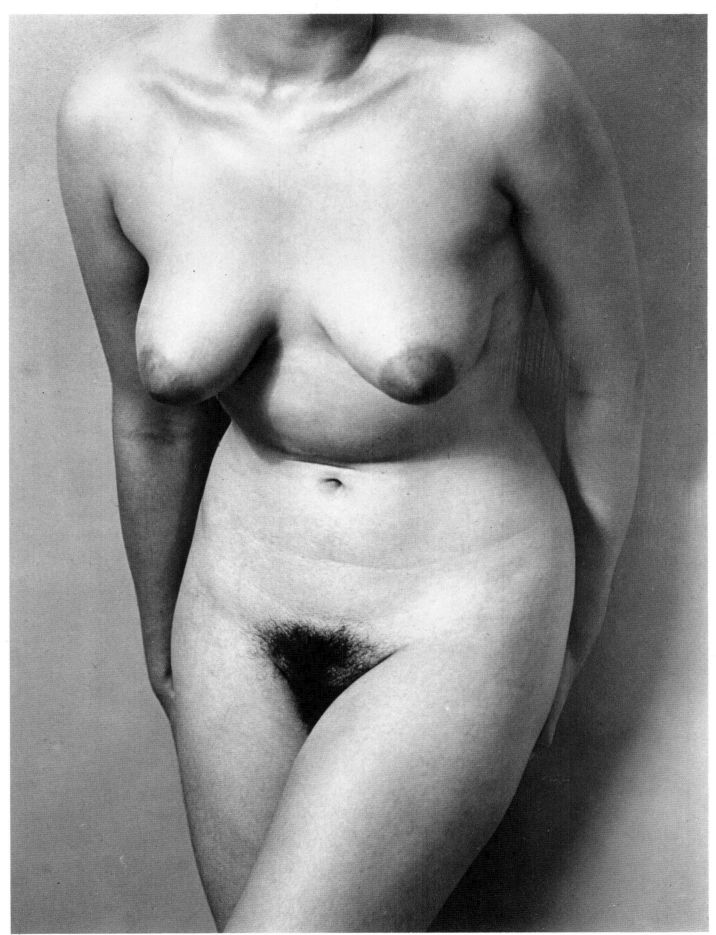

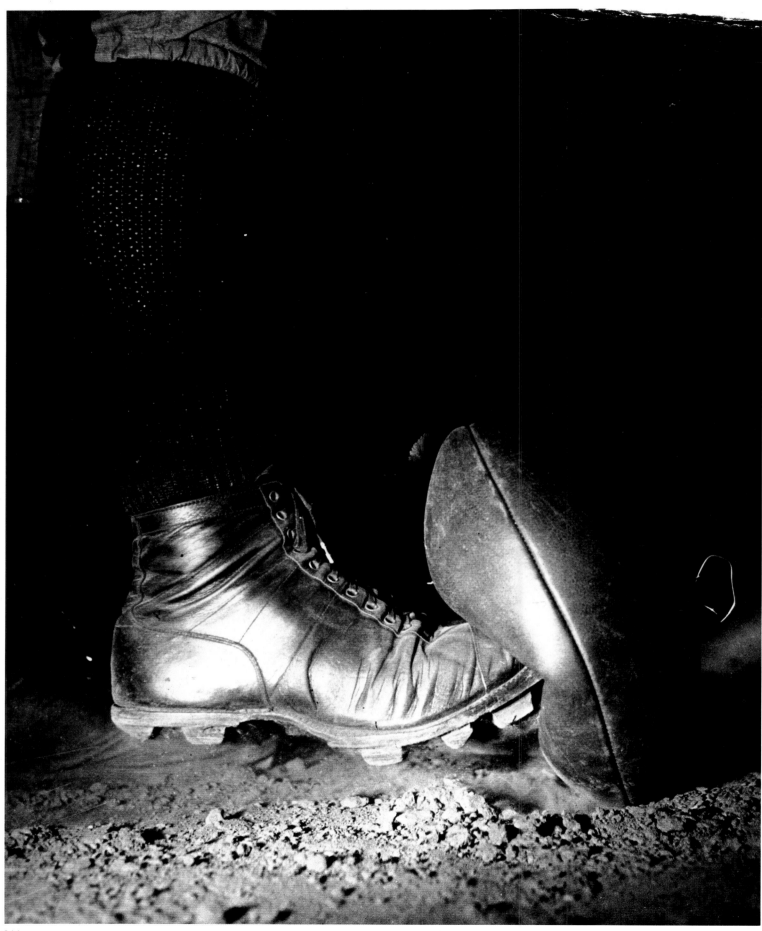

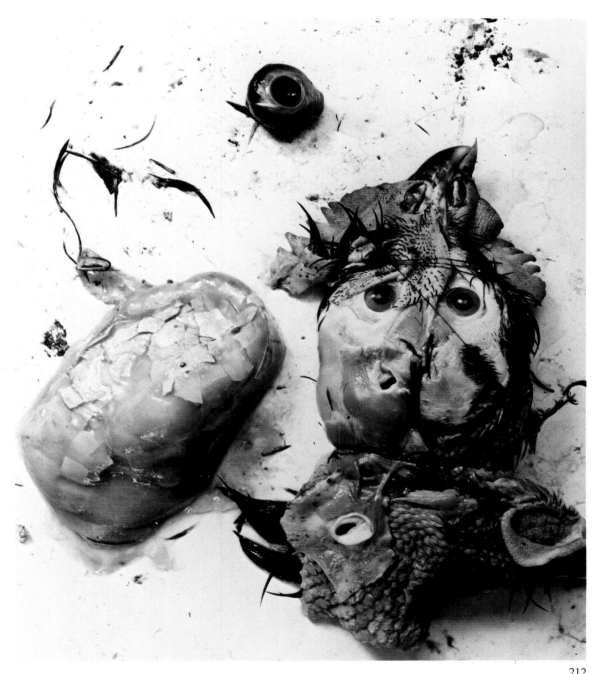

212

211. Harold E. Edgerton (United States).
Wesley Fesler Kicks a Footbal'.
c. 1937. Silver bromide print
212. Frederick Sommer (Italy–United States).
Still Life. 1940. Silver bromide print

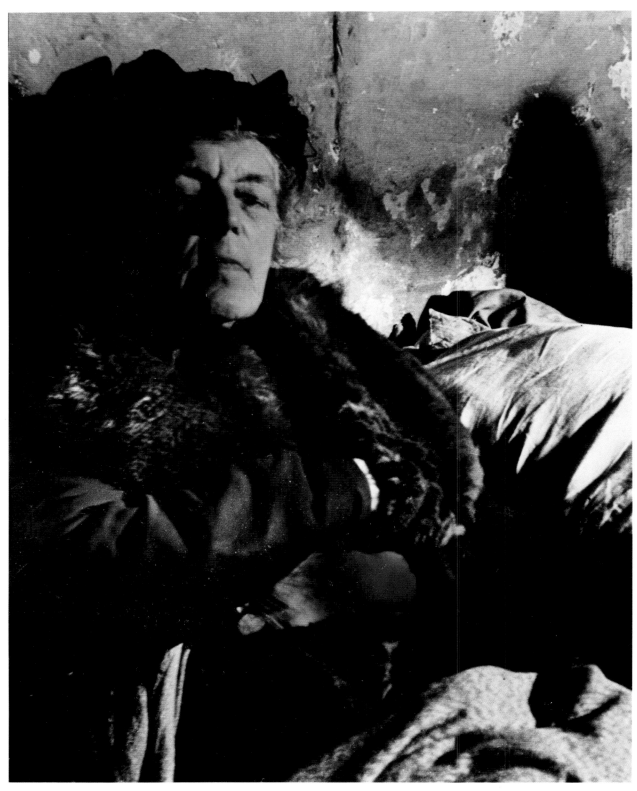

213. Bill Brandt (England).
Air Raid Shelter, Crypt of Christ Church,
Spitalfields, London, November, 1940.
Silver bromide print

NOTES ON THE PHOTOGRAPHS

NOTE: *Names, dates, and dimensions are given wherever they are known; the letters "n.d." indicate that no dates are known. In some cases, dimensions are not supplied, either because the print is believed to have been made by someone other than the photographer (as, for example, in the case of press or magazine pictures) or is a current print made from an old negative after the photographer's death. Dimensions are given in millimeters. One inch equals 25.40 millimeters; a modern 8 by 10 inch print, therefore, would be 203.2 by 254 millimeters.*

Frontispiece. Hippolyte Bayard (France, 1801–1887). *Portrait of the Photographer as a Drowned Man*. 1840. Bayard's direct positive process, 186 x 192. Courtesy Société Française de Photographie, Paris

One of four men who could be said to be the true inventors of photography. The others are Niépce, Daguerre, and Talbot. Here he is using the medium for the first time for personal publicity with a wry humor not seen again in photography for some years. His caption for this photograph reads in part:

> The corpse of the gentleman you see above is that of an ingenious and indefatigable experimenter.... The Government, which has been only too generous to Monsieur Daguerre, has said it can do nothing for Monsieur Bayard and the poor wretch has drowned himself.

The seriousness of his message has not made him forget his apparent passion for straw hats, which is demonstrated in some later and happier photographs using Talbot's process.

1. William Henry Fox Talbot (England, 1800–1877). *Carpenters on the Lacock Estate*. 1842. Salt print from a calotype negative, 130 x 105. Courtesy the Fox Talbot Museum, Lacock, England

Talbot, a modest landowner, scholar, and scientist who wished to draw well but could not, was the inventor of negative-positive photography, the principle which soon eclipsed the daguerreotype. From photogenic drawings made both with and without a camera, he progressed to the "calotype" (from the Greek *kalos*, "beautiful"), which became the basis for all negative-positive photography until the invention of the wet collodion negative and the albumen print.

Some say that Talbot did not take any great photographs, good as many of his are. But there is no doubt that he did, including this essay in photographic cubism. He has posed his models, ladders, and tools beautifully; and the boy is determined to show himself a first-class apprentice. Talbot's estate workers were fond of their moody squire and he of them. They made remarkable pictures together.

2. Robert Hunt (England, 1807–1887). Photogenic drawing. 1840s. 130 x 168. Gernsheim Collection, Humanities Research Center, Austin, Texas

Little is known of Robert Hunt, and not much of his work survives. This image comes from an album of photogenic drawings in which he has experimented by sensitizing his papers with various chemical combinations in pursuit of color and has chanced on a scarlet and yellow of Matissean vitality.

3. William Henry Fox Talbot (England, 1800–1877). *The Photographer's Daughter, Rosamund*. 1843–44. Salt print from a calotype negative, 95 x 77. Courtesy the Science Museum, London

This portrait seems to have been made earlier than it was because it was probably badly sensitized and underexposed. But it conveys more vividly than some technically much more competent prints of its date the feeling of the discovery of an entirely new medium and the magical sensation of nature itself fashioning an image.

4. Rev. Calvert Jones (Wales, 1804–1877). *Florence, "The Rape of the Sabines."* 1845–46. Printed by Henneman, 1847. Salt print from a calotype negative, 227 x 185. Courtesy the Science Museum, London

Taken on a tour of Italy, this could be described as the first photograph of violence. The negative has been unnecessarily touched up, but the sense of space created by aerial perspective is remarkably dramatic. The vestigial seated people were perhaps unnerved by the sight of a Welsh clergyman pointing a large box at them and did not wait the whole length of the exposure.

5. *Attrib.* Robert Hunt (England, 1807–1887). *Suzanna.* c. 1845. Salt print from a calotype negative, 125 x 155. International Museum of Photography, George Eastman House, Rochester, New York

In this undoubtedly long exposure of a girl in a garden, the photographer has nevertheless obtained some of the quality of an instantaneous snapshot. The "nerves" of a portrait subject are rarely well conveyed in early photographs, but they are here, eloquently.

6. Baron Louis-Adolphe Humbert de Molard (France, 1800–1874). *His Assistant, Louis Dodier, as a Prisoner*. 1847. Daguerreotype, 114 x 155. Collection Texbraun, Paris

A splendidly successful imposture: the photographer's assistant is acting the part of a prisoner, and although we see through the deception quite quickly, the image remains real and gripping. Staged pictures like this persisted throughout the nineteenth century in the work of pictorialist photographers like H.P. Robinson and William Lake Price, as well as in stereocards designed for home entertainment.

7. Gustav Oehme (Germany, n.d.). *Three Girls, Berlin*. 1843. Daguerreotype, 100 x 70. Collection Werner Bokelberg, Hamburg

These girls are not perhaps particularly likeable, but that is not the point. It is a beautiful group for its time or any time—simply a picture of them one day in Berlin in 1843 looking their best and keeping still for the length of the exposure. Oehme, like several early photographers, was an optician by trade.

8. Anon. (Germany). *Portrait*. Late 1840s. Hand-colored daguerreotype, 94 x 64. Collection Howard Ricketts, London

A simple, subtly tinted portrait showing very well the precise definition of which the daguerreotype was capable. Here, there is no sense of strain from the long exposure in the sitter, who seems to have an instinctive understanding of his role in the photographic process.

9. David Octavius Hill (Scotland, 1802–1870) and Robert Adamson (Scotland, 1821–1848). *The Newhaven Pilot*. c. 1844. Salt print from a calotype negative, 198 x 145. Collection Howard Ricketts, London

The historic partnership of Hill, a lithographer, and Adamson, a farmer's son, lasted only four years (ending with Adamson's death), yet it produced hundreds of photographs of great technical and artistic skill. The simple virtues of the calotype are well demonstrated in this beautifully preserved print. The sense of a sanguine human being is remarkably strong.

10. Baron Louis-Adolphe Humbert de Molard (France, 1800–1874). *Portrait of the Photographer's Wife, Henriette-Renée Patu*. c. 1847. Salt print from a wet paper negative, 168 x 120. Collection Texbraun, Paris

This is another example of the robustness characteristic of the early paper processes, their lack of fine detail amply compensated for by graphic strength. Humbert de Molard has recorded the strong character of his wife with great directness. She was evidently a talented painter of portrait miniatures. Ironically, photography, her husband's avocation, was her calling's deadliest enemy and almost complete destroyer.

11. R. H. Cheney (England, active 1850s). *Guyscliffe, Warwickshire*. Early 1850s. Albumen print from a calotype negative, 176 x 224. Collection Phyllis Lambert, on loan to the Canadian Centre for Architecture

A bold composition of buildings by a photographer of whom almost nothing is known. The picture nevertheless demonstrates a confident understanding of the medium's special capabilities.

12. Maxime Du Camp (France, 1822–1894). *Middle Eastern Subject.* 1849–51. Salt print by Blanquart-Evrard, 136 x 212. Gilman Paper Company Collection, New York

An exquisite photograph by the pioneer of Middle Eastern photography. Du Camp traveled in Egypt with Flaubert and initiated one of photography's most important and fruitful earlier preoccupations—the documentation of exotic places. The picture has a unique resemblance to an aquatint.

13. John McCosh (Scotland, 1805–1885). *Burmese Girl.* 1852. Salt print, 135 x 102. Courtesy the National Army Museum, London

McCosh, an army doctor, took the earliest surviving photographs of India as well as the first concerned with war (the Second Burma War). This is another example of how well the early salt print's economical means of definition could preserve the sense of a living human presence.

14. William Collie (Jersey, 1810–1896). *"The Jersey Patriarch" (Aged 102) and His Great-great-granddaughter.* c. 1848. Salt print from a calotype negative, 194 x 155. Courtesy the Royal Photographic Society, Bath

The old man was born in 1746 and must have been over forty at the time of the French Revolution. If the little girl had lived to the same age, she would have seen the Second World War. A good, plain photograph that moves the imagination.

15. Anon. (France). *Two Reclining Nudes with Mirror.* c. 1850. Daguerreotype, 80 x 110. Collection Werner Bokelberg, Hamburg

A lesbian fantasy for male delectation, strongly reminiscent of Courbet's great painting *La Sommeil.* The theme persists today in erotic photography of vastly inferior quality.

16. A. Le Blondel (France, n.d.). *Post-mortem Picture.* c. 1850. Daguerreotype, 90 x 120. Collection Gérard Levy, Paris

The daguerreotype was often used to record the dead, its unique unrepeatable image preserving a sense of sanctity. Although conceived somewhat theatrically, this marvelous post-mortem of a dead child with, no doubt, its father, is acutely sensitive to its subject. The father's presence is registered just enough to engage our sympathy, but our main attention is directed to the child.

17. Baron Jean-Baptiste Louis Gros (France, 1793–1870). *The Propylaea from Inside the Acropolis.* 1850. Daguerreotype, 200 x 250. Collection Bruno Bischofberger, Zurich

Gros was one of the many aristocratic or gentlemen amateurs who made such important contributions to early photography. This picture is an immaculate daguerreotype of beautiful color from a series taken while Gros was French ambassador to Athens.

18. Albert Sands Southworth (United States, 1811–1894) and Josiah Johnson Hawes (United States, 1808–1901). *Unidentified Old Woman.* 1850s. Daguerreotype (¼ plate), 108 x 82.5. Courtesy Boston Museum of Fine Arts

The partnership of Southworth and Hawes produced some of the very finest American studio portraits, which constitute an excellent record of the way many eminent Americans looked in the mid-nineteenth century. In this exceptional picture, though, it is extraordinary that an old woman's ill-tempered dignity can come down to us intact on a very small piece of copper. The slight movement blur seems to express her impatience, and the careless thumbprint suggest that the picture was not valued as much as the same photographers' pristine daguerreotypes of their paying customers. But it has lasted as well or better than any of them.

19. Louis Robert (France, 1811–1882). *Tree at La Verrerie.* c. 1850. Salt print from a paper negative, 270 x 325. Gilman Paper Company Collection, New York

A majestically simple view that could make us think of Cézanne. Though beautifully composed, it demonstrates some of photography's early interest in the untidiness of the world.

20. Henri Le Secq (France, 1818–1882). *Detail of Chartres Cathedral.* 1852. Photolithograph, 328 x 226. Collection Phyllis Lambert, on loan to the Canadian Centre for Architecture

Le Secq was a painter-photographer who spent only seven or eight years taking photographs, but he proves himself here and in plate 21 to be one of the greatest photographers of the nineteenth century. This detail of the cathedral shows the beauty of photolithography and is one of the very best of the many masterly photographs of such subjects taken by Nègre, Baldus, the Bissons, and others in the 1850s.

21. Henri Le Secq (France, 1818–1882). *Public Bathhouse or Swimming School, Paris.* c. 1852–53. Salt print, 125 x 174. Musée des Arts Décoratifs, Paris

Recently unearthed, this extremely rare subject for its time is a miracle and mystery of light, space, and suspended animation.

22. Charles Nègre (France, 1820–1880). *Place aux Aires, Grasse.* c. 1852. Albumen print, 165 x 215. Collection André Jammes, Paris

Nègre was a moderately successful artist who made many photographs of people, and particularly children, in the streets, using them as a basis for his paintings. In this remarkable unposed picture, he seems to invent modern street photography.

23. Charles Nègre (France, 1820–1880). *Young Girl with Basket and Baby.* Early 1850s. Salt print, 121 x 186. Collection Bruno Bischofberger, Zurich

Street children were photogenic and inexpensive models—as they are today. This must be one of the very first photographs taken from near ground level, a position that is still rare. It has made this picture exceptionally arresting.

24. Anon. (United States). *Blacksmiths.* 1850s. Hand-colored daguerreotype, 107 x 82. Walle Collection, Michigan

A unique and marvelously contrived piece of "reportage." The hammer has been well held for the long exposure, and the background figure is convincingly incidental.

25. Félix Teynard (France, 1817–1892). *Colossus, Decoration on Northeast Side of Throne (Thebes, Qurna).* c. 1851–52. Salt print, 271 x 362. Courtesy Metropolitan Museum of Art, New York

The documentation of the ruins of Egypt provided some of the best photographs in the early decades. Many were collected in very expensive albums, as this one was. It shows photography being entirely itself and holding its head very high. This is one of the most outstanding nineteenth-century photographs from Egypt, which is saying a great deal.

26. Braquehais (France, active 1850s–70s). *Veiled Nude with Suit of Armor.* 1854. Albumen print, 262 x 202. Collection André Jammes, Paris

Very little is known of Braquehais, not even his Christian name. There are not many surviving photographs by him, but he seems to have specialized in the nude. This one could surely not be surpassed by any of the smart fetishists of today.

27. Anon. (France). *A Domestic Servant.* 1850s. Daguerreotype, 90 x 68. Collection Howard Ricketts, London

An impressive, straightforward picture of a servant. The lower classes were rarely portrayed in daguerreotype portraits because of

the expense of the process. Though frequently depicted in salt prints, they had to await cheaper processes like the ambrotype and tintype before they could commission portraits of themselves.

28. Anon. (United States). *Man with Hat and Coat*. c. 1850–55. Pair of daguerreotypes, ¼ plate. Rubel Collection, courtesy Thackrey & Robertson, San Francisco

An inexplicable pair of images with undertones of Magritte. The surreal potential of photography was discovered early, if unwittingly.

29. Auguste Salzmann (France, 1824–1872). *North Wall, Jerusalem*. 1854. Salt print by Blanquart-Evrard, 237 x 331. Courtesy National Gallery of Canada, Ottawa

30. Auguste Salzmann (France, 1824–1872). *Cactus on Column of Porte Judiciaire, Jerusalem*. 1854. Salt print by Blanquart-Evrard, 330 x 225. Collection Stephen White, Los Angeles

Salzmann is now acknowledged as one of the great photographers, though little is known of his life. He went to Jerusalem and found it almost abstract. As the camera could not lie, his view was accepted. Plates 29 and 30 are both striking examples of photography seeming to adumbrate future characteristics of painting.

31. A. Le Blondel (France, n.d.). *Wine Drinkers*. 1850s. Salt print, 127 x 107. Courtesy Alain Paviot, Galerie Octant, Paris

Le Blondel shows himself to be subtle and gently humorous, partly because he has made no attempt to conceal a set-up scene in the studio.

32. Anon. (probably France). *Flemish Landscape*. Before 1855. Salt print, 185 x 234. Collection André Jammes, Paris

A landscape in a beautiful light that gains an extra dimension through what only the seated figure within it can see.

33. Colonel Jean-Charles Langlois (France, 1789–1870). *The Battlefield of Sebastopol* (One section of a fourteen-part panorama). 1855. Albumen print, 374 x 280. Collection Texbraun, Paris

The photographs taken of the Crimean War by Roger Fenton and James Robertson are justly famous. French ones are less familiar, but Langlois made a remarkable fourteen-part, 360 degree panorama which he later copied in paint on a canvas 100 meters long in Paris. In spite of the fact that he also painted clouds on the photographic print, this one part of the panorama gives perhaps a more graphic and extensive view of the battlefield than any other.

34. Joseph Cundall (England, 1818–1895) and Robert Howlett (England, 1830–1858). *"Crimean Braves."* Published 1856. Photogalvanograph, 249 x 198. Rubel Collection, courtesy Thackrey & Robertson, San Francisco

Robert Howlett is most famous for his pictures of Isambard Kingdom Brunel and the steamship *Great Eastern*. This picture was originally published with the soldiers' faces and beards heavily retouched, surely quite unnecessarily, and this is the only known unspoiled print.

35. Duboscq-Soleil (France). *Memento Mori*. After 1854. Daguerreotype, 82 x 70. International Museum of Photography, George Eastman House, Rochester, New York

A technically perfect daguerreotype with a subtle gray tonality not seen again until the platinum print.

36. Froissart (France, active 1850s). *Flood at Lyons*. 1856. Salt print, 225 x 337. Collection Sam Wagstaff, New York

An example of photography's ability to turn certain unpleasant re-

alities into dreams—the "surreal," which everyone enjoys in photographs.

37. *Attrib.* Charles Simart (France, 1806–1857). *Female Nude*. c. 1856. Salt print (enlargement from a small collodion negative), 433 x 282. Collection André Jammes, Paris

38. *Attrib.* Charles Simart (France, 1806–1857). *Male Nude*. c. 1856. Salt print (enlargement from a small collodion negative), 434 x 284. Collection André Jammes, Paris

These two photographs are probably enlargements, made at a very early date, from small negatives; the surface streaking from the crudely applied collodion is therefore emphasized. The patterning nevertheless adds to the graphic strength of a very singular pair of photographs. They are believed to have been taken by a sculptor and they certainly have the character of the best kind of artists' studies.

39. Anon. (France). *Farm Study*. c. 1855. Albumen print, 165 x 254. Collection Stephen White, Los Angeles

A very beautifully arranged but seemingly casual composition of man, horse, and light.

40. Henri Le Secq (France, 1818–1882). *Still Life*. 1850s. Modern print by Claudine Sudre from a paper negative. Bibliothèque Nationale, Paris

Le Secq was a mediocre painter, but his still lifes, like all his other photographic work, stand comparison with any in the history of the art.

41. Edouard Duseigneur (France, n.d.). *The Village Tailor*. Early 1850s. Salt print, 133 x 103. Collection Howard Ricketts, London

From an album by an amateur who owned a silk factory, this is an example of the extraordinarily high standards found in some of the entirely unvocational work of its time.

42. Anon. (France). *Nude*. c. 1850. Daguerreotype, 60 x 80. Collection Roger Thérond, Paris

An erotic daguerreotype of unique warmth, unlike many other daguerreotypes of nudes which make the models seem uncomfortably chilly.

43. Anon. (France). *Nude*. 1850s. Daguerreotype. Collection Michel Auer, France

A staggering picture, entirely photographic in conception. The cropping of the legs is revolutionary for its time in painting or photography. It stops beautifully short of indecency, giving us a vivid image of a lively girl looking wonderfully so after 120 years.

44. Nadar (Gaspard Félix Tournachon; France, 1820–1910). *Portrait of Napp* (?). n.d. Salt print, 263 x 205. Collection André Jammes, Paris

Nadar was and is the most celebrated of all French portrait photographers. Also famous for taking the first pictures from a balloon, he encouraged his subjects to adopt their own poses. This actor is perhaps posing as a stage character.

45. Count de Montizon (France, n.d.). *The Hippopotamus at the Zoological Gardens, Regent's Park*. 1855. Albumen print, 112 x 122. Courtesy the Royal Photographic Society, Bath

A portrait of a present given to Queen Victoria by the Khedive of Egypt, this photograph looks rather like a lively magazine or tabloid picture of the 1930s or even of today. With its implied question of who is confined, the crowd or the complacent animal, it is a unique example of humor in the serious *Photographic Album of the Year 1855*, published for the members of The Photographic Society of London.

46. Anon. (Great Britain). *Samuel Renshaw, Sickle Grinder.* 1854 or 1857. Hand-colored ambrotype (whole plate). Rubel Collection, courtesy Thackrey & Robertson, San Francisco

Samuel Renshaw perhaps commissioned this ambrotype in order to have a proud image of himself as a craftsman. Because it produced its image on glass rather than expensive metal, the ambrotype was the first process commonly commissioned by people of social rank lower than the middle class.

47. Benjamin Brecknell Turner (England, 1815–1894). *The Willow Walk, Bredicot.* c. 1856. Waxed paper negative, 300 x 401. Courtesy the Royal Photographic Society, Bath

An example, from another recently discovered photographer, of the occasional great beauty of the negative image—no positive of it is known.

48. Benjamin Brecknell Turner (England, 1815–1894). *Sunken Road.* c. 1856. Modern print from the original waxed paper negative, 300 x 400. Collection André Jammes, Paris

Turner continued making waxed paper negatives into the late 1850s, well after the wet collodion process was in general use. This modern print shows a fine freedom from any notions of pictorial tidiness.

49. Anon. (N. France or Belgium). *Portrait of an Old Woman.* c. 1850–60. Hand-painted photograph, 310 x 266. Collection André Jammes, Paris

Sensitively applied color has not destroyed the essentially photographic character of this portrait.

50. Henry White (England, 1819–1903). *The River at Bettws-y-Coed, North Wales.* c. 1856. Albumen print, 126 x 177. Collection Daniel Wolf, New York

White was drawn by the visual texture of foliage, and some of his pictures concentrate on that alone. The combination here of the archaic oval format with an essentially unarchaic photograph is oddly satisfying.

51. Edouard-Denis Baldus (France, 1820–1882; b. Germany). *"An Afternoon in the Country."* 1857. Salt print, 279 x 381. Gilman Paper Company Collection, New York

Baldus was a great documentary photographer of architecture and railways. This unusual alfresco scene looks forward to the Impressionists' preoccupation with prosperous or contented people in gardens and also to Jacques-Henri Lartigue, whose now famous boyhood snapshots recorded the same subjects with such effervescence nearly two generations later.

52. Adolphe Braun (France, 1811–1877). *Still Life.* c. 1855. Albumen print, 305 x 365. Collection Sam Wagstaff, New York

Braun was a textile designer whose first published photographs were of flowers. He became famous for his still lifes, alpine landscapes, and stereoscopic views of the streets of Paris. This picture is perhaps a textile designer's view of flowers, but of one who was above all a master photographer.

53. Arthur Backhouse (England, n.d.). *Pots and Pans at Nice.* 1855. Albumen print from a waxed paper negative, 215 x 275. Collection Robert Herschkowitz, London

This seemingly random assemblage of homely objects leaves no doubt at all that it has been carefully arranged, but for a photograph, not a painting.

54. Albert Sands Southworth (United States, 1808–1901) and Josiah Johnson Hawes (United States, 1811–1894). *Young Girl.* 1850s.

Daguerreotype (⅙ plate), 82 x 70. International Museum of Photography, George Eastman House, Rochester, New York

Another exceptionally vivid daguerreotype demonstrating once more how some early photographers could make their pictures look more instantaneous than the long exposure times would suggest was possible.

55. Gustave Le Gray (France, 1820–1862). *French Military Maneuvers, Camp de Châlons: The Guard Behind a Breastwork.* 1857. Albumen print, 271 x 362. Collection Sam Wagstaff, New York

Gustave Le Gray was one of the painter pupils of Paul Delaroche, as were Charles Nègre, Roger Fenton, and Henri Le Secq. Le Gray is famous for his combination prints of sea and skies, but he also took excellent landscapes and other subjects. Among them was a series of photographs of army maneuvers he made for Napoleon III, of which this is the most dramatic.

56. Anon. (United States). *The Franklin Fire Hose Co., Utica, N.Y.* 1858. Hand-colored ambrotype, 152 x 202. Walle Collection, Michigan

A nicely ingenuous picture, both lively and sympathetic. The writing on the firemen's belts reads backwards because the image in an ambrotype is usually reversed, as it is in a negative. Itinerant ambrotype and tintype photographers profited from being able to color their pictures.

57. Anon. (United States). *Gold Miners, California.* c. 1850. Daguerreotype (½ plate), 107 x 135. International Museum of Photography, George Eastman House, Rochester, New York

This is a very early example of the genre of photographs showing men at work. The spot of gold in the pan, touched in with paint, is a pleasant and ridiculous exaggeration. In all, it is an excellent, modest daguerreotype.

58. Anon. (France). *Two Standing Nudes.* c. 1850. Daguerreotype (whole plate). Rubel Collection, courtesy Thackrey & Robertson, San Francisco

This cool, artless, and graceful picture has the character of an artist's study rather than a pursuit of a definite image.

59. *Attrib.* Edouard-Denis Baldus (France, 1820–1882; b. Germany). *A Private House, Paris.* c. 1855. Albumen print, 438 x 332. Collection André Jammes, Paris

A mysterious and beautiful photograph. Its framing is unaccountable—the photographer seems to be interested only in the play of the light on the wall and the shuttered windows.

60. Capt. Linnaeus Tripe (England, 1822–1902). *Temple Fort, Southern India.* Before 1858. Albumen print from a waxed paper negative, 251 x 375. Courtesy Boston Museum of Fine Arts

Tripe was commissioned by the Indian army to make a photographic survey of the important monuments of India. This is one of the very best of his pictures in which the color, which seems exclusive to him, wonderfully enhances the image. He unfortunately seems to have abandoned photography on being promoted to higher rank.

61. Roger Fenton (England, 1819–1869). *Odalisque.* 1858. Salt print, 285 x 390. Rubel Collection, courtesy Thackrey & Robertson, San Francisco

Fenton was a fashionable portrait, landscape, and architecture photographer and first secretary of The Photographic Society of London. He was commissioned in 1855 by the picture dealers Thos. Agnew & Sons to photograph the Crimean War. The more than three hundred negatives he returned with provided the first on-the-spot photographic coverage of a war and included landscapes and portraits but

no action scenes, which were beyond the capability of the camera at the time. Later, Fenton made a small series of what could be called "orientalist" photographs, but it is not known where he took them. This one is perhaps the best of them, and it could be said to equal anything he did.

62. Charles Piazzi Smyth (Scotland, 1819–1900). *"Lookers-on Taken Unconsciously, Novgorod, 1859."* Lantern slide. Courtesy the Royal Society of Edinburgh

Here is an interesting, spontaneous document made by the Astronomer Royal of Scotland, who took the first successful photographs by magnesium flare (in Egypt). In this "snapshot" the camera was probably concealed but could have been simply unrecognized by the remarkably modern-looking Russians of Novgorod.

63. Roger Fenton (England, 1819–1869). *Clouds.* c. 1859. Salt print, 250 x 436. Rubel Collection, courtesy Thackrey & Robertson, San Francisco

In early photography, the problem of achieving correct exposure balance between a relatively dark earth (or sea) and a bright sky was overcome sometimes by making "combination prints" from two separate negatives taken with different exposures, one for either sea or land and the other for sky. This picture, though, is from one negative; the landscape has been thrown into nearly complete darkness in order to hold detail in the sky. It thus becomes a mysterious scene of intensely poetic feeling. Photography's technical limitations often produced arresting images which we find we must respond to.

64. Count Olympe Aguado (France, 1827–1894). *Admiration.* 1860. Albumen print, 152 x 203. Collection Texbraun, Paris

This is one of a series of *tableaux vivants* created by a French aristocrat of talent. It purports to represent a painter showing off his latest picture. It is at once serious, humorous, impressive, and trivial—a lively charade.

65. Anon. (Great Britain). *An Elderly Veteran and His Wife.* c. 1860. Hand-colored ambrotype (½ plate). Rubel Collection, courtesy Thackrey & Robertson, San Francisco

The old soldier—whose decorations reveal that he served at Waterloo—and his wife have probably been persuaded to sit for their portrait by their children or grandchildren. Both seem uneasy, the woman facing it out, the man dully resenting the ordeal. This is an excellent example of the tinted ambrotype and a rare human and social document as well.

66. Anon. *Niagara Falls with Group and Tower.* c. 1860. Albumen print. Collection Stephen White, Los Angeles

An extraordinary image, both unreal and sinister. The movement of the water during exposure has not transformed it into a substance of unearthly beauty, as so often happens. The group of figures seems ominous, and the topless tower could possibly go on upwards forever. Photography has contrived a bad but compelling dream.

67. Anon. (Great Britain). *Laying the Atlantic Cable (?).* 1858. Albumen stereocard. Collection Howard Ricketts, London

The subject matter of stereocards was as varied as that of television programs today. Besides giving viewers a glimpse of an historic event, this also depicts the life of British seamen, which no other kind of photography would have concerned itself with at the time. It is a particularly vivid example of stereo "documentary."

68. William Notman (Canada, 1826–1891; b. Scotland). *Victoria Bridge over the River St. Lawrence.* 1859. Albumen stereocard. Collection Howard Ricketts, London

Notman was a Scot who moved to Canada at the age of 30. He

opened a studio in Montreal and soon had a large business with branches in both Canada and the United States. He was a very accomplished photographer who left an important record of Canadian life. Here he (or his studio) has produced a marvelously bold stereocard that is as good to look at as a double image as it is through a stereo viewer.

69. Camille Silvy (France, active in England 1857–69). *Street Musicians in Porchester Terrace, London.* c. 1860. Albumen print, 276 x 221. Private collection, London

Silvy was yet another French aristocrat who took up photography, but he also became a successful professional in London, where he made many pocket-sized portraits on cards (called *cartes de visite*) and was a master of this popular and lucrative genre. Some time later, he became French consul in Exeter. In this picture, taken outside his London studio, his mastery of the medium has made a conventional subject into an exceptionally fine photograph.

70. Roger Fenton (England, 1819–1869). *Still Life.* c. 1860. Albumen print, 352 x 419. Courtesy the Royal Photographic Society, Bath

Fenton took a whole group of still lifes around this time. This is the least crowded and contrived, the least "Victorian" in feeling.

71. Victor Albert Prout (England, 1837–1877). *New Lock, Hurley.* c. 1862. From *The Thames from London to Oxford.* Albumen print, 109 x 280. Courtesy the Royal Photographic Society, Bath

This sophisticated image comes from a rare book of panoramic pictures of the Thames probably cropped from more conventionally proportioned negatives rather than made with a fully developed panoramic camera. The whole set is imbued with an exceptional tranquility, with no hint that its author would die insane at a tragically early age.

72. Felice A. Beato (England, b. Italy; active 1852–65, d. 1903). *Hypostyle Hall at Edfu.* After 1862. Albumen print, 348 x 251. Courtesy National Gallery of Canada, Ottawa

Beato worked in partnership with James Robertson in Malta, Egypt, Palestine, and India and then on his own in the Opium War in China. He subsequently spent many years in Japan, documenting a wide range of subjects there. This picture from Egypt shows the beautiful effect of "halation," in this case, the way in which bright light entering a dark space erodes the contours of its point of entry.

73. Désiré Charnay (France, 1828–1915). *Chichén-Itzá, Mexico.* c. 1860. Albumen print, 412 x 336. Collection Phyllis Lambert, on loan to the Canadian Centre for Architecture

One of the great series that the photographer took in Mexico. The endurance of those who could be called the explorer-photographers in the face of great technical and climatic difficulties was nothing short of heroic. Those photographers who, like Charnay and Samuel Bourne, used wet collodion glass plates, had to prepare and develop them on the spot in dark tents. In addition, Charnay had to withstand the hot and humid jungle of Mexico, and Bourne the extreme cold of the Himalayas.

74. Anon. (United States). *Two Burglars.* 1860. Albumen prints, each 89 x 66. Collection Howard Ricketts, London

Not from a conventional "Rogue's Gallery," these portraits were in a private album collected from police records for an unknown purpose, perhaps for a pseudoscientific classification of "criminal types."

75. Nadar (Gaspar Félix Tournachon; France, 1820–1910). *Hand of M.D....Banker.* c. 1860. Albumen print (printed by electric light), 150 x 190. Courtesy Société Française de Photographie, Paris

Only a photographer as inventive as the great Nadar would per-

haps have succeeded in making a portrait by showing only a hand. A strange image, interesting as anybody's hand, but much more so when we know it belongs to a banker.

76. Collard (France, n.d.). *Roundhouse on the Bourbonnais Railway (Nevers).* 1862–67. Albumen print, 311 x 225. Collection André Jammes, Paris

The railways of France were well documented by photographers such as Baldus and, here, Collard. This roundhouse has the pristine cleanliness and charm of a scale model.

77. Auguste-Rosalie Bisson (France, b. 1826). *Cabane des Grands Mulets, Savoie.* 1861. Albumen print, 222 x 391. Courtesy Art Institute of Chicago

Auguste-Rosalie Bisson and his brother Louis-Auguste are famous, among other things, for their alpine views, which were best-sellers in their day, particularly when peopled by climbers engaged in their newly popular and daring pastime. This one is more theatrical than most, suggesting a setting for Wagner's *Ring*.

78. Louis Rousseau (France, n.d.). *Envoy from Cochin China in Paris.* 1863. Albumen print, 178 x 127. Gilman Paper Company Collection, New York

This is an excellent example of youthful pride facing up to the photographer, a fruitful confrontation resulting in a strong portrait.

79. Anon. (United States). *Private Charles N. Lapham, Civil War Amputee.* 1863. Albumen print, 218 x 168. Private collection, London

This photograph was taken by order of the Union army's Surgeon-General as an example of particularly rapid recovery from a double amputation. In this unblinking picture, the decisive contour of the chair back is entirely at one with the subject's demeanor.

80. A. J. Russell (United States, 1830–1902). *Union Soldier at an Arsenal near Washington, D.C.* c. 1865. Albumen print, 203 x 330. Collection Sam Wagstaff, New York

A photograph of bold and forthright composition that could almost have been taken for a magazine of the mid-1960s rather than the mid-1860s.

81. Timothy H. O'Sullivan (United States, 1840–1882). *Dead Confederate Soldier.* 1865. Albumen stereocard. Collection Sam Wagstaff, New York

A simple, single view of this dead soldier would have been brutal enough; making it a stereocard invited the viewer to gloat. It is very different from nearly all other photographs of the Civil War—those by Mathew Brady and his associates—which were generally solemn and restrained and hardly ever used close-up.

82. Nadar (Gaspard Félix Tournachon; France, 1820–1910). *Self-portrait with Mme Nadar and Paul Nadar.* c. 1865. Albumen print, 190 x 140. Collection Roger Thérond, Paris

Quite early in his career, Nadar made this beautifully direct, simple, and personal picture which has not aged at all.

83. Adolphe Braun (France, 1811–1877). *Lake Steamers at Winter Moorings, Switzerland.* c. 1865. Carbon print, 365 x 473. Collection Sam Wagstaff, New York

This could be the best picture ever taken by Braun, one of the very best nineteenth-century photographers. It is a great photograph that defines its cold space and silence perfectly.

84. Samuel Bourne (England, 1834–1912). *The Cawnpore Memorial Well.* c. 1865. Albumen print, 192 x 310. Courtesy Marcuse Pfeifer Gallery, New York

Bourne and his partner, Shepherd, were among those who produced hundreds of views of India published in England as evidence of Empire. This is a variant of several pictures he made of the same subject. One feels it may have not been published widely because of its sense of strangeness. And yet it is perhaps more beautiful than all the others.

85. Adolphe Braun (France, 1811–1877). *Still Life with Deer and Wild Fowl.* c. 1865. Carbon tissue, 772 x 590. Courtesy Metropolitan Museum of Art, New York

Not a great photograph, perhaps, but a tour de force of photographic technique, casual brutality being combined with refinement. The perfect print seems as if it could have been taken yesterday in a studio with strobe lights.

86. Julia Margaret Cameron (England, 1815–1879; b. India). *Mary Hillier, Her Maid.* c. 1867. Albumen print, 343 x 279. Collection Sam Wagstaff, New York

Here Mrs. Cameron demonstrates her extraordinary audacity. The photograph is not a reject, she has signed it. The collodion has been applied very crudely and nothing is in focus, but this combination has produced an image of great strength and beauty. The "close-up" view and tight cropping are unprecedented.

87. Robert Macpherson (Scotland, 1811–1872). *The Falls of Terni.* Before 1867. Albumen print, 415 x 317. Collection André Jammes, Paris

A grand demonstration of waterfall photography, the moving water being blurred and simplified into a beautiful schematic pattern.

88. Robert Macpherson (Scotland, 1811–1872). *Bas-relief on the Interior of the Arch of Titus, Rome.* c. 1865. Albumen print, 368 x 279. Museum of Modern Art, New York

This picture testifies to the camera's abilities with architectural detail as well as to Macpherson's great talent. An Edinburgh surgeon who went to Italy for his health, he became one of the greatest photographers of Italian architecture and also made some fine landscapes (plate 87).

89. Julia Margaret Cameron (England, 1815–1879; b. India). *The Photographer's Son, Henry Herschel Hay Cameron.* 1865. Albumen print, 242 x 200. Courtesy Robert Self Gallery, London

A gentle and sensitive portrait of one of her sons by the greatest of women photographers; in style and feeling it could almost have been made by a member of the Photo-Secession movement over thirty years later. Henry Cameron himself later became a successful portrait photographer.

90. Cyprien Tessié du Motay (France, n.d.). *Young Woman.* c. 1867. Phototype, 295 x 215. Courtesy Société Française de Photographie, Paris

With Charles Maréchal, Du Motay obtained the first patent for a phototype method, but his pictures are very rare. This seems a particularly strong and lively portrait of a singular girl.

91. Carleton E. Watkins (United States, 1829–1916). *Self-portrait, Geyser Springs, The Witch's Cauldron.* 1860s. Albumen print, 413 x 521. Gilman Paper Company Collection, New York

A great landscape photographer of America's Far West puts himself into a dramatic picture. His mammoth plate has provided marvelous detail, which modern small-format photography cannot match. Watkins took the best photographs of Yosemite Valley, perhaps even better than those of the Englishman Muybridge.

92. J. Andrieu (France, active 1870s). *The Bridge at Argenteuil.* 1870–71. Albumen print, 377 x 294. Courtesy National Gallery of Canada, Ottawa

Much of the photography of the Franco-Prussian War proved to be merely an endless catalogue of damaged buildings. This picture, though, is vividly expressive. The bridge's replacement would be immortalized in paint a few years later by Monet and others.

93. Charles Marville (France, 1816–c. 1880). *The Church of the Panthéon Under Repair.* c. 1870. Albumen print, 369 x 274. Collection Phyllis Lambert, on loan to the Canadian Centre for Architecture

Marville takes a classic picture of repairs after the war. He was one of the great "recording" photographers and preserved the look of much of Paris before Baron Haussmann's extensive destruction and renovations.

94. Anon. (United States). *Divers at Pier No. 4, Kansas City Bridge.* 1869. Albumen print, 171 x 225. Collection Stephen White, Los Angeles

Pictures of work are often a celebration of our endurance of ordinary daily routine and also of hardship or danger. This picture is a lively and good-humored document of men preparing to take risks.

95. Dr. A. de Montmeja (France, n.d.). *Linear Incision of the Eye.* Published 1871 in *A Treatise on Operations Practised on the Eye* by Montmeja and Edouard Meyer. Retouched albumen print, 126 x 174. Collection Texbraun, Paris

This photograph and its similar companions in the book it comes from have been retouched with a loving morbidity far beyond the needs of their instructive purpose. Montmeja was a pioneer of medical photography, a field in which early examples often seem voyeuristic and convey a curious fascination with pathological imagery.

96. Charles Aubry (France, n.d.). *Flower Study.* 1864–70. Albumen print, 440 x 358. Courtesy Art Institute of Chicago

Little is known of Aubry except that he made several albums of flower studies, some of which were owned by Napoleon III. Like this one, the images are often enigmatic. Several use florists' wire: here, a piece of paper washed with watercolor was probably placed behind the wreath to provide a sense of space or sky. It is a baffling image as much in tune with 1930s fashion magazine surrealism as with its own time.

97. Pietro Th. Boysen (Denmark, 1819–1882). *Elisabeth Jerichau Baumann with Her Son in Rome.* 1873. Albumen print, 123 x 99. Courtesy the Royal Library, Copenhagen

Boysen set himself up as a photographer in Rome and has made in this picture a curious and intimate anecdote of two fellow Danes on a tour, an artist mother with her artist son. It is a good photograph which makes one wonder at the crudity of the "ROMA" lettered over the door and the seemingly begrudging presence of the bored "extra."

98. Fred Hardie (probably United States, n.d.). *Berber Entertainers, Tangiers.* 1870s. Albumen print, 216 x 158.5. Collection Stephen White, Los Angeles

This photograph has the style and sense of design of a twentieth-century fashion picture. The others in the album it comes from are all exceptionally good.

99. John Thomson (Scotland, 1837–1921). *The Bridge at Foo Chow.* Published 1873 in *Foo Chow and the River Min.* Carbon print, 127 x 98. Collection Stephen White, Los Angeles

John Thomson, famous for his pictures published in two books, *Street Life in London* and *China and Its Peoples,* today seems more and more like a photographer of the very first rank. This picture from a rare album is quite astonishingly framed. Any other photographer of the time would have raised or lowered the angle of his camera.

100. Dr. A. Hardy (Great Britain, n.d.) and Dr. A. de Montmeja (France, n.d.). *Sycosis, a Skin Disease.* 1872. Hand-colored albumen print, 120 x 93. Private collection, London

Photographers of pathology sometimes made much stranger images than one would think possible. It is hard to imagine how this specter evolved—unless, quite incredibly, it was inspired by William Blake—or even how it was accepted for publication.

101. Anon. *Hindu Priest from Southern India with Attendants.* 1870s. Albumen print, 273 x 232. Collection Paul Walter, New York

An image of sinister-seeming priestly power. The cropping of his attendants is exceptional and seems to emphasize his prestige.

102. Anon. (probably Great Britain). *Siamese Boy Musician.* c. 1875. Albumen print, 165 x 229. Collection Stephen White, Los Angeles

The often anonymous photography of exotic places produced in the nineteenth century sometimes throws up a perfect picture far above the norm. This is such a one.

103. W. L. H. Skeen and Co. (active in Ceylon, c. 1875–85). *Tamil Girl.* c. 1880. Albumen print, 273 x 213. Courtesy Boston Museum of Fine Arts

Hardly anything is known of the photographers. This is one of many of this kind produced by them and shows how beautiful the narrow depth of focus of a portrait lens can be. Like plate 102, it could scarcely be better.

104. Anon. (Great Britain). *Asylum Patient Suffering from Melancholia.* 1876. Albumen print, 94 x 56. Private collection, London

Within the first twenty-five years of its invention, photography began to be used to document human types. Many pictures were taken to identify people—whether orphans, criminals, or lunatics—or as part of scientific studies. These portraits often very movingly record personalities who would otherwise have been consigned to oblivion. This is an outstanding example.

105. Anon. (probably France). *Fat Woman.* c. 1875. Albumen print, 227 x 174. Collection Texbraun, Paris

A brutal photograph which is thought to have been taken for someone with an erotic interest in obesity. It has an acute pathos.

106. Anon. (Great Britain). *Barnardo Boy.* 1876. Albumen print, 90 x 57. Courtesy Dr. Barnardo's Homes, England

Dr. Barnardo, the famous British rescuer of orphans and abandoned children, pioneered this kind of "mug shot," first as publicity for his famous Homes and later as a simple record. Many are dramatically moving or curious. This one quietly conveys the sense of a common predicament.

107. Durandelle (France, n.d.). *Stonemasons at Work on the Paris Opera.* Published 1876. Albumen print, 374 x 280. Collection Texbraun, Paris

Part of an album full of very fine, objective pictures recording the building of the Paris Opera.

108. E. Montastier (France, n.d.). *Pierre Loti Dressed as Osiris for a Fancy Dress Ball.* c. 1880. Albumen print, 139 x 99. Collection Texbraun, Paris

Loti was a novelist with a passion for the exotic and oriental, popular themes of the time in art, decoration, and literature. Here, he has had made for himself a beautifully solemn record of his fantasy life.

109. John K. Hillers (United States, 1843–1925; b. Germany). *Albino Zuni Indians.* c. 1879. Albumen print, 254 x 337. Collection Peter Coffeen, New York

This extraordinary picture with its curiously theatrical proscenium

framing is remarkably ahead of its time. Poised between brutality and compassion, it seems rather more inclined to the former. It is one of the many examples in photography of equivocal attitudes to human suffering.

110. Léon Vidal (France, c. 1833–1906). *Study of Ringworm of the Scalp.* Published 1878. Photochrome (Vidal process), 109 x 72. Collection Texbraun, Paris

Vidal, whose process was one of the most refined ever devised, is better known for his pictures of French national treasures. He apparently could not bear to leave out embellishment even from a study of a scalp disease. An extremely bizarre but compelling image.

111. *Attrib.* H. F. Nielson (United States, n.d.). *Niagara Falls Frozen.* 1880s. Albumen print, 410 x 478. Courtesy Boston Museum of Fine Arts

A truly spectacular picture in which the bare foreground plays an important part.

112. Etienne Carjat (France, 1828–1906). *Léon Gambetta on His Deathbed.* 1882. Carbon print, 203 x 254. Collection Stephen White, Los Angeles

Deathbed photographs of famous people were occasionally taken early in photography's history. This view of the mortal remains of the notable French politician and fighter for the Third Republic demonstrates again the beauty of the carbon print. It is probably even a better photograph than Nadar's renowned image of Victor Hugo.

113. Anon. (probably United States). *Statuary in a Museum.* 1880s. Albumen print, 203 x 267. Collection Stephen Rose, Boston

This anonymous picture from an obscure album was taken in an unknown museum. It shows light and chance arrangement combining to make a compelling fantasy of living statuary.

114. Jules Robuchon (France, active 1870–90). *Saint-Jouin-des-Marnes, Poitou, Ruins of the Cloisters.* c. 1885. Woodburytype, 214 x 158. Courtesy National Gallery of Canada, Ottawa

A rare French example of the woodburytype which wonderfully fixes the detail of an exceptional barn.

115. Paul Nadar (Paul Tournachon; France, 1856–1939). *Michel Chevreul on His 100th Birthday, at an Interview with Nadar.* 1886. Albumen print, 565 x 410. Collection Sam Wagstaff, New York

This picture is famous because it was one of several taken at the first photo interview ever held. The occasion was the 100th birthday of Michel Chevreul, the chemist who, through his work on dyes, had developed the theory of complementary colors. The interviewer was Nadar and the photographer was his son Paul, who used the new Eastman Kodak roll film. Nadar appears in conversation with Chevreul in all the other pictures. But this static portrait is as good as any and its hallucinatory quality, combined with the damage caused by a kind of fungus that can attack photographs, make it a stunning image of defiant old age. Chevreul confessed in the interview that he had begun to appreciate photography only at the age of 97.

116. Giorgio Sommer (Italy, n.d.; b. Germany). *Shoeshine and Pickpocket.* 1870s. Albumen print, 235 x 194. Courtesy Boston Museum of Fine Arts

117. Giorgio Sommer (Italy, n.d.; b. Germany). *Ancient Roman Horn.* 1870s. Albumen print, 199 x 253. Collection Howard Ricketts, London

118. Giorgio Sommer (Italy, n.d.; b. Germany). *Pulling in a Boat, Naples.* c. 1875. Albumen print, 190 x 248. Collection Stephen White, Los Angeles

Sommer developed a large photographic business in Naples, and the work of his studio is now being reexamined with interest. These three prints demonstrate that he possessed more talent than would seem to have been strictly necessary for the earning of his daily bread. The shot of the museum object has a self-sufficiency and a boldly photographic sense of calligraphy. The studio set-up of a pickpocket at work—among many genre pictures Sommer made for the tourist trade—is much too good for us to feel the patronizing amusement we are generally entitled to with this kind of photograph. And the waterfront view is imbued with a rare vitality.

119. Peter Henry Emerson (England, 1856–1936; b. Cuba). *Rope Spinning.* 1887. Photoetching, 110 x 126. Courtesy National Gallery of Canada, Ottawa

A beautiful example of the work of this remarkable artist whose pictures are a cool contrast to his hot-headed involvement in controversy about photographic aesthetics. As the son of an American owner of a Cuban plantation, he was free of any need to earn his own living. After settling in his mother's native England, he became a fiery and influential advocate of photography as an art in its own right. Though he later became convinced of its innate weaknesses compared with drawing and painting, he went on producing great photographs, including the beautifully elegiac book *Marsh Leaves.*

120. Anon. (probably Scotland). *Construction of the Forth Bridge.* c. 1884. Silver bromide print, 483 x 400. Collection Phyllis Lambert, on loan to the Canadian Centre for Architecture

From a splendid set of anonymous photographs depicting the construction of one of the world's greatest steelwork structures, the Firth of Forth Bridge. An artist-photographer of the time would almost certainly not have attempted anything as boldly symmetrical as this.

121. A. Fong (China, n.d.). *Street Scene, Canton.* 1885–90. Albumen print, 273 x 216. Courtesy Boston Museum of Fine Arts. Sophie M. Friedman Fund

This Chinese photograph makes an interesting comparison with a similar scene by John Thomson in *China and Its Peoples.* It seems somehow especially credible that a Chinese took it, and the contrast between the few faces in sharp focus and those blurred by movement is subtly effective.

122. George Barker (United States, n.d.). *Niagara Falls.* 1888. Albumen print, 492 x 413. Collection Sam Wagstaff, New York

Our last look at Niagara: Barker made many excellent photographs of the falls, of which this is the most dramatic.

123. Baron R. von Stillfried (Austria, n.d.). *Studio Study.* c. 1890. Albumen print, 280 x 215. Pennwick Collection, New York

This example of studio kitsch has a subtle, touching charm. Von Stillfried, who was influenced strongly by Felice Beato and bought his Yokohama studio in 1877, trained many native Japanese in photography.

124. Jacob Riis (United States, 1849–1914; b. Denmark). *Blind Man.* 1888. Silver bromide print, 254 x 343. Museum of Modern Art, New York. Gift of the Museum of the City of New York

Riis was a journalist and social reformer who became passionately involved in alleviating the misery of tenement living in New York. He also took photographs to reinforce his work, and with him a new kind of picture emerges earlier than one might have thought— one with no aesthetic pretensions, but no lack of force. This one powerfully conveys the isolation of a blind man in the kind of late nineteenth-century urban street we are all too familiar with.

242

125. N. D. (Neurdien; France, n.d.). *Detail of the Eiffel Tower.* 1889. Albumen print, 220 x 270. Collection André Jammes, Paris

Photographs of steelwork are generally characterized by a gravity that seems appropriate to the serious subject of structural engineering. This one, though, transforms it into something like confectionery and has a Parisian panache.

126. Babayeva Studio (Russia). *Portrait of the Artist Ivan Constantinovich Aivasovski.* 1893. Albumen print, oil-painted, 285 x 209. Gilman Paper Company Collection, New York

In the nineteenth century some people amused themselves by combining photographs with drawings and watercolors in private albums. This more seriously conceived combination of an eminent Russian landscape painter with an oil sketch by him achieves a curious validity that is both impressive and outrageous.

127. Atelier Held (Switzerland). *Builders.* c. 1890. Albumen print, 257 x 201. Collection Bruno Bischofberger, Zurich

Another sympathetic study of daily work. Photography has the capacity to celebrate such mundane subjects and confirm their essential dignity and humanity.

128. Anon. (probably United States). *Nude Model.* n.d. Albumen print, 258 x 178. Collection Rodger Kingston. Boston

Its origins entirely unknown, this seems like a study of an art school model. In an altogether out of the ordinary way, however, the pose has a beautifully uncontrived grace and the girl gives us a sense of real personality.

129. Anon. (United States). *Flowers.* 1890s. Gelatin print, 114 x 152. Collection Stephen Rose, Boston

Here is an example of the high quality of so many anonymous photographs. What is so tantalizing about such images is that it will never be known if the photographer was consistently talented or if this was his or her only success—and perhaps an unconscious one at that.

130. Auguste and Louis Lumière (France, 1862–1954 and 1864–1948). *Untitled.* c. 1895. Stereo gum trichromate on glass. Collection Sam Wagstaff, New York

The Lumières were two brilliant brothers who, among other things, invented both the first successful motion picture projector and the autochrome process. This photograph was probably made as a test for the bichromated process, but is still a compelling image. It demonstrates again the strange origins of many strong pictures.

131. Carleton E. Watkins (United States, 1829–1916). *Cling Peaches, Kern County, California.* c. 1889. Albumen print 406 x 571. Courtesy Huntington Library, San Marino, California

While documenting an agricultural show, the photographer seemingly became fascinated by the beauty of this box of peaches and produced a sensual abstraction which we can probably enjoy much more than those who first owned the album.

132. Anon. (France). *Egyptian Dancer and Musicians.* c. 1890. Photochrome. Sotheby's, Belgravia, Ltd., London

This very attractive picture comes from a cheap tourist album printed in a photomechanical color process that has given it a clear boldness rarely found in hand tinting. The image is entirely convincing, even though we know it is not true color photography.

133. Skylar (United States, n.d.). *Guard at Polson Prison, Montana, with Gatling Gun.* c. 1892. Silver bromide print, 190.5 x 229. Collection Stephen White, Los Angeles

This strangely neutral document is apparently about the acquisition of a new Gatling gun at a prison in the American West. It is pregnant with all sorts of possibilities about man and gun but it tells us virtually nothing. Good photographs, like many compelling images, are often about unresolved enigmas.

134. Lloyd of Natal (probably Wales). *Zulu Girl.* 1885–90. Albumen print, 161 x 234. Collection Howard Ricketts, London

Exotic places were once the only respectable source of erotic pictures, presented as they were in the guise of serious ethnographic interest. This one records an impressively self-possessed girl.

135. Lala Deen Dayal (India, 1844–1910). *Hyderabad Famine.* 1890s. Gelatin print, 178 x 299. Pennwick Collection, New York

A terrible picture of victims of a famine: the photographer documented it for his employer, the Nizam of Hyderabad, who was distributing aid to the starving. The picture shows that while photography cannot convey the full horror of such suffering, it can leave us with unforgettable images that no other medium (except perhaps the greatest writing) could convey as powerfully or permanently.

136. Harry Ellis (United States, b. 1857, active in Paris 1900–1925). *London Pub Interior.* 1898. Silver bromide print, 114.5 x 171.5. Collection Stephen White, Los Angeles

A unique document of London life by an obscure but remarkable pioneer of flash who called himself "The American Flashlight Photographer." Eliza Doolittle's father and her earlier self can be imagined in this bar.

137. Count Giuseppe Primoli (Italy, 1852–1927). *Balancing Act.* c. 1895. Modern silver bromide print from the original negative. Courtesy Fondazione Primoli, Rome

Primoli was an Italian aristocrat who traveled widely and lived for some years in Paris. He is estimated to have taken about 25,000 photographs in his time, many of them brilliant snapshots, including a famous one of Degas coming out of a pissoir. This one records a useless but admirable performer's skill with originality and economy.

138. Edouard Vuillard (France, 1868–1940). *Misia and Thadée Natanson at Home.* c. 1900. Albumen print, c. 63 x 67. Collection Antoine Salomon, Paris

139. Edouard Vuillard (France, 1868–1940). *A Departure.* c. 1901. Albumen print, c. 63 x 67. Collection Antoine Salomon, Paris

These modest snapshots by a major painter marvelously demonstrate how an artist can sustain his personal vision in a medium over which he has so much less total control than his own. They thereby confirm the intensely personal character of the photograph in general.

140. *Attrib.* Edgar Degas (France, 1834–1917). *Back of a Nude.* c. 1890–95. Silver bromide print, 170 x 122. Collection Sam Wagstaff, New York

It is known that Degas took and worked from photographs. One cannot doubt for a moment the attribution to him of this picture, one of the greatest studies of the nude in all photography.

141. Anon. (Great Britain). *The Battleship* Hatsuse *on the Tyne at Newcastle.* 1900. Modern silver bromide print from the original negative. Vickers Ltd., London

This picture is a portrait of the city of Newcastle and British heavy industry at the turn of the century, as much as it is of the battleship built there, as so many were, for Japan. The *Hatsuse* was sunk soon afterwards by a Russian mine at Port Arthur.

142. Anon. (France). *"Study for Artists."* c. 1900. Gelatin silver print, 168 x 123. Collection Howard Ricketts, London

· This wonderful image qualifies as perhaps another document of human endurance. The model may have been a prostitute, but was more likely a working girl earning a few extra francs. As it turned out, she has helped create a picture very much superior to nearly all of the dubious genre called "Studies for Artists," which were, of course, intended for a wider public. Once seen in its authentic color, the picture is unthinkable in any other.

143. Anon. (United States). *Tennis Match at Smith College, Northampton, Mass.* 1901. Cyanotype, 98.5 x 235. Collection Sam Wagstaff, New York

A picture from an album of excellent photographs very probably taken by a girl undergraduate. The cyanotype blue, always beautiful, can sometimes seem completely apt, as it does here.

144. Auguste and Louis Lumière (France, 1862–1954 and 1864–1948). *Still Life.* 1899 or 1900. Stereo gum trichromate on glass. Collection Roger Thérond, Paris

A sumptuous demonstration from the Lumière Brothers just before they perfected the autochrome process.

145. H. H. Bennett (United States, 1843–1908). *Phyllis.* 1900. Silver bromide print, 98 x 140. Collection Peter Coffeen, New York

A first-rate American landscape photographer makes a winsome little study of a child—perhaps his granddaughter. Unexpectedly, the image does not pall.

146. Hans Watzek (Austria, 1848–1903). *Portrait.* 1898. Gum bichromate print, 343 x 203. Collection Noel Levine, New York

This very strong portrait demonstrates one of the dangers of the camera: speculation about the character of the subject could lead us into thinking him a very dubious individual. But we will never know whether photography has done him a great or partial injustice, or none at all.

147. William van der Weyde (United States, n.d.). *Man in the Electric Chair.* c. 1900. Modern silver bromide print, 160 x 208. International Museum of Photography, George Eastman House, Rochester, New York

An extraordinary document about which nothing is known: a macabre study of resignation combined with a grotesque kind of professional politeness.

148. Frank Meadow Sutcliffe (England, 1853–1941). *The Fisherman's Daughter.* 1900. Silver bromide print, 457 x 317. Collection Sam Wagstaff, New York

Sutcliffe is best known for his pictures of the fishing people of the village of Whitby in Yorkshire. Here, he poses his subject for a salon picture rather than in a natural setting. It echoes sentimental paintings of womenfolk waiting for the return of their men from the sea but holds our attention by being a strong study of a beautiful "girl of the people."

149. Lala Deen Dayal (India, 1844–1910). *Gypsy Girl with Lion.* 1901. Gelatin silver print, 197 x 146. Pennwick Collection, New York

Dayal here takes a strikingly modern reportage photograph of Indian life. This and his famine photograph (plate 135) show his versatility. Most of his pictures were princely portraits of great splendor.

150. Baron Wilhelm von Gloeden (Germany, 1856–1931). *Youth as Faun.* n.d. Gelatin silver print. Collection Robert Mapplethorpe, New York

Von Gloeden apparently put Taormina on the tourist map with his studies of lightly clad youths posing in a Classic manner. It was a way of legitimately catering to pederastic tastes, and the form had several exponents. But Von Gloeden was a good photographer and proves it here as well as in any of his pictures: a compelling image of corruption easily borne.

151. Gertrude Käsebier (United States 1852–1934). *Man on Roof.* c. 1905. Gum bichromate print, 196 x 159. Courtesy National Gallery of Canada, Ottawa

Käsebier was the most accomplished and admired woman member of the Photo-Secession movement, and best known for allegorical pictures of great sensitivity concerned with the state of girlhood. This unfamiliar picture of hers is a gum bichromate print, a process she rarely used.

152. Alvin Langdon Coburn (United States–Great Britain, 1882–1966). *Gertrude Käsebier.* c. 1903. Gum platinum print, 241 x 191. Rubel Collection, courtesy Thackrey & Robertson, San Francisco

Coburn took this picture during the year he worked in Käsebier's studio. He was one of the most original and lively members of the Photo-Secession and took the first abstract photographs, or "Vortographs," under the influence of the poet Ezra Pound and the group of artists, headed by Percy Wyndham Lewis, who called themselves "Vorticists." Only twenty-one at the time, Coburn seems in this portrait a littled subdued by the formidable personality of his lady mentor, who was then in her fifties.

153. Frederick H. Evans (England, 1853–1943). *A Norfolk Piscina, Little Snoring Church.* c. 1905. Platinum print, 229 x 127. Museum of Modern Art, New York

154. Frederick H. Evans (England, 1853–1943). *Deerleigh Woods.* c. 1905. Platinum print, 291 x 221. Courtesy National Gallery of Canada, Ottawa

Frederick Evans retired from bookselling and took up photography in the mid-1880s. Though he lived for a very long time, he abandoned his art when platinum paper ceased to be manufactured soon after the end of the First World War. Evans was an influential member of the English aesthetic photography group called "The Linked Ring" and was the subject of a remarkable panegyric by Bernard Shaw—a great devotee of photography—in Stieglitz's magazine, *Camera Work.* Evans produced some of the most refined prints in the whole of photography and has remained the greatest master of the beautiful middle tonal range of the platinum process.

155. Karl Moon (United States, 1873–1948). *A Navajo Youth.* 1907. Toned silver bromide print, 424 x 308. Collection Sam Wagstaff, New York

One of photography's happier tasks is recording fine specimens of the human race, but only a real photographer can do it well. Moon here has printed his picture on watercolor paper to make it look more artistic, but it was hardly necessary.

156. Edward Steichen (United States, 1879–1973; b. Luxembourg). *Rodin with Sculpture of Eve.* 1907. Autochrome, 159 x 98. Metropolitan Museum of Art, New York. The Stieglitz Collection

This majestic autochrome is one of many portraits of Rodin by Steichen. The others are mostly made in processes subject to manipulation, such as the gum print. This direct process has nevertheless produced an image no less dramatic. (Steichen evidently draped the great sculptor in a sheet that was being used to cover his sculpture *Eve.*)

157. Eugène Atget (France, 1857–1927). *Ragpicker's Dwelling, Porte*

d'Ivry. c. 1910–14. Printing out paper, 165 x 222. Gilman Paper Company Collection, New York

Atget is the essence of the solitary observer. He was both the passionate recorder of the real and also the seeker of the ghosts of things. He seems to tell us that, however deliberately human beings plan (or plant) their world, the accumulation of their different projects, placed in nature and time, can give us unaccountable feelings of self-generated personality. To record this mysterious code, he found exactly the right places to put his camera. This, though, is one of his records of human life and labor, just a little more beautiful than anyone else's would have been.

158. Eugène Atget (France, 1857–1927). *A Windmill, Somme.* Before 1898. Printing out paper, 177 x 215. Collection André Jammes, Paris

Perhaps because he was a completely unpainterly photographer, Atget's work became venerated by many painters. It was for a different kind of artist, however, that he made such documents as this, eking out his extremely frugal living.

159. Eugène Atget (France, 1857–1927). *Faun Sculpture, Versailles.* n.d. Printing out paper, 213 x 175. Courtesy Boston Museum of Fine Arts

A rare and haunting example of Atget's many studies of sculpture in formal gardens, at Versailles and elsewhere.

160. Robert Demachy (France, 1859–1936). *The Crowd.* 1910. Oil pigment print, 158 x 228. Metropolitan Museum of Art, New York. The Stieglitz Collection

Demachy was a founder-member of the Photo Club de Paris, the French equivalent of the Photo-Secession and The Linked Ring. He wrote a great deal on photography and believed very positively in manipulation of the photographic printing processes, though he generally produced rather shallow pictures concerned with erotic prettiness. This masterpiece comes as an impressive surprise.

161. Anon. (France). *Police at the Scene of a Crime.* c. 1910. Silver bromide print. Collection Sam Wagstaff, New York

Looking too good to be a scene from a film, this picture comes from the files of the newspaper *Le Matin.* It has wonderfully caught a very French feeling of bureaucratic self-importance.

162. Arnold Genthe (United States, 1869–1942; b. Germany). *Portrait.* c. 1910. Autochrome, 178 x 127. The Library of Congress, Washington, D.C.

Genthe is most famous for his pictures of the great San Francisco earthquake, that city's Chinatown, and a portrait of Greta Garbo. Here we have a masterly example of the autochrome which has languished unappreciated in the Library of Congress for a long time. Genthe's feeling for women has produced a portrait of one who is at once elegant and strong, though of a somehow problematic character.

163. Baron Adolf de Meyer (England–United States, 1868–1949; b. France). *Dance Study.* c. 1912. Gelatin silver print, 327 x 435. Metropolitan Museum of Art, New York. The Stieglitz Collection

A stunning photograph of an unknown dancer by one of the greatest *haute monde* and fashion photographers of the century. Taken at the time De Meyer was photographing Nijinsky in *L'Après-midi d'un Faune,* it is a beautifully unexpected image of the Diaghilev ballet.

164. Anon. (United States). Plate 31 from *Practical Poses for the Practical Artist.* 1912. Silver bromide print, 327 x 245. Collection Sam Wagstaff, New York

This composite photograph shows that elegance is not the monopoly of smart photographers. The others in the manual it comes from are hardly less good.

165. Anon. (Russia). *The Burial of Leo Tolstoy.* 1910. Silver bromide print, 209 x 277. Collection David King, London

We would think this a good photograph even before knowing that it is Tolstoy who is being buried, but it becomes that much more interesting when we do.

166. Anon. (Great Britain). *New Leyland Tipper at Wavertree, Liverpool.* 1914. Modern silver bromide print from the original negative. Courtesy Liverpool City Engineers, Reprographic Section

The unknown Liverpool photographer had been asked to take a picture of a proud new city possession—a garbage truck made by Leyland Motors. He has done it very well and unknowingly made a social document of curious power.

167. Heinrich Kühn (Austria, 1866–1944; b. Germany). *Still Life.* After 1911. Gum bichromate print, 362 x 475. Courtesy Boston Museum of Fine Arts

Kühn was a leading member of the Secessionist movement in Austria and is best known for his sensitive pictures of his children, though he photographed many other subjects. He later ceased to believe in the manipulation of prints, but his best work was certainly done when he did. This still life well expresses his gentle domestic preoccupation.

168. Richard N. Speaight (England, 1875–1938). *Victoria Sackville-West in Costume for the Shakespeare Ball.* 1911. Silver bromide print. Collection Robert Mapplethorpe, New York

A studio portrait of a remarkable figure in English Bohemian high society and literature. Later the lesbian lover of Virginia Woolf, Sackville-West has devised for herself an extraordinarily original costume that could seem to us to prefigure both fascist and punk style. Her fancy dress here purportedly represents Katherine in *The Taming of the Shrew.*

169. Mespoulet and Mignon (France). *Boy with Donkey Carrying Peat, Connemara, Ireland.* 1913. Autochrome, 90 x 120. Albert Kahn Collection, Hauts-de-Seine, France

A good autochrome made for a French banker who commissioned several photographers to make a world survey of color images, which eventually comprised 72,000 transparencies.

170. Lewis Hine (United States, 1874–1940). *Young Waitress.* c. 1915. Silver bromide print, 101 x 140. Collection Sam Wagstaff, New York

Hine gave up schoolteaching and used his camera to draw attention to the prevalent American social ills—poverty and child labor. His photographs were enormously influential in the reform movement. Later he took pictures that were more consciously aesthetic, but no less impressive. In this rare image the light has made the girl seem touchingly vulnerable, an effect emphasized by the sharpness of the objects that surround her.

171. Alfred Stieglitz (United States, 1864–1946). *Georgia O'Keeffe with Paints.* c. 1916–17. Silver chloride print, 102 x 127. Gilman Paper Company Collection, New York

Stieglitz made many masterly photographs of Georgia O'Keeffe. This one is more documentary than most of them, which are generally pure studies of her face and body, but it is no less beautiful for that.

172. Alfred Stieglitz (United States, 1864–1946). *Ellen Morton at Lake George.* 1915. Silver chloride print, 116 x 86. Courtesy National Gallery of Canada, Ottawa

A snapshot from a series which has a risqué feeling one does not associate with Stieglitz, though eroticism is a consistent feature of his work. It is a remarkable study of voluptuous form.

173. Arnold Genthe (United States, 1869–1942; b. Germany). *Doris Humphrey Dancing Naked*. c. 1916. Silver bromide print, 337 x 260. Collection Stephen White, Los Angeles

A soft and subtle study of a naked dancer with a real sense of physical freedom. Good dance pictures are surprisingly rare.

174. Lewis Hine (United States, 1874–1940). *Serbian Refugees Returning Home*. 1918. Silver bromide print, 79 x 125. International Museum of Photography, George Eastman House, Rochester, New York

Hine here has applied his more aesthetic style to a documentary subject, and the result is a moving and "painterly" photograph of the aftermath of the First World War.

175. André Kertész (Hungary–France–United States, b. 1894). *Cellist*. 1916. Silver bromide print. Courtesy the artist

Kertész is one of the very greatest photographers of the century, though it is not always realized that he has opened more photographic vistas than anyone else. He conveys a unique sense of complete personal identity with his medium. This early picture is one of the best of all photographs of music making, with the rapt, listening attitude of the performer and the shadows on the wall, which seem in sympathy.

176. Anon. (Germany). *Karl Liebknecht Speaking at the Grave of Fallen Spartacists, Berlin*. 1919. Silver bromide print. Courtesy Ullstein Bilderdienst, Berlin

A tragic picture strangely enhanced by the degeneration of the print and the picture editor's cropping marks. It is a reminder of the aftermath of the First World War, which was to lead to so much more death, including the murder of Liebknecht himself. He was the leader of the Spartacists, an early Social Democratic–Marxist party, and was later assassinated with Rosa Luxembourg, his brilliant and brave colleague.

177. Dr. J. B. Pardoe (England, n.d.). *Waiting for the Train*. 1923. Chlorobromide print. Courtesy the Royal Photographic Society, Bath

A photograph by an unknown amateur member of the Royal Photographic Society with an impressive feeling of truth unusual in pictures taken with exhibitions in mind.

178. August Sander (Germany, 1876–1964). *Tailors' Workshop, Germany*. c. 1924. Silver bromide print, 232 x 286. Collection Sam Wagstaff, New York

A not wholly characteristic masterpiece by a major photographer, whose work documenting the look, work, and way of dress of Germany's citizens stands as a monument of the form. Here, the artisans' relaxed attitudes and the play of sunlight in the room create a magic moment of reconciliation with daily routine.

179. Man Ray (United States–France, 1890–1976). *Louis Aragon and André Breton*. c. 1924. Silver bromide print. Collection Kasmin, London

A vivid and excellent double portrait of two French poets by a major fellow figure in the Dada and Surrealist art movements. A painter and filmmaker, Man Ray made many kinds of photographs, including photogenic drawings, which he called "Rayograms" and Solarizations. His best portraits, like this one, are unsurpassed for rigorous objective clarity.

180. Nathan Lazarnick (United States, n.d.). *Three Bareback Riders*. n.d. Printing out paper, 161 x 209. International Museum of Photography, George Eastman House, Rochester, New York

From an album by a forgotten photographer. The other pictures in

it suggest that his main interest was in automobiles. This image of unexpected stillness is exceptional and exceptionally good.

181. Edward Steichen (United States, 1879–1973; b. Luxembourg). *Skyscrapers at Night*. 1925. Silver bromide print, 419 x 342. Collection Joseph E. Seagram & Sons Inc., New York

A grand and spacious image of the skyscraper which somehow outclasses all others.

182. Edward Steichen (United States, 1879–1973; b. Luxembourg). *Princess Youssoupoff*. 1924. Silver bromide print, 254 x 203. Gilman Paper Company Collection, New York. Copyright © 1924 (renewed 1952) by The Condé Nast Publications Inc.

One can easily believe that this lady was a niece of the czar. Another example of Steichen's mastery of photography, it is of a particularly subtle color.

183. Anon. (pub. J. Mandel, Paris). *Postcard*. 1920s. Silver bromide print, toned and hand-colored. Collection Sam Wagstaff, New York

Photographic postcards are often banal, facetious, or boring, but they needn't be. This one defies all categories and has great style. The touched-up eyelashes and mouth do not harm the image.

184. Martin Munkacsi (Hungary, 1896–1963). *Goalkeeper*. 1926. Modern silver bromide print from the original negative. Courtesy Ullstein Bilderdienst, Berlin.

Munkacsi, who brought movement into fashion photography and became the highest paid photographer in the world, was also a great photojournalist. This is an exciting action shot for its time.

185. Mach (United States, n.d.). *Mr. and Mrs. John Locicero*. 1926. Silver bromide print, 356 x 304. Courtesy Mr. John Locicero, Rochester, New York.

A wedding photographer in Rochester, New York, has produced a moving image of the "sanctity" of middle-class Christian marriage. There may be a number of minor masterpieces of photography on the mantlepieces and upright pianos of the world.

186. Jacques-Henri Lartigue (France, b. 1896). *Bibi Lartigue and Denise Grey on Deck*. c. 1926. Silver bromide print. Collection the artist

Lartigue undoubtedly made the greatest family snapshots ever taken. What is less known is that, though he became a painter, he continued to take pictures of great vitality for over seventy years. This one offers further evidence of his incurable enjoyment of life.

187. Paul Strand (United States, 1890–1976). *Driftwood, Dark Roots, Maine*. 1928. Gold-toned platinum print, 192 x 244. Courtesy Boston Museum of Fine Arts. Sophie M. Friedman Fund. © 1980 Paul Strand Foundation

Strand, a protégé of Stieglitz, came to believe in photography without tricks, asserting that "handwork and manipulation are merely the expression of an impotent desire to paint." Though generally concerned with human beings, he made many photographs of botanical and geological phenomena. Pictures of this kind can seem self-consciously artistic, but here Strand has invested such a photograph with drama and a sense of menace. The exceptional gold-toning of this rare platinum print has helped considerably.

188. Doris Ulmann (United States, 1884–1934). *Old Woman with a Pipe*. 1920s. Platinum print, 203 x 152.5. The Library of Congress, Washington, D.C.

Doris Ulmann was a very rich woman who nevertheless took some of the truest and most sensitive pictures of poor whites and blacks of

her time. Dressed immaculately, she traveled extensively through Appalachia and the American South and had a servant to carry her camera, which was large since she despised small ones and the snapshot. She is undoubtedly one of the great woman photographers.

189. Albert Renger-Patzsch (Germany, 1897–1966). *Praying Hands.* c. 1927. Silver bromide print, 229 x 171. Courtesy Boston Museum of Fine Arts

This little-reproduced plate from Renger-Patzsch's book *Die Welt ist schön (The World is Beautiful)* combines pious symbolism (and an echo of Dürer) with the photographic equivalent of excellent drawing.

190. Werner Mantz (Germany, b. 1901). *Study in a Private Villa.* 1928–29. Silver bromide print, 173 x 226. Collection Phyllis Lambert, on loan to the Canadian Centre for Architecture

From 1926 to 1938, Werner Mantz took photographs mostly of interiors and exteriors of all kinds of buildings, and then, inexplicably, gave up architectural photography. Nearly all his pictures from this period, however, have a quality of being just that much better than one feels entitled to expect.

191. Martin Munkacsi (Hungary, 1896–1963). *Nude on Bed.* 1929. Modern silver bromide print from the original negative. Courtesy Joan Munkacsi, New York

Photographs can have a strong national or ethnic character. This melancholy but sensual nude could be said to betray Munkacsi's Balkan origins.

192. Walker Evans (United States, 1903–1975). *Man Sleeping on Brooklyn Bridge.* c. 1929. Silver bromide print, 100 x 55.5. Collection Timothy Baum, New York

Walker Evans was one of the most influential and admired photographers of the century. His rigorous interest in looking for its own sake was powerfully combined with his sensitive reaction to people and things. This early and unique print could at first give the feeling of a subject drawn by a young person at the suggestion of an art teacher. Further reflection might convince one that it could have come only from one of the great photographic eyes of the century.

193. Anon. (France). *"The Fattest Women in the World."* c. 1930. Silver bromide print. Collection Gaston Berlemont, London

The virtue of this photograph, an ordinary publicity shot taken for two carnival sideshow ladies, is perhaps that it is not "better" than it is. If it were technically more accomplished and artistically more ambitious, it would probably have become tiresomely hackneyed. As it stands, it is a very good record of its subjects which makes no claims for itself but has the strength to last.

194. Umbo (Otto Umbehr; Germany, b. 1902). *Artists' Rehearsal Room.* 1930. Silver bromide print. Rudolf Kicken Gallery, Cologne

Umbo, a very talented German, took all kinds of pictures but was strongly attracted to theatrical subjects and dress shop dummies. This bit of reportage is not wholly typical but is an entirely enjoyable picture of an enjoyed moment.

195. Henri Cartier-Bresson (France, b. 1908). *Face with Stocking Mask.* c. 1931. Silver bromide print. Courtesy Art Institute of Chicago

Cartier-Bresson is probably the most influential photographer of the last fifty years. He was a founder-member of the photographers' cooperative agency Magnum, whose ethos of morally committed photo reportage has—for good and perhaps a little ill—had as much impact on our photographic image of the world as anything else. He shows in this surprising picture, which he took as a joke, that he

could perhaps have gone successfully in a quite different direction.

196. Martin Chambi (Peru, 1891–1973). *The Gadea Wedding, Cuzco.* 1930. Modern silver bromide print from the original negative. Courtesy Edward Ranney and the Chambi family

Chambi, a Peruvian of great talent, was only recently discovered. The local photographer of Cuzco, he recorded the whole life of the place: groups, portraits, farming, the stones of Machu Picchu, and weddings. This must be one of the most singular and sensitive wedding photographs ever taken.

197. Anon. (Great Britain). *The All-British Globe of Death.* 1930s. Silver bromide print. Collection untraced

Another anonymous document of circus or fairground life shows how the camera can capture the finer (and odder) details of a period in a way nothing else can.

198. Dorothea Lange (United States, 1895–1965). *May Day, 1934.* Silver bromide print, 292 x 219. Courtesy Oakland Museum, California

Dorothea Lange, known mainly for her famous pictures of the families of migrant farmers during the Depression, took many others. This is a moving document of the American left of the thirties.

199. Anon. (Germany). *The Wehrmacht at the Feldherrnhalle, Munich.* 1935. Silver bromide print. Suddeutscherverlag, Munich

This is a photograph of a fateful moment in history when the German army made its oath of allegiance to Hitler. It is one of the most powerful of all images of the Third Reich which has nevertheless been lying little used in a Munich press agency—perhaps because the swastikas on the banners are barely visible, thus disqualifying it as a "Nazi" picture.

200. Margaret Bourke-White (United States, 1904–1971). *Russian Tractor Factory.* Late 1930s. Silver bromide print. Collection Paul Walter, New York

Bourke-White became the most famous woman photo-reporter in the world. She took the first cover photo for *Life* magazine. She went to Moscow for *Fortune* magazine to photograph Stalin and so pleased the dictator that he encouraged her to take more pictures of Russia. Among them was this one of burgeoning Russian industry which no doubt increased the confidence of Americans and others who wanted to believe in the Five Year Plans.

201. Ben Shahn (United States, 1898–1969; b. Lithuania). *The Mulhall Children, Ozark Mountain Family.* 1935. Modern silver bromide print from the original negative. Courtesy Fogg Art Museum, Harvard University, Cambridge, Massachusetts

Under the guidance of a brilliant photo editor, Roy Stryker, a division of the Farm Security Administration (set up under Roosevelt's New Deal) was established to photographically document agricultural poverty in America. Ben Shahn was a left-wing painter who took good photographs for the agency. The cropping of the boy's head in this one is not at all insensitive: it focuses attention on the girl, her doll, and their pets.

202. George Hoyningen-Huene (United States, 1900–1968; b. Russia). *Gary Cooper.* 1935. Silver bromide print, 252 x 204. Collection Robert Fraser, London

Hoyningen-Huene was perhaps the very best of the *Vogue* photographers of the thirties. The great stylish economy of this photograph does nothing to mar the good nature of Cooper's good looks.

203. Ansel Adams (United States, b. 1902). *Snowplow.* c. 1935. Silver

bromide print, 177 x 239. Courtesy Boston Museum of Fine Arts, Sophie M. Friedman Fund, and the artist

A surprising flurry of movement from the latter-day master of the Great American Landscape, who otherwise only recorded it in the waterfalls of Yosemite Valley. The simple bold design with none of the obsessive sharpness of the f.64 school makes one wish that he had tried this sort of thing more often.

204. László Moholy-Nagy (Hungary–United States, 1895–1946). *Photogram*. n.d. Silver bromide print, 500 x 400. Courtesy Art Institute of Chicago

Moholy-Nagy was one of the most brilliant men of ideas in design and photography of the twentieth century. He became passionately concerned with making photography a self-generated medium, but was also a master of the straight and reportage photograph. This "Photogram," made by laying objects on sensitized paper and playing light on them, shows both the interest and emptiness of photographic abstraction. With its strong suggestion of space and the fragment of a human head, though, this image seems more truly photographic than many others of its kind.

205. Hurrell (United States, n.d.). *Joan Crawford and Franchot Tone*. c. 1936. Silver bromide print. Collection Kasmin, London. Courtesy the artist

Hurrell was the master of the Hollywood film star portrait. This extreme example makes these two look as if they had been made up by a mortician, Joan Crawford's ear seeming the only sign of life—it could be called the apogee of a style.

206. Aaron Siskind (United States, b. 1903). *Savoy Dancers, Harlem, 1936*. From *The Harlem Document*. Silver bromide print, 331 x 270. Museum of Modern Art, New York

Siskind, who has since the Second World War taken pictures mostly of an abstract character, was once a brilliant documentary photographer, as *The Harlem Document* and *Tabernacle City* show.

207. Paul Strand (United States, 1890–1976). *Trois Rivières, Quebec*. 1936. Gold-toned platinum print, 150 x 119. Courtesy National Gallery of Canada, Ottawa. © 1980 Paul Strand Foundation

Another somber but beautiful Strand, and a rare revival of the platinum process (before the recent renewal of interest in the technique). Some may prefer his humane but rather rigid pictures of ordinary people.

208. Hans Bellmer (France, 1902–1975; b. Poland). *Doll*. Late 1930s. Silver bromide print, 185 x 179. Collection Timothy Baum, New York

Bellmer was perhaps the most sexually obsessed artist-draftsman of this century. This image is from his book of doll photographs, a catalogue of violation in which the prints were hand-tinted. This one escaped being colored and gains from it.

209. Dorothea Lange (United States, 1895–1965). *Lettuce Pickers, Salinas Valley*. 1938. Silver bromide print, 260 x 337. Collection Stephen White, Los Angeles

Different from most famous FSA pictures of work, which usually record the enforced idleness of unemployment, this is also a rare instance of a good photograph of workers actually at work. Painting generally treats the subject more sympathetically, since concentrated effort is difficult for the camera to catch well and, anyway, tends to dehumanize. Action often robs the worker of his or her individuality, as it does here, but this picture shows the arduous monotony of back-bending toil with a striking pattern of bodies, earth, and plants.

210. Paul Outerbridge (United States, 1896–1958). *Torso*. c. 1936. Trichrome carbro print, 394 x 285. Courtesy Robert Miller Gallery, New York, and G. Ray Hawkins, Los Angeles

Paul Outerbridge, a successful commercial photographer, sold prints like these for very large sums of money at the time he made them. Some of them are fetishist in a way we can well understand today. Most are immaculately taken. Outerbridge also made beautiful small platinum prints of still lifes.

211. Harold E. Edgerton (United States, b. 1903). *Wesley Fesler Kicks a Football*. c. 1937. Silver bromide print. Courtesy Dr. Harold E. Edgerton, Massachusetts Institute of Technology. Cambridge, Mass.

Dr. Edgerton is the father of high-speed photography. With the stroboscope's brilliant multiple flash, he has frozen the movement of bullets, cards being shuffled, and crops of milk splashing into saucers. While his work has been of considerable scientific importance, it has also produced images of beauty. This one has an odd documentary feeling about it as if a close spectator at a match had taken it by chance or cunning.

212. Frederick Sommer (Italy–United States, b. 1905). *Still Life*. 1940. Silver bromide print, 241 x 190. Collection Stephen White, Los Angeles. Courtesy the artist and the Light Gallery, New York

Sommer still makes photographs of extraordinary refinement today. He seems to have equated photography with graphic art in a uniquely close way: every part of his photographs seems to have been put by him onto the paper with great deliberation. This piece of photographic necromancy seems appropriate for 1940.

213. Bill Brandt (England, b. 1904). *Air Raid Shelter, Crypt of Christ Church, Spitalfields, London, November 1940*. Silver bromide print, 254 x 203. Gilman Paper Company Collection, New York

Brandt is understandably many people's favorite photographer. Sensitive and humane, he has been a great and good influence. This picture, though, is monumental and ungentle. Most of his wartime air raid shelter pictures carry a message of endurance with hope—the sense that "Britain can take it." This one records an old lady who is just old and tired, and it is a sad and memorable image.

NOTES ON THE PROCESSES

NOTE: *The processes are discussed here in a roughly chronological order, according to when they became publicly available. In all cases, these notes describe the original methods of the processes, many of which were later modified. Italicized cross-references appear in the text in those places where a fuller explanation of another process is necessary to understand the one being discussed.*

Photographic Processes

DAGUERREOTYPE

The daguerreotype was invented by Louis Jacques Mandé Daguerre, following many years of collaboration with Joseph Nicéphore Niépce (the inventor of the heliograph), and, on his death, with his son Isadore. The process was first reported, by François Arago, to the French Academy of Sciences in January, 1839. In August of that year, Daguerre published his manual by command of the French government, which, on the advice of Arago, had purchased the rights to the new process for the nation and awarded pensions for life to Daguerre and Isadore Niépce. The process produced a direct positive image on a silvered copper plate; since no negative existed, the resulting image was unique and, in the early years, laterally reversed.

In Daguerre's original process a silvered copper plate was very finely polished and made light-sensitive by exposure to iodine vapor in an iodizing box. It was then exposed in the camera, and the latent image, formed by the action of light, was developed by vapor of mercury heated over a spirit lamp. The mercury attached itself to those parts of the silver iodide affected by light, and thus formed a visible image; the mercury appearing very light, the silver rather dark (silver in minute particles appears black). The image was "fixed" in a strong solution of salt, to dissolve away the remaining light-sensitive silver salts. Many improvements to this basic process were found in its first couple of years, the first being the discovery by Sir John Herschel, in March, 1839, of sodium thiosulphate (now known as "hypo") as a fixing agent. This was much more effective than the salt solution and was immediately adopted.

The surface of a daguerreotype was extremely fragile, and in its original state the film of mercury forming the image could be easily wiped off. In August, 1840, Hippolyte Fizeau published a method of gold-toning the image, which not only increased the contrast of tone, but made the image physically stronger, providing some protection against surface abrasion and oxidation. Daguerreotypes still remained very fragile and had to be sealed behind glass in an airtight case to prevent the silver from tarnishing upon exposure to the atmosphere, and the image from being irreparably scratched even by the softest brush or cloth. Kept with their seal intact, however, they were permanent and would not fade. The cases were often decorative, similar to those for miniatures, and made of passe-partout or pinchbeck.

Throughout 1840 the use of the daguerreotype for portraiture was limited by the long exposures which were necessary, sometimes of several minutes even in strong sunlight. This was mitigated in America by the use of an elaborate studio set of reflecting mirrors and a camera with a concave mirror instead of a lens, which was designed by Alexander Wolcott. In England, late in 1840, John Frederick Goddard discovered that if the silvered plate was subjected to vapor of bromine after the vapor of iodine, it increased the sensitivity of the plate and considerably lessened the exposure time. Antoine Claudet independently discovered a similar result, using chlorine instead of bromine. These accelerating processes cut the exposure time to between ten seconds and two minutes in sunlight.

The daguerreotype process was announced in France virtually simultaneously with the publication of Talbot's photogenic drawing method in England. Because daguerreotypes were unique images incapable of commercial exploitation and could not be used to illustrate books or be collected in albums or mass-produced, their replacement by subsequent negative-positive processes was inevitable. However, this fact tends to obscure the enormous success and popularity of the daguerreotype from its announcement until the late 1850s. The process provided an image that was beautiful in a very precious way, in a sense valuable and jewel-like, very much like the miniature paintings they largely replaced. The sensitizing of the silver plate by means of vapor provided an image that was finer and more even than any attained, before or since, by other methods. It provided microscopic perfection of detail and a gradation of halftones arguably unequaled, within their short tonal range, by any other process. A well-made daguerreotype, taken in the studio, exhibited extraordinary detail and softness of tone in both highlight and shadow areas. The process, although basically very simple, depended for its success on proper timing at each stage. All shadow details could be rendered with an adequate exposure, but overexposure caused bluishness and solarization of the light areas. For this reason, daguerreotypes were generally less successful outdoors in extremes of light or shade. This disadvantage was sometimes utilized successfully, however, in landscapes, where a blueness of the sky, combined with warmer tones in the ground looked rather effective. In addition, daguerreotypes were often beautifully hand-colored, particularly in the flesh area of portraits or the highlights of jewels or fine clothes.

The daguerreotype was free of patent restrictions in France, and was enormously popular and successful in that country, although Talbot's paper process also had a large following. In England the daguerreotype was almost exclusively used by professionals, while amateurs preferred to experiment with Talbot's process. In America, however, the paper negative process was never taken up successfully, and the daguerreotype enjoyed a virtual monopoly of the market until the invention of the wet collodion process. American daguerreotypes have a quality of their own — technical advances and the introduction of steam-driven machinery meant that copper plates were electrotyped and machine-polished. They therefore exhibited an even greater clarity than European daguerreotypes, but perhaps lacked a certain softness and subtlety in the image, with the exception, perhaps, of the work of the greatest exponents, Southworth and Hawes.

PHOTOGENIC DRAWING

Photogenic drawing was the name which was given by William Henry Fox Talbot to the images produced by his earliest experiments during the 1830s and which he communicated to the Royal Society in response to Daguerre's announcement of the daguerreotype in France. Talbot showed examples of his prints at the Royal Institution on January 25, 1839, and presented a paper to the Royal Society on January 31, followed on February 21 by another paper containing all the working details of the process.

Talbot used smooth, good quality writing paper which he dipped into a weak solution of common salt and wiped dry. This was sensitized by brushing one side with a solution of silver nitrate and was then dried. The prepared paper, when needed for use, was washed

in a saturated solution of salt and could then be exposed wet or dry. The image "printed out," that is, appeared by the action of light, those parts exposed to light turning dark. Fixing was originally done with a strong solution of common salt, or in a solution of potassium bromide or iodide, until Sir John Herschel suggested the superior action of sodium thiosulphate ("hypo"). It was also found that repeated washings of salt and silver nitrate solutions and drying, before exposure, increased the sensitivity of the paper.

The name photogenic drawing is nowadays commonly used to describe *photograms* made by the photogenic drawing method. Talbot did indeed make many of his earliest images by the action of light through leaves, lace, or grasses laid directly on the paper, but he also produced many negative images in the camera by this process, the first documented being of the latticed window at Lacock Abbey in 1837. Because of their experimental nature and the inadequacy of the fixing agents, photogenic drawings vary in color from the normal pinkish or purplish brown, through lilac, lemon yellow, and pale blue to an orange russet. They are the most elusive of photographic images and perhaps convey more than any other process the wonder associated with the first photographs.

BAYARD'S DIRECT POSITIVE PROCESS ON PAPER
Hippolyte Bayard invented a direct positive process on paper in 1839, quite independently of either Daguerre's or Talbot's methods. He produced direct positive prints in the camera by March, 1839 and exhibited thirty of them in June of that year. He was never acclaimed as one of the independent inventors of photography since his method was not published, probably owing to the influence of François Arago, who was eager not to detract from the success of Daguerre's method.

Bayard used ordinary writing paper which he sensitized with silver chloride in the same manner as Talbot, but which he then blackened completely by exposure to light. After soaking it for a few seconds in a solution of potassium iodide, he exposed it in the camera. The image was formed by the parts exposed to light being bleached by the separation of iodine from potassium iodide and its combination with the blackened silver. When the image was formed, it was originally fixed in a solution of potassium bromide, but later, following Herschel's suggestion, in a solution of sodium thiosulphate ("hypo"). The print was finally washed in warm water.

Because of the absence of a negative, direct positives have the same disadvantage as daguerreotypes—they are incapable of direct duplication. For this reason, Bayard's method was not taken up, and Bayard himself turned to the negative process. However, these early images of Bayard's have their own feel and color, and have an obvious attraction, not only for their rarity, but for his accomplishment, which is felt even more when one knows the story of his lack of recognition.

CALOTYPE OR TALBOTYPE
The calotype process is a negative process on paper—essentially a much improved version of the *photogenic drawing* process—invented by Talbot and patented by him in 1841. This process, with various modifications and improvements, formed the basis for all paper negative techniques until the introduction of the albumen and wet collodion methods on glass, and was used by many photographers into the late 1850s. The use of this process ran concurrently with that of the daguerreotype, and although the technical competition between these two simultaneously announced processes is made much of by historians, more practical considerations such as patent restrictions and the geographical location or professional and social connections of photographers are more likely to have initially determined the process used. Later on in this period, since the two processes produced very different kinds of images, the deciding factor was more likely taste or function.

For the calotype, a good quality writing paper was prepared by brushing one side with a solution of silver nitrate. It was dried and then immersed in a solution of potassium iodide for two or three minutes to allow the formation of silver iodide. The paper was then washed and dried, at which point it appeared pale yellow on the coated side. When needed for use the paper was brushed with, or floated on a bath of, a mixture called gallo-nitrate of silver. The paper could then be placed either wet or dry in a dark slide and exposed in the camera. In good light the latent, or invisible, image formed in not much more than a minute. It was then developed, or "brought out," by washing with gallo-nitrate of silver; finally, it was thoroughly washed and fixed in a bath of sodium thiosulphate ("hypo"). The discovery of the latent image, subsequently developed, made exposure times much faster and formed the basis for most of today's photographic procedures.

The calotype process was much employed in France, with many useful modifications introduced by French photographers, as was the daguerreotype in England. However, the calotype never became popular in America, whereas the daguerreotype is thought by many to have reached its height there. Although the term calotype is often used to describe salted paper prints from calotype negatives, it strictly applies only to the negative process patented by Talbot. Calotypes appear a rather grayish or black brown, due to the gallic acid developer, whereas the prints from these negatives are usually made by the photogenic drawing method and, once stabilized, appear in various hues of brown. The main practical and commercially applicable advantage of the calotype over the daguerreotype was the possibility of printing any number of positives from one negative, and this fact was noted by Talbot who produced the first printed book to be illustrated by photographs, *The Pencil of Nature*, in 1844–45. The granular appearance transmitted by a calotype negative when printed is due more to the fibers of the paper than to the inherent grain of the silver salts. The effect was greatly improved by waxing the negatives to render the paper more translucent, and the ability of this gentle and sensitive process to record detail is very much underrated.

SALT PRINT OR SALTED PAPER PRINT
This literally refers to plain (salted) paper printing, which consists of sensitizing a good quality writing paper by immersing it in a solution of common salt, and then floating it on a bath of silver nitrate. The paper is exposed by contact in printing frames until the image reaches the required depth, and then it is washed, toned, and fixed with sodium thiosulphate ("hypo").

This method is virtually Talbot's original one for *photogenic drawing* paper, with the use of sodium thiosulphate ("hypo") subsequently added to fix the image. However, the term is commonly applied—when cataloging photographs where there is no more specific documentation—to all plain methods based on the photogenic drawing or calotype processes. Prints from these processes have a matte surface, the image or silver salts appearing to be slightly embedded in the paper rather than clearly contained in a medium or emulsion on the surface of the paper, as with the slightly glossy albumen paper.

CYANOTYPE OR BLUEPRINT
Invented by Sir John Herschel in 1842, this is one of the earliest photographic processes, and also one of the easiest and most practical. Until recently, it has been widely used by engineers and architects to reproduce technical drawings.

Suitable paper was brushed with a solution of ammonio-citrate of iron and potassium ferricyanide. It was dried in the dark and exposed by contact printing in daylight, which produced a weak green image. The print was then washed, which served simultaneously to remove the coating unaffected by light and to reduce the remaining salts, forming the image to an insoluble Prussian blue. The image was per-

manent and no chemical fixing was necessary. When white paper was used, the image appeared bright blue on a white ground.

Cyanotypes can be toned by chemical means to various other colors, but this is often unpredictable and sometimes affects their stability. The process itself is very fine, the image appearing matte and slightly embedded in the paper, as with any salt print. It has been used infrequently by photographers to produce camera images, undoubtedly because of its extraordinary and surprising color. A very early use of the cyanotype as a practical means of making a permanent record was by Anna Atkins, who made photograms of seaweed by this method to illustrate a privately published book in 1843. She also produced the text by this method. There was a later vogue for this process around the turn of the century when several photographers used it, including Frances Benjamin Johnston, Charles Lummis, and Edward Curtis, as well as many amateurs in America (as in plate 143).

BLANQUART-EVRARD'S IMPROVEMENTS ON THE CALOTYPE

Louis Désiré Blanquart-Evrard was the first in France to see the full potential of the paper negative process developed by Talbot in England. It was recognized that the mirror-like qualities of the daguerreotype, although exceptionally beautiful, were not compatible with the aims of artists and patrons in general, and that what was needed to satisfy them was a very fine paper proof comparable to a sepia drawing or a fine print. Blanquart-Evrard set about his own improvements to the process and made these public in 1844. So popular was his method in France that he set up a firm in Lille to produce prints from amateurs' negatives and to provide editions of prints for books and portfolios.

The paper was prepared by immersion for two or three hours in a bath containing a solution of gelatin and potassium bromide and iodide. The paper was then hung up to dry and stored for future use. Immediately before sensitizing, the paper was exposed to the vapor of hydrochloric acid for about fifteen minutes. It was then floated on the sensitizing bath, containing a solution of silver nitrate with nitric acid to give it an acid reaction, and could then be exposed wet or dry between two sheets of thin glass. The paper was exposed until the image was just visible, and then developed in a normal gallic acid solution at 80° F for at least fifteen minutes. When the desired intensity was reached, the prints were immersed in a bath of sodium thiosulphate ("hypo") for five minutes, during which time they were also gold-toned. They were then removed to a second bath of "hypo" for a further twenty minutes to complete the fixing, washed thoroughly, and put into a bath of hydrochloric acid to remove a yellow deposit and spots formed during the process. Finally they were washed again and left exposed to light for several weeks; during this time their rather reddish tone turned to purplish black.

The fine, rather matte tones of these prints lent themselves particularly well to the topographical and architectural photographs which Blanquart-Evrard published during the 1850s. Henri Le Secq's architectural photographs, Maxime Du Camp's of the Middle East, and Salzmann's of Jerusalem were all published in the first half of the 1850s, and they have in common a certain abstract impressiveness, brought about partly by the intense contrast of his method and partly by the particularly dark color of his toning, which compared favorably with an exceptionally fine lithograph.

WAXED PAPER NEGATIVES (see also WAXED PAPER PROCESS OF GUSTAVE LE GRAY)

Ordinary calotype negatives were often waxed after completion, to facilitate printing by rendering the paper more translucent. White wax was melted and spread over the back of the negative with a hot iron, and the excess absorbed between sheets of blotting paper. This should not be confused with Le Gray's method, in which the paper was waxed before sensitization.

WET PAPER NEGATIVE AND "ALBUMINE RAPIDE" PROCESSES OF HUMBERT DE MOLARD

Humbert De Molard was a country gentleman and friend of Bayard. A successful daguerreotypist, he experimented with the salted paper process from 1840 and had a particular interest in chemical accelerators.

De Molard produced his negatives by floating paper previously coated with a solution of iodide of ammonium on a bath containing a solution of silver nitrate, zinc nitrate, and acetic acid in water. The paper was then placed, moist side down, on a sheet of glass and exposed in the camera. Development was done by floating on a bath of a saturated solution of gallic acid and a saturated solution of ammonium acetate. The image appeared very rapidly; washing and fixing were performed as for other salted paper prints. When the prints were dry, he usually waxed his negatives to render them more translucent.

De Molard later claimed to have used a process he called *albumine rapide* for negatives, with success on both paper and glass, from about 1846. Little is known of the details of this method, but the paper or glass was evidently sensitized with a coating of albumen containing silver iodide, the sensitivity of which was increased by the expansion of the albumen by means of various amyloid or starchy substances.

The various experimental processes of the early photographers increase the interest of photography from this period, and De Molard's prints, like Bayard's, have physical characteristics that imbue their photographs with an aesthetic of their own.

WAXED PAPER PROCESS OF GUSTAVE LE GRAY

Gustave Le Gray, in France, perfected a development of Talbot's calotype process which, from its publication in December, 1851 (roughly coinciding with the relaxation of Talbot's patent restrictions in England), caused a renewed enthusiasm for the paper negative against the new wet collodion method on glass. Le Gray's method, by waxing the paper before sensitization, produced a very fine and detailed image. In addition, his method had the advantage over the calotype (which had to be used within a day of preparing the paper and developed within a day after exposure) of being able to be kept for up to two weeks after preparation and to be left several days after exposure before being developed. It was thus ideal for the traveling architectural or landscape photographer, and was particularly popular among amateurs until the latter 1850s.

A good quality, smooth paper was placed on a heated, silvered copper plate, and pure white wax was rubbed into it. It was then ironed between sheets of blotting paper to remove the excess. This had the effect not only of rendering the paper translucent, but also of filling up all the pores of the paper and making a continuous surface for coating that slightly absorbed the silver salts. The iodizing solution was made from rice water, milk sugar, potassium iodide, potassium cyanide, and potassium fluoride; the waxed paper was soaked in this for about an hour, then dried. The paper was sensitized by floating it for about five minutes on an acid solution of silver nitrate; it was then dried and exposed. The latent image was developed by immersion in a gallic acid solution for up to three hours. It was then fixed and washed as usual with other salt prints.

Prints from negatives by Le Gray's process could be on salted paper or albumen during the 1850s, and unless documentation about the negative existed it would be impossible to be conclusive about the negative process from the appearance of the print. An improvement on post-waxed calotypes, with the sensitive emulsion lying on top of a continuous, smooth, waxed surface, this process had the advantage of being as detailed as if on glass. However, the superior speed of the wet collodion method, combined with the robustness of glass plates for printing any number of prints from a single negative, caused the paper negative to become virtually obsolete by the 1860s.

ALBUMEN PRINT

The albumen print was introduced by Louis Désiré Blanquart-Evrard in 1850, and for the next thirty years was virtually the only printing method used. Thin, good quality writing paper was coated with albumen (made from fresh egg white), and then sensitized with a solution of acidified silver nitrate. The prints were fixed in plain "hypo" (sodium thiosulphate), and gold chloride was often used in the fixing bath to obtain a deeper, more purplish tone. The emulsion, and therefore the image, lay on the surface of the paper (as was not the case with the salt print) and produced a smooth, slightly glossy surface, which, uninterrupted by the surface of the paper, enhanced the richness of the tones and the very fine detail in the image.

Because of the period they cover, albumen prints may be printed from various types of negatives. Until 1851 or 1852, they were usually printed from paper negatives (calotypes), which were sometimes waxed to increase detail in the image by making the paper more translucent. Paper or waxed paper negatives were used, with various modifications to Talbot's original patent, by some photographers into the late 1850s, particularly English amateurs, including John Dilwyn Llewellyn and Benjamin Brecknell Turner. The albumen on glass negative had been invented in Paris by Niépce de Saint-Victor in 1848, but was not popular outside France. It is impossible visually to tell a print from an albumen glass negative from one from a collodion glass negative, unless extra documentation or the negatives themselves exist. Wet collodion negatives were introduced in 1851 by Frederick Scott Archer, and became the most popular kind of negative used throughout the life of the albumen print and the ones most often associated with it. They were simultaneously superseded about 1880 by the gelatin papers and dry plates.

Albumen prints in good condition vary from a dark, purplish, bitter-chocolate color through a range of browns to rich russet. The dark tones seem infinite in depth, like Goya's "blacks"—although made up of any color but black, they seem blacker than black—and the light tones are a slightly creamy white. The permanence of the dark tones and whites in albumen prints seems to bear some relation to the presence of gold toning. This process is particularly altered by fading, and most albumen prints from the mid-nineteenth century demonstrate this to some degree. Fading causes an alteration in the color and often the tonal balance of the print, to a common yellowish color, regardless of the color bias of the print when new. This does not necessarily destroy the visual power of an albumen print, for often the extraordinary range of tones produced by this process (unmatched by modern-day papers) is retained, although diminished, in a faded print, and localized fading occasionally enhances the distant tones of a landscape.

Albumen prints from collodion negatives were made in a variety of formats and for much wider consumption than had hitherto been known. During the period of their popularity, travel became more fashionable and gradually available to more people and so also did the supply of photographic views. Photographers traveled with heavy plates and portable darkrooms to Europe, the Middle East, India, and South America, producing some of the finest photographic prints ever. The increased accessibility of the medium led to a massive upsurge in the number of photographs produced, with an inevitable variety both in character and quality. Photography became a major industry in the late 1850s, with mass-produced *cartes de visite* portraits and stereoscopic views, and in the 1860s with tourists' views, the precursors of picture postcards.

But from a contemporary point of view, perhaps the most interesting and compelling development of the albumen/collodion period is the appearance of large-format photographs. In spite of the difficulty of dealing with the collodion negatives, photographers such as Frith in Egypt and the Bisson Frères in the Alps took photographs as large as 20 by 16 inches. The prints, being contact prints, lost nothing of the incredible detail and richness of this process by being so large,

and by the late 1850s the public could see some of the most spectacularly beautiful prints ever produced. Still using waxed paper negatives, Linnaeus Tripe made albumen prints of India and Burma which have a unique quality. Partly because of the texture of the waxed paper negative, they have a grain which gives them a dusky appearance, which is enhanced by the purplish tone and brushed-in skies. In England, Roger Fenton had been producing unrivaled architectural and landscape studies, and in his final still-life photographs communicated the texture and quality of fruit and flowers in a way that transcends the formal Victorian subject.

The intrinsic beauty of the albumen print from a collodion negative did not depend entirely on the technical virtuosity of its user. Julia Margaret Cameron produced prints which were made from cracked negatives or were often out of focus or suffering from uneven distribution of collodion over the negative, giving uneven tones. In spite of this, those prints of hers which have not faded badly are among the most powerful images of their time. Their milky sensuousness perfectly conveys the quality that her prints have of being agents of their time.

WET COLLODION PROCESS

The wet collodion process on glass revolutionized photography from 1851. Collodion, made from pyroxyline (a kind of guncotton) dissolved in a mixture of alcohol and ether, was introduced in England in 1847. R. J. Bingham, one of Faraday's assistants, was the first to suggest its use in photography, as was Gustave Le Gray, independently, in France. But the first wet collodion on glass negatives were demonstrated by Frederick Scott Archer late in 1848, and his perfected process was published in March, 1851.

A perfectly clean glass plate was coated with prepared collodion in which were dissolved bromide and iodide salts. As soon as the film had set, the plate was immersed in a solution of silver nitrate, thus forming silver iodide or silver bromo-iodide in the collodion. It was then exposed in the camera and developed while still wet, normally with a proto-sulphate of iron developer, but a pyrogallic acid developer was sometimes used. The negative was usually intensified, fixed in a saturated solution of sodium thiosulphate ("hypo"), and washed. Finally, in order to prevent decomposition of the pyroxyline film by contact with air and moisture, the negative was varnished with a spirit varnish, which also helped to protect it from scratching.

The method was clearly not without its practical disadvantages. Glass was heavy and breakable; the manipulation involved in coating the plates with collodion was an art in itself; and, most of all, the entire operation had to be performed in the dark "on site," while the plates were still wet. This made it necessary to transport dark tents, apparatus, glass plates, and chemicals to every location. The advantages of the glass negative were, however, so great that they far outweighed these hardships. Its speed was faster than the salt paper processes. Also, having a structureless film, very fine grain, and clear whites, this process afforded incredible detail and tonal range which have never been bettered. It became virtually the only negative process in use between the mid-1850s and the 1880s, when dry plates became available.

COLLODION POSITIVES (AMBROTYPES, FERROTYPES, TINTYPES)

"Collodion positive" is the technical term for each of these three, and, in England, was the name commonly applied until recently to positives on glass made by the collodion method, although the American name ambrotype has become more popular of late. Ferrotypes or tintypes are collodion positive images on "tin," thin sheets of iron enameled black or dark brown. Textiles, wood, and leather were also tried as bases for this process in the 1850s, but had little practical application.

Ambrotypes were made from about 1852, after the introduction

of the *wet collodion process*. It was found that a collodion negative, developed in an iron developer and treated with a bleaching process, would appear as a positive image when viewed by reflected light against a dark ground. The method was quickly adopted by photographic studios everywhere to produce a cheap version of the daguerreotype. The glass plates were produced in sizes similar to those of daguerreotypes, and in the same kind of decorative cases, with pressed brass or copper surrounds holding the cover glass against the plate. Behind the image was a piece of black velvet or paper, or sometimes the back of the image was lacquered black, causing it to appear positive.

Tintypes were originally introduced in the United States, where they were most popular, in 1854. They never enjoyed the same popularity in Europe, except for a late revival among seaside photographers in England in the 1870s. In America they became more popular than the ambrotype, particularly with itinerant photographers who traveled the large expanses of newly settled country taking portraits and views. At first also set, like the ambrotype, in decorative cases behind glass, tintypes were usually later placed in card or paper surrounds. They came into their own at the time of the American Civil War, when photographs of loved ones could be sent through the mail without breaking. Tintypes normally varied in size from whole plate to no more than a thumbnail.

The attraction of ambrotypes or tintypes often depends on their vernacular subject matter. Unlike daguerreotypes, which could not be afforded by many and have an overriding preciousness, these methods made it possible for many ordinary and extraordinary people to record themselves, their families, their homes and possessions, and very often their livelihoods. Many of the most interesting are of a particular trade or profession, as is our ambrotype of the firemen (plate 56).

STEREOCARD
A term referring to the format, not the process of a photograph. Two slightly different views of the same subject were mounted side by side on a card about 3½ by 7 inches. The system depended on the binocular vision of the human eye. When the viewer looked through a stereoscope, each eye saw only one of the images, and these two were fused into one seemingly three-dimensional image by the brain.

The two images were usually taken on one negative in a camera having twin lenses, about three inches apart, corresponding to the width between human eyes, and like human eyes having equal foci. In the early days a similar effect was obtained by a single-lens camera on a baseboard, the camera being moved across the baseboard between the first and second exposures, and the prints subsequently mounted side by side.

Stereocards were produced from the late 1850s in large numbers, reaching their height of popularity in the 1860s. They were invariably albumen prints on cards, but later, after 1880, they were made for a dwindling market on the gelatin-based emulsions. Stereo daguerreotypes, ambrotypes, and glass transparencies were less common.

LANTERN SLIDE
Lantern slides, the nineteenth-century equivalents of today's transparencies or slides, were positive images on glass made to be viewed by light transmitted from a projector.

The medium used to form the emulsion depended on when the slides were made: before 1880 the emulsion would have been albumen or collodion on glass, after 1880 a gelatin or collodion base may have been used. Slides were usually made by copying either in the camera or in a contact-printing frame, since to produce a very finely graded image it was necessary to use a slow emulsion. Direct positive methods, using reversal baths, were later employed. Whereas a negative had to have great opacity, a good slide had to be developed for optimum transparency and strong, pleasing color. For this reason,

slides were usually gold-toned before being fixed in the normal way. Finally the emulsion was protected by a cover glass of the same size, the two pieces of glass being bound together around the edges with a pasted paper tape.

Lantern slides came in standard sizes, in Britain 3¼ inches square and in the United States and Europe generally 3½ by 4 inches. They were frequently made, particularly in the late 1850s and 1860s, for the stereoscope, as was the image by Piazzi Smyth (plate 62).

GELATIN DRY PLATES
The gelatin dry-plate negative, so called to distinguish it from the wet collodion method, could be used dry and stored in the dark until needed. Light-sensitive silver halides were suspended in a gelatin emulsion, which had the property of never completely drying out.

The first published accounts of experiments with the gelatin dry plate were by Dr. Richard L. Maddox in 1871. Within two years, Burgess of Peckham, South London, was selling ready-made emulsion for photographers to coat their own plates, and ready-made dry plates were available by 1878. By 1880 they had become popular and, from then on, completely superseded the wet collodion method. The portable dark tent became obsolete, and there was little need for photographers to make their own plates anymore, although commercially made dry plates varied considerably in quality.

It is impossible to tell a print made from a dry-plate negative from one made from a wet-plate negative, unless the edges of the negative have printed and the method of coating is obvious. Any further difference in quality is more likely to be attributable to the method of printing. However, printing techniques changed at about the same time as the dry-plate became popular. So, broadly speaking, it is likely that an albumen print is from a wet-plate negative, whereas a gelatin silver print or one on printing out paper is from a dry-plate negative. Also current after the advent of the dry plate were platinum prints and the various gum and oil processes.

PRINTING OUT PAPER (P.O.P.)
Printing out paper, generally known as "P.O.P.," was the successor to the albumen print. Literally it meant a paper on which the image "printed out" visibly beneath a negative on exposure to daylight or strong electric light, but technically the name P.O.P. is applied only to silver chloride papers of this period. (The salt print, for instance, is also strictly a "printing out" method.) The paper was coated with silver chloride in a gelatin—or sometimes collodion—base, both types being handled in the same way. After the image was contact-printed to the required depth, prints were usually gold-toned, which gave a reddish or purple tone to the image, depending on the amount of toning received. They were finally fixed in sodium thiosulphate ("hypo") and washed.

P.O.P. papers were supplied by most manufacturers by the 1890s, and their availability corresponded roughly to that of the gelatin dry-plate negative. Besides pink or mauve base tints, papers were produced in glossy, matte, or "carbon" surfaces (the "carbon" being an attempt to imitate the appearance of a carbon print) and on double-weight papers and postcard formats. A further development was the self-toning paper, in which gold was contained in the emulsion and only fixing was necessary.

The surface appearance of P.O.P. is somewhere between that of an albumen print and a toned silver bromide print. The weight of the paper varies, but was often thin, as for albumen prints, when collodion was used as a base. Gelatin papers are more easily distinguished, particularly with their glossy surface, since gelatin is a thicker substance than either albumen or collodion and the image appears to be held inside the emulsion, like a glaze on top of the paper. However, with either base, P.O.P. prints have a slightly different color than albumen prints. The tone of the highlights appears pink or mauve in the case of tinted papers, and the color of the image

is generally of a redder or purpler tint, the light areas lacking the yellow cast of an albumen print.

Gaslight or silver bromide papers gradually superseded P.O.P., although P.O.P. was used, with diminishing popularity, until the Second World War. Many very beautiful prints were produced on these papers, in particular Atget's exhaustive and haunting documentation of Paris and its suburbs.

SILVER PRINT OR GELATIN SILVER PRINT

Silver print is a general term meaning literally any photographic print in which the light-sensitive salt contained in the emulsion is one of the silver compounds. Some nineteenth-century sources also refer to Talbot's method as "silver printing."

However, the term has been taken up in America by photographic historians to denote the standard black-and-white gelatin silver halide prints in use, in one form or another, from the 1880s up to the present. This is correct but imprecise, since the many papers in this category contain a variety of silver salts and since many were toned or finished to appear quite different from each other. The range of imitative papers on the market was enormous during the early years of the twentieth century, when bromide papers were produced to imitate platinum or hand-manipulated methods, with the advantages of being both quicker and cheaper. But without documentation it is hard to identify the many silver halide papers on visual evidence alone, particularly with well-preserved prints; therefore, a conglomerate term to encompass all the silver processes of the gelatin period is at least useful.

SILVER BROMIDE PRINT

A silver halide developing-out paper, in which the sensitive salt is silver bromide, suspended in a gelatin emulsion. Bromide paper is very adaptable, being fast and capable of enlargement.

Invented and first produced by Peter Mawdsley in 1873, bromide papers were produced commercially from about 1880. During the early years, they showed a marked lack of contrast and detail and were not as pleasing as their slower but beautifully detailed rival, printing out paper. This was later overcome, and the process became the most popular and widely used of the twentieth century, only recently being superseded by the resin-coated papers. (Resin-coated papers also contain silver bromide as the light-sensitive agent, but have so far been referred to as "resin coated" in order to differentiate the two types.)

Silver bromide prints have a cold, greenish gray cast to their blacks. They can be produced in many surfaces including matte, semi-matte, and glossy, and can be glazed. They can be toned to various shades, however, which can lead to confusion in certain periods. From about 1900, bromide papers were made to imitate platinum paper, which was more expensive and gradually became unavailable about the time of the First World War. During the 1920s, sulphide toning was popular and produced a permanent, brown image. Also at that time, a variety of textures for "art" photography were introduced with the use of papers having linen, canvas, or luster surfaces.

SILVER CHLORIDE PAPER

A developing-out printing paper in which the light-sensitive silver salt was silver chloride. Slow in response to light, it was first known as "gaslight" paper, since it could not be used for enlarging, but only for contact printing by gaslight. For this reason, it was also sometimes known simply as "contact" paper. Josef Maria Eder and G. Pizzighelli invented silver chloride positive paper; they published their results in 1881, but it was not generally available until about 1890.

This paper was very popular with amateurs, who, because of its slow speed, could handle it and even develop it under a low artificial light or a yellow safety light. Silver chloride papers were usually developed in a Metol-hydroquinone developer, which gave a blue-black color, and were produced in matte, semi-matte, and glossy surfaces. They remained popular until the middle of the twentieth century, perhaps particularly in America, where fine contact prints, rather than enlargements, have always been favored. In some ways, the matte-finished blue-black contact prints might be seen as the most satisfactory successors to the platinum print, and Alfred Stieglitz, always particular about his gray tones, used them in preference to bromide papers (plates 171 and 172).

CHLOROBROMIDE PRINT

As the name implies, these printing and enlarging papers were gelatin emulsions containing substantially equal parts of silver chloride and silver bromide. As such they were slower than bromide papers but, having warmer tones, they gave better blacks. Papers varied considerably in speed and color depending on the proportion of silver bromide to chloride. Later versions were dye-sensitized to increase the speed.

Invented by Josef Maria Eder in Vienna in 1883, the first chlorobromide paper available in Britain was marketed by Marion & Co. under the trade name *Alpha*. By direct development these papers gave a warm brown-black image color. With the use of various developers and gold-toning, colors from red, through purple and black, to blue could be obtained.

Because of their warm brownish tones these papers were favored by the pictorialists, and by the 1920s they were being produced in a variety of "art" surfaces, created both by paper texture and by the finish of the emulsion. These papers are particularly associated with this period, when an enormous quantity of amateur work was produced in the pictorial tradition (which is still little known), from the West Coast of America to Europe and Japan.

PLATINOTYPE OR PLATINUM PRINT

Although Sir John Herschel and Robert Hunt had observed the action of light on platinum salts as early as 1832 and 1844, respectively, it was not until 1873 that William Willis suggested the first practical method for making platinum paper, which then became generally available after the founding of the Platinotype Company in 1879.

Since the platinotype was a salted paper process, the paper was first sized to prevent the salts sinking too far into it. The paper was next sensitized by coating it with a solution containing potassium chloroplatinate and ferric oxalate and then dried, at which point it appeared pale yellow. The image was partly printed out under a contact negative, a gray-brown image with orange highlights being formed by the conversion of the ferric oxalate to ferrous oxalate. The image was then further developed in a solution of potassium oxalate, which dissolved the ferrous oxalate and precipitated finely divided metallic platinum, which formed the final image. The print was "fixed" by washing away all remaining iron salts in several successive baths of a weak solution of either hydrochloric or citric acid, and then washed.

Metallic platinum is one of the most stable substances known, and as such the prints are as permanent as their paper base, a major distinguishing factor of the prints today. They are normally a silver-gray color, but slightly warmer tones could be obtained with the addition of mercuric chloride. Platinotypes are distinctive for their matte surface, the image appearing slightly embedded in the paper, not contained in an emulsion layer, and for the beautiful, full range of grays in the mid-tone and shadow areas. For the greatest exponents of this process, most notably P. H. Emerson and Frederick Evans, these full and even tones facilitated an extraordinary tonal delicacy, for Emerson, providing the ideal medium for his lyricism, and for

Evans, qualifying his dramatic impulses. In fact, so intrinsic was the process to Evans's vision that he gave up photography when platinum paper became hard to obtain, because of its high cost, after the First World War.

AUTOCHROME

The autochrome was the first practical and commercially available color process. Based on the principles of the Joly process, patented in 1895 in Dublin, which used a three-color-lined screen on the plate, it was perhaps nearer to a system patented in 1892 in America, by J. W. MacDonough, which used a grained screen composed of particles of shellac. All these processes represented an improvement on other color methods in that they used only one plate instead of three, filters for the three primary colors being incorporated in the emulsion. What held this approach back for some years was the difficulty of mass-producing such a plate with an emulsion of consistent quality.

The autochrome process was invented by Auguste and Louis Lumière, and patented in 1904. It was perfected and made commercially available in 1907. Plates were manufactured by the Lumière brothers at their firm in Lyons, France, and were immediately a great success. During the first couple of years until the factory expanded, demand for the new plates was much greater than could be met.

Potato starch grains, 0.010 to 0.015 millimeters in radius, were dyed to the primary colors of red, green, and blue violet, and then thoroughly mixed. The resulting powder, which appeared a gray color, was evenly spread over a mirror-glass plate that had been coated with a tacky substance to which the particles adhered. The grains were machine-rolled to press them evenly onto the plate, and the surplus removed. Any minuscule spaces left between the grains were filled with black carbon. This layer was then evenly coated with a panchromatic silver bromide emulsion. During the first few years, both gelatin and collodion were used for the bromide emulsion, but the gelatin proved most satisfactory and it was used for all subsequent plates.

Autochromes were exposed in the camera with the glass side toward the lens so that light passing through the lens also went through the starch grains, which acted as minute color filters, before it reached the sensitive emulsion. The exposure was up to thirty times longer than for an equivalent black-and-white plate. In addition, the light did not affect all colors equally, so that a yellow orange filter had to be used to prevent excessive exposure of the blue violet. The plate was developed in Metoquinol, recommended by the manufacturers, or in a rodinol, amidol, or rytol developer. It was then rinsed and immersed in a reversal bath containing a solution of potassium permanganate and sulphuric acid. When all the metallic silver had been washed out and the primary image dissolved, the plate was reexposed to white light and then redeveloped in the original type of developer. Finally it was washed and dried, and the emulsion side covered with another piece of glass to protect it.

Autochromes were viewed either by projection or in hand viewers which held the plate upright, projecting the image by natural light onto a mirror inside a dark hood, where it could be viewed with extraordinary clarity. Without backlighting, autochromes are too dense to be viewed. One of the difficulties with this process was that of even distribution of colored grains on the plate. There was a one in three chance that grains of a similar color would be adjacent, and occasionally clusters of one color are clearly visible. Although obviously an obstacle to detailed color definition, this drawback affords autochromes one of their more attractive visual characteristics, giving them the appearance of an Impressionist or Pointillist painting. Autochrome plates continued to be used until the 1930s and were more successful than the rival color transparencies that came onto the market in this period. These were all finally replaced by the modern 35mm color slides.

OIL-PIGMENT PROCESS

This process produced prints which were made from pigment or ink applied by the photographer with a brush and were therefore manipulable by him. It was popular in "art" or salon photography circles from the turn of the century until the 1930s.

The process was particularly effective with large prints, but since contact printing was an integral part of it, it was necessary to produce an enlarged negative. (To obviate this, the bromoil process was invented, by which a bromide photograph, which can be enlarged, is converted to a pigment print.) A gelatin-coated paper was sensitized by brushing evenly with a solution of equal parts of potassium bichromate and methylated spirit and then pinned up by a corner to dry. Contact printing was carried out until all that was needed in the finished print was visible. The prints were then washed thoroughly in water until no trace of color was left in the darkest shadow areas. At this point the paper showed the subject only as a relief on the surface, the highlights being considerably raised above the shadow areas in the hardened gelatin.

Pigmentation of the print, carried out while the print was wet, might be done immediately, or the paper might be dried and stored for later treatment. On a flat surface, ground pigment was dabbed patiently and evenly onto the print with a polecat brush. The image appeared as the pigment was accepted or rejected in accordance with the degree of the light's action upon the gelatined surface.

There was considerable room for manipulation—from the hardness of the pigment and the skill and patience employed in pigmenting to the ability to strengthen or lighten different parts locally. Used by the members of the Photo-Secession movement in America and Europe, the process was particularly popular in England and France. Perhaps its greatest exponent was Robert Demachy (also a master of the gum bichromate print), who often left whole areas unpigmented or brushstrokes clearly visible.

GUM BICHROMATE PRINT

Based on Poitevin's patent of 1855 (see *Carbon Print)*, the gum bichromate process is a direct photographic method.

A gum arabic solution was first prepared, and then a saturated solution of ammonium or potassium bichromate and a pigment, which might conveniently consist of watercolor paint, was added to it. This was mixed very thoroughly with a palette knife and then brushed onto sized paper, applying it in two directions to achieve an even coating. It dried very fast and was ready for use. It was contact-printed under a negative, the exposure time being determined by an actinometer, since the image did not print out. Alternatively, since the speed of this coating was similar to that of P.O.P., a piece of the latter could be exposed simultaneously under a negative of similar density.

The exposed paper was then placed face down in a bath of cold water, and that part of the pigmented gum solution which had not hardened from exposure to light gradually dissolved away from the surface, leaving the image visible. During this stage the print could be "manipulated" or altered by the printer, who could aid isolated parts of the print to dissolve more rapidly or could, according to a certain design, mark it with a brush and warm water. Thus the printer could eradicate parts of the print, alter tonal values, or even leave brush marks. After drying, the print could be subjected to the whole process over again, making sure that the negative was registered with the first exposure, thereby altering further and increasing the richness of the print. When completed, the print was soaked in a solution of potash-alum to remove the bichromate stain and was finally washed in water.

By recoating, it was possible to make multiple gum prints in more than one color, and have reasonable control over the result. But most photographers working with this process developed their own meth-

ods by trial and error, and the variable elements were considerable. Results could be obtained which looked very much like wash drawings. The process was particularly popular with the Photo-Secessionists in Europe and America around the turn of the century and up until the 1930s.

GUM PLATINUM PRINT

A gum platinum print consisted of a combination of two processes, the gum bichromate and platinum, to render a very rich and subtle impression.

A fairly light *platinum print* was made first, and the finished print was then gum-sensitized as for a *gum bichromate print*. The print was then reexposed under the same negative, in register with the platinum print beneath. The pigment contained in the gum bichromate mixture in this case was usually a very transparent or thin black, which corresponded well to the tones of the platinum print and did not obscure it. When developed, this served to enrich the blacks and shadow areas, and the gum itself imparted a luxurious tonal density.

This process was not often used, perhaps because of the sheer luxury of it. However, it was much favored by Edward Steichen, who produced some of his greatest images in this process just after the turn of the century. In plate 152, two of Steichen's fellow Photo-Secessionists combine—Alvin Langdon Coburn made the print of Gertrude Käsebier.

PHOTOGRAM

A photographic image made without the aid of a camera. Talbot's earliest experiments with the *photogenic drawing* process were photograms on salted paper. Photograms can be made with any kind of photosensitive paper or film, by printing (exposing to light) directly through objects placed in contact with the emulsion, such as leaves, lace, or opaque objects of an interesting shape; the degree of translucency of the objects governs the resulting image. The term is usually applied to twentieth-century prints, the best known being by Christian Schad, who called his "schadographs," by Man Ray, who called his "rayographs," and by Moholy-Nagy, who called his photograms.

Photomechanical Processes

PHOTOLITHOGRAPH

Lithography is a method of printing an image by drawing upon a limestone, which has been prepared by polishing its surface, with a crayon made of soap and wax tallow, using lampblack for pigment. This composition underwent a change when the stone was etched with nitric acid: the fatty acids combined with the lime to form oleomargarate of lime. This adhered firmly to the stone, and the drawn image could be washed off with turpentine. As the stone was inked with a roller, the ink adhered to the affected parts of the stone, which corresponded with the original drawing, but was repelled by the unprotected part of the stone, which had become "wet" with calcium nitrate during etching.

This mutual repulsion of fatty substances and water is the basis of all lithography. A direct method was developed by Niépce, before the discovery of photography. He found that bitumen, normally soluble in turpentine, became insoluble after prolonged exposure to light. He later made the first photographic image by coating a pewter plate with bitumen dissolved in oil of lavender and exposing it to the light under an artist's print. When those parts shielded by the design were dissolved away, the image was left on the plate in hardened bitumen. The plate was then inked and etched in the normal way. Subsequently, also in France, Lemercier, a printer, Lerebours, an optician, and Barreswil and Davanne, both chemists—all involved in photography during the early years—developed Niépce's process and adapted it to the traditional method. By coating grained lithographic stones with bitumen dissolved in ether, exposing them under photographic negatives, and washing away the unhardened bitumen, again with ether, they obtained stones ready for etching and printing in the normal way. Those parts protected by bitumen prevented the acids acting on the stone, and in turn accepted the ink.

The process resulted in a very delicate, smooth print, owing to its virtual lack of relief, and the fine reticulation of the surface grain produced a subtle range of halftones. In 1853, Lemercier, Lerebours, Barreswil, and Davanne published the earliest portfolio of prints in photographic halftone.

From the mid-1850s other methods of photolithography were developed, mostly based on Poitevin's patent of 1855. Potassium bichromate was used as the light-sensitive agent in a gelatin emulsion, which adhered to the plate in a similar way, and methods involving the transfer of the image from a paper base onto the limestone or zinc plate became more usual.

PHOTOGALVANOGRAPH

Photogalvanography was a method of "engraving by light and electricity," or of printing photographically derived images by mechanical means, which was patented by Paul Pretsch in November, 1854.

A gelatin relief on glass was obtained by coating a glass plate with a mixture of gelatin containing potassium bichromate, silver nitrate, and potassium iodide. When dry, the plate was exposed to light through a photographic negative or other print. The plate was then washed in cold water or in a solution of borax or sodium bicarbonate. This dissolved out the unaltered chromium salts and caused those areas where the gelatin had been protected from the light, and not hardened, to swell up in proportion to the degree of exposure. The relief thus obtained was treated further with acetic acid, dilute copal varnish, and a weak tannin solution, in that order, to increase the swelling. The raised parts were also reticulated on the surface, coarsely or finely, in proportion to the degree of exposure to light.

This relief was made conductive by coating it with a metallic powder, and an electrotype cast was then taken. The resulting copper relief was backed with typemetal and could be used as a normal printing plate. The prints produced by this process were not sufficiently fine in the halftones for it to become very successful commercially, but it was used to produce a series of portfolios, *Photographic Art Treasures*, in 1856–57, which included prints from negatives by Roger Fenton, Oscar Rejlander, and William Lake Price as well as Cundall and Howlett's *"Crimean Braves"* (plate 34). The prints have a primitive quality which, associated with their early technical achievement, makes them rather attractive.

PHOTOTYPE ("PHOTOTYPIE")

"Phototypie" was the name given by F. Joubert to the method of printing he devised from principles contained in Poitevin's patent of 1855 (see *Carbon Print*). Joubert was a French engraver friendly with Camille Silvy, a French photographer resident in London. For the June, 1860, issue of the *Photographic Journal*, Joubert reproduced about

two thousand prints from a negative by Silvy, using his phototype method. The beautiful halftones and fine quality of this edition can hardly be bettered today, but his method was never published and remains a secret.

Cyprien Tessié du Motay and Charles Maréchal attempted to follow in Joubert's footsteps and formulated a method which was patented in England in 1865. Their prints were obtained with gelatine chromatized with sodium trichromate or other complex chromium salts, or chromium mercury complexes, which was spread upon a metal plate and then exposed under a photographic negative. Those parts exposed to light hardened, the rest was washed off, and the plate was dried. The hardened part of the chromatized gelatin adhered to the plate and could be inked directly and printed from. Although it is said that Du Motay and Maréchal were never able to print more than about seventy proofs from a single plate before the gelatin peeled, the prints were fine and displayed an excellent tonal range. Their process was subsequently further improved by others and became known as the collotype.

CARBON PRINT
The carbon print was patented by Joseph Wilson Swan in 1864. It incorporated the principles of Mungo Ponton's and Alphonse Louis Poitevin's patents of 1839 and 1855, respectively. Ponton discovered in 1839 that a sheet of paper coated with potassium bichromate became light sensitive. If exposed under a transparency, those parts left open to light hardened, while the rest remained soluble in warm water and could be washed away, leaving an orange image. However, it was not until Poitevin's patent of 1855 that a practical method of making prints, by incorporating carbon powder in the emulsion, was found.

Swan's process improved on this by using carbon tissue, which was marketed from 1866 by the firm of which he was a partner, Mawson and Swan. A piece of paper was coated with a gelatin emulsion containing pigment, which could be of any color. This "tissue" was sensitized by immersion in a solution containing potassium bichromate, then dried. It was next exposed in a contact-printing frame under a negative the size of the required image. The bichromated gelatin hardened under daylight in inverse proportion to the densities of the negative, the mid-tones remaining partially soluble. Since the hardened surface of the gelatin was uppermost, development was most effective from the back. For this reason, the tissue was placed face down on a new support, soaked in warm water, and squeegeed onto the support. Further soaking enabled the original tissue to be peeled off, leaving the underside of the gelatin exposed. This could then be immersed in hot water and the unaltered gelatin washed away. The original color of the tissue corresponded to the darkest color in the print, and the washing gradually exposed tones down to the paper base, by washing away the pigment contained in the unhardened part. The only disadvantage of this method was that the image was reversed from left to right. This could be remedied by a further transfer, but since this was not always carried out, the reversed image provides one method of recognizing a carbon print.

Carbon prints are grainless and have a very fine tonal range, enhanced by a deep gloss, when carried out expertly, as with Thomas Annan's carbon prints of Glasgow. However, artists' negatives were often retouched by companies that had acquired the rights to produce carbon prints from them, and the results suffer badly from lack of tonal gradation or true fidelity to the photograph. In this category are many of Julia Margaret Cameron's images and some of Rejlander's published by the Autotype Company.

WOODBURYTYPE
The woodburytype was a photomechanical process invented and patented in England by Walter Bentley Woodbury in September, 1864.

A sheet of talc-covered glass was coated with bichromatized gelatin colored with a little Prussian blue to make it visible. When dry, the sensitized gelatin film was stripped from the glass on its talc support and exposed to light under the required negative, on a glass base. After exposure, the unhardened gelatin was washed away with warm water, leaving a relief image in the gelatin, as with a carbon print, but without the pigment. This gelatin relief was then covered with a sheet of lead and forced through a hydraulic press at a pressure of four tons per square inch. This produced a very sharp intaglio mold in the lead, which could be used for printing, and several such molds could be taken from the gelatin relief. A mixture of gelatin and pigment or India ink the color of the final print was poured into this mold, and either white paper or glass, depending on whether a print or a transparency was required, was laid on top of it. These were then pressed together in a handpress. The superfluous gelatin was forced out round the edges, and what remained adhered to the paper or glass and formed the image, the highlights and darks being formed by the depth of the colored ink on the surface. During the setting or "drying" process, the gelatin contracted, making the relief on the image surface less noticeable. The print was placed in a weak solution of alum to harden, the surplus inky paper was trimmed from around its edges, and it was ready for mounting.

Like carbon prints, woodburytypes could be made in any color, depending upon the pigment chosen, but they were most commonly produced in a very beautiful shade of reddish dark brown, similar to a gold-toned albumen print. The gelatin gave the pigment a great luminosity, and the woodburytype is thought by many to be the most beautiful of the photomechanical processes. Because the woodburytype (like the carbon print) had to be trimmed around the edges before mounting, it was impossible to print directly onto the finished page. It was also permanent, and can be told apart from the carbon print by the slight relief left in the image surface.

In 1879, Woodbury patented an improvement and modification to the woodburytype, using tinfoil instead of lead, and this method became known as the Stannotype process. These processes became obsolete after about 1885, however, due to the enormous amount of manual work involved, and the photogravure and other methods that could be printed directly onto a final page or mount replaced them.

PHOTOETCHING
Photoetching is a term for photomechanical methods of reproduction using an intaglio metal printing plate produced by etching the plate in acid, when the image is formed on the plate by the direct action of light through a negative or transparency upon the sensitive coating which acts as a selective barrier against the acid during etching.

The earliest permanent photographic images, heliographs, produced by Joseph Nicéphore Niépce in 1827, were etched for printing. Niépce discovered that bitumen of Judea was rendered insoluble by the action of light. He used it to coat pewter plates, which he exposed to the light under a print or in the camera obscura. Afterwards the unhardened bitumen was dissolved away, leaving an image in insoluble bitumen on the plate. The plate was then etched in acid and could be inked and printed in the normal way. The printed images, however, were not continuous tone and this method was not sufficient to render the fine halftones of a photograph. Between 1839 and 1841, after the invention of the daguerreotype, various people, most notably Hippolyte Fizeau, produced directly etched daguerreotypes for printing, but these plates were not strong enough to produce many prints.

In 1852 Fox Talbot patented his first method of photomechanical printing, which utilized Mungo Ponton's discovery, in 1839, of the light sensitivity of potassium bichromate. He coated metal plates with a bichromated film of gelatin which, after exposure to light through a transparency and subsequent etching, produced plates somewhat similar in character to those of Niépce. Talbot immediately began to

improve on this method and over the next few years invented the bases of today's crossline and halftone screen processes and the grain gravure. He introduced crossline screens by exposing the plate twice, once to the negative and a second time through a piece of gauze or a ruled screen, which produced an image with ink-holding crevices small enough to survive the process of wiping the plate clean before printing. He then perfected a method of coating an exposed plate with a layer of powdered resin. The plate was heated until the granules adhered to the surface, and the plate was then etched. The fine particles of resin held the ink in varying degrees in the halftone areas according to the action of light. Talbot produced many fine prints by this method, both from his own negatives and those of other photographers. He patented this method in 1858, and it formed the basis for later grain photogravure techniques.

By the time Emerson produced his *Rope Spinning* (1887; plate 119), the term photoetching would have been synonymous with photogravure, and it may have been a matter of taste rather than technique which made the publisher call his prints photoetchings.

PHOTOGRAVURE

A photomechanical process, the grain photogravure is perhaps the finest method of reproducing a photograph. Since it is an intaglio process, the surface of the plate can retain and print larger quantities of ink than is possible in the case of lithography or letterpress printing.

The process, closely resembling Talbot's photoglyphic engraving of the 1850s and utilizing Swan's carbon tissue, was evolved in Austria in 1879 by Karl Klič. The copper plates were prepared by covering them with an even layer of bitumen or resin powder, in a dust box, and then heating the plates until the dust adhered but did not homogenize. A transparency, prepared from a negative, was contact-printed onto a carbon tissue, but not developed. The carbon tissue was then soaked and placed face down on the grained copper plate, under weights, until it adhered. The whole "sandwich" was then soaked in warm water until the tissue backing peeled off and the warm water developed the image on the plate by washing away the unaltered gelatin. This hardened gelatin image acted as a resist on the plate, which was then etched, by degrees, in varying strengths of ferric chloride solution. The etched plate was trimmed and could be printed in the normal manner on a copperplate press.

The hand-pulled photogravure was particularly popular with the Photo-Secessionists around the turn of the century and perhaps reached its height in their work, much of which was published in this form in Stieglitz's magazine *Camera Work*. At their best, photogravures display an extraordinary richness and a range of tonal values which approximates that of the platinum print, and it is no coincidence that most of the main exponents of the photogravure had previously worked in platinum. The dark areas of a gravure have a very fine, charcoal-like quality, which is also similar to the dusty quality of a gum bichromate print, again used by the Photo-Secessionists. The white areas expose the paper on which it is printed, and since this was usually a fine Japan tissue or India paper, its whiteness was often retained longer than a chemically affected photographic paper.

P. H. Emerson, a proponent of the photogravure as a final visual statement, was the first to use the process in place of a direct photographic method. The photographs in his later books, particularly *Marsh Leaves*, have the simplicity and economy of a Japanese print. Of the Photo-Secessionists, James Craig Annan and Alvin Langdon Coburn were the finest interpreters of the process.

PHOTOCHROME OR VIDAL PROCESS

The photochrome, devised by Léon Vidal in 1873, was based on the work of Louis Ducos du Hauron, in France, although Vidal refused to acknowledge this until late in life. Du Hauron took out patents in 1868 for both additive and subtractive color processes. Using three negatives obtained through three primary color filters, he printed from them onto bichromated gelatin sheets containing the respective complementary primary colors in carbon pigment. After washing away the parts unaffected by light, he superimposed these translucent sheets upon each other to form a color print.

Vidal, in order to simplify the method and adapt its use to industry, replaced the triple negatives by three identical ones on which the operator could apply resists by hand, blocking out different areas for each color. From these, printing plates could be made and printed in register, exactly as is done in chromolithography. The final clever touch that distinguished Vidal's process was the addition of a fourth printing plate, obtained by the photoglyptic or woodburytype method. When printed in a very transparent and glossy black ink, this fourth plate provided a tonal overlay to the three-color print, both increasing the contrast and detail and visually welding the image together.

Photochromes were made in the workshops of *Le Moniteur Universel*. The first to be made were for a luxurious publication, *Le Trésor Artistique de la France*, which illustrated works of art from the Galerie d'Apollon at the Louvre. Many of these objects were of enamel, silver or gold, which amply demonstrated the extraordinary virtuosity of the process for depicting rich detail. The present, little-known image (plate 110), is possibly, along with another plate in the same book, the only known instance of a photochrome taken from life. The *Egyptian Dancer and Musicians* (plate 132) was taken after the photochrome process was adapted to mass production.

TRICHROME CARBRO OR COLOR CARBRO

The carbro process derives its name from the synthesis of the two processes involved in its make-up: the *carbon* and *silver bromide* processes. Trichrome carbro (or color carbro) is a method of printing colored photographic images by superimposing three color carbro prints in primary colors, made from three separation negatives, on top of each other to form a full-color print. The carbro process is a modification of the ozotype process formulated by Thomas Manly about 1905, the important factor being Manly's discovery that the hardening of a sensitized carbon tissue can be effected directly from a bromide print.

To make a trichrome carbro print, three separate carbro prints in primary colors have to be made first. Three silver bromide prints are made, of equal density, from the color-separated negatives. To avoid any interference in the chemical action between the bromide print and the sensitive tissue, the prints must be made on non-supercoated paper and must be developed out fully and fixed and washed thoroughly. The pigmented carbro tissues—one in each of the primary colors, yellow, magenta, and cyan—are in turn sensitized in a bath of potassium bichromate, potassium ferricyanide, and potassium bromide. They are then soaked in a solution of acetic and hydrochloric acids with formalin for about twenty seconds and are placed, still wet, directly in contact with their appropriate color-separation bromide print, coated surfaces together. The tissues and prints are squeegeed together, making sure that no air bubbles exist between them, and the chemical action starts immediately. Chromium salts, liberated from the silver bromide image by the bleaching action of the acid, harden the sensitized tissue locally in direct proportion to the densities of the bromide image. After about fifteen minutes, the two are stripped apart and the pigmented tissue is squeegeed face down onto a transparent plastic support to dry. (The bromide print will be bleached and will need redeveloping.) The image is developed by immersing the "sandwich" into hot water (about 95° to 100°F) until the pigmented gelatin can be seen oozing out of the sides and the backing of the tissue can be easily pulled off. Completion of the development is accomplished by gentle agitation in the warm water,

allowing all the unhardened pigmented gelatin to be washed away, leaving a relief image.

When dry, the three separate color images are transferred one by one, starting with the cyan, to a temporary paper support, which is brought into contact with the image on its plastic base under water and then removed and squeegeed together. The magenta is second and it is registered when the sandwich is removed from the water, but before it is squeegeed down, at which stage they may be viewed through the plastic support and moved slightly against each other. Finally, the yellow is transferred in the same way. The combined three-color image is then transferred in one to its final paper support. Although this stage seems unnecessary, it is advisable since the cyan

must be on top in the final image, and to start by registering the magenta over the yellow image, which is hard to see, would present problems. The temporary and final paper supports are brought into contact under water, squeegeed together, and left to dry. This sandwich is then put into hot water and the backing paper of the temporary support peeled off. The print is then hung up to dry.

The trichrome carbro method is still in use by printers and is thought by many to be of superior quality, at its best, to any other color process. The gelatin coating containing the pigments and the slight relief of the surface give the image a real depth and luminosity. In recent years, however, the process has been superseded by the dye-transfer method, which is cheaper over an edition of prints.

ACKNOWLEDGMENTS

The primary research for this book was done by its contributors: the collectors, curators, and photographic dealers who have provided all the pictures. Where the collection has any virtue they, after the photographers, must take the credit. Where it has none, the author is certainly to blame.

I owe them all a considerable debt of gratitude, but none more than Sam Wagstaff of New York and André Jammes of Paris. Mr. Wagstaff, with his wide range of appreciation and his capacity to enjoy, indeed to live for, photographs, taught me more than anyone else about the nature and extent of the great riches hitherto unsuspected by me. He set an example which has been the largest single influence on the character of this book. André Jammes first introduced me to the splendors of early French photography, which completely dissolved any British photographic chauvinism that I may have been involuntarily harboring (while leaving my admiration for the several great British photographers unshaken). He sees collecting as "both rescue and creation" and has proved his definition magnificently. Many others have made indispensable contributions, but not of quite such a seminal nature as Wagstaff's and Jammes's.

Valerie Lloyd, Curator of the Royal Photographic Society, who has written the notes on processes for this book, not only found two of its best photographs but is also more responsible than anyone else for pointing me in the right directions. Many of the principal American contributors were recommended by her, including Sam Wagstaff and Weston Naef of the Metropolitan Museum of Art. Mr. Naef sent me further, insisting that I should go to the West Coast at a time when my nerve was failing. In Los Angeles I found Stephen White, who has the best personal collection of a dealer that I have seen, composed both of pictures by little-known and unknown photographers and rare images by famous ones. In San Francisco I found Seán

Thackrey and Sally Robertson in a gallery full of the very finest English photographs and with a commission to make a great collection for a client. I have gratefully taken advantage of it. Mr. Naef also urged me to go to a photographic seminar at the University of New Mexico at Albuquerque where, he said, I would be bound to meet people who could help. I did indeed find several good things there, apart from the pleasure of meeting Beaumont Newhall and hearing him lecture. Eugenia Janis, of Wellesley College, Mass., gave a lively talk and flashed Henri Le Secq's *Public Bathhouse* (plate 21) onto the screen. She very generously and without hesitation told me she had found it in a bundle of his prints, lying unnoticed in the Musée des Arts Décoratifs in Paris. This alone, a picture I value a little more than any other, made the trip much more than worthwhile.

The enthusiasm of the photographic fraternity (and sorority) for spreading their gospel kept me going further. When in California for the second time, I took the advice of the New York dealer Daniel Wolf and went on the most expensive taxi ride of my life, from Beverly Hills to San Marino and back. He had told me that the Huntington Library had an extraordinary photograph of peaches by Carleton Watkins, which had to find a place in this book. As I expected, he was right, and it is now plate 131.

In Paris, having gathered a rich harvest from André Jammes, I looked for more. Robert Gordon, an American photographer who is also an authority on the paintings and life of Claude Monet, and who has been a very valuable consultant, introduced me to several collectors. First to Georges Sirot, a greatly respected pioneer of the collection of photographs in France, who has unfortunately since died. Then to the Texbraun (Hugues Autexier and François Braunschweig) and Gérard Levy, a distinguished expert on photography and Oriental antiquities, who has contributed the extraordinary post-mortem

daguerreotype (plate 16). Texbraun have provided some of the rarest and most striking images printed here and were highly informative about them.

I then went to Germany, and in Hamburg I found the most passionate enthusiast for photographs that I have ever met, Werner Bokelberg. He is a photographer who spends all the money he makes from his own work on collecting that of others, particularly daguerreotypes. Later I saw him in New York, where he was picking up a remarkable Stieglitz for which he had been saving for more than two years.

London has by no means proved a photographic desert, although too many of the best photographs that come up for sale cross the Atlantic. Howard Ricketts, who once ran the photographic department at Sotheby's and now deals in historical arms, has provided more pictures than any other source in England. I cannot imagine this book without his photographs, especially the *"Study for Artists"* (plate 142). He also directed me to the National Gallery of Canada in Ottawa, where James Borcoman spent nearly fourteen hours personally pulling out boxes of photographs to show me from his first-rate and expanding collection. On my way back to New York from Canada, I stopped in Boston, where Clifford Ackley at the Boston Museum of Fine Arts proved himself one of the most discriminating curators of photography alive. He had just bought the extraordinary Atget (plate 159) from the good-natured Stephen Rose of the same city, another dealer with a highly individual and idiosyncratic collection of his own.

At the end of my search, on my last trip to New York, Sam Wagstaff told me about the Gilman Paper Company Collection. Harry Lunn of Washington, D.C., the most influential and ubiquitous of dealers, who has given me very valuable advice over the last two years, introduced me to its curator, Pierre Apraxine, and I obtained a bonus of nine photographs of the first rank from a collection that promises to become one of the three or four best in the world. I have been very lucky.

The list of people below, to whom I extend the warmest thanks, is long. All have been of great help, whether as direct contributors or for their advice or encouragement, or both.

Great Britain: Christopher Barker; Noel and June Chanan; Bruce Chatwin; Brian Coe of the Kodak Museum; Sue Davies of the Photographer's Gallery, London; Harold Evans; Germano Facetti; Robert Fraser; Jo Gannon; Philippe Garner; Hilary Gerrish; Lawrence Gowing; Ron Hall; Mark Haworth-Booth of the Victoria and Albert Museum, London; Robert Herschkowitz; Ian Jack; Kasmin; Harold Landry; Nick Lott; Sue Mann; Anthory d'Offay; Michael Rand; Ann Turner of BBC Television; John Ward of the Science Museum, London.

United States: Timothy Baum; Stuart Bennett; Peter Coffeen; Roy Flukinger of the Gernsheim Collection, University of Texas, Austin; G. Ray Hawkins; Theresa Heyman of the Oakland Museum of Art; Evelyn Hofer; Martha Jenks of Eastman House; Rodger Kingston; Susan Kismaric of the Museum of Modern Art, New York; Noel Levine; Simon Lewinsky; Jerald Maddox of the Library of Congress; Robert Mapplethorpe; John Marmaras; Richard Pare of the Seagram Foundation, New York; Arthur and Marilyn Penn; Marcuse Pfeifer; David Pratt of the Fogg Art Museum, Harvard University; Grant Romer of Eastman House; Larry Schaaf of the School of Photojournalism, University of Texas, Austin; Joel Snyder; David Travis of the Art Institute of Chicago; Leonard and Jean Walle; Paul Walter; Stephen Wirtz; Lee Witkin; Clark Worswick.

France: Agnès de Gouvion St. Cyr; Alain Paviot of the Galerie Octant, Paris; Mme Christiane Roger of the Société Française de Photographie.

Germany: Ute Eskildsen of the Museum Folkwang, Essen; Professor L. Fritz Gruber; Op Ten Hofel of Photo Historama, Leverkusen; Rudolf Kicken; Jeane von Oppenheim of the Wallraf-Richartz Museum, Cologne.

Switzerland: Erika Billeter of the Kunsthaus, Zurich; Bruno Bischofberger.

The following books have been of particular use to me: Cecil Beaton and Gail Buckland, *The Magic Image,* Boston: Little, Brown, 1975; Erika Billeter, *Malerei und Photographie im Dialog,* Bern: Benteli Verlag, 1977; *A Book of Photographs from the Collection of Sam Wagstaff,* New York: Gray Press, 1978; Helmut and Alison Gernsheim, *The History of Photography* (rev. ed.), New York: McGraw-Hill, 1969; André Jammes and Robert Sobieszek, *French Primitive Photography,* New York: Aperture, 1969; Beaumont Newhall, *The History of Photography* (rev. ed.), New York: Museum of Modern Art, 1964; Aaron Scharf, *Art and Photography,* London: Allen Lane The Penguin Press, 1968.

Special personal thanks are due to Gilvrie Misstear for her invaluable help in the preparation of this book.